ARNOLD WEINSTOCK
AND THE MAKING OF GEC

Also by Stephen Aris

The Jews in Business
Going Bust
Sportsbiz
Watergate (co-author)

ARNOLD
WEINSTOCK
and the making of
GEC

Stephen Aris

Aurum Press

First published in Great Britain in 1998
by Aurum Press Ltd, 25 Bedford Avenue,
London WC1B 3AT

A catalogue record for this book is available from
the British Library.

ISBN 1 85410 470 5

2003 2002 2001 2000 1999
10 9 8 7 6 5 4 3 2 1

Design by Don Macpherson
Typset in Times by Action Typesetting Ltd, Gloucester
Printed and bound in Great Britain by MPG Books Ltd, Bodmin

FOR A.W.

CONTENTS

PREFACE

My interest in Arnold Weinstock goes back 30 years – to the time when I was a young business reporter on the *Sunday Times* and he was just beginning to attract attention for the changes he was making at GEC. This was before he became a national figure with the takeovers of AEI and English Electric.

As a young man in the 1960s, I was impressed by his informality, his approachability and his evident delight in debate. Provided you had done your homework and could demonstrate that you knew what you were talking about, you had his full attention. This was flattering and highly stimulating.

Many years later, I approached him again to ask if he would be willing to cooperate in a full-scale biography. He answered within three days. The response was negative but not entirely so. 'Dear Stephen,' he replied, 'I am flattered by your suggestion, but for the moment I am completely occupied with budgets and cannot entertain any diversion for the next several weeks. Perhaps we can return to the subject another time if your publisher remains keen. – Yours, Arnold Weinstock'

Encouraged by the friendly tone, I set to work. However, as months turned into years, it became clear that my quarry was going to be harder to flush than I had first reckoned. My later letters were answered by the Honourable Sara Morrison, to whom the job of gatekeeper had been assigned. She too held out a distant prospect of success. 'I've talked to Arnold – and we agree! He doesn't want a biography done now. Sorry to be a pain – but my message is that for now it would have to be without his help.' But, she added, 'later might be different'.

In the end, we reached a compromise whereby it was agreed that, while Weinstock would not actively assist, he would do nothing to obstruct and that I would have a free hand to approach anyone I liked. As far as I can tell, he has been as good as his word. He has taken the entirely pragmatic line that, if he banned his friends from talking to me, then that would leave his enemies in command of the field. Some key witnesses I approached later told me that before agreeing to see me they asked Weinstock for permission – to which he characteristically replied, 'Make up your own mind.'

This is, therefore, in no sense an authorized or official biography. What it is, I hope, is a full-length action portrait of one of the most

remarkable businessmen Britain has seen this century. It is based, primarily, on long conversations with Weinstock's closest friends and colleagues with whom he built the 'new GEC'. Not a single one refused to see me. Without exception, they were courteous, helpful and most illuminating – and without their help this book could never possibly have been written. I thank them all most warmly.

But there are special debts I have to acknowledge. I owe a great deal to Sir Kenneth Bond, who spent many hours on separate occasions reliving, for my benefit, the early years of his long association with Arnold Weinstock and patiently explaining to me what they did and why. Like other writers on this subject, I have drawn heavily on the pioneering work of my former *Sunday Times* colleague Oliver Marriott and his co-author, Robert Jones. I am also grateful to Sue Willett of the Centre for Defence Studies, King's College, London, for some most stimulating suggestions and for the loan of her research material into GEC and other defence companies.

Without the encouragement of family and friends, I would have been quite lost. Berry Ritchie helped me through the hard bits and Nick Faith read the entire manuscript in draft and made a number of valuable suggestions as to how it could be improved, many of which I have adopted. Though authors often refer to their publishers through gritted teeth, my relationship with Piers Burnett of Aurum could not have been happier. He was patient in the face of extreme provocation (late delivery), encouraging when the manuscript eventually appeared, and a master craftsman when it came to copy-editing. Remarkably, he also knows a great deal about the subject and was able to put me right on a number of recondite (and not so recondite) points. Thanks also to Bob Ducas, my agent and long-time friend.

Among those who agreed to be interviewed or helped in other ways are: Iann Barron, Malcolm Bates, Sir Michael Bett, Colin Bramald, Sir Peter Carey, Lord Carrington, Michael Clark, Lawrence Clarke, Ian Davies, Stephen Dawson, Roland Dunkley, Fred Emery, Sir Richard Evans, Gwynneth Flower, Peter Gillibrand, Adrian Hamilton, Barry Hedley, Christopher Hird, Major Dick Hern, Jonathan Hunt, Derek Jackson, Martin Jay, John Nelson, Michael Lester, David Lewis, Dr Robin Mansell, Roger Matthews, Brian McArthur, Professor Ian Mackintosh, Constantia Michael, Professor Kevin Morgan, Sir Claus Moser, Brian Oakley, Sir Graeme Odgers, Sir Geoffrey Owen, Jack Pateman, Sir Geoffrey Pattie, David Ponting, Philip Ralph, John Reed, Lord Rees-Mogg, Sir Derek Roberts, Jeff Salter, Peter Stothard, John Streeter, Sir Robert Telford, Steve Thomas, Lord Tombs, Philip Treloar, Graham Turner, Sir Alan Veale, Arthur Walsh, Ray Wheeler.

I am most grateful for the patient and expert help given by the staff of

the British Library, the British Library Science Reference and Information Service, the City Business Library, the Guildhall Library, the London Library, the LSE, News International, the Westminster Reference Library, the West Greenwich Library, Woodlands History Library, Blackheath and the Campaign Against the Arms Trade. Datastream International Ltd kindly provided statistical material and NatWest Securities Ltd made their research into GEC available.

Greenwich, 8 October 1997

ONE

LEAVING STOKE NEWINGTON

Arnold Weinstock was the accidental child of elderly parents. 'I don't think I was intended at all,' he has said. 'I was a mistake.'[1] When he was born at 50 Belgrade Road, Stoke Newington, on 29 July 1924, his mother was already forty-five and his father was in his fifties. Weinstock was the last of Golda and Simon Weinstock's six children – all boys. In fact, the gap of almost eighteen years between Weinstock and the next youngest, Jack, was so wide that he was, in effect, an only child. The consequences of his early years marked him for the rest of his life.

The Stoke Newington into which the young Weinstock was born was bustling and cheerful. And though it was not exactly prosperous, it was a congenial stopping place for the Jewish immigrant familes working their way northwards from the stews of the East End. Familes who succeeded in settling in the Edwardian terraced houses in the tree-lined streets that run at right angles off Stoke Newington Road felt that they had achieved something.

Stoke Newington is still a haven for immigrants, but the Jewish community has long since gone. In its place are Turks, West Indians and, most recently, a large contingent of Kurds, who gather most afternoons in what was once a factory but now serves as an ill-lit, shabby community centre on the main road, opposite the entrance to Belgrade Road. Built in 1926, it would have been a feature on the Weinstock family's landscape. Outside 50 Belgrade Road on the afternoon I called was a rusting Mini of uncertain vintage. The house itself looked dirty and uncared for, and one of the first-floor windows was boarded up.

In an unpublished autobiographical memoir, Harold Pinter, the playwright, who was brought up only a few streets away from the Weinstocks in the 1930s, paints a vivid picture of life in the borough of Hackney of which Stoke Newington is a part:

It brimmed over with milk bars, Italian cafés, Fifty Shilling tailors

and barber shops. Prams and busy ramshackle stalls clogged up the main street – street violinists, trumpeters, matchsellers. Many Jews lived in the district, noisy but candid; mostly taxi drivers and pressers, machinists and cutters who steamed all day in their workshop ovens. Up the hill lived the richer, the 'better-class' Jews, strutting with their mink-coats and American suits and ties. Bookmakers, jewellers and furriers with gown shops in Great Portland Street.[2]

By 'up the hill' Pinter is referring to Stamford Hill, which is still a very Jewish area and is home to the ultra-Orthodox Lubavitch Foundation.

The Stoke Newington area was one of the first stepping stones on the road out of the East End for the immigrant Jews who, like Simon and Golda Weinstock, had arrived in such numbers from Eastern Europe from the 1880s onwards – fleeing from the oppressive regime of Tsar Alexander III and his successors. As Morris Beckman describes it in his account of Jewish life in Hackney in the 1920s and 1930s:

By the early 1920s, the more successful Polish and Russian Jewish immigrants who had made a bit progressed from the dockside slums towards the greener areas of Hackney, Clapton, Stoke Newington and Stamford Hill. They moved into tranquil tree-lined roads and streets, into terraces of large multi-roomed Victorian and Georgian houses. Not only were they blessed with the luxury of front and back gardens, but families no longer had to sleep three, four, even five in a bedroom. It was worth working fingers to the bone for, and this they did.[3]

Even so, 50 Belgrade Road was hardly luxurious. With its steep-pitched, gabled roof and bow-fronted windows in the mock-French manner, it was typical of the turn-of-the-century terraced house that developers had built in the spreading North London suburbs for upwardly mobile, working-class, first-time buyers. The house stands, pressed against the pavement, in the middle of the terrace, just off the busy Stoke Newington High Road, which runs like an arrow northwards from Whitechapel and the East End towards the uplands of Stamford Hill.

Simon and Golda arrived in England from their native Poland just after the turn of the century when the influx from Eastern Europe was at its height. In 1881, there were only 15,000 alien Jews in England; but by 1901 the number had risen to 95,000, of which the vast majority had settled in the East End. Like thousands of others, Simon found work of a kind in the cut-make-and-trim sweatshops of the clothing trade. It was here that Simon learnt his business as a master cutter, cutting the cloth

from paper patterns and stitching the panels together to make ladies' coats and suits.

This business was the staple of the East End, but in the early 1920s the Jewish rag trade moved its headquarters to the streets around the Middlesex Hospital just north of Oxford Circus, where it remains to this day. By the time Arnold Weinstock was born, his father was working for a small garment business called Hitchcock and Willings. On his son's birth certificate his father describes his job as 'Tailor – Journeyman'.

Just how large the Jewish community in Stoke Newington was can only be guessed at. In his biography of Harold Pinter, Michael Billington quotes the historian V.D. Lipman's estimate that North London Jewry was around 40,000 strong by 1930 – of whom a surprisingly large proportion would have been unable to write or even speak much English. As Morris Beckman says:

> I cannot recollect a single one of those immigrants, my parent's contemporaries, who had qualified in a secular profession. Any natural zest for academic achievement had been drained by the flight from persecution and then, when they reached England, [by] the effort to acclimatize and make a living. Made wary by bad experiences and the irrational hostility whence they fled, they introverted and socialized only with their co-religionists. They conversed in their native German, Polish, Russian, Lithuanian and Latvian but their main *lingua franca* was Yiddish. As a result many could only speak fractured English until the day they died.[4]

That Weinstock's mother, Golda, (neé Schag) was poorly educated is clear from her youngest son's birth certificate. In the space set aside for her signature, there is a plain X – described as 'the mark of Golda Weinstock – mother'. It seems that not only was Golda unable to write a word of English, but she was incapable of signing her own name. More than seventy years later I asked Weinstock if he would care to elaborate. He replied that he had 'no recall of his mother being able to write in English'.[5] It is perhaps a little graceless to labour this point, but the fact that someone who is so renowned for the sharpness of his mind and brilliance of his intellect should have had a mother who apparently could neither read or write, is quite remarkable. And it is a fact that makes his own achievements all the more impressive.

Perhaps unsurprisingly, therefore, Weinstock was, by his own account, a slow starter. The picture he paints of himself as a small boy is of an awkward, lonely and somewhat difficult child who did not respond well to teachers, rabbis and others in authority. He was, he suggests, a bit of a handful. Although not particularly devout, the Weinstocks, like most

of their neighbours, were practising Jews who were anxious to bring their children up in traditional Jewish ways. But the young Weinstock was a rebellious spirit who would have none of it. 'There used to be a rabbi who came to teach me Hebrew,' he told me, 'but I used to stand at the top of the road with my bicycle and when I saw him coming I used to ride in the opposite direction.'[6] He never did learn Hebrew.

While still a very small boy, Arnold Weinstock suffered a double blow. When he was five, his father, Simon, who had had a poor heart for some years, contracted pneumonia and died of congestive heart failure. It is more than possible that his health had been undermined years before by the appalling working conditions in the East End. Four years later, in 1933, his mother Golda died of cancer and the nine-year-old was taken in by his unmarried brother, Jack, who was a hairdresser and who lived not far away in Highbury – a step up socially from Stoke Newington. There were two other brothers, the eldest, Harry, and Henry, who later migrated to Canada where he died in 1993. But the difference in ages was so great that the young Arnold saw little of them during his early years. Later, Henry would pay an occasional visit. By all accounts, he was the wildest of the four Weinstock boys and had a reputation for making jokes. Rumour has it that at one stage he got into financial difficulties and was rescued by his youngest brother. If his parents had lived longer, Weinstock's upbringing and even his character might have been very different. As it was, deprived at an early age of the warmth and security of the traditional Jewish family, he was left very much to his own devices.

One consolation was music. As he told the BBC's Sue Lawley while being interviewed as a guest on *Desert Island Discs*, the BBC's popular radio programme, 'My love of music originated when I sang as a boy in a synagogue.' It was nurtured by weekly visits to the gallery of the nearby Sadler's Wells Opera House to hear singers like Joan Hammond. At that time he would have been about thirteen or fourteen. It was a love that grew into a lifelong passion that is one of the defining characteristics of his life. Mischievously, he told Sue Lawley that his first ambition was to be an ice hockey player ('a marvellous game') but 'now that I am older, I would like to have been a conductor.' The works he said he would most like to have with him on his desert island were both choral pieces: Bach's *St Matthew Passion* and Mozart's *Requiem Mass*.[7] But just as his likes are intense, so are his dislikes. As he once famously remarked, 'I suppose there *are* people who have stayed to the end of *Pelleas and Melisande*.'

Weinstock is not a man much given to hero worship, but there is one person who in his eyes can do no wrong: the Italian maestro, Riccardo Muti. One of the surprising features of his choice of records on *Desert Island Discs* was that they were all, without exception, conducted by Muti. 'I'm a Muti groupie,' he says. Weinstock makes a point of attend-

4

ing as many Muti performances as possible and has been known to jump into the GEC jet and fly off (at his own expense, it should be added) to hear a Muti first night at La Scala. And when a memorial concert was held at the Royal Opera House in October 1996 for Weinstock's son, Simon, who had died the previous May, it was Muti who came to conduct the memorial concert.

'He'll do anything for him and any orchestra he's conducting,' says Sir Claus Moser, who shares Weinstock's love of music and has been a close friend since they were undergraduates at the LSE. Sir Claus also says it's easy to tease Weinstock on musical matters.

Roughly speaking, his taste stops with Mozart and goes backwards from there. So, I'll say, 'We're going to hear some Beethoven,' and he'll groan. He's not very keen on the heavy romantics. And I've never managed to get him to Wagner. But on Mozart and earlier, he's extremely knowledgeable and extremely critical. He applies his very high standards to music.[8]

Lord Carrington, who was briefly chairman of GEC after leaving the Foreign Office in 1983, tells the story of the party he and his wife, Iona, held at Christie's, the auction house of which he was then chairman, to celebrate their golden wedding anniversary. The Pavilion Opera company, a troupe much favoured by the country-house set, had been engaged to perform Donizetti's *L'Elisir d'Amore,* after which there was to be supper. Weinstock accepted the invitation – but on one condition. He explained that he had some doubts about the possible quality of the performance of the opera, so he and his wife, Netta, would just come for the dinner, if Lord and Lady Carrington didn't mind. He was as good as his word. As he came up the stairs during the closing moments of the performance he was heard to remark, 'Just as I feared.'

In his entry in *Debrett's Guide to the Peerage,* Weinstock singles out the Albion Road Central School for special mention. The school, which was a short walk from the Weinstock family home and from brother Jack's house in Highbury, no longer exists: it was demolished after the war and replaced by a modern building which houses what is now a primary school called Grasmere. But though he would have got a basic grounding in the three Rs at Albion Road, it seems that no teacher managed to capture his interest. It was not until he was evacuated at the beginning of the Second World War at the age of fifteen that his imagination was kindled.

The outbreak of war in September 1939 saw one of the greatest mass migrations of children in the country's history. Equipped with gas masks and labels, over half London's children were sent out into the countryside

to avoid an enemy bombardment of the great cities that the government thought to be imminent and inevitable. The little party from the Albion Road school, accompanied their teachers, were billeted on the inhabitants of Withybrook, a small village deep in rural Warwickshire. It was the first time the young Weinstock had seen the countryside and he was not very impressed. 'It was in the middle of nowhere with no electricity and no running water. There was an outside loo ... most primitive.'[9]

But if the facilities were not up to much, he was agreeably surprised at the warmth of his welcome. 'The wife of the farmer with whom I lived had been a schoolteacher. She was very kind to me. And it was a very happy time despite the lack of all these mod cons.' In this he was lucky. Evacuation on this scale made matching evacuees and their hosts a very hit-and-miss affair. And many children found their hosts not to their liking, and vice versa. Poor children from the inner cities could not get used to country ways and country folk sometimes found the habits and ways of the townies hard to take.

The teacher who had taught Weinstock mathematics and music in London had come to Warwickshire and it was he who succeeded in making contact with this shy, awkward and introverted child. Weinstock has said of himself at this time, 'I wasn't appealing by any means. I was horrible.' The schoolmaster in question was called Freddy Fog. He was a lay preacher. And 60 years later, Weinstock still remembers him with great affection: 'He was a sort of surrogate father. He helped me enormously. He made me take an interest in work which no one had been able to do before.'[10]

Once planted, the seeds grew rapidly. Every morning Weinstock would walk the two miles from the farm at Withybrook to the little village school at Monk's Kirby and every evening he would trudge back again. But the time was not wasted. He says that he remembers learning the whole of *Macbeth* while walking backwards and forwards to school – 'I never had a look at the thing in class at all.' Within four months of arriving at Monk's Kirby, he had taken and passed his school certificate. In 1941, barely 18 months after arriving in Warwickshire, he was on his way to Cambridge to read statistics at the London School of Economics, which had moved there to escape the Blitz.* Already, Stoke Newington must have seemed a long, long way away.

*Although Britain had been at war with Germany for two years when Weinstock went up to Cambridge, he was too young to be called up for military service. On the first day of the war, Parliament had passed an act under which all men aged between eighteen and forty-one were liable for conscription. The call-up began in October 1939, with those aged from twenty to twenty-three, and moved progressively, but slowly, upwards. Although, in July 1941, the manpower shortage led the government to extend the age of call-up downwards to eighteen and upwards to fifty-one, Weinstock was only seventeen; therefore it was only after he left university in 1944 that he became liable for military service.

In *Enigma*, his account of the codebreakers of Bletchley Park, the novelist Robert Harris paints a vivid portrait of wartime Cambridge:

> By mid-afternoon the narrow cobbled streets were deserted. By nightfall, with not a light to be seen, the university was returned to a darkness it hadn't known since the Middle Ages. A procession of monks shuffling over Magdalene Bridge on their way to Vespers would scarcely have seemed out of place. In the wartime blackout the centuries had dissolved.[11]

It was the darkness that Weinstock remembers. 'Trumpington Street is very, very wide,' he recalls, 'and during the blackout it was so dark it was impossible to see on the other side. So the little clique with whom I hob-nobbed – mostly a table-tennis clique at that time – used to whistle the theme from the last movement of [Beethoven's] Choral Symphony and by that means we could recognize each other. It was a rather useful way of making contact.'[12]

In its move from Houghton Street in central London to Cambridge, the LSE not only changed its location, it also changed its character. 'For the first time in the history of the School it took on the aspect of an under-graduate college,' said the School's director, Alexander Carr-Saunders.[13] It also became a great deal smaller. In the last year before the war, the student body was some 3,000 strong: in the first year at Cambridge, there were some 560 regular students. The School itself was attached to Peterhouse College, where the LSE dons had dining rights at High Table. During the day, the LSE students used Grove Lodge, a large house near Peterhouse, but nearly everybody lived in digs in the town. The LSE students were different from the Cambridge undergraduates in that they did not have to wear gowns and were a good deal more left-wing. Some young fogies of the day found the newcomers hard to take. A writer in the Cambridge University *Conservative Review* reminded the visitors that 'airing your own opinions on public affairs, or your host's pictures, or your hostess's cook, on first sitting down to table' was not regarded as good form. But apart from the occasional spat, the two communities mixed well enough. 'LSE lectures and classes became increasingly inter-twined,' says Ralf Dahrendorf in his history of the LSE.

> Many Cambridge undergraduates could not resist the pleasure of listening to Harold Laski. Also, LSE brought with it the as yet forbidden subject of sociology, and Cambridge' students went to hear Ginsberg. Nor was this a one-way traffic. Law students went to Cambridge lectures, such as those by Lauterpacht, and used the libraries. The Economics Departments were virtually integrated.[14]

7

Among Weinstock's contemporaries were Norman MacKenzie, the Fabian historian, O.R. (Lord) McGregor, the social scientist, Ralph Miliband, the LSE lecturer, (Sir) Kenneth Berrill, head of the Conservative Government's 'think tank' and Steve Wheatcroft, a LSE professor. One man who remembers Weinstock well from those days is Claus Moser. Both boys were studying the same subject and both were Jewish – but from very different backgrounds. Moser's family were wealthy, highly cultivated, Berlin bankers, refugees from Nazi Germany, while Weinstock was a chippy, working-class boy. Moser went on to a distinguished career as an academic at the LSE, as well as becoming head of the Government Statistical Service and chairman of the Royal Opera House.

Moser says that although he and Weinstock were friends at Cambridge they were not particularly close – it was only later that the relationship developed to the point where the Mosers would go to concerts and to Glyndebourne with Weinstock and his wife, and have dinner with the Weinstocks at their flat in Grosvenor Square. Class, Moser implies, was one reason why the two young men were not exactly soul-mates at Cambridge. What was Weinstock like at that time, I asked? 'Well, I can say this, but you can't,' Moser replied. 'Really, he was working class, very Jewish. A bit crude and coarse. I don't mean in his language. But in his manner.' Of himself, Moser says, 'I was a tremendous intellectual snob. I also worked terribly hard and did very well. I got a better degree than Weinstock and he was better than me at ping-pong. I remember him slipping away to put money on the horses at Newmarket. He was interested in horses even then.'[15]

At the end of the three years at Cambridge, Moser came down with his expected First while Weinstock graduated with a Second. To what extent the study of statistics at Cambridge contributed to his very distinctive business style is hard to say. Weinstock himself says little about his time at Cambridge. 'The only thing I can remember of my years as an undergraduate was the title of the first economics textbook I ever saw: *The Customer is King*. And I have never forgotten that.'[16]

Despite this disclaimer, the study of economics and statistics must have played some part in shaping what was to become one of the sharpest and most analytical minds in modern British business. Later, those with whom he worked were continually amazed at his grasp of detail and at his ability to analyze figures and to put his finger on weaknesses. Much of this must be inherent. But it is, I think, reasonable to assume that the three years he spent studying statistics helped to discipline an already inventive and inquiring mind. Certainly, Claus Moser thinks so. 'I like to think that his clarity of thought owes something to his training in statistics.'

Even though his spell at Cambridge had ended in the summer of 1944, his education was not over. He was now 20 and liable for military service.

But the end of the war was in sight, and instead of being posted to a military unit fighting overseas, he was sent to the Admiralty at Bath as a junior administrative officer on £420 a year. Although this was quite a decent wage for a young, unattached man, Weinstock found it difficult to make his money last. In his interview with Sue Lawley he confessed that he has always liked to eat well. 'I used to spend my salary in the first four or five days and then I was back to the canteen.' Quite what delicacies on which to spend his money he would have found in wartime Bath is something of a mystery. But despite this sybaritic streak, he was sufficiently in tune with the times to welcome Clement Atlee's incoming Labour government. Forty-six years later, he told an interviewer that he remembers feeling pleased when the Labour Party won the election in 1945. 'I felt we had to have a welfare state. I believed in the idea of a health service. I did not believe in poverty.'[17]

During the three years he spent with the Admiralty he found another mentor who was every bit as influential as Freddy Fog had been four years previously. James Mackay was a brilliant classicist with degrees from Oxford and Glasgow, who rose to become a very senior civil servant at the Ministry of Defence and the Home Office in the late 1960s. Twenty years previously, just after the outbreak of war, he had joined the Admiralty Secretariat in Bath, where the Navy has many of its major departments, and in the summer of 1944 he became Arnold Weinstock's first boss.

Weinstock's image these days is such that it is difficult to imagine him as anyone's employee, but his feelings towards Jim Mackay are, so close colleagues say, ones of reverence and gratitude. Weinstock himself has said:

> He had a huge influence on me. He took great trouble to educate and train me. I used to write first drafts for quite important meetings, which maybe went ultimately to the First Lord. So I had very early acquaintance with matters of considerable weight, although I didn't have responsibility for them.[18]

Jim Mackay was, according to those who knew him, was a tall and imposing man with a keen, orderly mind. After his retirement he became a member of the 'great and the good'. He was much in demand for such public chores as membership of Lord Annan's committee of inquiry into public broadcasting. But in 1944 he was in his early 30s and had just left Glasgow University, where he had been a lecturer in humanities. What Jim MacKay did was to fill in a missing piece of Weinstock's education. If the study of statistics had taught him how to order, quantify and analyze data, what Jim MacKay instilled in him was the art of memo writing: how to set out his thoughts on paper in a persuasive way. Years later,

Weinstock would tell his colleagues at GEC that Jim MacKay had taught him to think logically: he was a stern critic and used to tear his protégé's efforts to shreds. As we shall see, the memo was a key instrument of management at GEC and one which Weinstock went to an infinite amount of trouble to perfect. Memos were never dictated: they were written out in longhand and almost always went through several drafts. His friend and lifelong business partner, Sir Kenneth Bond, told me:

> I think what set Weinstock off on his working life was his spell at the Admiralty where everything was dealt with in a formal manner, putting things down on paper, writing minutes and things like that. He was taught to think clearly and express himself in writing. It was a basic training in looking at and analyzing the facts and I think it did more for Weinstock in setting him off on his career than any dealing would have done.[19]

The other legacy of his time with Admiralty was, so his friends say, an abiding love of the Navy. When his daughter, Susan, was married in 1974, he asked Bob Telford, then head of GEC-Marconi, which was building torpedoes for the Navy, to use his influence with the admirals to obtain permission to hold the wedding reception at the Royal Naval College at Greenwich.

Weinstock likes to give the impression that, all things being equal, he would have quite liked to have had a full-time career as an Admiralty civil servant. When I went to see him almost 30 years ago when I was gathering material for a book on Jewish business, he told me that the reason he didn't follow this path was because he thought the chances of a Jew rising high in the civil service were limited.[20] On the other hand, he told Sue Lawley that he left because the money wasn't good enough: 'I am always a bit extravagant. I loved the Admiralty and worked very hard. But I really couldn't stay because I needed more money.'[21]

However much he might have been tempted to stay on to become a permanent civil servant, when his demob papers arrived, Weinstock was in exactly the same position as hundreds of thousands of other young men in 1947: in urgent need of job. The question was: what to do?

Quite by chance, it was his elder brother Jack, the hairdresser, who supplied the answer. Among the people whose hair Jack cut was Louis Scott, who had an estate agency based in Mayfair. On Jack's recommendation, Scott hired Weinstock as a junior assistant. One of features of the close-knit Jewish community of North London was that a great deal of what would now be called 'networking' and mutual assistance went on. It was not what you knew, but who you knew that counted. Cousins, nephews, brothers, uncles, brothers-in-laws – everybody helped every-

body else and many a business relationship was cemented by a blood or a marriage tie.

The immediate postwar years were boom-time for estate agents, many of whom, like Scott, also dabbled in property dealing. As I wrote in my book *The Jews in Business*:

> From their vantage point as young clerks in West End and subur-
> ban offices, they could watch and sometimes, as far as the ethics
> of the profession allowed, even participate in the great property
> game. They saw the dramatic effect of the twin forces of inflation
> and demand on the price of land and property and, as they were
> often responsible for the mechanical side of these deals, they could
> hardly fail to notice just how large the profits generated were. For
> an ambitious lad the rewards could be high, even if he stuck to
> estate agency and resisted the temptation to start developing on his
> own.[22]

Some like Sir Harold Samuel, Jack Cotton and Joe Levy became property developers on a heroic scale, transforming the face of London and Britain's other large, war-damaged cities. It was a business that required a sharp eye, a penchant for detail, an instinct for the market and a gambler's nerve.

By his own account, Weinstock felt that spending six years with Louis Scott was not something he would have chosen to do if he had the option. He has described the time he spent in the property business as 'messing about in property' and 'unconstructive', and gives the impression that he found the unstructured, wheeler-dealering nature of the business uncongenial.[23] Nonetheless, those who worked with him were struck by his immense capacity for work and extremely thorough approach to each problem. He read all the books on law, planning and taxation, and he would examine each deal from every angle; what was lacking, it seems, was, in contrast to Louis Scott, a nose for the deal.

Louis Scott was not just an estate agent: he was also a buyer and seller of businesses as well as property. Very often, before selling them on, he would ask Weinstock to run an eye over them and, if necessary, knock them into shape. This was the part of his work that Weinstock liked the best; and where others might have been content with a cursory glance, Weinstock would immerse himself in the detail of running the business. Even at the age of 23 he had the instincts of a manager, not a dealer. Thus, the very first business Arnold Weinstock ever managed was a high-class West End restaurant-cum-club in Berkeley Square called the Empress Club.

But Louis Scott did a much greater service to Arnold Weinstock than merely giving him his first job: shortly after he joined the firm, Scott introduced him to Netta Sobell, the daughter of Michael Sobell, the founder of Sobell Industries, a successful radio and electrical goods business. In 1949, Weinstock and Netta were married and, although Weinstock was to remain at Louis Scott's for another five years, it was the Sobell connection that was to be all-important. As the younger of Michael Sobell's two daughters, Netta was something of a catch. Not only would the Sobells become extremely rich, but her family connections were to change the direction of Weinstock's life and career. The Sobell family business was to be the platform from which the Weinstock rocket was launched. Netta was to be a loyal partner and admirable foil: while Weinstock was emotional and volatile, Netta, to whom he has been married for nearly 50 years, has seemed content to play a supporting role. In a rare newspaper interview she was asked what it was like being married to Weinstock. She replied:

> He is the most marvellous husband. Kind. A strong sense of humour. He is forever playing jokes around the house. He remembers birthdays, anniversaries and flowers, and all the things which mean so much to wives. Living with him makes you want to improve yourself, to be more efficient yourself, to be a better person.[24]

Why did Weinstock stay on in the property business and not go and work for his father-in-law there and then? The answer seems to be that Michael Sobell wanted to run his own business and was not ready to hand it over to someone half his age and whom he hardly knew – even if that person had married his younger daughter. The two men were very different: Michael was outgoing and expansive while Weinstock was shy and introspective. And although both were born Jews, Michael was as devout and conformist as his son-in-law was agnostic and independent. Throughout his long life, Michael Sobell was a conspicuously loyal and dedicated member of the Jewish community who, as his obituarist put it when he died in 1993 at the grand age of 100, 'was an industrialist who believed that giving money away was as important as making it.'[25]

Throughout the 1960s and the 1970s, Michael Sobell donated millions of pounds to Jewish and other charities in England and Israel. He gave £1.1 million to build the Sobell Youth Centre in Islington; he was an active supporter of the Jews College and was a prominent member of that formidable fund-raising machine, the Joint Palestine Appeal. He was also president of what was then the National Society for Cancer Relief and a stalwart of the Variety Club of Great Britain. When he died, he left the

bulk of his fortune – some £49 million – to the charitable Sobell Foundation.

Weinstock is proud of his Jewish origins. He delights in telling Jewish jokes and anecdotes and, in playful moments, has been known to tease his executives with the suggestion that they might profit from learning Yiddish. His sense of humour can be droll. During one takeover, when the opposition suggested that they would concede if GEC could manage another half-a-crown (12.5p), Weinstock pulled the coin out of his pocket and plumped it down on the table, saying: 'There you are.' But for all his mannerisms, Weinstock has never displayed the public commitment to Judaism that was such a feature of his father-in-law's later life. Very shortly after his marriage in 1949, he and Netta paid their first visit to Israel. For Zionists these were stirring times. The year before, Israel, after a long and bitter conflict with the British, had finally won her independence. And, immediately after the proclamation by David Ben-Gurion of the State of Israel, the new nation had triumphed in a short yet decisive encounter with her Arab neighbours. As Christopher Sykes put in it in his history of the birth of the modern state:

> Israel after the war became a land exalted by a just pride of achievement. Even its enemies could not doubt the immensity of what the nationalist party had accomplished. Within three and a half years of suffering such as few other people had undergone in the whole course of recorded history, after the loss of a third of its whole population in the world, the Jews had formed a Jewish state, only fifty-one years after Theodore Herzl had called the first Zionist Congress.[26]

Weinstock remained largely unaffected by this fervour. The visit reinforced his latent sympathy for Israel but it did not make him a Zionist. His friends say he had little sympathy with the hard-liners who came to power in Israel after the victory in 1967. In 1969, talking to me about Israel, two years after the end of the Six-Day War, he said, 'They are a beleaguered people with enemies on all sides and one always has some sympathy with the underdog. Besides they are Jews and I am a Jew.'[27]

Even so, he plays no part in the highly organized and sometimes slightly self-conscious social life of the Jewish well-to-do; he attends none of the many fund-raising balls and dinners; and he remained seemingly unaffected by the 1967 Six-Day War which caused such a crisis of conscience throughout Anglo-Jewry, especially among businessmen. When I asked him about his attitude, he replied, 'I was out of the Jewish community for years, but as I get older I get just that bit more aware of Jewish values, though it is an intellectual awareness, not a religious

13

one.'[28] Thirty years later, he told Carol Leonard that he adheres to certain Jewish traditions 'out of respect to my parents.'[29] He gave a bar mitzvah for his only son, but it's worth noting that both his son and his daughter, Simon and Susan, married non-Jews – or, as conforming Jews would put it, they 'married out'.

Weinstock himself 'married in'. It has often been said that it was his good fortune to have married the boss's daughter and that with the marriage came instant wealth and security. What this version of the story overlooks is that at that time Sobell was by no means a rich man. The real money did not come until the Sobell business was publicly floated in 1958 – nine years after Weinstock's marriage to Netta and four years after he had joined the company.

Michael Sobell was an entrepreneur in the classic mould. He was born in 1892 in Boryslav in the Galician part of Austria where his father, Lewis, dealt in commodities. In 1899, when Michael was seven, the family left the anti-Semitism of Austria for the relative security of Dalston in East London. When he was eleven, Michael was sent to the Central London Foundation School in Cowper Street, on the northern fringes of the City of London. The family was probably a little better off than the Weinstocks less than a mile away in Stoke Newington, but in most other respects their backgrounds were very similar. Unlike Weinstock, though, Michael Sobell was from the first determined to be the master of his own fate. 'My father was comfortable,' he said, 'but I had to make my own way in the world. There was nobody to help, only God, and he is the greatest helper of all. I am simply an ordinary man who has been lucky.'[30] However true that may be, it was also true that, like many entrepreneurs, Sobell made his own luck.

Like Stoke Newington, the environment in which Sobell lived and worked was a Jewish community made up of the sons and daughters of first-generation immigrants who were beginning, and in some cases already had, made their way as garment makers, small-time manufacturers, estate agents, property dealers and shopkeepers. Not many, as yet, had gone into the professions, and university graduates were in a tiny minority. For most, the first priority was to establish themselves and to escape from the traditional ghetto trades that had imprisoned their fathers and worn down their mothers. The last thing they wanted to be was cutters, pressers and the like.

Michael Sobell started out as a young man in the 1920s as an importer of what were then new-fangled electrical devices from the USA, especially small radios and refrigerators. Broadcasting, or as it was then known, radio telephony, was in its infancy. The first test transmissions had been made by Marconi early in 1920, two years before the BBC went on the

air, with engineers transmitting readings from Bradshaw – the railway timetable. When they later switched to records and recitals by local musicans, listening figures rose sharply. But by 1922, when public broadcasting began more or less simultaneously in London, Manchester and Birmingham, it was clear to everybody that a new mass-market industry was in the making. There was a sudden explosion of firms making radio receivers, and famous names such as Pye, McMichael, Ferranti and Ekco all made their appearance during this period. In the 1930s came Ferguson and Thorn Electrical Industries. Like Sobell Industries, Thorn was the creation of an Austrian-Jewish refugee, Jules Thorn, who had left his native Vienna in the mid-1920s.

Compared to Thorn, Michael Sobell's first foray into the radio business in 1934 in the form of a company called Solectric was on a tiny scale. But Sobell felt himself to be sufficiently committed to the electrical trade to change the family name from Sobel to Sobell, as he thought it to be more suitable for the business in which he was now engaged. During the war, the business prospered, the workforce grew from no more than a dozen to 180, as Sobell undertook contracts for the Admiralty and the Ministry of Aircraft Production.

But the big expansion came in the years immediately after the war, when he was persuaded by Viscount Hall, the former miner and Labour MP, to set up a radio business in a government-built ordnance 'shadow' factory at Hirwaun, near Aberdare in the Rhondda Valley. What persuaded him to go was the government's promise that those firms setting up in development areas would qualify for a special allocation of materials. In Sobell's case, this meant a guaranteed supply of precious and hard-to-come-by radio valves. Another attraction was cheap labour. According to Keith Geddes's history of the radio and television industry:

> Sobell found it difficult to get engineers to work in the area until the
> lady responsible for personnel went to a resettlement camp for Poles,
> correctly surmising that South Wales would be no more foreign to
> them than any other part of Britain, and recruited a number of good
> Polish engineers. These were later followed by several Czechs.[31]

One of these was Kurt Vesely, who became the company's chief engineer, in which post he remained throughout all the changes of the 1950s and 1960s. Geddes writes:

> In 1949 [Vesely] was an unknown refugee from communism,
> speaking poor English, and was glad enough to be engaged as a
> humble 'bench engineer' though he had held more senior positions
> in Prague both before and after the war. Initially put on to radio

15

receivers, he found that the company's current model betrayed an alarming unfamiliarity with contemporary practice, and looked as if it had been designed out of a physics textbook.[32]

However successful Sobell may eventually have become – when he died in 1993 he was worth close to £50 million – he had a hard time becoming accepted in the radio business. Starting in 1941, he applied six times to join the Radio Manufacturers Association (later the British Radio Equipment Manufacturers Association) and six times he was refused. This organization, representing the established manufacturers, had what was euphemistically described as a 'Fair Trading Agreement' with the Radio Wholesalers' Federation, which agreed only to handle the products of RMA members. To protect their position and to maintain their monopoly, RMA members agreed amongst themselves not to admit any new members. This boycott remained in force for nine years and was not lifted until 1950. In an attempt to break the radio dealers' cartel, Sobell turned for help to Isaac Wolfson's Great Universal Stores, one of the country's leading mail-order houses and furniture retailers with over a thousand stores. It was a logical move – in those days radiograms, clad in walnut veneer with panels of bird's-eye maple or sycamore, were just as much pieces of furniture for the front room as they were bits of electrical equipment. The one drawback of the GUS as a retail outlet for Sobell's radiograms was that they were not equipped to offer any service. To remedy this, Sobell began what he called 'Home Maintenance' – a scheme which involved a fleet of 100 vans and a guarantee to the customer to provide service within 48 hours of receipt of a telegram. In addition, he offered two years' free maintenance.

In one respect, the GUS connection was fortunate; in another, it was nearly Sobell's undoing. In 1952, the talented Kurt Vesley had taken Sobell Industries into the television era with the successful manufacture of the firm's first TV set. Once again, GUS was the main retail outlet. But as demand slumped, GUS cancelled its orders, leaving Sobell with very large stocks on his hands – and with a big overdraft that had been necessary to finance them. Relations between Sobell and Wolfson, a ruthless and unscrupulous businessman at the best of times, cooled to well below freezing point. As a result, when things improved and GUS returned with a bulk order, Sobell curtly refused to have anything to do with them.

Things now took on a distinctly bizarre twist. GUS, by now desperate for stock, turned to EMI, who accepted the order but sub-contracted it to Sobell, who agreed that the sets would carry the EMI brand name, Columbia. Unhappily for EMI, Wolfson had insisted on a get-out clause in his contract with EMI which allowed him to renege on the deal if there was a change in the hire-purchase regulations. Unsurprisingly, there was

and he did. The result was that EMI was in a dreadful fix: under the terms of its contract it was still obliged to pay Sobell for the TV sets it had sub-contracted him to make for GUS, but with no prospect at all of being paid by Wolfson.

EMI's misfortune was Sobell's opportunity. Shrewdly, Sobell had not gone very far with the GUS order when the news arrived that GUS was pulling out for the second time. This time all the cards were in his hand. Exploiting the fact that EMI was, in theory, committed to take at least £1 million worth of his TV sets, he negotiated an extremely complicated but advantageous deal whereby EMI bought Sobell Industries for £300,000 with the proviso that he and his directors had the right to buy back the factory and the assets.

It was in the middle of this drama, that Michaell Sobell, by now sixty-three, invited his twenty-nine-year-old son-in-law to join the business. The apprenticeship was over. For the first time, Arnold Weinstock was to be given the chance to show what he could do.

TWO

RADIO DAYS

Arnold Weinstock came to join his father-in-law in the radio and TV business for a simple reason: Michael Sobell, who just been in hospital for a prostate operation, was still unwell. He was in the middle of negotiations to buy the business back from EMI and, as there was every indication that these would be successful, he needed somebody to help him to run the re-born business. Not unnaturally, in the spring of 1954 he turned to his son-in-law, who was then just four months short of his thirtieth birthday.

The invitation could not have come at a better time. Weinstock himself had by now exhausted almost everything that Louis Scott had to offer. And although he had enjoyed his time as a part-time company doctor and had proved to be extremely effective in the laborious and detailed business of obtaining planning permission for the properties on the agency's books, it was plain that he had no gift for the property game itself – or at least, not for the version of it that was being played in post-war London. It may have been highly profitable, but Weinstock found the naked pursuit of money boring and unsatisfying. To him, though he had always been appreciative of the things it could buy, money was not so much an end in itself but rather a measure of business success.

By this standard, Sobell Industries (or Radio and Allied, as it was about to become) did not seem, at first sight, to be a particularly glittering prize for an ambitious son-in-law. Having sold his business to EMI for £300,000 in 1953, Michael Sobell bought back the factory, the stock and the trademark for roughly the same amount in a deal negotiated by Weinstock on his arrival the following spring. But as EMI owned the Sobell name, the business was renamed Radio and Allied Industries.

The headquarters at Langley Park, near Slough, were rather grand. They were located in a country house which had been rented from Slough council on twenty-year lease at a peppercorn rent. A imposing drive with rhododendrons swept up to the front of the house, which contained an

19

orangery and a magnificent central staircase. The factory at Hirwaun in West Wales was, by contrast, a very run-down affair. Martin Jay, who came to work for GEC a few years later and was posted to Hirwaun as a management trainee, has vivid memories of the old Radio and Allied factory. 'It was very much the personal bailiwick of Arnold and Sobell and it was very GEC. There was not much investment and it was pretty grotty. There was just a tiny little R&D operation at Slough. The factory in Wales had been put up in the war and the roof leaked.'[1] The picture Weinstock himself paints of the business at this time is also far from flattering. As he told Brian Connell, 'We had little money, a clapped-out ordnance factory in South Wales and an old plant, and loyal managers and a workforce of decent people, with bad memories of old days, who wanted to earn a fair living.'[2]

What is more, the industry he had entered was seriously overcrowded and highly volatile. By the mid-1950s there were over thirty different brands of TV on the market, produced by some twenty separate manufacturers, each with their own design, production and distribution facilities. By the late 1950s, the industry was selling four TV sets to every one radio receiver. (The age of the transistor had not yet arrived.) If there was one single event which put television on the British map it was the Queen's coronation in 1953. At the time it was by far the most ambitious outside broadcast ever mounted by the BBC and it brought home to millions the attraction of a medium which was being vigorously, if not frenetically, promoted.

The TV market may have been an exciting place in which to be, but it was also very dangerous. The 'stop-go' economic policies of the Conservative government in the late 1950s sent sales of luxury consumer items like TV sets into wild gyrations. In 1956, the year ITV was launched to compete with what was then a single BBC channel, sales dropped by nearly 20 per cent after the government increased hire-purchase deposits by 50 per cent; two years later, the sudden removal of these controls by the chancellor of the exchequer, Derek Heathcoat Amory, promoted an equally sudden pre-election boom, only for the market to collapse again in 1960. Some of the industry's leading firms like Ekco, Ultra and McMichael, who had set the pace in the early years, failed to stay the distance. That Radio and Allied managed to avoid the fate of larger and technically much more sophisticated manufacturers is very largely down to the flair and boldness of Arnold Weinstock himself. In later years, Weinstock's aversion to risk became legendary; he was a byword for caution. But recalling this period in an interview with Charles Leadbetter of the *Financial Times*, Weinstock said that he was obliged to gamble.

We had no option and we had nothing to lose. In the mid-1950s it was all risk. My father-in-law was being boycotted by the radio trade, we had little money, an old factory and no way to sell our products in a heavily overpopulated industry. The risk of failure was enormous. But we turned out to be the only survivors of the more than twenty companies who were around at the time.[3]

The thing about Arnold Weinstock that struck everybody who knew him at that time was his enormous self-confidence. Quite how and when the rather shy and awkward teenager metamorphosed into the decisive and opinionated master of Langley Park is something of a mystery. But by the 1950s he plainly knew exactly who he was and what he wanted. Something of this is conveyed by an early photograph which shows a tall, rather stooping man in spectacles. His overcoat is dark and well cut in the 'Teddy Boy' style that was fashionable in the early 1960s. In the idiom of the time, Arnold Weinstock was a Mod not a Rocker. The hair is carefully combed back, exposing a wide forehead and a rather feminine mouth puckered in a quizzical half-smile. He is gesticulating, his right hand outstretched and his palm held upwards either in greeting or as if he had just made a point and was waiting for a reply. At a glance, with his smooth hair and natty appearance, he could easily be taken for a successful band leader – which, in a way, is exactly what he was.

'Arnold appeared on 1 April 1954 and called himself manager,' his friend and business associate of twenty-eight years, Sir Kenneth Bond, recalls. He says that Michael Sobell never really played any part after Weinstock appeared.

If he interfered afterwards, Arnold would just get up from his desk and walk out. They got on okay, but Arnold wasn't having any interference. If he was going to be responsible, he was going to run it – and he would run it his way. He didn't want endless arguments and then to be told at the end of it, he was wrong.[4]

David Lewis, who was to become the third member of the GEC inner circle, has similar memories. At the time Weinstock joined his father-in-law, Lewis was Sobell's legal adviser. 'I first met him about the time when Sobell Industries was being sold to EMI and I remember he was very strong minded,' he says. His first encounter with Weinstock was a little prickly. They had hardly sat down when Weinstock began to dictate the business letter they had been discussing. Lewis protested. Not only was he some twelve years older than Weinstock, but as the company lawyer he thought it was his job to draft this sort of letter. Lewis says:

I told him, 'You provide the facts and I'll write the letter.' It was really the only time we clashed. But I will say this: that throughout his career he wrote excellent letters – clear and to the point. Quite different from the rest of my colleagues on the board. The one thing I liked about him was that, if you were pushing a draft around, Arnold was always conscious of the balance of a sentence.

Besides drafting letters, there was important work to be done at Radio and Allied. Weinstock spent the first two years at Langley Park familiarizing himself with every detail of the radio and TV business, though his visits to Hirwaun were rare. He was never greatly concerned with the technical side of the operation. In Kurt Vesely he had a highly competent designer and he was content to let Vesely get on with it. He was greatly interested, to the point of fanaticism, in any improvement or innovation that would cut costs and therefore improve profits.

But on new technology, Weinstock's touch was less sure. The printed circuit, invented during the war by a Jewish refugee called Paul Eisler, was about to revolutionize the manufacture of radios, TVs and other electronic equipment. Based on a photo-etching technique, it allowed components to be soldered to a board to form complete circuits. The potential of the new technology was obvious and printed circuit boards, originally developed by Philips, were beginning to sweep the industry. However, a design fault on the first versions meant that the valve-holders over-heated, damaging the board, and it took Philips a year or so to put this right. Meanwhile, Radio and Allied stayed loyal to the old technology – 'Arnold was not convinced that printed circuits were the answer,' says Kenneth Bond – and eventually Radio and Allied was the only firm still using the outmoded plated circuits.

At Radio and Allied, as he was to do at GEC, Weinstock turned for help to experienced people within the organization. However well justified his later reputation for ruthlessness may have been, his willingness to trust people that he inherited and his reluctance to discriminate against them in favour of those he had hired himself is one of his most attractive characteristics – though it goes without saying that they had to be competent. Happily for Weinstock, there were several people at Radio and Allied who came into that category, including John Banner, the production man.

In their history of the British electrical industry, Robert Jones and Oliver Marriott tell the story of how delighted Weinstock was when Banner unearthed a man in Scotland whose business was making church pews and who had discovered an entirely new way of processing wood veneers. As Weinstock told them:

We heated layers of a special kind of veneer between layers of glue in a great steam machine. The end product could then be chopped up like a Swiss roll and each case cost around £2 each instead of £4 10s (£4.50). It made a vital difference, and several competitors fell out after that.[5]

As TV sets were in those days as a much a status symbol designed to ornament the front room as a piece of electrical equipment in a box, it is easy to see that halving the cost of making the cabinets was every bit as important as cutting the cost of assembling the components.

Manufacture was one thing, distribution was another. As we have already seen, distribution had not been one of Michael Sobell's strong points, thanks very largely to the dealers' boycott. To help him overcome this, Weinstock turned to Leslie Bentley-Jones, who during his time with Thorn had earned the reputation of being the best sales manager in the business, and invited him to become joint managing director. Bentley-Jones's job was to rebuild the outlets Sobell had had before the sale and buy-back deal with EMI – something he did with great energy and skill. Outwardly, Weinstock would defer to the older man's knowledge and experience, but at the same time, he would be scheming to convert Bentley-Jones to his way of thinking. 'Arnold would manage Bentley-Jones,' Bond says. 'He would make a suggestion to which Bentley-Jones would reply, "I think we need a complete range." Arnold would then work on Bentley-Jones and after a couple of weeks Bentley-Jones would say, "What we need to do is this." To which Arnold would say, "What a good idea – let's do it."'[6]

One of Weinstock's best ideas was to flout the industry's convention that new models should be brought out to coincide with the annual Radio Show at Earls Court in August. Instead, he decided that he would do far better if he jumped the gun and brought out his new models in the spring. The ploy worked brilliantly. The public liked having something new to buy in the summer instead of waiting for the show at Earls Court, it was popular with the dealers for much the same reason and it was good for the factory as it spread out production more evenly throughout the year.

One of the weaknesses of Radio and Allied when Weinstock took over was that, although it had competent technicians and engineers, there was little financial or legal talent available. For a small, private company, this was no great matter. But for the fast-moving, acquisition-minded concern which Radio and Allied was about to become, the lack of these skills was a disadvantage. With his father-in-law playing little active part in the business and with Bentley-Jones a sick man (he died suddenly in 1960),

Weinstock needed help.

In 1957, he turned to two people who were, as things turned out, to play absolutely key roles in the making of the modern GEC: Kenneth Bond and David Lewis. Together with Weinstock himself, these young men were to form the cabal that was to rule GEC for more than thirty years. And it was to be their skills, their characters, their strengths and their weaknesses that would shape the company and to create its very distinctive culture. They were called 'the triumvirate', but that implies equality. They were, in fact, more like a kitchen cabinet of cronies with Weinstock as prime minister. In the GEC days, it was a cabinet that was, in effect, in permanent session. There were no formal agenda and no regular, fixed meetings. The three all had offices next to one another on the fifth floor and tended to drop in for a chat whenever they felt like it. The day's business started when Weinstock arrived at Stanhope Gate at around 10.30 or 11.00 a.m., it continued over lunch and did not stop until Bond left at around 6.00 to catch his train back to Gerrards Cross. Weinstock himself often did not leave until 7.00 or 8.00 p.m.

Although the three men shared a common purpose, it quickly emerged that each had a very different personality. As Lewis explained it:

> Arnold was the creative person – he had a hundred ideas before breakfast. Kenneth was the fact man and dealt with the money and so on, and I was the analyst and sceptic who would ask, 'Why this?' and 'Why that?' But all the time Arnold would keep putting out ideas – and he would put out the craziest ones just to see how people would react.[7]

David Lewis, the lawyer, was the oldest of the three. When I went to see him in the summer of 1996 in his flat just behind Madame Tussaud's in the Marylebone Road, he had been retired for fourteen years and was just short of his 84th birthday. He warned me that his memory was none too reliable, but, as so often with people of great age, the further back in time we went, the sharper the focus became. Lewis explained how his connection with Michael Sobell started in the years before the war, when he was with a firm of solicitors that did work for Sobell. When Lewis returned after the war, he took over Michael Sobell's work, as the senior partner had by then retired.

At the beginning, the relationship was a professional one, but over the years Lewis and Sobell became friends, and it was during the negotiations with EMI that Lewis first met Weinstock, who was impressed by his clear legal mind and, especially, by his expert knowledge of company tax legislation. 'I wasn't really involved in the running of the business at that stage,' says Lewis. 'I was a professional director and I accepted invita-

tions from all sorts of companies to become a director if it helped them.' Even after he joined GEC in 1963, Lewis only accepted the offer to become a director on condition he remained a partner in his firm. 'In the early days in Stanhope Gate I had a private line from my office to my practice. I was not prepared to step into this thing because I didn't know what it would be like. I was a low-key person. I was always a backroom boy.' While Weinstock became increasingly well known, Lewis remained in the shadows, a role that seems to have suited him. He particularly relishes a photograph that was taken of all the GEC people at the time of the AEI takeover, in which he is described in the caption as 'R. Clark'.

As with Lewis, it was the EMI/Sobell negotiations that brought Kenneth Bond and Weinstock together. Like Weinstock, Bond came from a quite modest if rather more genteel and suburban background: his father started off as a sorter with the Post Office, while two uncles emigrated to southern Africa to better themselves and others went into business and the City. The Bonds were, it seems, strivers and Ken was no exception. He won a place at the local grammar school at Selhurst in Kent and on returning from the war, trained to become an accountant. By 1954, he had become a partner with Cooper and Cooper, one of whose clients was EMI.

Though Bond was four years Weinstock's senior, the two men found they spoke the same language and shared the same approach to business. They were practical, very down-to-earth and slaves to detail. Weinstock was quick to recognize a kindred spirit, and in 1956 he asked Bond to act for Radio and Allied in the purchase of its first acqusition under his leadership: the well-regarded but ailing McMichael business, which had been a public company since 1930. It was the first time Weinstock and Bond had joined forces on the business warpath and McMichael's was to be the first of many scalps.

Over time, Weinstock and Bond developed a very close rapport. They trusted each other's judgement implicitly and their skills complemented one another. Bond says:

> I can't remember us ever falling out over anything. He was obviously responsible. If I was unhappy about something, I would go on about it. Very often, if I was unhappy, he would either modify his views or we wouldn't go ahead. But it happened very, very rarely. There was no point-scoring. I didn't attempt to score points at his expense, and so he never attempted to score points at my expense. Arnold used to say, 'If a problem is too complicated, there's something wrong. You haven't established the proper facts.' Once you have established the proper facts, the facts then provide the answer. We would look at something; if it wasn't at all clear what we should do, we would look again. And then something would emerge.[8]

That two men should form such a close and long-lasting working relationship is rare but not exceptional. Amongst businessmen, one thinks of Simon Marks and Israel Sieff or Roy Thomson and James Coltart. Being a tycoon can be a lonely business and even the most self-confident and self-contained have found it useful to have a kindred spirit with whom they can exchange ideas and test out new notions. When, years ago, I rather naïvely asked Lord Sieff to describe his relationship with Simon Marks, he replied that they were 'like David and Jonathan'.[9] And it was much the same in this case. Over the years, Weinstock and Bond worked as a pair. Their views about the business, what it was and where it was going, were identical. Like an old married couple, they knew each other's thoughts long before they were spoken. But the odd thing about this relationship is that they were never personal friends. Their tastes, their background, their lifestyles and their friends were all completely different. Apart from golf and bowls, Bond, so his friends say, has few interests outside his family and six children. He used to complain that going on family holidays was like planning a major military campaign. Although, in retirement, he is a multi-millionaire, he lives quietly with his wife in a quite modest house on an executive housing estate in Gerrards Cross, where he has been for the past forty years. (As he went up the ladder, the number of bedrooms in the Bond house increased to a suitably impressive eight, though in retirement, he and Lady Bond have reverted to a five-bedroomed home.) In the early Radio and Allied years, Weinstock was Bond's neighbour in Gerrards Cross but not for long. Very soon he moved into town, where he lived in grand style in Grosvenor Square. He was a *bon viveur* who would host dinner parties at the flat or take Netta and the chidren (even when quite young) out for elaborate meals at Claridges; holidays were almost always spent in smart resorts in the south of France.

Weinstock and Bond rarely saw each other outside working hours. And although the door between their offices was never shut, their colleagues were struck by a lack of warmth or even normal courtesy in their dealings with each other. Bond was the archetypal commuter: a man of fixed habits who took the same train from home and back every day. Weinstock's working pattern was much more erratic: he used to arrive and leave several hours later than everybody else. But though Bond would be in his office when Weinstock came in, the two men rarely said 'good morning' or 'good night' to each other. They just picked up where they had been the day before. Even in an office where a lack of frills was taken to be a sign of virtue and where people were encouraged to speak bluntly, this absence of the common courtesies was thought a little strange.

As Bond is, in private, the most courteous of men and Weinstock, while brusque, is highly civilized, the most plausible explanation is that

the two men had become so used to each other, so much extensions of each other's personalities, that they took each other for granted, and therefore saw no reason to waste time and energy on such conventional niceties.

Whatever the reason, when the time came, some thirty years later, for Bond to retire, Weinstock found it difficult, by all accounts, to take in the fact that he had actually gone.

According to someone who was there, the day after Bond had retired, Weinstock inquired, 'Where's Ken?' On being told that he had retired, Weinstock replied crossly, 'But it's Friday. Ken shouldn't be at home on Friday. Ring and ask if he's all right.' There then followed some argument about who should do the ringing. Eventually the person concerned agreed that he would ring provided the call was on Arnold's phone. When asked why he was not in, Bond said he had retired. Was he feeling well? 'Yes. Fine. Never felt better. It's really nice knowing it's Friday and I don't have to go to work.'[10]

A year after the McMichael deal, Bond finally succumbed to Weinstock's repeated invitations to abandon accountancy and join him in the radio business. 'I had three unsolicited offers at the same time,' Bond recalls. 'EMI had asked me to be their finance director, there was an offer from a produce company and there was Arnold.' He had already decided to leave the accounting profession – 'I thought I couldn't spend the rest of my time auditing.' But after some debate, he rejected the EMI offer. For a 37-year-old who was shortly to be married to turn down an important job with a prestigious company in favour of a young and almost unknown quantity like Weinstock working in an industry where rival companies were collapsing all around might be thought to be a bold step. But Bond says, 'I thought it was better to join the man, rather than the company. EMI was very political with lots of factions. I thought it better to join a business run by the owners.'

The other attraction was the prospect of making more money as a shareholder of a small company than as an employee of a large one. 'I was told when I joined in April 1957 that there was an intention that the company would go public,' says Bond. And as a man with a head for figures, he could not have failed to have been impressed by the record. In Weinstock's first year in charge, profits were £577,000; by the second year, they had risen to £886,000; and by 1956/57, helped by the acquisition of the McMichael radio and TV business, they topped the £1 million mark for the first time. In three years, profits had almost doubled, while turnover had risen from £3.7 million to £4.7 million. It was, by any standards, a quite remarkable performance. While other firms were falling off the roller-coaster, Radio and Allied had been taken for an exhilarating

ride; and Radio and Allied was still a private family concern, the
Weinstocks and the Sobells owned 95 per cent of the shares. But there was
only one way in which the owners could capitalize on this success and that
was to float the company on the London Stock Exchange.

The idea of unlocking at least part of the capital by means of a public
flotation was something that had been in Weinstock's mind for some time.
And although, as we have just seen, the vast majority of the shares were
held by Michael Sobell and his two sons-in-law, Arnold Weinstock and
Stanley Rubin, small parcels were also earmarked for key executives such
as Leslie Bentley-Jones, Kenneth Bond and David Lewis.*

It was during the preparations for the flotation in the summer and
autumn of 1957 that the triumvirate was formed. 'The three of us had a
great number of meetings to work out the practical details: what the share-
holdings would be, what the tax angles were and so forth,' said David
Lewis. Lewis pointed out that apart from realizing the cash that was
locked into the business there were substantial tax advantages to the flota-
tion. 'I have forgotten the details,' he said, 'but I know I saved them a lot
of money.' It was agreed that the most important thing was that the
Weinstock and Sobell families should retain control.

Early in 1958, Radio and Allied asked S.G. Warburg, the up-and-coming
merchant bank, to prepare the company for sale to the public. In later life,
Weinstock was to stress how much he disliked the City. 'I am not a City
man,' he told one interviewer. 'We have never issued shares, we have never
had to borrow. It is not a place where I feel fufilled and I don't actually like
it. The counters are passed around ever faster without any real asset being
created.'[11] As his colleagues were to learn, it is unwise to take much of what
Weinstock says too literally. He loves teasing and will often throw off a
remark for the pleasure of witnessing the effect he knows it will create. He
has a large number of merchant-banking friends, there have been several
City figures on the GEC board and in his early years he enjoyed the support
of such City notables as Sir Charles Villiers and Ronald Grierson. In GEC's
go-go years, the relationship between the company and the City was warm,
close and mutually advantageous.

That Arnold Weinstock should have turned to Siegmund Warburg is
not surprising: like himself, Warburg, a refugee from Nazi Germany who
arrived in Britain in 1938, was an outsider as far as the City was
concerned. In actual fact, Warburg was a member of one of Germany's
most distinguished banking families which had, at least until the arrival of

*Although Stanley Rubin who married Michael Sobell's other daughter was, like his father-
in-law, a horse-racing enthusiast (though he preferred National Hunt racing to the Flat), he
never played a significant part in the business. Relations between the two brothers-in-law
were, by all accounts, not particularly close.

the Nazis, an honoured position in German society as the leading bankers in the great mercantile city of Hamburg. In 1958, S.G. Warburg attracted much criticism from traditionalists in the City for the part it played in what came to be known as 'The Great Aluminium War', in which it took the side of the American invaders, acting for Reynolds Metal in the battle for British Aluminium.

With the flotation of their company in May 1958, the Sobells and the Weinstocks became millionaires. In valuing the shares at nine shillings (45p) apiece, the City was not being over-generous. The making and selling of radios and TVs was seen to be a risky business and one much prone to the stops and go's of government economic policy. Even so, the flotation valued the company at £2,250,000 – which was quite a tidy sum in those days. It had taken Michael Sobell, who had started his business career in a very humble way, buying parcels of goods in the States and importing them into Britain, more than forty years and a couple of bankruptcies, to reach this point: his son-in-law, admittedly with the benefit of a flying start, had made it in just under four. Arnold and Netta bought The Abbey, a large, detached home on a private estate on South Park Crescent in Gerrards Cross, a district much favoured by stockbrokers and within easy reach of Langley Park – and the newly married Kenneth Bond and his wife, Jennifer, bought a property nearby.

However strong the working relationship between the members of the triumvirate might have been, the impression is that they there were never what the Americans call 'buddies'. 'Things drew us together,' says Lewis. 'We went to race meetings sometimes, but I was never really close. With Kenneth we were friends but we did not live in each other's pockets.' For his part Bond says that in the more relaxed days before the acquisition of GEC, he and Weinstock would sometimes slip off to the races at Hurst Park, Ascot, Windsor or Kempton.

Horse racing was a passion that Weinstock shared with his father-in-law. But it was one that neither could afford to indulge in on any large scale until 1958, the year which saw the flotation of their company and the victory of Sobell's horse, London Cry, in the Cambridgeshire Handicap. It was Sir Gordon Richards, the hugely popular champion jockey and trainer, who was responsible for this early success. Sobell's career as a racehorse owner really began to blossom in 1960 when, with Weinstock, he bought the late Dorothy Paget's Ballymacoll Stud in County Meath, Ireland. According to Major Dick Hern, who has trained most of the Weinstock horses for the past twenty-six years, it was the purchase of this stud, whose brood mares were the envy of the industry, that was the real foundation of the Sobell/Weinstock racing partnership. Significantly, it was Sobell who took the initiative: Weinstock, ever cautious, argued that he did not have the money.[12]

When Sir Gordon retired in 1970, Sobell then sent his horses to Dick Hern at West Ilsley in Berkshire. A year later, Sobell and Weinstock bought the stable from Sir Jacob Astor. The partnership with Dick Hern has proved to be enormously fruitful. 'If Lord Weinstock has confidence in his trainer, he is very inclined to take the trainer's advice,' Hern told me. 'Some owners make the mistake of, shall we say, trying to take too much power.'[13] Hern's most famous victory came in 1979 when Troy, with Willie Carson on board, beat the Queen's horse and his own stable-mate, Milford, to win the 200th Derby by seven lengths. Troy went on that year to win the Irish Derby, the King George VI and Queen Elizabeth Stakes and the Benson & Hedges Gold Cup. The very next year Ela-Mana-Mou running in the colours of Weinstock's son, Simon, won the Eclipse Stakes at Sandown and the King George VI and Queen Elizabeth Stakes. And in 1983, the Weinstocks' most successful filly, Sun Princess, won the Oaks and, later, the St Leger.

Weinstock would, on occasion, give the jockeys who worked for him a hard time. According to Willie Carson, who became the stable jockey at West Ilsley after Joe Mercer was sacked in 1976, 'He always takes the piss and even tells me how to ride his horses! I answer him back and we get on well. If you do, you get a clash of characters. He digs and digs and digs to try and get you annoyed. Anyone who is annoyed always tells the truth – but I don't fall for his style.' However unkind Weinstock may have been to people from time to time, to his horses he was more forgiving. When they reached the end of their useful lives, says Dick Hern, Weinstock was quite happy to have them put out to grass rather than sold in the ring as jumpers. 'I know a lot of rich men who will send up very old mares empty. That sort of person don't deserve to have good horses,' says Hern scornfully. 'But that wasn't Lord Weinstock's way.' This concern for the well-being of his horses was a characteristic he shared with his father-in-law. When Sobell's horse London Cry, which had won six of its first nine races, was finally retired, Sobell suggested that it be given the freedom of the garden of his home in Surrey. And when the horse was sent to stud in Australia, Sobell insisted on travelling with it to make sure it was safe.[14]

At the time of the flotation in the spring of 1958, the outlook was too uncertain for Weinstock and Bond to make bold predictions as to how well the business would do. The most they would promise was that the annual profit would be no less than £828,000, which was the average of the previous three years. As things turned out, they were being far too pessimistic. In the first year after going public, Radio and Allied made a little over £1.2 million, while the following year the profit rose further to just under £1.3 million.

Part of this success stemmed from the consumer boom the Tories had engineered to help them win the 1959 election, but it owed even more to the principles on which Radio and Allied was being run. The basic principle was to extract as much cash from the business as possible by keeping costs and overheads to the minimum and by delaying payment to creditors as long as was practical. Quite when Weinstock's very distinctive business philosophy took shape is hard to say precisely, but those who have observed him or have worked most closely with him are all convinced that the lessons he learned at Radio and Allied were to determine the course of the rest of his business life. It may be an over-simplification to say that the methods he used to run GEC were merely those he had developed at Radio and Allied writ large, but they are many who would argue that this was indeed the case.

One of the most distinguished members of this school of thought is Sir Robert Telford, who joined Marconi straight from Cambridge as a graduate apprentice many years before its takeover by Weinstock's GEC and rose to become general manager and then managing director of GEC/Marconi – a post he held for sixteen years. He has been chairman since 1981. Born in 1915, he is nine years older than Weinstock and is unquestionably one of the Grand Old Men of British Industry. Almost no one has watched Weinstock at work more closely and nearer at hand than Sir Robert, who remains one of his greatest admirers. 'I never had so much freedom and responsibility' he says, and continues:

[Weinstock's] business philosophy was fashioned in and by Radio and Allied. Essentially it was: make a good product, and then cut costs and overheads as hard as you can to squeeze out the maximum profit. There was no question that it was the right approach for the industry at that moment when firms were going bust right, left and centre. But the important thing in our game was capital expenditure. Radio and Allied never did any R&D and eventually they just faded away. The thing about Weinstock is that he is a corner-shop man. With him, it's all about money in and money out.[15]

Another witness to stress the importance of the Radio and Allied days is Martin Jay. Son of Douglas Jay, the Labour cabinet minister and polemicist, and brother of Peter, the broadcaster, Martin was one of the first of a whole series of bright young men from distinguished backgrounds or families to be hand-picked by Weinstock as his personal aides in the field – his 'eyes and ears' is how Jay puts it. Referring to the system invented by Bond and Weinstock to assess the performance of GEC businesses, he says:

I think the ratio approach is very good if you are in the short-term business of getting orders in one month and sending them out the next. And it worked perfectly in Radio and Allied days. He always had the Radio and Allied model in mind where sales were turned into profit very quickly. It was a very important period.*

As noted, competition in the radio business was fierce and the weaker suppliers were often driven under by the pressure exerted by the larger and more aggressive manufacturers. Not only were the suppliers forced to cut their prices to the bone, they also found that their customers, in an effort to improve their own cashflows, were very loth to pay their bills on time. Roland Dunkley who joined GEC in 1952 and rose to run GEC's defence research operation at Stanmore tells of a 'blind' recruiting session he and his colleagues were conducting for the company: so-called because candidates only discover the identity of the company after the interview has started. 'When we told one man who we were,' Dunkley recalls, 'he almost walked out on the spot. We asked him why he was so angry and he said that his father had run a company supplying loudspeakers for Michael Sobell's radio sets. He told us that he believed that it was a refusal to pay bills that had driven his father out of business.'[16]

For all the success Radio and Allied was enjoying, Weinstock and Bond were nervous. However profitable the firm, its share of the market was still very small – no more than five per cent. Fearing that the good times for the radio business would not last, they cast around to see if they could not use their financial muscle as a public company to strengthen the business by further acquisitions. According to Jones and Marriott, they talked to, or at least considered, almost everybody who was anybody in the industry: Jules Thorn, Ekco and even EMI, which had just bought Morphy Richards, who made irons and other domestic appliances. But for one reason or another, none of these ideas led anywhere.

There was, however, one other obvious candidate: the General Electric Company or, as it was usually known, GEC. This business was in an entirely different league to the Ekcos, the Pyes and the other minnows that made up the electrical goods industry. In 1960, GEC was one of the giants of Britain's electrical engineering industry with a turnover of over £100 million. It advertised under the proud slogan 'Everything Electrical', and its range of products embraced everything from light bulbs and tele-phones, dishwashers and washing machines to locomotives for British

*Other bright young men to serve at Weinstock's court were William Waldegrave, a cabinet minister in the Major government, and Rupert Soames, son of Lord Soames, Winston Churchill's son-in-law and a former Tory Minister.

Railways, engines for London Underground trains (the Piccadilly and Metropolitan line trains were powered by GEC) and mighty turbo-alternators for power stations. Included in the enormous range of GEC products were radios and TVs, which in 1960 were not doing at all well. In the nine months up to December, they lost the company £300,000, while the dishwashers and washing machines lost a further £900,000 – this at a time when Radio and Allied was some £800,000 in the black.

There was, of course, no question of an upstart like Radio and Allied making a bid for GEC itself. But there might be, so Weinstock and Bond thought, some advantage to be had from a discussion with them about the domestic side of the GEC business. The domestic appliances division – the radios, TVs and white goods – accounted for about a fifth of GEC's total turnover and, on its own, was about five times the size of Radio and Allied. Accordingly, Weinstock and Bond went to see the GEC people at their Magnet House headquarters in London's Kingsway to sound them out.

Weinstock and Bond were so encouraged by the response that they asked Harry Moore of merchant bankers Philip Hill and Higginson, who had acted for them in the abortive talks with Ekco, to arrange an appointment for them with Arnold Lindley, who besides being managing director had just taken over as chairman after the brutal ousting of his predecessor, the 73-year-old Leslie Gamage. (On being told by one director who was also on the board of Morgan Grenfell, the merchant bank, that 'I don't think you appreciate that the City thinks you are too old,' Gamage turned to his protégé, Arnold Lindley, and inquired, 'Did you know this?' to which Lindley replied, 'I have heard it.'[17] Five months later, a mortified Gamage decided he had no option but to resign and Lindley took his job.)

Lindley knew that time was not on his side; he sensed that GEC was vulnerable, both Joseph Lockwood's EMI and George Nelson's English Electric had made overtures earlier in the autumn of 1960. And privately Lindley was being told that he had do something about GEC's management, which was widely thought not to be up to the job. Lindley was therefore receptive when Harry Moore suggested that a deal with Radio and Allied would not only strengthen GEC's lacklustre consumer goods division, but might also help with the company's management problems. Just before Christmas, Michael Sobell, Arnold Weinstock and Kenneth Bond called on Arnold Lindley and Tom Kerr, GEC's deputy managing director, to float the idea that the two businesses should merge. The suggestion was that Radio and Allied would take over the running of GEC's TV business and that Charles Richards of Morphy Richards, who had left after his firm was bought by EMI, would be brought in to help out. The meeting went well. It was agreed that, subject to a clean bill of

health from accountants Touche Ross, the merchant banks should negotiate the price with Philip Hill acting for Radio and Allied and Morgan Grenfell for GEC.

Within a matter of weeks the deal was done. To finance the purchase it was agreed that GEC would issue 5,000,000 new ordinary shares of which 3,250,000 would go the Sobells and the Weinstocks in respect of their holding in the family company. As GEC's shares were valued at 31s 6d (£1.57), and as the families also received cash for some of their shares in Radio and Allied, the GEC deal meant that they were now worth some £8 million between them. In the three years since the firm had gone public, the value of the business had more than tripled. Even more significantly, with 14 per cent of the shares of an enlarged GEC, Weinstock and his father-in-law had become the firm's largest single shareholders. They therefore had a very direct personal incentive to do what they could as soon as they could to improve the company's disappointing performance.

The beginning was farcical. Kenneth Bond recalls the visit to the GEC headquarters at Magnet House in Kingsway to complete the deal. Housing over 2,000 people, it was a complete rabbit warren. To confuse matters, nobody had seen fit to give them a key to the executive washroom. They wondered if somebody was trying to tell them something.

THREE

EVERYTHING ELECTRICAL

When Arnold Weinstock arrived at Magnet House in the spring of 1961, the founder of GEC, Hugo Hirst, had been dead for seventeen years and much of the glory had faded. None of his successors were a patch on Hirst himself, and throughout the late 1940s and 1950s, the company had slumbered. It was losing money on the heavy electrical side, into which it had moved at the end of the First World War, and it had largely missed out on the TV boom. Dividends were being paid out of current cash flow leaving little to be ploughed back in vital research and development. The company was consuming its own seed corn. As the 1960s began, GEC's share price was no higher than it had been twenty years before and the profit for the financial year 1961 was less than 3 per cent of turnover. As the directors commented bleakly in their report to shareholders:

> In the first place, margins in the heavy engineering industry are meagre and this part of the company's activities have contributed little to earnings this year, and secondly, the extremely unsatisfactory state of trade during the year in the radio, television and domestic equipment industries has resulted in substantial losses.[1]

Quite what Lord Hirst, the elder statesman of GEC, would have made of this state of affairs is hard to imagine. Few people these days can remember who Hirst was and what he did. But his achievements in first creating and then building GEC into what became, in the inter-war years, Britain's leading electrical company are every bit as remarkable as Weinstock's own. Indeed, as he was a innovator and a creator, rather than a rationalizer and a reorganizer, it could be argued that of the two lords of GEC he is the greater.

Certainly, Weinstock was well aware that he was standing on someone else's shoulders. In 1986, the year of GEC's 100th anniversary, the

company's annual report, normally the most austere of documents, contained a fulsome tribute to the founder, in which the achievements of the two men were compared.

Without Hirst, GEC would never have reached the point where it could compete with the Americans and the Germans then striving for the domination of the electrical industry; without Weinstock, GEC would never have accomplished the task Hirst perceived but left undone – the rationalization of an entire industry.

Comparisons, it is said, are odious. But in this case, the parallels between the careers of Lord Hirst and Lord Weinstock are so close as to be uncanny. Both were outsiders, both Jewish. Neither had any technical training nor even any practical knowledge of manufacturing industry; both relied heavily on a long-time business partner whose task was to restrain their more exuberant flights of fancy; both bought large country houses and more or less turned their backs on traditional Jewish society; both became prominent and successful racehorse owners; both took to hiring bright young men as their personal aides; and both hoped that their only sons would succeed them at GEC only, sadly, to see those hopes cut off by early deaths. These parallels should, of course, not be pushed too far. In many other respects Hugo Hirst was a very different, and in many ways, less attractive character than Arnold Weinstock. He was reckless where Weinstock is prudent; flamboyant where Weinstock is reticent; quarrelsome where Weinstock is placatory; and politically partisan where Weinstock is studiously impartial. But even so, there is no question to my mind that Weinstock has, to some degree at least, modelled himself on Hugo Hirst.

Hirst (born Hirsch) was the son of Jewish parents who ran a small but prosperous distillery in the village of Altenstadt in Bavaria, where he found the anti-Semitism of Prussia, which had absorbed Bavaria after the defeat of her allies, the Austrians, at Königgrätz in 1866, increasingly irksome. In 1880, aged seventeen, he came to England at the suggestion of an uncle who had set up as a medical consultant in Wimpole Street.

After a number of false starts, the young Hirst found himself working on the fringes of the new-fangled electricity business. Batteries, accumulators and all the other bits and pieces of what was soon to become a vast mass-market consumer and industrial business were his stock in trade. Hirst not only had faith in the burgeoning electrical business, but he turned out to be a brilliant salesman with a flair for spotting and exploiting the potential of other people's technical innovations. His biggest single coup was the acquisition of the Osram business, which made light bulbs,

a German invention. (Osram had begun as a joint venture but passed into GEC's control during the First World War.)

However vast a catastrophe the First World War may have been in human terms, for GEC it was the making of the company. Not only did it enable Hirst to buy the hugely profitable Osram business from the Public Trustee at a knock-down price, but it generated millions of pounds in orders from the British government. As Jones and Marriott put it:

> Almost all GEC's staple products were needed for the inanimate raw material of warfare: for example, lamps and motors for ships, arc generators for wireless sets, cables and electrical instruments for telephones, telephones themselves, signalling equipment, magnetos for motorcars, motorboats and aeroplanes, and carbons for searchlights. The result of all this activity from the Government was a massive rise in profits.[2]

By the outbreak of the Second World War, GEC had established a commanding position at the lighter end of the British electrical industry and was strong in domestic consumer goods but less well established as a radio manufacturer. As the historians of the industry remarked:

> In *GEC Journal*'s annual reviews of progress, domestic receivers were sandwiched in among electric cleaners, street lighting and industrial cooking appliances, suggesting that they occupied rather a small angle in top management's field of view, while the division of control between Coventry, Wembley and the company's Kingsway Head Office must have impaired the capacity for rapid and decisive action in a fast-moving game.[3]

But by 1961, GEC, which twenty years before had employed 40,000 people, had lost much of its dynamism. In fulfilling its slogan 'Everything Electrical', the company had spread its resources too widely and had become more like an enormous bazaar of electrical odds and ends than a focused, profit-orientated business. From a distance of more than thirty years after the event, the purchase of Radio and Allied looks like a reverse takeover (which, in effect, it turned out to be), but that was not how it seemed at the time. The original plan was that Weinstock would run the domestic appliance and radio business, while Arnold Lindley (who had been with GEC since 1918 and, after forty years waiting in the wings, had only just become managing director) would run the overall business. Weinstock himself says that he had no grand design and that 'the consumer goods side was all that I was aspiring to'. Nonetheless, as the director in charge of the domestic equipment side of GEC and of the radio

and TV operations of both GEC and Radio and Allied, Weinstock was part of the company's inner circle. And as a representative of the largest single shareholder, he had a direct interest in the whole company.

On his arrival, Weinstock became a member of the six-man management committee which, apart from himself, consisted of Arnold Lindley, the chairman and managing director, Tom Kerr, the deputy managing director, E.H. Davison, the finance director, Olliver Humphreys, the research director, and R.N. Millar. As part of this team, Weinstock was in a good position to see for himself what was going wrong. He was genuinely shocked by what he discovered at GEC. The way in which the company was organized and managed was, he thought, the antithesis of the way business ought to be run. GEC may have had many more products and have been a great deal more complicated than the business he and his father-in-law had managed, but he saw no reason why the principles that had made Radio and Allied so profitable should not apply to GEC. Nor did he like the endless meetings and the corporate intrigue. There were so many rows that, after a few weeks, Weinstock retreated to the old Radio and Allied headquarters at Langley and refused to come back. He did not return until the deputy managing director, Tom Kerr, one of the few GEC managers Weinstock respected, had been sent to make peace. As Weinstock explained:

> I took part in the discussions but I didn't like the decisions, especially on capital expenditure. There usually seemed to be inadequate information on which to base decisions. It never occurred to me that Big Business was run like that. The things that did get done in the operating companies got done independently of what was decided at the headquarters in London.

What frustrated Weinstock more than anything else was the complete lack of management information. At Radio and Allied he had had everything he needed, either in his own head or very close at hand; at GEC he was forced to rely on figures produced by others that turned out to bear little or no relation to the facts. What made matters worse was that the man in charge could not read a balance sheet and had no head for figures. 'Arnold Lindley was basically a nice guy,' says Kenneth Bond, 'but he had no financial sense at all. When you produced a balance sheet he would ask which side the assets were – and things like that.'[4]

Under a system devised by the finance director, E.H. Davison, all the figures for the operating units had to be available within ten days of the end of each month. But, however crisp and decisive this might have sounded, in practice it was, so Bond says, a nonsense. 'It was much too early for the figures to mean anything and I just used to jot whatever came

into my head on a piece of paper. There was no way of finding out what was really going on.' Weinstock and Bond liked Davison, but he was, says Bond, basically more of a bookkeeper than a management accountant and he would insist on these very early returns. Accordingly, in the summer of 1962, Weinstock arranged for Davison to be fired and summoned his old friend and partner, Kenneth Bond, up from Langley to London to fill the office Davison had just vacated. The stage was set for what was one of the most effective exercises in management ever seen in British industry. In time, the 'Weinstock system' with its hard-driving emphasis on managerial accountability and quantifiable performance would become legendary. It should be said that this 'system' did not come into being overnight: it took several years of trial and error for it to be refined, but by the mid-1960s, the main elements of what was, for many, a new and thoroughly alarming system of management were in place and in force.

As noted, Weinstock's ideas about business first took shape at Radio and Allied, but it was during those initial years at GEC that the kitchen cabinet of Weinstock, Bond and Lewis, who became a GEC director in 1963, developed the distinctive way of working that was to become their hallmark. It was refined and developed after the great takeovers of 1967/1968, but it was during the first half of the 1960s that the seeds were sown.

It did not take long for Weinstock and Bond to see what was wrong with GEC: it was over-borrowed and under-managed. As Bond recollects it:

> As Arnold tried to find out what was going on, the first thing he realized was that there were no real controls. The old electrical businesses were run by general managers who were engineers not financial controllers. So they would put in for capital expenditure without any idea of where the money was going to come from. Arnold would look at this and he would ask: 'Where's the money going to come from? If you haven't got it, you got to find it.' They couldn't understand that. So we had to close businesses and send people home – if only to prove the point that they didn't have the right financial attitude.[5]

A lack of control was not the only problem. To Weinstock and Bond what was even more alarming was the divorce between the manufacturing businesses and the sales network. Instead of dealing directly with their own customers, all contacts were through the centralized sales organization based in Magnet House. As Weinstock told Graham Turner, the author and journalist:

The company was still essentially a giant wholesaling business with thirty-one Magnet Houses dotted round the country selling everything from sockets to plugs to switchgear. The headquarters of the company in Kingsway also doubled as a warehouse with 200,000 square feet of space and over 2,000 people. Magnet House was ridiculous. It was a rabbit warren with people shut away in hutches making work for each other. The basement was packed with goods that nobody wanted – there were enough lightning conductors there to last the whole of Europe for fifteen years. My heart fell six inches when I went out of that back door at night and looked around. It was a great tomb in which the business was stifling to death.[6]

With the arrival of Bond at GEC headquarters in the summer of 1962, the two men set about imposing proper financial controls and dismantling the branch system. 'It was like the dissolution of the monasteries,' says Bond. He goes on:

With Arnold arriving, the politics virtually disappeared. We got people focusing their attention on things that mattered. It had been a very weak management. If there had been anybody who was any good, he would have been out long before. GEC was basically a wholesale business. Arnold decided he would close all the branches, which meant that the product businesses would have to get on with their own selling instead of leaving it to the branches. It was a big change. But having shut the branches, the next thing that had to be done was to re-establish a direct connection with the customer. That was the real revolution that took place.[7]

But not everything was done by numbers. Later, Weinstock was to become notorious for his reluctance to visit factories.* But in those early days he and Bond did occasionally venture out to inspect the empire.

Seeing people on their home ground would tell you a lot. Often, knowing that we were coming, they would arrange a big lunch for us. But Arnold would say, 'No, we're not having lunch. We're going to have a sandwich.' It was not as organized a visit as they would like. And if Arnold didn't understand what they were doing, there would be an inquest on the spot. Often the managing director

*As ever, Weinstock has a rational explanation for what others regard as eccentricities. 'If I went every day to one plant for only half a day,' he said in 1996, 'I could not cover all the GEC factories in a year. So I never visit factories. Even if I did, the result would be minimal, because people would know that I wouldn't be back for a long time.'

didn't know what was going on either. And you could find out a lot of what was going on in a matter of a few minutes.[8]

Bond remembers a visit they made to Union Works, a five-storey building put up at the turn of the century where men were sitting round making light fittings. 'One visit there convinced you it had to go.' Nor did Four Ashes, the GEC fuse-gear plant, impress. 'It was a terrible place. It wouldn't be countenanced today. The products were pretty awful. The working conditions and everything else were bad. We closed down a lot of these places just to get out of the business.'

Deciding which businesses to get rid off or close down was the easy part. Bond says that GEC had called in management consultants like Urwick Orr or Touche Ross to make recommendations.

> But when we read their reports, they never made sense to us. They never got down to the realities of the situation. The reality of the situation is the product: what they are making, who they are selling it to, and can they make it for the purpose of making a margin on it? Now what happened in the old GEC was that the managers would say, 'We need ten of each component. Would you quote a price?' They would be told that the price was £50 each but if they ordered a 100, they could have them for £25 each. So they would order 100, sell ten of them at £37.50 and the rest would just go to stock. It was very easy for us to establish the businesses that were not worthwhile and that we had to get out of them. Don't forget that when we arrived, the turnover of GEC was not much more than £100 million. It wasn't all that big, even allowing for inflation. It was not like going into a motorcar company.

Weinstock's and Bond's ideas about management were clear, simple and refreshingly uncluttered by the kind of academic theory so beloved of management consultants and business school professors. In the early 1960s, management education was all the rage and British business was suffering one of its periodic bouts of inferiority complex. Compounding this situation, British universities were being compared unfavourably with the Harvard Business School and MIT; Lord Franks wrote an influential report recommending the establishment of high-class business schools at London and Manchester; and graduates flocked to join McKinsey, Urwick Orr and the other high-profile management consultancy firms who seemed to be engaged in overhauling the management of virtually every major British company, from ICI downwards.

To Arnold Weinstock, a graduate in statistics from the London School

of Economics, these efforts to pump up the theory and practice of business into a full-blown academic discipline seemed to be quite irrelevant to the matter in hand. To him, management was, as he told me himself shortly after he took over as managing director, 'the arrangement of the most economical use of resources'[9] There was nothing theoretical or abstract about it. In one of his very first annual reports for GEC, he remarked sharply, 'The choosing of men for the senior positions is difficult because men of the right attitudes and the right dynamism are comparatively rare. It seems to my colleagues and myself that too much is currently expected of special training in the new business schools.'[10] This antipathy to business schools and their products had its effect on the company. As Bond puts it:

> By and large, the people we got in GEC were people who had come up through GEC. Most of the managers were engineers. We never favoured sending people to business school or anything like that. It's true we did have a GEC management centre, but that was for people down the line and people coming up. I was never quite sure myself whether it was a good thing or a bad thing. Certainly one can say that for middle managers the damage caused by absence from the desk is likely to be less than for the managing director in charge of the day-to-day running of the business. I don't object to high-flyers going away to study for an MBA, but I don't think the company should pay for it. It's up to the individual.[11]

If Weinstock and Bond were sceptical about the worth of the new business schools, they had even less time for the new management gurus of the consultancy business. At a time when the famous Kinsey report on sex in America was all the rage, Weinstock dismissed McKinsey & Co., the management consultants, with a joke which, if a little laboured, much amused his managers: 'As GEC is not, as far as I'm aware, involved in the sex industry in Scotland, I see no reason why we should have any further dealings with McKinsey.'[12]*

If business academics and management consultants were a particular *bête noir*, personnel officers were barely higher in his estimation. In a internal memo to his managing directors written in March 1975 and marked 'private and confidential', he wrote:

*He is still singing the same song. Thirty years later he told the *Financial Times* in a valedictory interview after his retirement: 'Consultants are invariably a waste of money. There has been the occasional instance where a useful idea has come up, but the input we have received has usually been banal and unoriginal, wrapped in impressive-sounding but irrelevant rhetoric.'

This memorandum is not meant in any way to be critical of personnel people, but I should like to make clear, although I thought I had already done so on several occasions in the past, that interviews with applicants for management posts, even quite junior ones, should never be allowed to be conducted by personnel departments, or even the most senior members of them. Managing directors, or, at very least, departmental managers, must interview applicants for managerial positions (and, indeed, all of management potential).

Even the selection of applicants for interview must not be left to personnel staff. They cannot be a critical arbiter of whether a man will be a competent manager of a production engineering department, or of a marketing department, or any of the specialized functions of the business. Their rôle in these matters is to deal with procedures, check on references and ensure that terms of engagement are in accordance with GEC practice.[13]

The impact that Arnold Weinstock made on GEC was such that by the autumn of 1962 it was clear to everybody that the amiable Arnold Lindley did not have the force of character to push through the reforms that were needed. And if Lindley had to go (or rather, be pushed upstairs), then the other Arnold was the man to succeed him. Of the original six directors who made up the management committee, he was the obvious candidate. Davison had already gone, Humphreys and Millar were too old and out of contention and Tom Kerr, the deputy managing director, was already a Weinstock fan. In December, the board named Weinstock as the next managing director of GEC. Lindley put up a show of resistance by insisting that his title should be chairman and chief executive. But after what Bond calls 'a bit of a row' with Weinstock, Lindley withdrew. Two years later he stood down as chairman in favour of Lord Aldington, better known as Toby Low, who had just completed a stint as deputy chairman of the Conservative Party.

On 1 January 1963, just twenty months after joining the company, Arnold Weinstock took charge of GEC. His rise had been meteoric. When he joined, his only claim to fame had been as the successful manager of a medium-sized radio and TV business whose main asset was a run-down factory staffed by cheap labour in South Wales. However profitable and well run Radio and Allied may have been, it was essentially a low-tech assembly operation. There was next to no R&D, most of the components were bought in and the main work of the factory was to put them together to make the finished product. But now, less than two years later, Weinstock was in charge of one of Britain's leading engineering companies which had a turnover of more than £100 million and employed some 40,000 people.

The British have become so accustomed to their reduced economic and

industrial condition that it's often forgotten that it was British scientists who pioneered the development of radio telephony, radar and the computer. At the time of the First World War, Marconi's US subsidiary was the biggest manufacturer of radio equipment in America and, though the Americans rapidly overtook Britain during and after the Second World War, in the early 1960s Britain was still the world's second-largest producer of electrical capital goods with 12 per cent of world markets. GEC may have been smaller than its rivals AEI and English Electric, but its range was impressive even if its financial performance was poor. Not only did it have a substantial stake in both the heavy and domestic ends of the electrical engineering industry, but it was also as well placed as any European company to play a leading part in the coming technological revolution represented by the integrated circuit and the microchip.

When Weinstock assumed command, GEC was a major manufacturer of custom-made computers for scientific and industrial use; it was also, in partnership with Mullard, Britain's largest manufacturer of semi-conductors; and in its research laboratories at Stanmore and Wembley it had a storehouse of scientific talent. However, before this could be properly deployed, some urgent repair work was needed.

On 12 March 1963, a little over ten weeks after he had become managing director, Weinstock decided to issue a general call to arms. He sent a long memo to all his managing directors and departmental heads in which the sting was at the beginning, not the end. 'We have by now received preliminary budgets from all Groups and Subsidiaries. None have been acceptable and all have to be revised,' he wrote. He then told his managers exactly what he expected of them.

> We live in [a] hard and competitive world. All forms of human society are in competition. Political systems compete for survival, nations compete with each other for better living standards (or to preserve those they have), industries compete for the spending power of the public, and within industries, companies struggle for existence and expansion. The survival of the fittest is the law of nature. We can organize to meet its challenge and in some circumstances shade the harshness of its effects, but we cannot change it. These are the conditions in which we exist. To meet these conditions, we must combine all our talents and our endeavours, so that, working together, we may be strong and competent, and thus preserve and extend the position of GEC in the world.[14]

After pointing out that there was a direct relationship between profits and costs and between costs and efficiency, Weinstock went on berate the company and its managers.

In most fields we are not the most efficient producer. So let us accept the first basic rule, which is that, no matter what, we cannot allow our costs to rise. If we are required to meet a national wage award we must find the means to increase productivity so that labour costs per unit do not rise.

The message was one of belt-tightening, self-sacrifice and austerity.

We cannot generally increase other salaries for the present, but if we have to do so in some cases, we must do our job with fewer administrative people, fewer clerks, fewer assistants, fewer managers, and, indeed, even fewer non-productive departments. This is the second golden rule, that notwithstanding that our business expands, the total of overhead must not be allowed to rise.

Weinstock went on to make some practical suggestions as to how overheads might contained: 'For example, out of every five people engaged in non-productive work, let us try and make do with four. A reduction of even 15 per cent in the total GEC overhead would make a startling difference to its profitability.' This reference to profitability led Weinstock on to wax philosophical.

In this country, we live in a system of something like free enterprise. Under such a system, profitability is the yardstick of performance. In competition such as we meet today, where we (the GEC) have no monopolies and very little in the way of protection, prices cannot be fixed artificially high. The great splurges of expenditure when the country dramatically increased its living standards and its capital expenditure, is [sic] over. There is no spontaneous explosive expansion for our products; we have to create our markets and our expansion. There is no shortage of our goods ... no pent-up demand waiting upon its release. Above all, we cannot get any more for our products than our competitors.

The memo concluded with more practical suggestions.

Distinguish between expenses (particularly overhead) on the one hand and sales and profits on the other. Fix your expenses as low as possible and then apply rigid control over them. Get fair prices for your products and produce and sell as hard as you can. The profits will follow. This is not by any means all that has to be done, but it will do for a start.

That this stern directive should be sent to the managing directors was indicative of the way Weinstock intended to run the company. While Radio and Allied had been small enough for him and Bond to exercise total control, the sprawling GEC was quite another matter. The problem was how to bring some kind of order into a loosely managed group of companies. Instinctively, Weinstock looked to Radio and Allied as a model. He saw GEC not so much as an integrated group but as a series of autonomous operating companies, each responsible for its own fate. And just as he would be judged by the success of GEC as a whole, so he believed that each managing director should be judged by the performance of his own company.

In another memo to the managing directors written in February 1965, he chided them for allowing the cash position to deteriorate, for rising overheads and for uncollected debts.

> It should be clearly understood that we are engaged in industrial warfare. We must grapple with our competitors in the UK, a task which is, in the case of many products, bad enough, and with our competitors in overseas markets, which is a damn sight worse. We will either gain victories or be vanquished, and, in the end, it is a question of survival for the Company as a whole, for individual units of the Company, and for individual managers in the trading units.[15]

To his readers, the threat must have been clear and unmistakable. 'If you re-read the memoranda as I have asked,' he added, 'you will see that I am nagging constantly to increase the degree of direct control which managers exercise over matters for which they are responsible, and in particular for the expenditure for which they are responsible.'

While he did his best to lift the morale of his demoralized troops, in private he was dismissive. Of the GEC managers, he said caustically, 'You don't need to fire them. Just tell them what's expected of them and they'll all go.'[16] Of the 7,000 workers that went in the months after Weinstock's arrival, a fair proportion were managers.

Arthur Walsh, who went on to a distinguished career with GEC before leaving to become chairman of STC, the telecoms company, well remembers the impact Weinstock made on his particular outpost at the defence laboratory at Stanmore. 'He stirred up managers, got rid of managers I personally would have got rid of, and he did it in what people call a ruthless fashion. But then I don't know any other way you can get rid of people. And yes, there was a period of turbulence.'[17]

Walsh, who had joined the company in 1952 straight from Cambridge, where he had won a exhibition at Selwyn to read physics, was not a

typical GEC manager. In the first place, he was a socialist. His grandfather Stephen had been rescued as an infant from the steps of the Liver Building in Liverpool, had spent his early teens picking stones from coal tips and eventually rose to become a cabinet minister in the first Labour government. Walsh was disheartened by his first years at Stanmore laboratories, which were being run by GEC on behalf of the Ministry of Aviation. (The staff used to joke that the MOA was a giant, flightless, extinct bird.) 'I decided it was worse than the civil service,' Walsh said. 'It was a home for retired gentlefolk, the sort of place where managers got on by playing golf with the chairman.' He was on the point of leaving to join the British Aircraft Corporation when he was introduced to what he describes as 'this young lad who'd just joined the board'. The two men instantly hit it off. 'He walked around as if he was interested in what was actually happening, even though he had no real background,' Walsh recalls.

I suppose I was over-enthusiastic but I showed him the proposals we had put together – a big, fat book. And he went through that – quite critically. At one point he asked, 'Would you rather have a posh carpet in your office or a posh carpet in your house? Would you like to be in a winning team or a losing team?' The place was very badly run. But when Arnold arrived you got a sense that somebody would do something about it. This guy looked after the cash that came into the company.

One of the signs that things were about to change was the arrival of a man from Stanhope Gate who, Walsh says, took every single item of cost apart in detail – from the overheads to the components.

I was quite impressed. I had spent my time in quantum theory and other jolly useful things. And to see this going on, you could see the influence of Arnold. Each month you were asked to produce a report. It was not the first time I had to do this, but nobody read them before. But he did. And you were scared to send it because you'd ask yourself: 'What the hell is he going to find this time?'

Weinstock's main weapons in the fight to revive GEC were the monthly reports and the telephone. If something in a management report caught his eye, he would be on the phone immediately to the person responsible. He rarely, if ever, said who he was. On one occasion, after GEC Electronics had taken a full-page advertisement in the *Financial Times* showing pictures of bees in a honeycomb with copy proclaiming that the company offered high-tech solutions to problems, Weinstock

anonymously rang Stanmore to say that he was in need of 'a digital finger extractor' and could they help? He later rebuked the company's managing director for wasting money.

To a buyer in some remote corner of company, to find Weinstock himself on the line demanding an explanation of this, that or the other was infinitely alarming. 'It may have been unusual, but, by God, it was effective,' said Arthur Walsh. 'He got a direct response. He didn't ring up to wish them the time of day. When he called, there was usually something wrong. And when he started probing things, you had better worry about it.' Normally nobody had bothered with the buyer. The laboratory was usually given an order to go buy so many parts and that was that. Sometimes it was just a secretary who did the buying. 'But Weinstock turned that upside down,' said Walsh. 'He wanted to speak to the buyer himself. And he did. Everybody knew that one day they might be rung up by Arnold and it made a big difference.'

Over the years, the managing directors grew cannier and took steps to protect themselves from these frontal assaults; but their defensive measures, in turn, provoked a number of angry memos from Stanhope Gate.

> Wherever possible, I make my own telephone calls to executives and I am obliged to waste a great deal of time while connections are made through switchboards and then secretaries. I can understand that there are circumstances in which calls should be intercepted by secretaries, but it cannot be necessary to have anything like as many as I find to be the case. It appears that quite junior officials have this facility, which is expensive and wasteful.

At Radio and Allied, Weinstock and Bond had known what was happening on a day-by-day basis. At GEC they were largely in the dark. Weinstock saw a solution:

> Because we didn't have that degree of control we couldn't do the same things as we had done at Radio and Allied Industries. We had to develop a set of efficiency criteria quickly which could be applied generally. The figures did not have to be exactly right, just so long as they were adequate to show up the tendencies of the different elements of the business.[18]

In 1966, almost three years after Weinstock had become managing director, Dave Powell, a financial man whom Bond had hired from English Electric and who was later to be given the key job of shutting

down the Woolwich telecommunications plant, was sent to the States to see how they did things there. On his return, he wrote a report which described the criteria GEC's American rivals used to judge themselves. The main indicators, Powell reported, were ratios relating to sales, costs, stock-turn, debtors and margins. Weinstock later explained that he and Bond refined these figures into a set of statistics and ratios which they used thereafter as benchmarks to measure the performance of the operating companies and their managers.

> This gives us snapshot every month of each operating unit, expanded with a commentary by its management. It can be misleading if you are not told the truth, but generally it has worked. At the end of each month, for over thirty years, I have taken home two bags of these monthly reports to break the back of this rather onerous but necessary chore. Between Friday and Sunday I would go through the reports, writing notes and comments on them to be picked up by management.[19]

While Weinstock regarded these monthly reports as an essential management tool, the GEC managers saw them in a rather different light. 'The monthly account was your exam paper. You got marked,' says Ray Wheeler, who was a divisional director in the early 1980s.[20]

In a memo to managers dated 30 November 1966, Weinstock drew their attention to the Powell report and set some targets for them to aim at. He was, he said, looking for an annual sales:capital employed ratio of at least 2; for a sales:inventory ratio of at least 5; and for annual sales per employee of £4,000.

While the setting of specific financial targets was an important aspect of the Weinstock system, its centrepiece was the annual budget meeting at which the managing director of every GEC company was summoned to head office to be quizzed by Weinstock and Bond about what he had done in the past year and about what he hoped to do in the year ahead. These budget meetings rapidly became the focal point of the GEC year: an event which managers regarded with decidedly mixed feelings. Even the most confident were apprehensive and some were frankly terrified.

Sir Graeme Odgers, who saw the system in operation at first hand some ten years later, explained to me the importance of these budgetary meetings.*

*Odgers joined GEC in 1976 after a spell working for Tony Benn at the DTI in charge of the Industrial Development Unit, which advised the Labour government on help for industrial 'lame ducks'. In 1993, he was appointed chairman of the Monopolies and Mergers Commission.

What they amounted to was a personal compact between the individual managing director and Arnold as to what the performance standards were going to be over the coming period. The standards were in terms of profitability and cash flow. There were two crucial elements in this process: first, the statistical criteria against which the business was going to be judged and second, the personal relationship that was going to control that performance. You have got to have both. That was what I found so impressive. It was no good having the systems – they can be as brilliant as you like. But if you don't have that personal relationship you are not going to have control. If you have the personal relationship but don't have information flow you are not going to have the control either. What Arnold managed to do was to provide the combination.[21]

From the start, Weinstock and Bond put relentless pressure on the managers of the operating companies to squeeze as much cash out of their business as possible. In 1963, the general manager of GEC's turbine plant at Erith in Kent was a young man called Francis Tombs, who is, coincidentally, an almost exact contemporary of Weinstock. He had joined GEC as an apprentice at the age of fifteen at the outbreak of war, but when peace came, the young Tombs left to catch up with his education and later to begin what proved to be a distinguished career in the electricity supply business. In 1957, he returned to GEC. While Weinstock was just beginning to make his mark in industry, Tombs was in charge of one of GEC's largest plants employing some 3,000 people. Tombs, who was to go on to become chairman of the Electricity Council, Turner & Newall (now T&N) and Rolls Royce, clearly recalls the early days of the Weinstock era.

The company was in a parlous state and Arnold's solution was to drive it as a cash business. For most British engineering businesses at that time, cash was something you borrowed from the bank. People didn't realize that companies went bust not because they weren't making a profit but because they could not pay the bills. But Arnold did. He put tremendous screws on cash. Kenneth Bond would ring up and ask, 'How much have you got in the bank?' And I would say, 'One and a half million.' And Kenneth would say, 'Okay, I'll take a million.' And when I said, 'That doesn't leave enough to pay the wages bill,' he would say, 'Well, you better collect some bills then.' This was a weekly event and the maximum cash was expected from the business at the cost of investment. Arnold worships cash. The cash mountain is no accident. There's

always been one. He feels secure with a big cash mountain. He has a unique conviction that cash is security.[22]

The drive for cash was one imperative. The elimination of waste and corporate excess was another. In one of the very first memos Weinstock wrote to all senior managers, he suggested that all lights should be switched off when buildings were not in use. 'The elimination of waste in all contexts will contribute towards a reduction in overhead expenses and result in better control of the business,' he wrote. 'A special effort is required to educate our employees as to their responsibilities in this matter.' A group of GEC executives still remembers returning with Weinstock from a rare expedition away from Stanhope Gate. It was already dark and, as the train passed the GEC factory at Stafford, its lights blazing, Weinstock exploded. It took some tact and courage to remind him that the plant in question was on shift work. Later, in response to an increase in the cost of long-distance calls made before noon, he stopped just short of an absolute ban ('I am reluctant to make an absolute mandatory direction'), but issued a directive suggesting that managing directors made a daily log of all such calls and that they should 'try and stop the chatty ones altogether'.

The size of GEC's telephone bills continued to bother him for years. In March 1972, he told the managing directors that, as a result of monitoring all calls at the Stafford site over a five-day period, it had been discovered that 41 per cent were private and that, when the exercise was repeated a month later, the figure was 35 per cent. 'It is not possible to avoid the conclusion that there is gross abuse of the telephone facility by the Company staff,' he wrote, 'and I wish every unit to institute a monitoring procedure to make regular checks on private calls.' The possible implications of this directive were disturbing. Was it suggesting that the switchboard operators should eavesdrop on people's calls or that the management should bug the phones?

The GEC style was shaped by a very strong Puritan ethic – one which emanated directly from Weinstock himself. However expensive his personal tastes, he regarded lavish expenses, big company cars and all the other time-honoured perks of big business life with absolute horror. Though he himself used the company Rolls for visits to his country house at the weekend, for trips around London during the week he preferred the black taxicab that was part of the GEC car pool and was chauffeured by an ex-*Evening Standard* driver called Bernie. Its appeal was that was manoeuvrable and had the added advantage of not attracting attention.

In May 1982, he discovered that a GEC supplier was claiming that 100 engineers from the company had accepted an invitation to a product launch. A quick call from Stanhope Gate established that, although the

number was exaggerated, the supplier had no difficulty in naming forty GEC engineers who had accepted. 'I did not believe we could be so stupid in GEC,' Weinstock wrote to his managing directors.

> Suppliers who want to sell to us should call on us, not the other way round. Invitations to attend product launches, usually made to large audiences and which frequently include the lure of hospitality, such as lunch or booze, or both, should not be accepted.[23]

There was no question of there being one rule for the officers and another for the sergeants' mess. One of GEC's few frills was a fleet of private planes belonging to MAGEC Aviation, a company Marconi bought from the construction company, McAlpine. When Weinstock used the company jet for private jaunts to Muti concerts in Milan or Vienna, the bill was always paid out his own pocket – as were his seats at Covent Garden. But such trips were rare, as Weinstock, according to GEC's former chairman, Lord Carrington, detests air travel. 'I remember travelling in his plane. It was a very bumpy flight and Arnold was getting crosser and crosser with the pilot. But when he complained, the pilot inquired, 'What do expect me to do: get out the steam roller?' Even Arnold had to laugh.'[24]

As far as GEC and its managers were concerned, the age of austerity began on the very day Weinstock became managing director. And nobody was spared. According to Bond, relations between Weinstock and Lindley, which were already more than a little tense, deteriorated still further when Lindley, who had remained as chairman, was asked to account for his expenses. As Bond remembers:

> The higher you went, the fewer privileges you had. I know all this because Arnold Lindley used to draw expenses of £100 a week. We asked him to account for his expenses. And of course he couldn't. The whole principle was entirely wrong. Another director was aghast when we asked him to account for some expenditure he had charged up.[25]

At the end of March 1963, just two months after Weinstock had taken over, the Magnet House headquarters in Kingsway had been sold for £3 million. Four months later, the GEC top management moved into a modest office block at 1 Stanhope Gate, just behind the Hyde Park Hilton, where it was to remain for the next thirty-five years. Instead of a headquarters staff of more than 2,000, Weinstock made do with less than 100. While the address might have been smart, there was nothing lavish about Stanhope Gate. As mentioned, Weinstock took up residence on the fifth floor, with

Bond and Lewis a few paces down the corridor. His style was informal: he usually worked in his shirtsleeves and his door was almost always open. It was the pictures of his beloved racehorses and the TV set (which showed either stock-market prices or racing depending on the time of day) that caught the visitor's eye. One visitor recorded his impressions thus:

> The desk is not fussily neat but carefully organized. Beyond a sloping reading desk, there is a telephone with 250 short-dial codes that put him in direct contact with his managers throughout the company. He eschews the egotistical paraphernalia which fill the offices of many other businessmen. There are no framed awards or pictures of him clasping former US presidents around the shoulders. He does not revel in the trappings of power. The furniture is sparse, cheap, functional and slightly tatty.[26]

For several years, the world did not pay much attention to Arnold Weinstock. His arrival at the company created little stir and, even after he became managing director at the beginning of 1963, he remained little known outside the electrical industry. By the time the outside world had come to realize who and what Arnold Weinstock was, the management techniques used to transform an entire industry had already largely been developed and the style perfected.

With the benefit of hindsight, it all looks so obvious and simple. What Weinstock and Bond were saying was that performance is something that can be measured and that even businesses within a business should be held accountable for their own successes and failures; if the managers of the business wanted to invest money to improve their business, they either had to earn it first, or at least demonstrate that they had the capacity to earn it later. This idea of the internal business as a discrete profit centre is now commonplace, but at the time it was a wholly new way of looking at things. Furthermore, the Weinstock message was put across with such force that it was, in effect, not so much an exhortation as a moral imperative. As Weinstock saw it, GEC managers did not just have responsibilities: they had duties. And those who neglected them did so at their peril.

Just how demanding the new regime would be did not emerge immediately. But in the early spring of 1966, an anonymous letter arrived at the offices of the *Sunday Times Business News* that purported to describe Weinstock's management methods. The author listed the number of people who either been fired or asked to leave at very short notice and went on to say, 'I don't mind Arnold wielding the axe. I don't even object to him plunging in the dagger. What I do resent is the way he jumps up and down in the blood.'

The editor of the business section, Anthony Vice, assigned the story to two young reporters, myself and Oliver Marriott. We were sceptical about how far we could trust anonymous information, but obviously the first thing to do was to run a Companies House search on GEC and its subsidiaries. We were not very hopeful. Although companies are obliged by law to register changes in their board membership, information is often both out of date and unrevealing. In this case, however, it was different. An inspection of the files of three GEC subsidiaries – GEC (Telecommunications), GEC (Domestic Equipment) and Osram (GEC) – revealed that over the previous sixteen months, no fewer than fifteen directors had resigned. In some cases the record was exceptionally frank. The Osram file stated: 'J. Ellis was appointed a director on 1 April 1965 and was removed from his office on 12 November 1965.' For GEC (Domestic Equipment), the record read: 'Donald Campbell was appointed on 1 June 1965 but resigned on 15 June 1965.'[27]

The next step was to contact as many of the people involved as possible. One man complained about being rung up over the weekend at his golf club and berated by Weinstock. Another, a finance man, admitted that his relationship with Weinstock and Bond had never really gelled. 'It was probably my fault,' he told us. 'I had become used to working on my own and I continued to work that way.' A third man, who resigned at very short notice after a dispute with Weinstock over the control of a subsidiary, said, 'Subjectively, I always thought this would happen with Arnold. You have to tolerate a complete lack of protocol.' But, though the accounts varied, the picture that emerged seemed to throw new light on the personality of Arnold Weinstock and the GEC top management. Up to then, the story had been one of reconstruction, accompanied by universal praise for an ever-rising share price. Now there was a new angle to the story – one that needed investigation and explanation. Armed with the dossier, Marriott and I made an appointment to see Weinstock.

Weinstock went straight on to the attack. 'Before we begin, gentlemen,' he said, 'there are two things I want to say. The first is that I deeply resent the *Sunday Times* going behind my back and listening to a lot of tittle-tattle. The second is that the person sitting beside me is my legal director, David Lewis.' But what really shook us was that on the table in front of him was a copy of very same letter that had been sent to us. We muttered something about the letter only being a starting point for our inquiries and, after things had calmed down a little, we embarked on a very interesting discussion.

We quickly established that not all the fifteen people who had left had been fired. Five were of retiring age and one had died. But it was equally clear that the remaining nine had been fired for one reason or another. To his credit, Weinstock fudged nothing. He discussed each case in full,

giving his reasons as to why he had acted as he did. On leaving, we thanked him for giving us two hours of his time. 'That's all right,' he replied drily. 'I haven't had to before.' We were impressed by such candour and, perhaps rather naïvely, concluded an account of our investigation with the following comment:

> To many, Weinstock's methods may seem unduly harsh. And undoubtedly the image of the company has suffered. But does it really matter? Weinstock would rightly argue that a company should be judged not by its image but by its results – and these, by any standards, have been magnificent. They have been achieved by setting for his senior men both standards and penalties higher than elsewhere. Life in GEC may now be tough, but for many it is also rewarding.[28]

The article, entitled 'Profits and the Man', created something of a stir. It did much to fix in the public mind an image of Weinstock as a tough and ruthless operator. But behind the scenes, life continued much as before. In their history of GEC, AEI and English Electric, Jones and Marriott tell the story of what later came to be known as the 'Osram purge'[29] It occurred in the spring of 1967 and the role of chief hatchet man was played by David Lewis, the legal director, whom Marriott and I had met in Weinstock's office the year before. The two historians relate the sequence of events at Osram as follows:

> A week before Ellis was removed, Clifford Nancarrow was made finance director. Then, in the autumn of 1966, Jim Shanks was hired as commercial director from Plessey and David Lewis, one of Weinstock's inner circle , became chairman to take a firmer grip of Osram. The purge happened the following March. Two directors, Nancarrow and Anthony Willoughby (the technical director who was a long-serving Osram man), and thirteen executives were called in individually for a short talk by managing director Pat Sanson and given a letter of dismissal. Most of them left before lunch the same day. They included the chief accountant and the management accountant and most of the executives in a department run by Nancarrow called Management Services which disappeared in the purge. It was considered unnecessary and to be taking far too long to set up a computer programme for invoicing and stocks. But this was not the end of the trouble. In June 1969, the reforming Jim Shanks himself was fired.

Despite such wide-ranging and seemingly well-thought-out manoeuvres,

the reshaping of GEC was, as the principal architects tell it, a surprisingly haphazard business. There was no blueprint or grand design. The approach was pragmatic. Basically, Weinstock and Bond made it up as they went along. As Bond explained it:

> We took decisions on *ad hoc* basis. It's all very well having a grandiose scheme. The problem is that often you are not in a position to do anything about it. The plain fact is that it was quite apparent what had to happen. And if an opportunity occurred, then we had to decide whether we should do this or that. We did what seemed to be most sensible at the time. And if it meant disposing of things rather than doing nothing, we did it.[30]

As an example of their thinking, Bond cited the decision to sell the turbine generator plant at Erith that was being run by Francis Tombs.*

> Of the four manufacturers we were the smallest. There was AEI, English Electric, Parsons and ourselves. We were told by the Central Electricity Generating Board that there wasn't room for so many and they wanted to reduce the number of manufacturers down to two. So, we took the view that something had to happen, and we sold our business to Parsons, while retaining a share – and it was the GEC people who finished up running the Parsons generating business. Tombs in particular. We weren't trying to shed the business on the grounds we didn't want to be in it. But something had to happen: we had to break the log jam.

Bond continued:

> We had a number of instances like that. I remember in Australia there was a joint telecommunications company and another in South Africa. Everyone accepted the fact it would be much better if one company took responsibility for managing the thing. But though everybody agreed in principle, they never did anything. So eventually we sold our shares to Plessey or somebody. Not only were we acquisitive but we were also prepared to dispose of things.

The questions Bond and Weinstock asked of man and machinery were almost identical. Is he or it up to the job? Are we getting value for money? Would we do better if he or it was scrapped or replaced?

*Tombs claims that Weinstock came to regret his decision to sell Erith. He says that Weinstock told him that it had a 'cracking good' management team and that it was one of the worst management decisions he ever made.

It was not long before it was clear that this hard-headed approach was yielding results. In the five years after Weinstock joined the board, pre-tax profits rose more than sixfold – from £3.2 million to £19.4 million. Even more dramatic was the change in sentiment on the stock market. Once seen as a sleeper, Weinstock's GEC was now regarded as a growth stock *par excellence*. In 1961, GEC was by far the smallest of the big three engineering companies. It was capitalized at a very modest £36 million compared with English Electric's £45 million and AEI's £82 million. Now, with a stock-market price tag of £140 million, against English Electric's £107 million and AEI's £105 million, GEC was the biggest of them all. Since 1961, its shares had risen by some 284 per cent. What this meant was that the £5.5 million Michael Sobell and Arnold Weinstock had received in GEC shares when they sold their business in the spring of 1961 was, on the assumption that none had been sold, now worth a cool £19.5 million. However parsimonious Arnold Weinstock might have been with the company's money, personally he could afford to make one or two expansive gestures.

In 1967, Weinstock took a step that hundreds if not thousands of successful businessmen have taken before him: he bought a country seat. The place he chose, Bowden Park in Wiltshire, is no ordinary house. Built by the famous architect James Wyatt in 1796 for a Bristol merchant called Dickenson, the house is regarded as one of Wyatt's most successful smaller works. The facade, with its central domed portico and four Ionic pillars, has been praised for its elegance and lightness of touch.[31] When the Weinstocks bought it, there were long flowerbeds near the house, but now most of the twenty-acre garden is given over to lawns and rough grass, with lots of shrubs, deciduous trees and some bedding plants around the swimming pool. There is also a traditional English kitchen garden and a section where potatoes and other vegetables are grown commercially. In the greenhouse, there are orchids, bougainvillaea and hibiscus which were often cut over the weekend and taken back to decorate the Grosvenor Square flat. Altogether a staff of nine full-time and two part-time gardeners was needed to keep the place tidy.

By all accounts, Weinstock, who came down from London most weekends, was a stickler for neatness, insistent that everything should be just so. As early as Wednesday, the gardeners would begin sprucing the place up, raking the gravel on the drive, clipping the hedges and weeding the lawn in preparation for the arrival of the Weinstocks. Weeds were something that troubled Weinstock a good deal. He had a stick with a cutting hook at one end and he used to wander about slashing at the weeds and grumbling: 'Why do I have to do this. What have I got gardeners for?'[32] The fact that he chose to spend his leisure time cutting out the weeds from the lawn could perhaps be seen as a metaphor for his professional life. It

might even be something for psychologists to ponder. In any event, there was, as the autumn of 1967 approached, to be plenty of scope for corporate pruning and weed-killing.

FOUR

THE BIRTH OF A GIANT

The events that were to propel Arnold Weinstock from being the head of an important engineering company into an industrial icon of the 1960s had their origins a few months after he had taken charge at GEC. In the autumn of 1963, Harold Wilson, the leader of the Labour Party, set out for the delegates to the party conference at Scarborough his vision of Britain's industrial future. He talked about the 'white heat' of a technological and scientific revolution that was to transform British industry. And he called for an end to class distinction in British boardrooms. 'At the very time when the MCC has abolished the distinction between amateurs and professionals,' he said, 'in science and industry we are content to remain a nation of Gentlemen in a world of Players.' According to his biographer, Wilson only settled on the subject of his keynote speech the night before, but its impact on press and public was profound. As Ben Pimlott writes:

> The speech was, in a sense, 'extremist' – it advocated government intervention in almost every aspect of the nation's economic life. Yet it appealed far more widely than just to Labour Party members. It captured a moment, saying what many young and intelligent people across the spectrum urgently believed. Just as Mrs Thatcher in the late 1970s managed to strike a chord among many normal Labour voters, so in 1963 there were plenty of Tories who found a great deal to agree with.[1]

Equally important, the ideas that Wilson had sketched out to the faithful at Scarborough were to assume a tangible form when, a year later, Labour swept to power after twelve years in opposition.

As far as GEC was concerned, by far the most important and influential of Labour's initiatives was the creation of the Industrial Reorganization Corporation. Headed by Frank Kearton, the fast-talking,

idiosyncratic head of Courtaulds, the textile company, which he had, some years before, rescued from the unwelcome attentions of ICI, the IRC was a new kind of animal on the industrial scene. It was born out of the belief that British companies were losing out to their American and European competitors and that in order to survive they needed to merge. The early 1960s had already seen a wave of mergers, but the new Labour government felt that it was time that the state took a hand. Officially, the IRC's brief was 'to promote or assist the reorganization and development of industry', but in practice it was there to persuade, cajole and, if necessary, browbeat companies to merge.

The idea of what was, in effect, a government-sponsored merchant bank had been borrowed from the Italians. Their *Istituto per la Riconstruzione Industriale* (IRI) had been created in the fascist era to salvage as much as possible from the wreckage of the Wall Street crash and, over the subsequent thirty years, IRI had grown to become Italy's biggest commercial enterprise. By the mid-1960s, IRI directly controlled more than half Italy's steel output, its telephone and communications system, much of the country's shipbuilding and engineering, a major shipping line, the motorway network, a stake in the car business (as the owner of Alfa Romeo) and the national airline, Alitalia.

To interventionist-minded Labour politicians of the centre, it was an exciting, yet pragmatic, idea: an attractive alternative to the Left's doctrinaire nationalization. However, to the bankers, industrialists and stockbrokers who were called in to help make the IRC work, the idea that they were becoming agents of the state would have seemed quite shocking. With the possible exception of Kearton himself, none of those most closely involved with the IRC were Labour supporters and from the outset there was a determination to downplay the exercise. It was meant to be a very low-key, word-in-your-ear-old-boy, sort of operation. As Ronald Grierson, the IRC's first managing director, told a audience of businessmen at a conference in Glasgow in March 1967:

> I am anxious to leave you with the thought that the IRC is essentially a very modest institution. Far from believing that we know the answer to any industry's problems, we start from the premise that the only people from whom we can learn are the leaders of industry themselves – and by leaders I mean not just the big boys but the bright boys – and that any plan we might put before them has almost certainly occurred to them already.[2]

Officially, the IRC came into being in December 1966, but, in fact, work had started six months before. As early as its second meeting at the end of July, it considered a request from the government to look at the

scope for rationalization at the heavy end of the electrical industry. The pressure was coming from the nationalized Central Electricity Generating Board, who believed that even after GEC had sold its Erith operation to Parsons, there were still too many firms making too many turbine generators – and that the number should be reduced. The big power station building boom had already peaked and the CEGB could see that if nothing was done to reduce manufacturing capacity, by the early 1970s the industry would be in deep trouble. This theme was taken up the newly formed Department of Economic Affairs, which, some months later, called Kearton and Grierson in and told them that the rationalization of the electrical industry should be one of their first priorities.

From the beginning the focus was on Associated Electrical Industries. While Arnold Weinstock was demonstrating his ability, almost daily, to improve the fortunes of GEC, at AEI much had been promised, but very little delivered. The high point of the company's fortunes had been in 1955 when it made a profit of £15 million. And although it frequently promised that it would soon surpass this figure, somehow, when the results came in, they always fell short – often by quite a large margin.

Measured by turnover, AEI was the much bigger company. Its annual sales were £260 million compared with GEC's £180 million. Created in 1928 as the result of a clandestine, American-sponsored merger between British Thompson Houston and Metropolitan Vickers, AEI regarded itself as the standard-bearer of British engineering and tended to look down on Hugo Hirst's GEC. In his book, *Take-Over*, published two years after AEI had disappeared into the maw of Weinstock's GEC, Sir Joseph Latham, the defeated AEI chief executive, described the company's reaction to GEC's bid: 'The officals and staff were shocked and even affronted, particularly because in such parts of AEI as Metropolitan Vickers, proud of its worldwide reputation, GEC were regarded as mainly "traders".'[3] The City and its friends would have had little trouble decoding this message. What Latham was trying, not too subtly, to suggest was that the upstart GEC was a Jewish business.[*]

AEI had an honoured place in Britain's industrial history. From its base at Trafford Park, Britain's first trading estate on the outskirts of Manchester, 'Metrovick', as Metropolitan Vickers was fondly called, had made a heroic contribution to the war effort: in addition to searchlights, radar installations, guns and gun mountings, by the time the war ended, the aircraft factory had turned out more than 1,000 Lancaster bombers. In the immediate post-war years, AEI, which had prospered from the price-

[*]This would not be the last time Weinstock would be subject to the British establishment's anti-Semitism. In May 1973, Weinstock was blackballed by members of Brooks, the St James's Street club. His proposer, GEC chairman Lord Aldington, and his seconder, Charles Villiers, both resigned.

fixing rings of the 1930s, remained largely insulated from competition. Overseas it enjoyed a captive market in the countries of the fast-dwindling British Empire and the emerging Commonwealth, while at home it bene-fited from its membership of the industry's cartel. 'The market was dominated by the BEAMA [British Electrical and Allied Machinery Association] cartel,' says Sir Alan Veale, who was a senior manager at AEI but stayed on after the takeover to become one of Weinstock's most trusted lieutenants. 'There were ten manufacturers in the country and they shared out the work *pro rata* between them.'[4] But as the 1950s came to an end, things began to change. The power station bonanza was almost over and, as the flow of work began to dry up, the BEAMA cartel started to break apart.

In 1963, AEI was led by Lord Chandos, who had held the same posi-tion from 1945 to 1951 and then returned to the company in 1954. Better known as Oliver Lyttleton, Colonial Secretary in the 1951 Churchill government, Chandos was an adroit politician, socialite and fixer. (After leaving AEI, he became the first chairman of the National Theatre, where he managed to antagonize both Sir Laurence (later Lord) Olivier and Kenneth Tynan.) Chandos understood the City and was a great help to AEI in raising money for its vast post-war expansion schemes, but he was essentially a politician rather than a businessman. He came from a differ-ent world and talked a different language to the engineers who actually ran the company. Furthermore, his determination to push through large and expensive projects like the building of a turbine generator plant at Larne in Northern Ireland was to prove foolish. As Alan Veale said, 'It was a quite incredible folly that anyone should do this. But I think the explanation was that Chandos was politically responsible for Northern Ireland development.'[5]

At the end of 1963, Chandos, disheartened by his failure to raise the company's profitability, passed the chairmanship to Charles (Mike) Wheeler, who was also the nominal chief executive. Three years later, as the pressures mounted, Wheeler handed over as chief executive to Sir Joseph Latham, who had joined AEI some years before from the Coal Board.

Wheeler and Latham had even less success in restoring AEI to finan-cial health than Chandos. The basic problem was the failure of top management to integrate the various parts of the business and run it as a coherent operation. There was also the same divorce between sales and operations that was such a feature of the pre-Weinstock GEC. Although it presented a unified face to the outside world, AEI was very far from being the sum of its individual parts. 'The big companies were fighting each other like drunken sailors,' says Veale.

The biggest rivalry was between Metrovick at Manchester and BTH at Rugby. And what made the problem worse was Latham's style of management. He was distant and remote. He did not have a hands-on approach. And he was against appointing divisional heads to the AEI board because he was afraid they would gang up on him.

The result was that there was an almost total lack of communication, confidence and understanding between the top management in their lavish Grosvenor Place headquarters, with a boardroom overlooking the gardens of Buckingham Palace, and the executives actually running the companies.

As the boss of AEI, Latham was a strange mixture of insight and inertia. Intellectually, he realized that the company was in a serious mess, but, like Wheeler before him, he was unable to produce the desired results. In his highly defensive account of the GEC–AEI takeover battle he wrote:

> I became Chief Executive of AEI on 1 January 1967. It was clear from the start that there were long-term problems and tasks, but the early months of 1967 had to be devoted to action to obtain rapid short-term improvement. First, the company had to be invigorated and convinced that outstanding efforts were needed and that there must be greater drive and urgency everywhere. Second, there had to be a number of changes in management. Third, there had to be substantial increases in productivity by reducing manpower and speeding up rationalization and concentration. Profits had to be increased quickly.[6]

The IRC would have agreed with all of this – save in one respect. The more they looked at the problem, the more they thought that the answer lay in some kind of merger. And the more they talked to people in the industry, the more they came to think that the solution was specifically an AEI/GEC tie-up. Whether this thought came from GEC or whether it was an IRC idea is not wholly clear. What Kenneth Bond says is: 'I suppose we looked at the possibility of buying AEI over a couple of years when GEC was relatively healthy.'[7]

Initially, the IRC hoped for an arranged marriage. With this in mind, it organized a discreet private dinner on 12 June 1967 at the Institute of Directors in Belgravia. Those present were Frank Kearton and Ronnie Grierson from the IRC, Lord Renwick, a director of AEI, chairman of ATV and a partner in Greenwell's, the City stockbrokers, Kenneth Keith, chief executive of Hill Samuel, the merchant bank that had just finished a detailed proposal for a AEI/GEC merger to be underpinned

by a £15 million loan from the IRC, and, lastly, Joseph Latham. The purpose of this gathering was to establish whether or not Latham would be prepared to see his company join forces with Arnold Weinstock's GEC.

The proposition was, of course, not put as bluntly as that. Officially, what the dinner party was talking about was the rationalization of the electrical industry. According to Latham, Kearton opened the discussion by saying that government departments had been pressing the IRC to act in the electrical industry for some time; he added that Kenneth Keith was critical both of the industry and the AEI record. 'Throughout the talk,' Latham continued, 'there was no specific suggestion that there should be a merger between GEC and AEI, although Keith obviously favoured this possibility.' But the subject of what amounted to a GEC takeover was always just below the surface. 'The IRC people,' Latham reported, 'said that they had talked to Arnold Weinstock, who would be prepared to link with AEI under pressure but showed no anxiety to do so, particularly as he did not wish to enter the heavy electrical industry.'[8]

Latham explained to his fellow diners that he was opposed to the establishment of a new, large electrical company, that he thought there were few common interests between his company and GEC and that he had reservations about GEC's depth of management and its suitability as a manufacturer of heavy equipment. In plain language, he was saying that GEC was a one-man band that knew nothing and cared less about AEI's core business and was only there to make a quick turn. By the time he had finished, it was clear to Kearton, Grierson and Keith that there was no chance of an agreed merger and that if the rationalization they wanted was to happen, then they would have to rely on Arnold Weinstock. Their problem was that they were divided about whether they could say so publicly.

While Kearton and Keith were becoming increasingly convinced that the IRC should take sides and openly back GEC, Ronnie Grierson, the merchant banker from S.G. Warburg, was far more cautious. As Douglas Hague and Geoffrey Wilkinson write in their authoritative account of the IRC:

> Grierson was deeply concerned because the IRC Board was divided on the fundamental question of whether the Corporation should remain fully neutral in the current struggle or come down firmly on one side or the other. He could see nothing wrong in the IRC backing a merger proposal possibility, but he was totally opposed to supporting one party publically or seeking to influence shareholders in accepting or rejecting a bid. If the IRC persisted in its

present course, he would be unwilling to represent these views and would prefer to withdraw as Chief Executive.[9]*

Although they had a good idea from their friends and supporters at the IRC and in government as to which way the wind was blowing, Weinstock and Bond were careful not to show their hand: as Bond has explained, they were playing a waiting game. Their strategy was not only to remain on good terms with the IRC, but to cultivate their contacts with ministers and civil servants at the Department of Economic Affairs, the Board of Trade and the Ministry of Technology, while at the same time preparing contingency plans for a quick yet decisive engagement with AEI. As Jones and Marriott remark:

All these talks probably helped GEC win the takeover battle, because people in key positions realized how different Weinstock was from his public image at that time, which tended to be linked with adjectives like 'abrasive', 'aggressive' and 'ruthless'. To these men, on the contrary, he appeared as a man who had taken the trouble to come in person, explain what his plans were, and try and convince them of their rightness by rational argument.[10]

Weinstock and Bond liked Kearton: they thought he was a 'doer' and they cultivated him in the belief that the IRC's support for a GEC bid, if and when it came, would be critical. In this, they were entirely right. Later, however, after the deal had been done, relations with Kearton cooled. Bond told me:

He played a big role with the government, of course, in getting the merger through. But once it had happened, he seemed to get second thoughts about whether the thing he had created [sic] would just run amok. I don't know why. For a period of time, he tried to lay down the law to Arnold. But Arnold's first concern was the health of the business, not pussy-footing around. But with Kearton, the thing having been created, he was saying 'slowly, slowly, slowly'. I think that Kearton was trying to protect himself against any criticism for the role he had played in the making of the new GEC.[11]

With Kearton and the IRC now firmly on his side, Weinstock waited for events to take their course. The moment for GEC to strike came quite suddenly with the publication in September 1967 of AEI's half-year

*Grierson was as good as his word. While the GEC–AEI battle was still raging, he resigned as managing director of the IRC and later in the year joined GEC as a vice-chairman.

figures. They revealed a fall in profits from £6.9 million to £3.7 million and showed that, far from being on the road to recovery, as Latham had suggested, AEI was in very bad shape. 'The poor figures came as no surprise,' Weinstock said, 'but the optimistic statement did.'[12] These results were the signal for which Weinstock and Bond had been waiting. The next day they called on Kenneth Keith at Hill Samuel and asked if the bank would act for GEC in a bid for AEI.

On 27 September, Frank Kearton summoned a meeting of the board of the IRC which was attended by everybody except Sir Charles Wheeler, the chairman of AEI, and Sir Joseph Lockwood, the chairman of EMI, which had a joint venture with AEI in British Domestic Appliances making washing machines and other useful items. Kearton reported that the previous afternoon Weinstock had told him that GEC intended to bid for AEI. Weinstock had said that he was not asking the IRC for money, but had suggested that, before the offer was announced, the relevant ministries and major customers, such as the CEGB and the Post Office, should be told that the IRC supported GEC. After extracting a pledge from Weinstock that the merger and the merged businesses would be conducted in an 'industrial statesmanlike manner', Kearton gave his blessing.

The IRC board was, with the significant exception of its managing director, Ronnie Grierson, happy to follow its chairman's lead. It decided that at the very least the merger would break the 'log jam' that was holding up the effective rationalization of the industry and agreed that GEC should have its backing. And when, with the battle still raging fiercely, a furious Latham wrote to Kearton on 25 October to protest about the IRC taking sides, Kearton spelled out what had, by that time, become the position not only of the IRC, but of the government, the majority of firms in the City and the City editors of the influential broadsheets. At the *Sunday Times*, for example, the decision was taken not just to report the bid but openly to support Weinstock. In an article entitled 'The Weinstock Bid for Power', the *Business News* editor, Peter Wilsher, wrote: 'The GEC's bid for AEI is the biggest, and in many ways the most hopeful, move we have seen since Mr Wilson started talking about the restructuring the economy. It will need very strong and serious argument to justify its failure.'[13] In his letter to Latham, Kearton took a similar, if rather more measured, line.

In your circular of 20th October you refer to the IRC's support of the GEC offer. In giving this support our Board have proceeded on the strong practical conviction that the huge tasks of reorganization facing the industry could be more powerfully undertaken by these two companies jointly than by either of them alone. Our Board also feel that, while size is not the sole factor, there is in the case of the

electrical manufacturing industry a strong argument for creating a group with sales exceeding £400 million and that such a group, far from being a over-diversified giant, would bring Britain further into line with some of its North American, European and Japanese competitors.[14]

Though the issue was ultimately decided in the marketplace, the IRC's public support was crucial, as Weinstock knew it would be. The battle formally opened on 13 October when GEC offered five of its 'B' shares and £4 in cash for every eight AEI shares, thus valuing the company at £120 million. The struggle ended on 9 November when, having raised its bid by another £32 million, GEC secured the support of more than 50 per cent of the AEI shareholders.

On the eve of the final day, Wednesday, 8 November, when the outcome was still undecided, Arnold and Netta Weinstock went to the opera to see *The Marriage of Figaro* at Covent Garden. It was, some thought, a rather theatrical gesture: a public display of insouciance – rather like an election candidate popping off to the cinema while the count was going on. But Weinstock himself briskly dismissed such a notion. As he said to me the following week:

> It was simply that I had a long-standing engagement to go to the opera that night and I saw no reason to break it. The only thing I could have done was to help them count the acceptances at Hill Samuel and there were plenty of people doing that already.[15]

In the aftermath of defeat, Latham reflected ruefully on the reasons. In his book he wrote candidly:

> The hard facts were that AEI had a poor profit record, had disappointed stockholders repeatedly and had yet to reap the benefts of its recent changes. GEC had a good profit record and in recent years had realized their promises. The price offered for AEI stock was higher than any market price for years and after the two improved offers only a miracle could have deflected the bid.[16]

Latham also acknowledged the importance of the 'Arnold factor'. 'The great advantage GEC enjoyed was that the company had been virtually controlled by one man, Arnold Weinstock, and in business as in politics this policy is often highly successful in the short term.'

The capture of AEI was a brilliant coup. The generous use of GEC paper – both equity and loan stock – meant that Weinstock needed to use up comparatively little of his precious store of cash to gain the prize. And

the high price of GEC shares in the run-up to the bid meant that there was no significant dilution of the equity. For an increase in shareholders' funds of £96 million (up from £93 million to £189 million), Weinstock acquired assets worth £185 million – almost double. The mathematics alone indicated to Weinstock and Bond just how great the financial benefits might be of rationalizing what had become Britain's second-largest manufacturing company and Europe's third-largest electrical firm. Certainly there was plenty of scope.

As they surveyed what they had bought, Weinstock and Bond calculated that, in a business that now extended into almost every corner of electrical engineering, there were over ninety separate product groups where the two companies overlapped. The first questions they asked were: where should we apply the knife and how deep should we cut? But before that, they had to choose the men to do the deed. Bond set out the decisions they faced like this:

> As we saw it, the really important thing was the outlook and ability of the person who was given the responsibility of bringing together the different businesses. The problem with AEI was that they had acquired businesses which they had never really integrated. They had never carried out their own rationalization. There had been acquisitions, but nothing else had followed. Having given someone responsibility, you have got to combine those businesses in the most effective manner. So we said, 'Give us your proposals.' In our minds, the question always was whether we had given the right person the job. Who should we give the job to? Maybe we should have given it to someone from outside?
>
> It's not an exact science. It's sucking and seeing. When one's responsible for running a business, one has to do the best one can. It's rather like a football manager: he starts with the team he's got and if he goes out and buys people at £5 million a time, the money is going to run out. If things are better today than yesterday, that's an improvement. And that's where Arnold Weinstock was meticulous in checking up on the progress of people: whether they had this and whether they had done that. In his own mind he was marking their card all the time, doing an audit or an examination.[17]

Weinstock and Bond had such a low opinion of the top management at AEI that there was no chance of the old executives playing a role in the new company; even though, out of politeness, Latham, Wheeler and John Barber, the finance director who had come in from Ford, were offered

seats on the GEC board. 'My relations with Barber were very good,' says Bond. 'I asked him what he wanted to do and the hopes I had were that he wanted to get Latham out. There was no one else of any consequence. Many people in AEI were quite pleased that we got the Grosvenor House people out. They had had enough.'

Inevitably, the casualties among AEI's managerial ranks were heavy. Some were already close to retirement, but many saw clearly they had no future at AEI/GEC and were encouraged to look for other jobs. It was GEC 'trusties' like Doug Morton, who had survived the earlier purges and had earned Weinstock's respect by sorting out GEC's heavy electrical plant at Witton, who led the charge. There was, however, some new blood. A handful of the AEI managers running the plants were asked to stay on to help with the reorganization.

Prominent among the survivors was Alan Veale, a tough, pragmatic engineer who had had little time for AEI's high command and who had made his reputation as a highly effective manager of Metrovick's heavy engineering plant at Trafford Park, which at the time of the takeover employed 12,000 people. 'I started to bring things back to the centre,' says Veale. 'I was king for the day and I left Trafford Park as heir apparent.' The year before the takeover, Veale had been transferred from Trafford Park to BTH Rugby as managing director and had already started a rationalization plan by bringing a number of outside operators back to the centre. 'The plan was that I would spend two years sorting out Rugby and then move back to Trafford Park.'[18] The first intimation Veale had that great changes were about to happen was when someone from Stanhope Gate turned up in his office and announced, 'I'm taking over.' 'Oh no, you're not,' Veale replied, and chucked him out. That afternoon Weinstock himself rang up and said that there had been a misunderstanding. The upshot was that Veale and Morton were appointed as joint managing directors of the power engineering operation of the two companies and told to get on with it.

The first task, Veale said, was to sort out the management; to decide who did what. Veale and Morton met with Weinstock to handpick the people. Each divisional manager was called in and asked what he intended to reorganize and how. Veale found the contrast between the vacillation of AEI's top management and Weinstock's crisp decisiveness most striking. The whole exercise was, he said, fairly quick.

It's an ability to get decisions that's characteristic of Arnold's style. He was always there. He had the courage to associate himself with a move. He had no friends. He would look at it objectively. But once you are on his team, Arnold was a tremendous friend and a very loyal man. When you're outside, you are just a statistic. You

become a member of his team once you have established you can
do it. Throughout this period I felt I was on trial.

The prospect that Morton and Veale were facing was gloomy. The
business was in a bad state. AEI's main transformer factory at
Wythenshaw, a prime candidate for what would be now called 'downsiz-
ing', was on short time and demand was also slack for Rugby's large
electrical machines. But before Morton and Veale could start wielding the
knife, there was some book-keeping to be done. 'Arnold was very keen
to ensure that the profitability of AEI was not exaggerated and adequate
provisions were made for every single doubtful contract,' says Veale.

Reporting to shareholders after the takeover, GEC informed them that
AEI had made a loss of £4.5 million in 1967. As AEI had said that it
expected to make a profit of £10 million in that year, this represented a
quite staggering swing of £14.5 million between forecast and outcome. To
what degree this surprising result reflected Weinstock's reported desire to
minimize AEI's profitability is impossible to say. But it must be said that
Bond believes that one cause does not preclude the other; the opposite, in
fact. AEI was 'probably not making any profits at all' and he does not
accept the suggestion that GEC massaged the figures to present AEI in a
bad light.

> AEI made forecasts and we compared our figures with their fore-
> casts. It was not us that was under scrutiny but the accountants who
> put their name to the AEI forecast. The plain fact is that it was they
> who had audited the previous accounts and they hadn't audited
> them very well.[19]

In the months after the takeover, Morton and Veale put much effort
into bringing AEI's system of financial reporting into line with established
Stanhope Gate practice. 'We set up the system of financial control with
the ratios and all that,' says Veale, 'but the point always was that Arnold
would never actually approve anything you wanted to do. It would always
be your decision – if he allowed you to proceed.' As word of Weinstock's
fondness for his ratios spread and as the fame of the Weinstock system
grew, people inside and outside GEC came to believe, not without some
justification, that the company was being run on some kind of financial
auto-pilot. But, as Weinstock himself was point out, the figures were not
everything. In a back-to-basics memo written in March 1970, he sounded
a warning:

> In the complications and difficulties of reorganization and rational-
> ization, I am just a bit concerned with the temptation to desert the

substance for the shadow and accord to arithmetical signposts, such as operating ratios, a pre-eminence it was never intended to attach to them.The operating ratios are of great value as measures of efficiency but they are only the measures and not efficiency itself. Statistics will not design a product better, make it for a lower cost or increase sales. If ill-used, they may so guide action as to diminish resources for the sake of apparent but false signs of improvement.

Management remains a matter of judgement, of knowledge of products and processes and of understanding and skill in dealing with people. The ratios will indicate how well all those things are being done, and will show comparison with how they done elsewhere. But they tell us nothing about how to do them. This is what you are meant to do.[20]

The message to the AEI managers was the same as he had preached to the GEC people four years previously: no alibis. Again and again they were told they must take responsibility for their own actions; that if they succeeded, they would reap their just reward and if they failed, then heaven help them. In case this might have sounded too abstract, Weinstock and Bond were always able to supply some practical examples. Bond quoted a typical example:

I remember a case in an AEI cable contract. I said, 'I'm not going to approve this. If you think you can put in a tender for £1 million or so, you can do so. But if not, you've lost the tender.' So, just to be on the safe side, they put in for an extra quarter of a million. I made some iinquiries a few weeks later to find out what had happened. It turned out that even with the quarter of a million added on it was the lowest tender. They just didn't have a clue as to what they were doing. The trouble was that the manager running this business was not responsible for the tender. They had an estimator with an estimating department. So that if anything went wrong, the manager would say, 'We under-quoted for that job.' He wouldn't take responsibility.

What matters at the end of the day is whether the business is successful. We didn't know the product. We didn't know how they made up the estimate. I found out that one of our companies would produce estimates for turbine generators based on the weight of the machine. In the old days, when the biggest was 33 megawatts, that was probably about right. But when they started going up the scale – to 375 and 500 megawatts – that was absurd. They used to build up estimates on the back of previous estimates without ever

working out whether the first estimate was soundly based. It was really primitive. Unbelievable. Some people might say it was all ritual. But for Arnold it wasn't.[21]

Although the work that Veale and Morton were doing in rationalizing and slimming down the heavy side of the business at Trafford Park and Rugby was important, the question of what to do about AEI's cables and telecommunications factory at Woolwich in south-east London was even more pressing. Perched on the side of a narrow escarpment above the Thames, the factory was symbol of almost everything that was wrong with the company. It was old, badly laid-out and had been devoted for the past sixty years to making a product, the electro-mechanical Strowger telephone switching equipment, which was now in the process of being phased out by the Post Office in favour of electronic exchanges (see chapter nine). Its level of productivity was appalling. When GEC came to look at the books, it discovered that the gross sales per employee were something like £500 – which had to cover wages, overheads and margin. But the trouble was that there *was* no margin. It was Woolwich, more than any other single factor, that scuppered AEI's chances of beating off Arnold Weinstock; for it was the £3 million or so that the telecommunications side lost in 1966/67 that had caused AEI to miss its profit forecast by such a huge margin. What GEC could never figure out was why, instead of rationalizing and cutting back, the AEI management had over the previous two years hired thousands and invested millions in an operation that was never going to make money. 'It's a mystery to us,' Weinstock said, 'where the work was supposed to come from. No allowance was made for improvements in productivity.'[22] With a total of six telecommunications factories within the new group scattered throughout job-hungry development areas in Scotland, the North-east and the Midlands, it would have been a brave, if not a foolish, man who would have stepped in to make the case for Woolwich.

Although it was Weinstock himself who attracted most of the odium, it was not he who decided that Woolwich should close. The suggestion came from George Tomlin, who was then running GEC's telecommunications division, after he and his staff had done a detailed appraisal of the entire operation. The plans were then submitted to Stanhope Gate for appraisal by Weinstock and David Purle, the deputy managing director of AEI/GEC telecommunications, who had been moved to the headquarters specifically to look after Woolwich.

But while Tomlin and his team had taken the initiative, it was Weinstock who endorsed the final decision and it was he who ruled that the unions should be kept in the dark. Jack Scamp, the head of GEC's labour relations, had had a couple of meetings with the unions in the

course of December 1967 and January 1968, during which he indicated that there would be redundancies generally, but he said nothing specifically about Woolwich. And it was not until they were summoned for an official meeting early in February that they discovered for the first time that the company had made up its mind without them and that Woolwich was to be closed.

'We were not consulted, we were told,' said George Doughty of DATA, who led the union delegation. If the unions had been given time to inform their members, much of the bitterness might have been avoided. But GEC's decision was leaked so that the news was all round Woolwich a couple of hours before the unions had even met Scamp to hear the worst. The consequences were disastrous; the company appeared to be ruthless and uncaring and the unions ineffective and out of touch.

However logical the decision to close Woolwich might have been, the blow, when it came, was heavy. The factory was by far the largest in the area: it covered 40 acres, boasted a canteen that could hold 1400 people at a sitting and had its own amateur dramatic society and a 17½ acre sports ground just up the road at Charlton. The first official word the workers at the factory had that their jobs were to go was over the factory tannoy on the afternoon of Friday, 2 February. The news sent shock waves right through the community. The previous year had seen the final stage in the long decline of the Woolwich Arsenal, which in its heyday had employed 75,000; now another 5,500 jobs were to disappear. To the people of Woolwich, GEC's statement that the redundancies would fall in an area where 'unemployment figures are the lowest in the country' was to add insult to injury. As one resident put it, 'I can understand them wanting to provide jobs in Scotland, but why make Woolwich a distressed area to do it? It was a bloody great bombshell.'[23]

The decision to close Woolwich had far more than local significance. It was to be the first really major confrontation between Weinstock's GEC, the workers and the unions, and the noisy row that followed did much to establish Weinstock's image as a hatchet man in the public mind. Community leaders, local MPs and others rushed to protest. The Reverend Michael Covington wrote to the local paper to complain about the lack of consultation. 'This reported action of the management of GEC,' he wrote, shows a lack of consideration for human dignity and the rights of the working man.'[24] This complaint was echoed by Christopher Mayhew, the MP for Woolwich East. In a speech in the House of Commons on 8 February, he described GEC's 'extraordinary misconduct' in announcing the closure without prior consultation as 'a crime against normal industrial behaviour'.[25]

In the weeks immediately following the announcement, the shop stewards, the convenors and the branch officials were busy trying to make the

affair a national, rather than a local, issue. The climax of the campaign came on 12 March, when four trains were hired to take the Woolwich protesters to Westminster for a march on the House of Commons. In Belvedere Road, near Waterloo Station, they were joined by delegations from many of the AEI/GEC factories throughout the country, as well as workers from the former GEC turbine plant down the river at Erith, from Osram, from British Insulated Calenders and from Vickers at Crayford. They carried slogans which asked: 'Who governs: the Arnolds or the 'Arolds?' But for all the rhetoric and the indignation, it was a low-key event. As the *Kentish Independent* reported: 'The march was an orderly affair although there was some singing from a section of the marchers.'[26]

Of senior trade unionists or of ranking Labour politicians there was no sign. Having given Weinstock such conspicuous backing in the takeover of AEI – to the point where the President of the Board of Trade, Anthony Crosland, just waved it through without any reference to the Monopolies and Mergers Commission – cabinet ministers were prepared to turn a blind eye to the ensuing redundancies, however politically awkward. The government line was spelled out by John Stonehouse, Minister of State for Technology. He told a meeting that severe unpopularity with traditional Labour supporters was a price the government was prepared to pay for the 'fundamental restructuring' of British industry. He went on to praise the AEI/GEC merger in Weinstockian terms. 'If the merged firm carries on in the same way as the original parts,' he said, 'the merger might as well not have happened. Unless the merger is followed by an immediate and substantial output, redundancies must not only be expected but must be welcomed as a step in the direction of greater efficiency.'[27]

Over the years, Tony Benn, who had taken over from Frank Cousins as Minister of Technology in 1966, has presented himself as 'the working man's friend'. But that is not how he came across during the Woolwich dispute. In a talk to students at the Woolwich Polytechnic, the only mention he made of the battle that was raging right on their doorstep was to say that, with mergers like AEI/GEC, what he liked to call 'MinTech' was 'very happy to assist in any possible way.'[28]

If the Wilson government was wooing Weinstock, the converse was equally true. In his diaries, Tony Benn recorded that he had a call from Arnold Weinstock.

He said he had read Hansard on the Industrial Expansion Bill Second Reading and thought there was scope for a Government that was really determined to modernize industry and added that he would be glad to help in any way he could. So I suggested we should have lunch together. Of course, if I were suspicious, I might say that he wanted to woo me over a row going on about the

closure of the AEI plant at Woolwich under the AEI–GEC merger. He may be genuine and anyway we do get on well.[29]

By his own account, Benn was fascinated by Weinstock, but, like many, did not know quite what to make of him: 'a very complex character'. Nonetheless, he was impressed by the lifestyle. After a dinner with Arnold and Netta at the flat in Grosvenor Square, he wrote, 'They live in a flat which is fantastic – it is like a first-class cabin on the QEII with no evidence of human habitation. If they moved out, somebody else would be able to move in without having to move a single thing.' Benn was sufficiently impressed by Weinstock's reputation to ask if he could attend some of his board meetings. Weinstock replied that, in fact, he didn't have board meetings, as he did not believe in that way of working, but if the minister would like to attend a budget meeting that could be fixed up. 'I find him agreeable, easy to work with but incredibly primitive politically,' Benn wrote. 'Not so much reactionary as primitive. He described Brian Abel-Smith at the LSE as a troublemaker when he is a middle-aged Fabian social engineer.' But Benn was not going to let a small disagreement about a don at LSE stand between them. His entry ends: 'I have certainly got good relations with him and want to build on them.'

Although GEC had quite deliberately given no advance warning to anyone of the decision to close Woolwich, Weinstock and Jack Scamp moved quickly and effectively to neutralize union opposition. Scamp was not a man of Weinstock's own choosing. Very shortly after Weinstock had joined the company, the top management decided that GEC needed a senior personnel man to supervise relations with the trade unions. Weinstock objected strongly. He said that he had no time for personnel managers and that the only sort of managers he wanted were those that could run businesses. Ignoring these objections, the board chose Jack Scamp, a calm, cheerful man with the manner of 'a friendly sergeant major from a rather superior regiment' who went on to become, as chairman of the Motor Industry Joint Labour Council, the outstanding labour-relations trouble-shooter of his day.[30] Between November 1965 and February 1967 he had helped to resolve some thirteen disputes in situations where the official peacemaking machinery had either broken down or had been exhausted. But now he had a major problem on his own doorstep.*

What concerned GEC was not so much the local protests but the danger that the unions across the country would join hands in an attempt to force the company to back down. As Jack Scamp said to me some three

*Having failed to block Scamp's appointment, Weinstock sent him out into the field on a cost-cutting mission which he performed so successfully that Weinstock changed his mind about Scamp's usefulness. His prejudice about personnel managers, however, remained.

years later, 'If everybody in GEC had come out in protest against Woolwich, Weinstock's plans would have received a nasty setback.'[31] And so, in a series of meetings with the two leading trade union barons, Les Cannon of the Electrical Trades Union and Hugh Scanlon of the Amalgamated Engineering Union, Weinstock and Scamp prepared the ground for a deal. With redundancy payments linked to length of service and a guarantee that the company would make up two-thirds of lost earnings in the first month, the terms would be generous: 'the most civilized I have ever encountered' was how Clive Jenkins, the flamboyant leader of ASTMS, the white-collar union, described it.[32] But the key element in the GEC strategy was to play on the marked reluctance of unions and plants not directly involved to come out in support of those who were. 'It's my impression,' said Scamp, 'that brotherly love does not extend far beyond the factory gates.'[33] The GEC factories were so geographically scattered that the shop-floor leaders simply did not have the organization to build a common front. The workers at Woolwich did try and raise company-wide support, but when they appealed to their fellow workers at Coventry all they got were expressions of sympathy. (The attempted workers' takeover at Liverpool where three factories were being closed down failed for much the same reason. There was a joint shop stewards committee, but it never became an effective body.)

The crunch came at a meeting with Weinstock and Jack Scamp on 26 March, attended by the unions' national officials and the Woolwich shop stewards. It was reported later that when Scamp and Weinstock refused absolutely to reconsider the closure, union officials then worked out a formula for a phased run-down of the plant. This plan was turned down flat by the men at Woolwich the next day and a motion was passed unanimously to bring Woolwich to a halt by blacking all aspects of the factory's work. But as the weeks passed and no one came to the rescue, resolution crumbled and the blacking was lifted.

After Woolwich and Liverpool, there were isolated attempts to black the movement of some goods, but that was about as far as it went. As the authors of an anti-GEC pamphlet which appeared in 1972 observed: 'The company learned, in its first decisive confrontation, that the unions would not lead a combine-wide fight against closures, and that the rank and file were not yet able to.'[34]

In its official statement announcing the closure, GEC said:

That while [it] deeply regretted the necessity of making large numbers of people redundant, the planned integration is clearly in the best interests of the business, the majority of the employees and the nation. While in the short-term these plans will mean a redistribution and some contraction of the number of persons employed,

in the long term they will provide greater security and an expansion of employment opportunities.[35]

Two years after the closure, a team from PEP (Political and Economic Planning) visited Woolwich to find out what had happened since. The picture was depressing but not catastrophic. It found that although 20 per cent of the 5,500 made redundant by GEC and four other engineering works that had closed were still out of work, the figure included some who chose not to look for further work on account of age and others who had found a job but had lost it again. The number of hard-core, long-term unemployed was relatively small.[36] But if the closure was not a tragedy in human terms, for Woolwich itself it was a disaster. It was a milestone on a path that has taken it from being a major industrial centre to one of the most severely depressed areas in London.

For GEC itself, the victory at Woolwich – for that is what it was – set an important precedent. Arnold Weinstock had asserted management's right to fire workers a whole decade before the Thatcher administration launched its own assault on union power. In the aftermath of Woolwich, an atmosphere was created which made it unusually difficult for the unions to resist closure. And although one of the by-products of the dispute was the setting up of National Joint Consultative Council to improve communications between unions and management, it had little or no effect on companies decisions on closure and layoffs. The rank and file nicknamed it 'the burial party'. If Woolwich was the largest of the closures, it was very far from being the last. Throughout the winter of 1967 and spring of 1968, there was a steady exodus. By May, six months after the takeover, some 11,380 people had been laid off. Among the plants most affected were those at Witton, Coventry and Willesden.

Although there was still much cutting, chopping and changing around to be done, by the summer of 1968 Weinstock was looking ahead. 'It's just like playing with a one-armed bandit,' he remarked shortly after the AEI takeover. 'Getting one or two lemons in the window is not too difficult, but you need three in a line before all the money comes pouring out.'[37] Weinstock's third lemon was the largest electrical company of all, Lord Nelson's English Electric. The logic behind this objective is not difficult to follow. As John Williams has pointed out in his essay on GEC:

The possibilities were especially enticing in the heavy engineering sector because this was an area in which both AEI and EE had invested heavily from the late 1950s. The resultant over-capacity, especially as CEGB orders fell in the mid-1960s, reduced their profits, increasing the weight of this debt and making them vulner-

able to outside bids. But once they were all under a single control, acquired under terms which had written down this capital expenditure, excess capacity could be more easily shed. Even where excess capacity continued, it was no longer a basis for desperate price-cutting competition between rival companies.[38]

The first indication anybody outside GEC had of what was in Weinstock's mind came in July, when he attended a meeting at the IRC's office in Pall Mall to consider a rearrangement of the nuclear power consortium. As the meeting broke up, Weinstock asked to see Frank Kearton, the chairman, and Charles Villiers, the new managing director, alone. He told them that a start had been made on combining GEC and AEI but he could now see that 'the whole jigsaw could be put together much more sensibly if GEC also had the English Electric pieces to fit into it.'[39] There is no indication that GEC had at this stage prepared any serious plans for an English Electric takeover: what Weinstock was doing was taking his courtship of the IRC one stage further by making them privy to his thoughts. He knew that if or when the time came to make a play for English Electric, the IRC's support would be just as important as it had been in the battle for AEI.

The opportunity came much sooner than anticipated – and from an unexpected quarter. In late August, less than a month after Weinstock's little *tête à tête* with Kearton and Villiers, John Clark of Plessey made an opportunistic lunge at English Electric. Although Plessey's bid was cunningly timed to catch English Electric on the back foot (the company was heavily burdened by debt and had just published a poor set of half-year results), there was never much chance that it would succeed. For one thing, Plessey was much smaller, though more profitable, than its target. For another, the industrial logic of a Plessey/EE link-up was less than compelling. Although there was some overlap between English Electric's and Plessey's radar and aerospace businesses, there was no match at all in heavy electrical engineering: the area that most concerned the IRC, Whitehall and the CEGB.

Confident that the IRC and Whitehall were already on his side, Weinstock launched his own offensive within days of the Plessey bid. But instead of taking the battle to the market as he had done with AEI, he sought to outflank the Plessey bid by seeking the support of Lord Nelson and the English Electric board. English Electric was an entirely different proposition from AEI. First, it was comparatively well managed. GEC knew and admired many of English Electric's top management, particularly Sandy Riddell, the deputy managing director. 'He tried to enforce disciplines,' says Kenneth Bond. 'He was a very shrewd Scot who came up through the business and could see some of things that the people

responsible for those businesses couldn't always see.' Second, relations between the two companies were free from the acrimony that had existed between GEC and AEI. The English Electric chairman, George Nelson, may not have been the driving force his autocratic father had been (he was known in the company as 'half-Nelson'), but he was quiet and sensible: what is more, he got on well with Weinstock, with whom he had, a month before, been discussing the possible purchase of AEI's turbo-generating interests.

On 26 August, the two men met privately at Nelson's house in St John's Wood. Here Weinstock told George Nelson for the first time what had already said to the IRC: that he favoured a full-scale merger between AEI/GEC and English Electric. Nelson was more than half persuaded by the force of Weinstock's arguments; and although it would be wrong to say that the outcome was decided there and then, in the debate that followed over the next ten days, it became increasingly clear to English Electric and its advisers that they had little option but to submit to Weinstock's overtures. If they had rejected these, there was an outside possibility that the prize would go to Plessey. Far more likely, however, was that Weinstock would mount an full-scale AEI-style takeover bid that they would be incapable of resisting.

These factors proved to be decisive. On the afternoon of Friday, 6 September, the news was announced of the largest merger Britain had ever seen. Arnold Weinstock, who only eight years earlier had been a comparatively minor radio and TV manufacturer, was now in charge of the country's largest industrial company with a labour force of nearly quarter of a million people. As the *Financial Times* acknowledged: 'At the age of 44 [Weinstock] is undisputed master of a major industry. His decisions over the next few years will determine not only the future of the General Electric Companies but also the prospects of a significant sector of the British economy.'[40]

By acquiring Britain's two leading electrical engineering companies in two years, not only had the outsider had swept through the field to win the race, but in so doing he had pulled off a brilliant financial coup. While the twin bids valued the assets of the two companies at £460 million, Weinstock had spent less than £16 million of GEC's precious cash on their acquisition. The greater part of both deals was financed by GEC paper in the form of equity and loan stock; but because GEC shares were so highly priced in comparison to its rivals, the equity was not seriously diluted, only rising from £57 million to £137 million. By far the biggest problem was the two companies' level of debt and borrowing, which is why the emphasis from the start was on shedding labour, cutting costs and squeezing out as much cash as possible.

One of the objects of creating a monolith whose turnover approached

£1,000 million was to build a company that could compete on equal terms with the biggest and the best in Europe, if not in Japan and the United States. And, on paper at least, it seemed as if this ambition had been achieved. The 'new' GEC ranked eighth among the world's electrical corporations and was third in size in Europe, behind Philips of Holland and Siemens of Germany. Even more importantly, the new grouping had a portfolio of products and skills that should, all things being equal, have placed it at the forefront of the technological revolution. As some saw it, Weinstock's GEC was *the* chosen vehicle of the revolution that Harold Wilson had foreseen as being forged in the 'white heat' of technology. For others, GEC was the unacceptable face of monopoly capitalism. But what was really surprising was the willingness of almost everybody – politicians, civil servants, the City and the press – to take Arnold Weinstock on trust by putting so many of Britain's industrial assets and so much of her future in the hands of a man about whom, in truth, remarkably little was known. While his predecessors had created their companies by a combination of guile, ingenuity and brute force, in Weinstock's case the opportunity was more or less handed to him on a plate – courtesy of the Establishment. He may have had to fight hard for AEI, but, between them, the IRC, the compliant and agreeable George Nelson and an accommodating President of the Board of Trade in the shape of Anthony Crosland made him a present of English Electric. The tentacles of the new group touched almost every aspect of electrical engineering, from massive turbo-generators to the humble domestic toaster. And in many vital areas, it had an untrammelled monopoly. According to figures published by its godfather, the IRC, the new company's share of the UK market was as shown in the table on the following page.

With Marconi, GEC had acquired a high-tech company with a worldwide reputation in communications. At the time of the takeover, Marconi was putting the finishing touches to the Post Office's satellite station at Goonhilly Downs and was supplying many of the world's broadcasting companies with studio equipment and transmitters. In Elliott Automation, which had been acquired by English Electric, with help from the IRC, the year before, Weinstock had a company as full of scientific and engineering talent as it was short of cash. It was doing pioneering work on custom-built computers for scientific and industrial use, its early-warning and battlefield radar held the promise of huge defence orders and it was also strong in the rapidly growing avionics business. As GEC itself said in its 1969 annual report: 'The expertise of Elliott Flight Automation with Marconi's established position and reputation in communications and navigation aids, combine logically to create a most powerful avionics group.'

It is not difficult to see why the mergers created such enthusiasm. With

PERCENTAGE OF UK MARKET SHARE

Locomotives and equipment	90
Grid switchgear	70
Turbo-generators	50
Process control and automation	50
Defence electronics	50
Transformers	45
Smaller switchgear	40
Electrical machines	40
Telecommunications	40
Industrial valves and cathode tubes	40
Electrical consumer goods	30

(source: IRC Report 1968)

a foot in almost everything that seemed vaguely modern, there seemed to be no reason why GEC, under the dynamic leadership of Arnold Weinstock, should not, almost single-handed, become not only Britain's, but Europe's, leading high-tech company. As a result of pioneering work by British scientists during the war, the new group's radar was world-class; and with its expertise in instrumentation and process control it was, so GEC boasted, 'the largest automation company in the world'.[41] But all that was for the future. The question now was: would Weinstock and GEC be equal to the challenge offered by the opportunity?

FIVE

ASPECTS OF ARNOLD

L ate one Friday night in the mid-1970s, Weinstock was musing on the great events of 1967/68 which had transformed the company and made him the most powerful and influential industrialist in the country. 'It's an extraordinary thing: life,' he said to one of his directors, who was then running what was known as 'the odds and sods brigade'.

> I very much wanted to buy AEI. I thought it would make GEC. And I went for this thing. But frankly it was a load of old rubbish: not nearly as good as I had hoped. Whereas English Electric, which the government had pushed me into when I was dead against, thinking it was a lot of puff and wind, was an absolute winner. I couldn't have been more wrong.[1]

This story should, perhaps, be taken with a pinch of salt. As we saw in the last chapter, Weinstock had been eyeing English Electric from the moment he had acquired AEI. But whatever his real opinion about English Electric, once he had acquired control he lost no time in imposing his own views and his own personality on his new colleagues. And though he thought more highly of Lord Nelson of English Electric than he did of Mike Wheeler of AEI and Arnold Lindley of GEC, Weinstock made it very clear from the start that it was he who was in charge. Sir Bob Telford, whom Weinstock promoted from general manager to be managing director of Marconi, remembers being summoned by Weinstock to meet him in Lord Nelson's office at English Electric just before the takeover. Nelson, knowing Weinstock's fondness for racing, had taken the trouble to install a TV in the office. Telford was struck by Weinstock's informality. He says that 'to see the way Weinstock swept me into Nelson's office, turned on the TV to watch the racing and generally treated the place as his own was quite remarkable.'[2]

Everybody I have talked to agrees that Weinstock was clear from the

start as to how the main lines of the business should be organized; and in little more than ten weeks the Grand Design had been completed. In a stream of memos sent out to his senior managers over five days before Christmas 1968, Weinstock revealed his plan. The defence and electronics businesses of Elliott-Automation/Marconi were to be merged with the GEC Defence Research Laboratories at Stanmore to become GEC-Marconi Electronics; the three turbine and switchgear operations were to be brought together under a new management company known as GEC Power Engineering; the components, measurement and electro-mechanical controls businesses were to be grouped together under a holding company called GEC Electrical Components; and industrial cables and distribution equipment came under the umbrella of GEC (Cables and Equipment).

At Chelmsford, Marconi's Bob Telford was put in overall charge of a £200 million empire that embraced radar, communications and avionics. Telford says that the question of how Marconi would fit into the new GEC/AEI/EE empire was settled almost at once. Marconi asked if it could keep its own name, and initially Weinstock agreed. But after pressure from the GEC people, it was decided that the company should be called GEC-Marconi. By the same token, the official title of the new company – The General Electric and English Electric Companies – never stuck, and by 1970 the group was known simply as GEC.

With a turnover approaching £1,000 million, the combined group was nearly ten times bigger than GEC had been in 1961, the year of Weinstock's arrival. But although Weinstock and Bond had a good deal of respect for English Electric's management, initially, at least, they were taking no chances. Of the eleven senior managers picked to run the new groupings, only one, Bob Telford of Marconi, was a new boy. The others, like Doug Morton and Alan Veale, were old GEC and AEI hands who had already proved themselves in Weinstock's eyes.[*]

As ever, what Weinstock wanted were hard men who could cut and prune without flinching. At Power Engineering, Doug Morton had control of the largest group of its kind in Europe. But that in essence was the problem. As we have seen, Weinstock's instinct at GEC was to move out of the heavy end of the power supply business as fast as he could – hence the sale of the turbine business to Parsons. But now with the acquisition of the English Electric turbine businesses, GEC was more deeply involved than ever before.

As we have seen, the pruning of AEI was hard and painful. In 1968, the first full year after the AEI takeover, some ten plants were closed

[*]In choosing the men to run the divisions after the initial reorganization, Weinstock was more eclectic and, by 1971, when GEC had been reorganized in twelve divisions, there were five GEC men, four from English Electric and three from AEI.

and 12,635 jobs (including the 5,500 at Woolwich) were lost.[3] But with a surplus of capacity and a dearth of orders from the main customer, the Central Electricity Generating Board, it was clear that further shut-downs and redundancies on an unprecedented scale throughout the enlarged group were inevitable. It followed that it was the heavy end of the business that was first to feel the effects of the Weinstock axe. In the winter of 1968/69, some 4,500 employees were laid off at the switchgear plants at Newton-le-Willows near Liverpool and at Witton just north of Birmingham. And there was more to come. In 1996, looking back over nearly thirty years, Sir Alan Veale told me that, by the time the rationalization of the power-engineering end of the company had been completed, the number of factories had come down from fifty-five to twenty-seven and the number of people employed had been cut by 50 per cent.

By the end of 1969, the total number of redundancies had risen to 25,225 from twenty-two different plants across the Midlands, London and the Northwest. In 1970, there were a further 8,347 redundancies with another 3,000 or so earmarked for the first half of 1971. By the summer of that year, the reconstruction programme was all but complete.

GEC has never published full details of the closures and the accounts of the restructuring in the annual reports contain little hard information on job losses or factory closures. The closest the company came to acknowledging the extent of the upheaval was the comment of the new chairman, Lord Nelson, when he remarked that:

Reorganization on the scale and complexity of the present case naturally provokes an atmosphere of uncertainty among staff and workpeople. Where plant closures have proved to be unavoidable, careful regard has been paid to social factors involved, and the Company has done its best to ease hardship on individuals by effecting transfers within the Company whenever possible, by assisting people to the maximum to find alternative suitable employment, and by a fair and realistic approach to termination arrangements.[4]

GEC has always been frugal in the amount of information it publishes about itself. But some individuals have done their best to water a parched landscape. In the summer of 1971, Jack Scamp and others at GEC helped me to compile the most detailed account available of the closures and redundancies to date. My research showed that in the first 1,000 days after GEC took over AEI, the total number of plants had been reduced from 160 to 119: of the casualties, thirty-two had been closed and nine had been

sold as going concerns; additionally, seven further plants were under sentence of death. Altogether some 40,000 jobs had disappeared from the GEC payroll and some 33,572 workers had been laid off; this was out of a combined labour force for all three companies, pre-merger, of 265,000 people – a drop of 12.6 per cent.*

Compared to the problems of scaling down the heavy end of the business, the difficulties presented by the consumer side – the fridges, washing machines, toasters and irons – were more financial than structural. But even here there was scope for reorganization.

One of Martin Jay's first jobs at GEC was to sort out the post-merger problems on the domestic appliance side and marry the English Electric and GEC/British Domestic Appliances operations. The best-known brands were Hotpoint, Morphy-Richards and Astral. Jay says:

> There were three different product lines, three different service oper-
> ations – it was chaos. Sometime later, Arnold and Edward Heath got
> into a wonderful correspondence about a bloody Hotpoint washing
> machine which wouldn't work and kept flooding at a time when GEC
> was trying to sell the government some more power stations. Heath
> took the line that 'if you can't make a washing machine work, why
> should I buy one of your multi-million pound power stations?'†

Jay says that, as far as he could see, Weinstock didn't have any long-term plan to develop the domestic side of the business. 'What he looked at was the month-by-month results and over a period of time he parted with more and more of the consumer products companies.' In the late 1970s, Jay was sent up to Liverpool to be managing director of a company called English Electric Consumer Products with orders from Weinstock to make it profitable within a year or shut it.

The Callaghan government was reaching the end of its term and Jay says that industrial relations were 'about as difficult as they had been in the UK since the war'. Jay was under intense pressure from Stanhope Gate to squeeze more profit out of the business but to do that he needed to change trade union attitudes.

*The disparity between the number of jobs lost and the number of workers dismissed is explained by the fact that some businesses were sold with their labour forces intact. If one takes all labour movements into account the number of people directly affected rises to between 60,000 and 70,000.

†Weinstock's high profile made him very vulnerable to such complaints. Harry Evans, the then editor of the *Sunday Times,* for whom I worked, was so incensed by the failure of his GEC toaster to work that he ordered the *Insight* team to investigate why Britain's leading industrial company should produce what he regarded as such a rotten product.

The crucial thing was that if any feed line stopped then the main line stopped. So you had to have flexibility on each of the feed lines and that meant overtime. And though overtime was written into the contracts, the unions had the view that if you were going to offer overtime you had to offer it to everybody. We said 'no'. And that became the great argument I was having with the shop stewards. And we got to the point where I said that unless you agree to do this by Friday week, we are going to have to shut. And, sadly, they wouldn't. So we shut.

Jay believes that Weinstock's hard line on labour relations – particularly where redundancy payments were concerned – actually made reorganization more difficult than it need have been.

He wasn't really willing to lubricate the wheels. For example, if you are prepared to put a little more into severance arrangements, the people who remain feel that the people who are leaving have been fairly treated. And Weinstock was very, very tough about not doing that. Glen Trollope [the personnel director who succeeded Mike Bett] was very clever at obeying instructions from Stanhope Gate while sugaring the pill.

Both Scamp and his immediate successor, Sir Michael Bett, told me that GEC's main tactic when dealing with the engineering unions was to play one plant off against another in the belief that those still in work or not in dispute would be very reluctant to come out in support of those whose jobs were at stake. Bett recalls a confrontation with someone whom he describes as an arch-militant.

He was a graduate manqué who became a semi-skilled machinist who then challenged the management totally. So we sacked him. We had a very long strike, physical damage, arson, all sorts of problems. It was a question of gritting our teeth and going through to the end. And we won. The reason we kept winning was because we were a conglomerate. The unions could take out Newton-le-Willows and maybe we'd lose money because of a long strike, but you had the whole of the rest of the business going. The unions were divided by the nature of the group. That helped us to rule: of that there is absolutely no doubt.[5]

The way in which GEC dealt with its labour relations and personnel problems throws a revealing light on Weinstock's many-sided character. There were times, so his colleagues say, when they recoiled in horror at

87

attitudes which seemed to them to be reactionary in the extreme. Gwynneth Flower recalls an incident where Weinstock complained to her about the size of the redundancy payments GEC was obliged to make. 'I said, "These people have worked for the company for the best years of their life." He answered, "I don't see that makes any difference. They are of no further use to the company and I see no reason to pay more than we are legally obliged to. It's not my fault if it's too low. After all, it's the shareholders' money."' On other occasion, hearing that the government was withdrawing its contribution to private-sector redundancy schemes and making companies 100 per cent liable, Weinstock let it be known that if the government was not paying its share, nor would he. It was only after the personnel staff had drawn straws, so the story goes, that someone went in to dissuade him from doing what he proposed.

These stories suggest that Weinstock shared the visceral anti-trade-union prejudices that were so commonplace in the 1960s and 1970s among the leaders of British industry, but in fact, the record shows that he was far more critical of his own managers than he was of organized labour and its representatives. 'Don't expect consistency from Arnold,' says Mike Bett.

> As Oscar Wilde said: 'It's the hallmark of a small mind.' If you tried to be consistent, he would say, 'Be relevant, for God's sake.' One day, he would tell me to fire everybody and then the next day he would pay Hugh Scanlon's fine to stop him being sent to prison. You have got to understand that when you are working with Arnold you are on a roller coaster on different surges, views, opinions and facts. He is an arch-pragmatist but one with certain principles.

If Weinstock had been as root-and-branch an opponent of organized labour as the average member of the Institute of Directors, it's very doubtful if men like Jack Scamp and Mike Bett, both very distinguished labour-relations experts, would have agreed to work for him or lasted any time at all at Stanhope Gate. Even so, they needed all their diplomatic skills to soften the impact of Weinstock's harshest *diktats*. 'Jack was immensely courteous and thoughtful about people in a dispute,' says Bett. 'Jack was not a blind negotiator. He understood the other side. It's a basic rule in this business: know thine enemy. The other thing was that he was able to tell Arnold: "Get off my back. I know this dispute."'

In an attempt to repair the breach with the unions caused by the mishandling of the Woolwich closure, Scamp suggested, at a private dinner with the union leaders at the Hyde Park Hotel the following winter, that they should get round the table with himself and Weinstock to discuss the company's future manpower plans – an idea that led to the formation

of a body that came to be known as the GEC/EE National Joint Consultative Council. Normally any consultation with the unions would take place at district or plant level. But as the scope of GEC's operations were so wide, it was thought that an umbrella organization of this kind might be useful.

That negotiations leading up to the formation of this council proved to be rather sticky was largely due to the presence of Arnold Weinstock. He is, on his own admission, an impatient man, and he found it difficult to understand why the unions did not regard the problem in quite the same light as he did. For him, the issue was crystal clear: if the unions did not agree to the cutbacks, the company would go out of business and then everybody would be worse off. But that's not how the unions saw it. 'We are here to protect as far as possible the jobs of our members,' said DATA's George Doughty. And it was only after a couple of rather acrimonious exchanges that Scamp took Weinstock gently to one side and explained that things might go a little more smoothly if Weinstock left the job to him.

Weinstock was always pressing Scamp to speed up the negotiations and was frequently concerned at the cost of the operation ('He was frightened that we were giving them the earth,' Scamp told me[6]), but from that point Weinstock retreated to Stanhope Gate and left Scamp to get on with it. 'At no time was I ever in conflict with Arnold,' he said. Virtually the only time that Weinstock descended onto the battlefield was during the Liverpool crisis of 1969, when tempers were running so high that Scamp advised Weinstock as chief executive to make a personal appearance. He did and it was, by all accounts, a *tour de force*.

When Weinstock wishes, he deploys a brand of wintery, self-deprecatory charm that is all his own. Mike Bett remembers taking the stewards of the turbine-generating business to see him in his office. 'The first thing we did was to talk about racing. He gave them a tip and they put money on it and lost. So I had to go in a week later and say, "You've got me into trouble. I have got this industrial relations problem." "So, what is it?" he asked. "Well, you gave them that tip and they are £26 down as a result. And this is going to sour industrial relations."' Weinstock stumped up and the stewards got their money back. Bett says:

> The stewards had this love/hate relationship with him. I remember taking all the nuclear-industry shop stewards to see him and Arnold gave them a one-hour lecture on the nuclear industry. And as they walked out they said to me, 'Real class,' even though they disagreed and weren't going to do what he wanted. He might smirk and say it was all bluff, but he did it brilliantly.

The setting up of the union council was one consequence of Woolwich: the decision to take the debate right down to the shop floor was another. By the summer of 1969, a distinct pattern had developed: the council would discuss with the management the background to a closure and the following day the news would be broken through the union machinery to the men at the plant concerned. The time lag was so short because the unions did not want to give the impression that they were engaged in secret negotiations with the management about redundancy behind their members' backs. Once the unions had been officially consulted, there would follow a series of meetings between the local management and the shop stewards representing the men at which the closure proposals would be thrashed out. They were often very noisy affairs with the management ranked along one side of the table and up to 100 shop stewards on rows of chairs on the other. Scamp himself held the ring.

As an exercise in consultation these meetings were undoubtedly useful, but on no occasion in the course of more than thirty closures, so Scamp said, did GEC ever succeed in obtaining the men's agreement to a shut-down. On the other hand, nor did the unions, for their part, ever succeed in stopping a single closure. In the last resort, force prevailed and all the unions could do was to negotiate terms that would make the consequences less painful. But GEC was not oblivious to the social consequences of what it was doing. It was Weinstock's own decision to keep the former AEI 'white elephant' at Larne in Northern Ireland going in preference to the Nethertin plant near Bootle in Lancashire. Larne was saved not because it was a more efficient plant but because of the dire social effects such a closure would have in an area of high unemployment. But the choice was the company's and, in the last analysis, the unions had very little say in the matter.

While the AEI takeover was an emotional affair which generated a good deal of fear and resentment among the managers, in contrast, there were English Electric/Elliott-Automation people who welcomed Weinstock's arrival.

Elliott was a remarkable company founded by a remarkable man, Sir Leon Bagrit. It attracted many of Britain's best research scientists and was a pioneer in the development of radar and computers for industrial and scientific use. But the company often promised more than it could deliver. 'Elliott's problem was that it was too innovative and never really developed a good solid product of its own,' says Jack Pateman, who joined Elliott as a radar expert from the RAF and went on to become head of GEC Avionics, the largest part of Bob Telford's Marconi empire. When asked about the impact of the takeover, Pateman was clear:

GEC made a difference – no question. English Electric was crawling with consultants. But the moment GEC took over English Electric, the consultants were fired. GEC immediately set about putting together all the components of what was then the total company: generally getting it organized in a sensible, business-orientated way and putting the responsibility in the hands of the men who were running the individual companies. One of the great differences was simply the availability of capital. Under Elliott there was never any money about – no capital. As a result, there were a number of things you couldn't do. But GEC comes into the picture and makes capital available. It enabled one to expand one's horizons as far as the business was concerned and Elliott and Marconi were just put together under one control. The essential thing was that the company was organized along the lines of the market – never mind the technology. It was the marketplace that mattered.[7]

On 29 November 1968, seven weeks after the merger, as was his style, Weinstock wrote to all his managers. In a memorandum, headed simply 'The General Electric and English Electric Companies Ltd', once again he set out in plain, four-square language what they had to do and how they should go about it. It is a classic text and deserves to be better-known than it is.

Every company has its own style of management. There is a distinction between 'style' and 'system' because systems can be changed at will, while style depends on the natural and developed characteristics of managers. I am writing this memorandum sooner rather than later so that we may have the best chance of starting our relationships in what will be for us the right way, and to explain some basic attitudes to the job.

After introducing the main members of the senior management team, he continued:

The real success of our new Company depends on the individual directors of our many product units. Our help (or lack of it) from H.Q. does not relieve you in the least of the responsibility for that part of the business which is in your charge. You will, of course, see that your sub-managers are given well-defined, specific tasks and objectives and then discharge their duties effectively.

Our philosophy of personal responsibility makes it completely unnecessary for you to spend time at meetings of subsidiary boards

or of standing committees. Therefore, all standing committees are by this direction disbanded and subsidiary boards will not need to meet again (except, perhaps, for statutory purposes once a year). If you wish to confer with colleagues, by all means do so; even set up again any committee you and the other members feel you must have for the good of the business. But remember that you will be held personally accountable for any decision taken affecting your operating unit. And also remember that you are not obliged to join any such gathering. Incidentally, on this matter of personal responsibility, *prior permission from H.Q. is required for any proposal to employ management consultants.* [author's italics]

The managing director of every operating unit is responsible to me. You will have very considerable autonomy in the running of your unit, subject to certain controls of which you will receive details soon; these are largely financial, but monthly reports should cover everything of consequence concerning the business, including important technical matters.

After setting some deadlines for the submission of budgets, Weinstock went on:

This is the point at which this memorandum should stop. But at the risk of being boring, I think it is desirable that I should add a few general remarks.

The justification of our existence is to satisfy the needs of consumers. That satisfaction has a certain value to them which can be assessed by comparison with other offers from our competitors to meet similar needs. In order to perform this task, we have to make use of resources, and this process involves cost. The difference between the two, the created surplus, is profit. Clearly, in a competitive economy we operate most efficiently and creatively when profit is optimized. There are several indices we shall ask you to use to measure efficiency, but, at the risk of over-simplification, we may say that profitability in relation to capital employed is the main one by which your performance will be measured.

It is said to be possible to maximize short-term profitability by omitting to do those things which are required for the survival of a business in the long term. It would be extremely stupid to follow such a course, particularly in industries such as those in which we participate. But that is not to say that money may be wasted in injudicious investment or recklessly conceived programmes of research. We must always be concerned with getting value for the Company's money.

There will be, in the coming months, a full dialogue between us

on all these and related matters. But there are some things which can be done now with advantage. Administrative, commercial and similar overheads are too high throughout the Group. See where you can reduce them – and save any other expenses, as well. So, too, are stocks and debtors generally excessive. Try and cut these both by more rigorous production and stock control, and by more persistent debt collection. All that is required to achieve these simple things is more concentrated effort by your executives towards directly stated objectives.

We have begun the process of re-organization on which will be based the future form of our Company. We will no doubt make mistakes; there may be disappointments; there will be frustrations. In these next ensuing months, patience and calm will be much needed. What is now thought best is not necessarily the shape of things for all time, and experience may require changes in some of our decisions.

We are embarking on a monumental task, nothing less than bringing up to the highest standard of efficiency a considerable part of the British electrical and electronics industries. Do not underestimate the difficulties. We simply cannot afford avoidable problems, such as personality clashes, personal prejudices, divisive, misplaced loyalties. We are now one Company, one Group, and, heaven only knows, we need each other's help in every way.

In this introductory memo to what he made a point of calling 'his' managers, Weinstock had struck a lofty note. But the grand manner soon disappeared, to be replaced by something downright querulous. Significantly, the next memo, dated 9 January 1969, came just a few days after the new boys had submitted their November reports and it was immediately clear that, once again, the headmaster was far from pleased.

The most striking feature of the November reports is their complacency. For a company desperately short of money, up to its ears in debt and earning (if you are not too severe about the accounting) about 6 per cent on capital employed, this is really astonishing. One chap says of an overspend of a large sum against budget that it is all right because it is on the right curve for his five-year plan! In almost every case where things have not gone right, the reports tell us of what seem like acts of providence; extra provisions are required because a machine does not work or a contract is coming out badly. There is no explanation, no retribution; only the company suffers. Another £50,000 must be provided – then another, then another. No one, apparently, is at fault, nothing has

93

been done to prevent a recurrence. Just make a provision, and on to the next duff budget.

This will not do for me, and much pain will be avoided if that is understood thoroughly and quickly. When things go wrong, I want to know why – in detail, and what is being done about it, and who is okay, and who is not. Managers are responsible not only for the job but for keeping me informed frankly as to what is going on; and since the monthly reports are the managers' reports to me, I expect the managers at least to sign them, even if they do not themselves write every word. Loss-making activities cannot be tolerated. In every case where the P&L account reads red, I should like in next month's report to be told what action is being taken to rectify the position.

There will be no more borrowing. Clearly, therefore, we shall have to do lots of things such as reducing stocks and debtors and selling assets from which no return is being made. I hope that no one will in future tell me that we are making losses in particular activities to maintain prestige and that there will be no further cases of quoting deliberately under cost (not even after evoking a complicated formula, complete with the rubbish jargon that goes with it, in justification). As we are not really concerned with sexual life in Scotland, you need not trouble yourselves further with the McKinsey report! You may, if you wish, follow or reject its advice in specific instances, but the responsibility is exclusively yours and I will not listen for an instant to the excuse, if something goes amiss, that the manager was following McKinsey. Similarly, while looking ahead is absolutely essential, the arithmetical exercise which is contained in The Five-Year Plan will not help at all in the solution of our great and urgent problems. What is wanted from managers at present is detailed supervision of the activities for which they are responsible and the intensive application of plain common sense.

If the tone of the first memo was that of a general addressing his troops before a decisive battle ('Some of us here believe we are involved in a crusade,' he told the journalist and writer Graham Turner), the second memo was what the army would call, quite simply, a bollocking. To anybody who knew him, the written words conjured up the familiar voice with its rather flat, nasal tone. And to anybody who had been on the receiving end of a Weinstock wigging, the whiplash sarcasm and the heavy irony would have been equally recognizable.

In taking his managers to task, Weinstock was not acting on a momentary whim. Everything that people say about him suggests a quite unusual

degree of self-control: he himself says he's never been drunk. Though the internal memos and the personal anecdotes suggest someone who is quickly and easily irritated, it is rare for him to raise his voice or lose his temper in public.

While the logistical aspects of the reorganization were settled very quickly by 'the intensive application of plain common sense', it took a little longer to decide who should do what. As Weinstock saw it, there was no mystery or fashionable management mumbo-jumbo of a kind so beloved by the consultants about how GEC should be run. The key to the success of the whole enterprise lay in the hands of the individual managers of the individual units. He believed with an uncommon passion that just as the fortunes of the company depended on their success or failure, so too did their own personal fate and fortune. And it was for this very reason that he devoted a great deal of his energy to picking the team that would do his bidding and deliver the goods.

There was nothing remotely 'corporate' or bureaucratic about this process. His executives were handpicked by Weinstock himself and they were left in no doubt at all that they were his people who had been personally selected to carry out his wishes. As Mike Bett says, 'I have no doubt that I was there to implement his general will.' Another of the people who caught Weinstock's eye was a remarkably unstuffy merchant banker called Ray Wheeler who was hired in the early 1970s to be an associate director, looking after a rather mixed bag of GEC businesses. This is account of his first meeting with Weinstock:

I was at Hambros, but I had already made my mind to go into industry. I started to do things at Hambros where I was chairman of a company we had taken over. And I really enjoyed it. It gave me a taste for business. One day, quite suddenly out of the blue, Kenneth Bond rang up.

'Like you to pop round,' he said.

'Anything special?' I asked.

'Well, you'll find out when you get here.'

'What time?'

'Well, I usually start at 7.30.'

I thought that was a bit rough, coming from the City. But I was there at 7.30. It turned out that the job was something at the centre – corporate deals and wheels, which was the thing I was trying to get out of. So we had this longish conversation and suddenly Arnold, who never came in early, drifted through the inevitable open door – it was all on the fifth floor – so I jumped to my feet and Arnold slumped into a chair in the corner. In his braces, with his feet over the edge of a chair – behind me. I was sitting facing

Kenneth who was in the opposite corner – triangle to triangle. And Kenneth said, 'Don't stop.'

After a few minutes of this, and after Arnold had fired one or two over my right shoulder, I said, 'This is no good. I can't carry on like this. Either you move or I move.' And he said, 'Well, I'm not going to move.'

So I went and sat in that corner. It was ridiculous, typical. Just the sort of thing he would do. He's impish. It was his style.

He did this to managers. He had this bloody great television in his room. And you'd be in the middle of a really tricky bit of the budget and Arnold would switch it on with his remote control – probably to watch Cyrus or Troy or whatever his famous horse was called. Or alternatively he'd make a phone call.

This meeting went on. And Arnold made some pretty barbed remarks. And I reckoned it was all over. Whatever it was it was a no-go area. So I became perfectly relaxed and said what I wanted to do, which was to run some industrial businesses and prove whether I could succeed or fail. And Arnold said, 'Like at our expense?'

And I said, 'Well, yes, of course, somebody's got to lose or win. But you might win, you never know.'

Arnold said, 'Well, that's a hell of a risk. You know nothing. You are just a merchant banker.'

And I said, 'That's the nastiest thing you could have said.'

And he replied, 'Yes, that's why I said it.' And then Arnold just got up and sloped off.

So I got up to go, too. And Kenneth said, 'Sit down. What are you doing?'

And I said, 'Well, I'm going. It's been pretty disastrous. I came to talk about one thing, and you've talked about something entirely different. Lord Weinstock doesn't seem to know why I'm here. So I think I had better go.'

'No, not at all,' said Kenneth. 'That was a great success. You'll be hearing from us.'

With its 119 factories and 230,000 employees, the new GEC had become Britain's largest industrial company. Although the company had all the outward trappings of a modern corporation, with a chairman, a managing director, a sixteen-man board and twelve divisional heads, Weinstock, aided by Bond and Lewis, was to run it more like an old-style family business whose owners lived over the shop and knew everything there was to know about the business. Obviously, the new combine was far too large for even someone with Weinstock's gargantuan appetite for detail to be

able to run it in a completely hands-on manner. But his system of holding his managers to account by means of reports and budget meetings came very close: it was Weinstock's way of ensuring that he remained completely in charge and in control. His other weapon was the memos.

In gathering material for this book, I have had the opportunity to study over 300 of Weinstock's private and confidential memos which he has sent to 100 or so GEC managing directors over a period of nearly thirty years. I have already quoted from a number of them. There are several points to be made about these most revealing documents. First, they are much better and more carefully written than the standard company memo. There is a complete absence of anything that might be described as 'management-speak'. Second, there is almost no discussion at all of broad policy matters: the question of what sort of company GEC is and where it might be heading is never debated or even raised. The great Nimrod disaster (see chapter six) is alluded to only in passing and there is no indication from the managing director as to what lessons, if any, might be drawn from it. Third, a picture emerges of a man whose pen is quick, whose interest in the minutiae of company affairs is insatiable and whose wrath is easily aroused at the merest suspicion of waste or extravagance.

In December 1974, in the panic following the energy crisis, Weinstock wrote to Doug Morton, one of his most trusted managing directors who had been moved from power engineering to look after the telecommunications business. In a memo headed 'The Sensible Use of Resources', Weinstock suggested that, as it was a company that accounted for a sizeable part of the UK's economic resources, it was up to GEC to make people more waste-conscious. 'We must by example and in every other way bring about that attitude of mind,' he wrote, 'which understands the scarcity and the real costs of fuels, raw materials, wrappings, paper, food and the thousand and one things it is so easy for every individual to waste every day.' As part of what he described as 'this war on waste' he suggested that all lights should be switched off whenever and wherever possible. 'It might be a good idea,' he suggested with an apologetic PS to Osram and Claugen, GEC's light bulb makers, 'to remove every other bulb in offices and corridors, which would forthwith reduce consumption by half.'

The memos, many of which run to several pages, cover subjects that in a company the size of GEC would normally have been delegated as a matter of course to quite junior managers. There is one, for instance, written right at the end of Weinstock's long career, on the subject of staff expenses. After a stern preamble reminding managers that expenses are not allowed 'where the justification is flimsy or over-stretched', Weinstock then goes into enormous detail as to what should and should not be done. It is, he says, permissible for a unit to bear the cost of the

evening meal of the executive when he is away from home. 'But,' he adds, 'this arrangement should not be abused by charging more than is reasonably necessary, and must not include the cost of drinks or cigars and cigarettes.'[8]

Sometimes, when thwarted, he would fire off an angry and impetuous salvo on the subject in question. In June 1982, we find him writing to all managing directors to complain about them taking time off, when he himself was at work.

I tried unsuccessfully yesterday to contact several GEC senior executives, but found units were closed with no one at all at work. When factories are shut down for works' holidays, is it always necessary that all (or most) senior executives should also take time off? Is it possible that yesterday, Tuesday, 1st June 1982, in every unit where the factory was closed, there was no case of need for any manager to be present to deal with an urgent or important matter? What happened if customers needed service of one sort or another, or even wanted to get an answer to the telephone?[9]

But apart from the whinges, the exhortations and the occasional temper tantrum, the overwhelming impression one gets from these documents is of a man with an indomitable desire to control. Lord Carrington, the former Foreign Secretary who was briefly the chairman of GEC, is a Weinstock admirer. 'He is one of the most remarkable men I have ever met' he told me. But, he added, 'It would be disingenuous to suggest that Arnold was not a bit of a dictator. What he said went.' Nothing was too small or inconsequential to escape his notice. It was, for example, company policy that all increases for senior managers had to be approved by Stanhope Gate. As late as 1986 Weinstock was writing to all managing directors of UK subsidiaries to tell them that salary increases of all senior managers earning over £35,000 had to be personally sanctioned by him.

When asked what it was like to work for Arnold Weinstock, ex-GEC managers give conflicting answers. Some, like Ray Wheeler, stress how stimulating it was not to be molly-coddled and left to fend for themselves.

When I arrived Kenneth said, 'Your room's down the end. I don't know which one it is but you'll find it. There's a desk, a chair and four other people.'

I asked, 'What are the name of the companies I'll be looking after?'

'Well, there's a list of names here,' he replied.

'What about the figures?'

'That's your job. You've got to get all that. Get on with it.

There's a telephone directory over there. And for Christ's sake don't stay in there very often. Anybody who stays here gets murdered.'

Far from being put off by this austere welcome, Ray Wheeler says he loved his two and a half years at GEC.

The great thing was that Arnold knew everything.* Not by using spies but by doing it himself. But within that remit you were totally responsible. There was no argument. You couldn't hide behind a system. There was nobody saying: 'Oh well, head office told us to do this.' His line was that you were entirely on your own – and that either it works or it doesn't. And he would say, 'And I shall know if it works. And if it fails, by God, I'll be down on you.' So everybody knew where they stood. But that's not true of most companies. Most companies had their hierarchies and layers and bumph filling in. It was only the accounts that mattered at GEC.

Other managers, like Gwynneth Flower, who recently retired as the head of a London training and enterprise council but in an earlier incarnation worked for GEC-Marconi at Stanmore, found Weinstock considerate and courteous.

He had a reputation for being tough and ruthless. But he always treated me like a gentleman. I remember one long meeting at which at one point he broke into Yiddish which, from my reaction, it was clear to him I had not understood. Arnold then said, 'I think we'll take a short break here, so I can give Gwynneth a Yiddish lesson.' On another occasion, Arnold quite suddenly in the course of a conversation broke into Latin. I thought he was testing me. But he wasn't. He was quoting from the 'Misere' in Mozart's C-minor mass.[10]

She continues:

I used to see Arnold perhaps five or six times a year when called to Stanhope Gate for budget meetings. It was easy to get over-awed. Arnold would sit at the front with his rather big feet splayed out and with the top brass of GEC behind him. His practice was to fire detailed questions about the business at managers that came from every angle. He was constantly probing to see if you knew your

*William Rees-Mogg, who was a GEC director from 1981 to 1996, told me that he once tried to work out how much he knew about the operations of GEC's 100 subsidiaries and came to the rapid conclusion that Weinstock knew 100 times more than he did.

subject and were on top of the job. We used to come to these meet-
ings with whacking great files, the contents of which he seemed to
know intimately. He was prone to apologies for not remembering
names. 'Please excuse me, I'm an old man,' he would say. But I
could see nothing wrong: he had a memory like an elephant. He went
to great pains never to give direct orders. He preferred to try and get
his way through debate and argument, which sometimes got quite
heated. He would not hesitate to bring in people who supported his
line and you had to hold your own. I know some people who said that
they were not going to stand for this and if that was his attitude they
were going to leave. And many did. But he never forced you. You
were left in no doubt what his view was and, of course, you couldn't
forget that, at the end of the day, he was the boss. If you were really
determined, he would let you do your own thing. But he would watch
you like a hawk for the next six months or so.

But while many found dealing with Weinstock to be challenging and
stimulating, there is also general agreement that he was an exceptionally
hard taskmaster who would not hesitate for a second to use his power if
he felt it necessary. He says of himself, 'I am not diplomatic, I am fairly
blunt. I am not malicious and I do not harbour any hostile feelings towards
anyone. I like to have an argument about an issue, say openly and in
complete frankness what I think, and then once we have decided the best
way ahead I accept it and I expect others to do the same.'

But ultimately, for all the wit and humanity of the private man,
Weinstock's GEC was a cold, unforgiving place animated by intellect and
logic. Despite his emphasis on the business being a collegiate activity, a
consortium of equals dedicated to a common purpose, one has the strong
impression that there was little time given or effort made to cultivate a
rich garden in which the plants had the space and freedom to grow
towards the sun. As the *Financial Times*'s Charles Leadbetter remarked,
'[Weinstock] seems to believe that action should flow like a logical conse-
quence from a reasoned argument. Managers may revel in the devolution
of power, but their egos are deprived of the oxygen of praise. There is a
motivational austerity at GEC.'

Whether on the phone or when questioning his managers face to face,
Weinstock rarely praised anybody for anything. He believed that praise
was a currency that is easily devalued and that a well-done job speaks for
itself. When asked why he left after five years, Mike Bett replied:

Arnold can grind you down. He goes on and on. And you become
– not an apparatchik – but an Arnoldchik. I've seen it happen to
others. You become not so much a 'yes-man', but you do get in a

rut. You are looked on to deliver to a certain level and that's your function. You are not looked upon as being able to rise above that. You can do that job. You are honoured to that extent. But I was still young enough to say that there might be more to my life than being an Arnoldchik. I had some goes at him about what he needed to do by bringing other people in. He said to me, 'Mike, you are probably right but this leopard ain't going to change its spots.' The trouble was there were no young people coming through with senior responsibility other than their own business. There was no group feel, no group management, no group perspective.

Ray Wheeler concurs:

He's a bully. He bullies people by the use of intellect. He breaks them mentally – or sees how far they can go. Singularly unattractive if you are not strong. If you are strong – wonderful. I loved it. I really enjoyed it. If there is a criticism it is that the managers, many of them, were bombed out. They had lost their will. I have seen fully grown, tip-top men in tears. And that's not right. If they can't stand up to it, they shouldn't bloody well be there. It's a tough world.

A similar view comes from Mike Bett:

You didn't know whether you were senior. You merely had prestige or you didn't. It was a bit like a court where Arnold was king. If you went to lunch in the boardroom, Arnold would sit you as the guest opposite him. All the rest would sit around and would be occasionally allowed into the conversation. But the interesting thing to Arnold was you. And you were supposed to be interesting to him. Arnold was very witty and very funny. But he could also be more caustic and nasty in his invective than anyone else I knew. You either enjoyed it or you didn't.

The further away from Stanhope Gate you were, the more likely you were to see only the more intimidating aspects of the managing director's character. To those who had Weinstock's confidence, he was what one long-serving GEC man described to me as 'a tremendous friend and a very loyal man'. But those outside the inner circle were regarded as 'a statistic'. Bob Telford recalls that shortly after a long debate about who should head up the American marketing operation for the combine, one of the GEC old-timers said to Weinstock, 'I'm afraid we made a bad decision. We've got the wrong man.' To which Weinstock replied, without even looking up, 'Well, unmake it then.'

To the vast majority of his employees, he was a remote and distinctly frightening figure. His remoteness stemmed, in part, from an innate shyness: his managers say that on his very infrequent factory visits he was awkward and ill at ease. They say he lacked small talk and was not sufficiently familiar with the nuts and bolts of the factory operations to talk engineering. 'He didn't like the hardware,' Lord Tombs told me:

I think he was very confused about engineering really. He used to make extravagant remarks like: 'Why do I need engineers? I can get them ten a penny.' And then the next moment he would be complaining about how much they cost. It was all very ambivalent. He always was and probably still is uncomfortable with technology. He recognizes the dependence on technology of many of his businesses but he is very uncertain and uncomfortable in dealing with technological matters.[11]

Rather than engage in technical discussions with the engineers, he tended to pick on small details. On visits, he had a habit of picking up all the telephones to see if they had been made by GEC. He also was quick – sometimes, too quick – to find fault. The former manager of the Borehamwood plant vividly remembers his only meeting with Weinstock. As they toured the factory, Weinstock, who became increasingly short-sighted as he grew older, spied a workmen reading what he thought was a newspaper. 'Look at that man slacking,' he cried. It was only with great difficulty that he was persuaded that the man in question was not slacking at all but consulting an engineering blueprint.

Derek Jackson was for four years the executive in day-to-day charge of one of GEC's largest and most disastrous contracts, the ill-fated Nimrod project. Yet, throughout that time, he says he never met Weinstock face to face.

Three or four times, he'd phone me at home quite late after seven. The wife would answer, but without saying who he was, he would bark, 'Where is he? He's not at the office.' The wife would reply, 'Well, he's got more than one plant, you know.' To which there would be another bark. 'Where the hell is everybody?' he would inquire. I suppose the worst problem of the lot was that he somehow engendered a spirit of fear.[12]

What upset Jackson most about the this style of management, apart from the rudeness to his wife, was what he saw as Weinstock's cold-hearted, callous attitude to him and the other people working for him.

When I got the Nimrod job, I remember being taken aside by my boss, Jack Pateman, who said that he'd just been to see Arnold and had told him what my CV was. But he'd only got halfway through when Arnold replied, 'I'm not interested in his CV. He'll either do the bloody job, in which case it'll be fine. Or he won't, in which case we'll fire him.' That was Arnold – about me! He'd never met me. He didn't know who the hell I was.

Not only were managers subject to the disciplines of the monthly report and the annual budget meeting, but they all knew that at any moment the telephone could ring and that on the other end of the line they would hear that unmistakable voice asking the question to which they did not know the answer. 'The managing directors stood in enormous awe of this man,' says Sir Graeme Odgers. 'He could be very fierce. He could be ruthless. When the telephone call from AW came, you used to see strong men go pale. It was a formidable experience being on the end of that telephone.'

Meeting Weinstock face to face could, on occasion, be equally daunting. Odgers remembers a visit they made together to the States:

We had a very good meeting in the morning, but when the time came to visit the GEC factory that afternoon, Arnold's mood had changed. He was, in fact, in a bloody bad temper. It was a complete disaster. He criticized the film and the office furniture. It took them months to recover. He was not in any way a diplomat in the front line and he could often have a bad, rather than a good, effect.[13]

As a private employer, Weinstock could also be both generous and unforgiving in almost equal measure, as his former farm manager, Graham Stewart, discovered. For thirty-one years, Stewart managed the Weinstock estate at Bowden Park. As he told an industrial tribunal in 1994: 'From an early stage, Lord Weinstock and I were on very good terms. I believe that we were on much closer terms than those normal between a landlord and his farm manager.' Weinstock had treated Stewart very well: he had paid for Stewart's three children to be privately educated; had lent him £3,000 to buy GEC shares and had provided a five-bedroomed house on the estate rent-free. From time to time, the Weinstocks used to drop over for supper and the two men, who had set up a potato-growing business together, got on very well.[14]

Quite why the friendship went so badly wrong is not wholly clear, but it is obvious that money was at the root of the problem. When Weinstock learnt that there was going to be a £4,400 loss on the farm, he dismissed

Stewart, rescinded his promise of a six-figure golden handshake and asked for his £3,000 back. According to Weinstock's lawyer, what caused the problem was Stewart's decision 'to momentarily leave his job as farm manager to concentrate on the potato business. All bets were off and Lord Weinstock wanted to have his money.' Stewart was so upset that he took Weinstock to court. 'He is an exceedingly powerful man who controls everything about him with a firm grip,' he testified. 'He has, in my experience, a habit of only seeing those parts of a story which coincide with his views or of convincing himself that the facts are as he wants them to be rather than they actually are.' In the event, the dispute never went to a full hearing. Stewart was not reinstated in his job but he continued to live in the farm manager's house – though no longer rent-free.

But however forthright Weinstock's style might have been, as we have seen, he was by no means a complete autocrat. He delighted in debate and argument, and would welcome in through his ever-open door anybody who wanted to argue with him. The only caveat was that he was that he expected his people to know their stuff and to be able to hold their corner. As the *Observer*'s Pendennis noted, 'No public school false modesty; deals in a proletarian type of rudery and direct questioning, not meant to be taken seriously: you are supposed to answer back. Has a devastating simplicity of view that goes straight to the point: no craftiness or trickery: believes that profits can be maximized by the application of open intelligence and sheer professionalism.'[15] His executives say that he expected to be challenged and the very last thing he wanted was unquestioning obedience. 'The worst mistake that somebody could make was to listen to everything Arnold said and then carry it out to the letter,' says Bob Telford.

> If Arnold had somebody who listened to everything he said and then did it, the result could be blackened bones in the desert. Arnold knew this himself and half-expected and even hoped that people would challenge him. I remember him saying of one unfortunate man: 'That bloke did what I told him, the stupid idiot.'

The wiser heads in GEC grew to realize that, as Stanhope Gate often knew much less than they did about a specific business, the way to survive was not to take what they said too literally. As one ex-GEC director told me:

> The Weinstock style is absolutely necessary, but it has to be blended with managers who are strong enough and self-confident enough to do only a third of what Stanhope Gate says. They don't

pretend to understand the actual business. They shout at you. If people accept a stream of abuse and advice as instructions, which they often do, then the business gets in a pickle.[16]

As Odgers put it to me:

It's a very tough environment, GEC. But it's very unpuffed up. Arnold was one of the most unpuffed people I have ever met. I remember attending one of his management meetings where a managing director had produced a £12 million profit compared with a budgeted £8 million. When the chap comes in for his review there's not a word of commendation. But there was a lot of questioning about the cleaning bill which had gone up because of the move from full-time to part-time cleaners. A.W. went on quite a bit about this. It was quite extraordinary. But the interesting thing was that the managing director came out of the meeting as pleased as punch. The body language said that Arnold was really quite pleased. He was also saying that the budget looks about right – but watch it. A.W. did all this quite instinctively. It's his way, his style. And it's extraordinarily effective.[17]

As stories about Weinstock's management methods began to spread, the idea took hold that the man was a something of a despot who took active pleasure in hurting people by cutting short their executive lives. Weinstock himself denies that he was unduly harsh, but there is no question that there existed in GEC what the current marketing director and former junior defence minister, Sir Geoffrey Pattie, described to me as 'a climate of fear'.[18]

Weinstock's reputation as a ruthless operator is now so firmly entrenched in business mythology that it tends almost completely to obscure other contradictory aspects of an extremely complex and paradoxical character. He is in many respects a man at odds with himself: on the one hand, there is the control freak who frets about the last light bulb; on the other, there is the boss who believes in giving his underlings almost untramelled freedom. In private, his tastes are expensive; in public, he is parsimonious beyond parody. One side of him is warm and witty, the other is cold and unforgiving. He can reduce tough men to tears, is intellectually incredibly self-assured yet he is very vulnerable to criticism, is shy and is easily hurt. His friends and colleagues say that he loves to tease and to provoke. They also say his undoubted fierceness is sometimes a pose which he puts on for effect.

'Up to a point, he plays to the public to fit in with his image, but it's not the real man,' says Sir Claus Moser. 'He will take the hard line to fit his

image, but in actual fact he's a rather soft human being.' As an example, Moser tells the story of Weinstock on the committee of the British Museum, which he joined as a favour to Moser, who is the chairman of the trustees. 'One of his pet hates,' Moser says, 'are Japanese prints. So when the director announced that he intended to buy some more, everyone braced themselves for a tirade from Arnold. The more so because they've all heard it before. 'If the director wants to bankrupt the Museum, I suppose he should be allowed to do so in his own way.' Arnold grumbled.' But having made his point, Moser says, he doesn't press it, as others might, by pedantically insisting that his objection be noted. 'To say that he withdraws with good grace is an understatement. Somehow he will manage to make us all feel good, while making it quite plain that the course we have chosen is not his. He has a very tough exterior, very brilliant, with high moral principles but not very many certainties underneath – there is a tremendous warmth. He is the kindest man imaginable – the first flowers in hospital come from him. If I was in trouble of some kind – financial, sexual or whatever – he would be one of the first people I would go to.'

Both his former head gardener, David Ponting, and his friend and West Country neighbour, William Rees-Mogg, testify to his love of children. Rees-Mogg tells how Weinstock once entranced his four year-old daughter throughout a whole train journey from Bath to London by giving the wrong answers to simple arithmetical puzzles and allowing her to put him right.

But while Weinstock may be very warm and witty, there is, at the same time, often a sharp edge to his humour and he especially enjoys jokes which put guests or opponents on the spot. He takes particular pleasure in deflating politicians he thinks pompous. Some years ago, before the collapse of apartheid, there was a Stanhope Gate lunch with a visiting South African politician. When the talk turned to the discrepancy between white and black wages, Weinstock chipped in with the observation that he thoroughly approved of the ANC's idea of equal pay for whites and blacks. Before this verbal hand grenade had had time to explode, he added, wickedly, 'Furthermore, I think the rate for whites should be brought down to the present black level.'[19]

While the day-to-day business of GEC and corresponding responsibility was delegated to the battalion of managing directors, what actual freedom they had was severely circumscribed. What was unusual was the degree to which, right from the very start, power in GEC was concentrated in the hands of one man. One of the very first things he did on taking over at GEC was to change the articles of association to ensure that the managing director (i.e. himself) was a permanent member of the board and was not obliged, as the other directors were, to retire by rotation. The only

way the managing director could be removed from his position, the revised articles state, was on grounds of misconduct. Furthermore, the GEC board was a joke. However impressive it may have looked on paper, all the senior GEC people I have talked to agree that it had no meaningful function. 'Nobody took any notice of the main board,' says Ray Wheeler. 'Basically, it never met. My job was to report to Arnold about these ten companies where I was effectively the executive chairman.' When Arthur Walsh, who ran the Marconi business for many years, left to become the head of Standard Telephone and Cable (STC), he rang Weinstock to ask his advice about how to deal with his new board which consisted of some thirty people. I said, "I can't get along with this board. What do you do?" And he said, "I don't have one." So I asked Walsh, 'What do GEC directors do?' 'Talk to Arnold,' he said to me. 'At GEC the phrase "a majority on the board" just doesn't apply. It's a question of whether Arnold wants it or not.'

Out in the field, the managing directors tended to echo Weinstock's view and paid little or no attention to the board. When asked whether he thought the directors should have played a more active part in setting company policy, Alan Veale, one of Weinstock's earliest protégés, replied:

> They don't know anything about the detail of the business, so why should they have anything to say that's worth listening to. Arnold's door was always open and if there were things to be discussed and decided, then I'd go in and have a chat and get it sorted. That's the way it worked.[20]

During Weinstock's time, GEC board meetings, so insiders say, were largely pro-forma. Directors were appointed not because they were expected to map out the company's strategy or to give wise advice as to its future direction, but because of their City, political or Whitehall (particularly MOD) contacts. We have already seen how skillfully Weinstock played his cards to gain the support of the Industrial Reorganization Corporation, and as the years went by he built up such a strong network of civil service friends, primarily in the Department of Trade and Industry and in the Ministry of Defence, that ministers, especially junior ministers, thought several times before taking him on.

Over time, Weinstock developed a finely honed technique for deflecting criticism from Whitehall. One minister recounts how he summoned Weinstock and his team to explain why a defence project was late. The minister banged the table, barked that it was not good enough and inquired what Weinstock was going to do about it? Weinstock nodded and said, 'You're right, minister. It isn't good enough. And if you tell me which of my team here is responsible, I'll fire them immediately.'[21]

However furious the Ministry of Defence and the armed services might become with GEC, though – and there have been some ferocious rows over the years – the relationship between GEC and government was essentially a cosy one. In the course of time, five former ministers and well over a dozen ex-MOD and service personnel, as well as senior civil servants from other key government departments, have worked for GEC.[22]* But the interesting thing is that, although the politicans have all been Tories (the latest being Lord Prior, who will retire in March 1998 after thirteen years as chairman), they have mostly come from the wetter, non-Thatcherite wing of the party. But even in this respect Weinstock is not an easy man to pigeonhole. As far as I can make out, his choice of politicans depended far more on how useful he thought they might be to GEC than on their party political allegiance. For example, when Lord Carrington resigned as GEC chairman in 1984 to become Secretary-General of NATO, Weinstock's first choice to replace him was not Jim Prior, or, for that matter, any other Tory, but Labour's Denis Healey. As the ex-chancellor wrote in his memoirs:

Almost as soon as Parliament returned from the summer recess, I was invited to leave politics for business. Arnold Weinstock, whom I had met a good deal as Chancellor, asked me to take Peter Carrington's place as chairman of his company, GEC. It took only seconds to refuse Weinstock's invitation. A full-time career in business was even less appetizing than being an international civil servant in charge of NATO or the IMF.[23]

If he had talked to Peter Carrington, Denis Healey might have revised his blithe assumption that he was being invited to take up a 'full-time career in business'. Carrington told me that, although he admired Weinstock enormously, he did not much enjoy his time at GEC. For a man who very much liked being at the centre of things with hundreds of civil servants at his command, Carrington found he was not exactly fully employed. Half-joking, he has said, 'My only decision was whether to change the light bulb in my office.'

If the chairman of GEC's board felt he was something of a cipher, much the same could be said of the men appointed to be chairmen of the GEC subsidiaries. For the most part, these posts, so one former GEC

*In September 1995, there was a lively row over the appointment of Richard Needham, a former trade minister in John Major's government, to the GEC board. While in opposition, he had been personal assistant to Jim Prior – later, as Lord Prior, chairman of GEC – between 1974 and 1979. As a minister, Needham went on a trade mission to China with Prior in 1992. Between 1993 and 1995 he visited Indonesia five times and his department approved export licenses to Indonesia for Hawk attack aircraft, for which GEC supplied thermal-imaging and electronic-warfare equipment.

senior executive told me, were largely reserved for men who had been kicked upstairs or had fallen out of favour. He said:

> It's what one does in GEC that matters, not what one's called. Titles don't matter in GEC. If you are a chairman, you don't do anything. It's bad enough being a chairman: worse still is being a deputy chairman. If you are a managing director, you are in the main line. But if you drop back, you become a chairman or a deputy chairman and thus become a member of what we called 'The House of Lords'.[24]

The scale of Weinstock's reconstruction of the electrical industry was such that it was not until late 1970, almost two years after the English Electric merger, that the benefits began to show through. In September of that year the company made an elaborate presentation to the IRC, the 'godfather' of the new GEC. In a session lasting six hours, the IRC were told that, in the three years since the merger with AEI, the workforce had been cut by 20,000 (a fall of about 20 per cent), while on a turnover that hovered just below the billion-pound mark, pre-tax profits had risen from £49 million to £68 million – an increase of 38 per cent. (As the £49 million figure included a fifteen-month contribution from English Electric, the percentage increase is even more impressive.) The IRC's managing director, Charles Villers was hugely impressed. He told Weinstock that he was 'full of satisfaction, even excitement, at the way the concept embarked upon three years earlier was coming true'.[25]

As far as the City was concerned, throughout the early 1970s, GEC could do no wrong. By 1975, the number of people employed at GEC's factories in Britain had stabilized at around 170,000. But while the labour force had fallen by more than a third in five years, sales over the same period had risen by over 50 per cent: from £924 million in 1971 to £1,407 million. This represented a dramatic increase in productivity, with sales per employee rising from £4,102 in 1971 to £6,829 by 1975. Even more to the City's liking was the 178 per cent rise in pre-tax profits from £63 million to £174 million.

For any company such figures would be mightily impressive. But for a company as large as GEC, operating primarily in low-growth, low-margin sectors of the market against a background of chronic labour unrest, this performance was, on the face of it, quite remarkable. On closer examination, however, it is clear that, when adjusted for inflation, the figures are nothing like as flattering. In later years, as criticism of GEC intensified, Weinstock has tended to brush aside this point. As a statistics graduate, he argues that it is unfair and misleading to adjust the figures of a heavy engineering and electronics company by a price index

that includes many things, like food, that GEC did not make or sell. But this did not prevent his accountants including in the 1975 annual report a detailed analysis of the effect of inflation on the company's figures over five years. This showed that there was no increase at all in the real value of sales between 1971 and 1975 and that profits, instead of leaping by 178 per cent, rose by a respectable but more modest 52 per cent. Thus, the increases in productivity, while real enough, had been far less spectacular.

For the first five years, nearly all of Weinstock's and Bond's energies had been devoted to consolidating their new empire, to putting its finances on a firm footing and to the cementing of existing relationships with their major customers. But looking ahead, there were big problems. From a financial point of view, GEC had been transformed between 1967 and 1972. As a business, however, it remained as dependent on government patronage as ever, if not more so. In theory, one could argue that Weinstock and Bond had a choice: they could either throw their lot in with government and settle for a highly profitable, if unspectacular, existence living off fat government-guaranteed defence and electricity supply contracts or they could gamble on new technologies and emerging private-sector industries very much as the old GEC under Lord Hirst had done in the inter-war period. In practice, in real life nothing is as clear-cut as this. And though, thirty years later, the outcome is plain enough, in the early 1970's the path ahead was by no means clear and Weinstock was fretting about the implications for GEC of such close ties with the public sector.

In 1972, the chairman, Lord Nelson, writing on Weinstock's behalf in words that were almost certainly penned by Weinstock himself, observed:

> When we review progress since our merger period and look ahead, we have to conclude that we experience greater travail in those fields where Government, or a State-owned undertaking, is a monopoly customer than in the private sector, at home or overseas, where we can operate in a genuinely competitive environment. The difficulties arising in dealing with the public sector are not caused by personal relationships, which remain good even in trying conditions. They stem from the customer's monopoly position and the conflict raised between its so-called 'commercial' interests and its 'national' responsibility for the separate industries which supply it. In the absence of the closest collaboration with the supplying industries, the decisions of such State-controlled monopolies must be arbitrary; yet they may be decisive factors in the ability of the suppliers to survive in international markets. The importance of the issue cannot be overstated.[26]

This *cri de coeur* was the product of Weinstock's frustration at the inability of the Post Office to make up its mind about which system it should adopt for its telephone exchanges – a delay that was costing GEC dear in export markets. But, on a wider front, his outburst reflects a dilemma that has both haunted and frustrated Arnold Weinstock throughout his working life: namely, how to build a competitive international business while relying for orders almost wholly on the government at home. In his valedictory interview with the *Financial Times*, he complained bitterly about the lack of constructive government support.

Historically, our foreign competitors were helped much more than we were, particularly in realizing their international ambitions. This is notably true in the industries with which GEC operates: industries connected with public utilities and, of course, defence. In these areas, until you have demonstrated a new system you won't get customers for it. And if you can't sell at home, you are not likely to sell it anywhere else.

The German electricity generating utility ordered a big gas turbine, for instance, so that Siemens could design and build such machines and associated systems for sale internationally. The French behaved similarly and so on. But the UK didn't. Yet for us at GEC it was essential to acquire big gas turbine technology.[27]

Then, even more than now, GEC's commercial life depended on the patronage of the state and its monopolies: specifically the Ministry of Defence, the Post Office and the CEGB. In the early 1970s, forty per cent of the business of GEC's largest and most profitable subsidiary, Marconi, was directly in the gift of the Ministry of Defence; it was the MOD which paid for the research laboratory at Stanmore; and it was the MOD which underwrote about half GEC's entire research and development budget. The Post Office was virtually the only buyer for GEC's telephone exchanges and other communications equipment; the CEGB was the main purchaser of GEC's turbines and switchgear; and British Railways, as it then was, was the only UK customer for the diesel engines and the rolling stock GEC produced.

It is this symbiotic relationship with government that has been GEC's greatest strength, but also, many would argue, its greatest weakness. Nowhere has that special relationship been closer – and more fraught – than with the generals, admirals and air vice-marshals at the Ministry of Defence and with their masters, the politicians. By the mid-1970s, the ever-increasing reliance of the armed forces upon a whole range of electronic devices was presenting GEC with hugely profitable opportunities. But there were also problems of equal magnitude.

SIX

ARMS AND THE MAN

In buying English Electric, Arnold Weinstock consolidated his hold on a market that was on the verge of a quite revolutionary change: what is more, it was a development that could not have come at a better time. Neither AEI or GEC was exactly a stranger to the defence business. As we have seen, AEI's Metrovick had played a vital part in the Second World War building much of Britain's bomber strike force, while GEC itself had designed Sea Slug, the navy's first guided-weapon system, and had managed the defence research laboratories at Stanmore for the Ministry of Supply and Aviation. But it was, above all, the acquisition of English Electric and its subsidiaries, Marconi and Elliott Automation, that made the new GEC a major player in the defence business.

The pioneering work of Guglielmo Marconi in telecommunications, dating back to the turn of the century, had made the man himself and his company world famous. His success in 1918 in transmitting the first-ever wireless message from England to Australia, followed by his work on short-wave radio, laid the foundations of modern broadcasting. And just as Marconi's development of wireless telegraphy led to Britain being one of the first countries in the world to set up a national broadcasting network, so during the Second World War Marconi's scientists had helped to give Britain a world lead in radar.

While Marconi's expertise was primarily in communications, Elliott was among the leaders in the fast-growing applied sciences of avionics and computer technology: its semi-conductor operation at Glenrothes, run by the brilliant Ian Mackintosh, was the first plant in Britain to make the new integrated circuits that were to revolutionize the electronics industry and turn the defence business upside down. And when GEC set up its avionics division, which later became the single most successful part of its burgeoning defence business, it was staffed almost completely by Elliott people.

But it was in America not Britain that the invention was made that was

to transform the electronics industry and change the face of the defence business. Supported by defence research contracts, it was the work of a small group of scientists at the industrial laboratories of Texas Instruments and Fairchild that led directly to what is arguably the most significant invention of the second half of the twentieth century: the silicon chip.

The creation of the chip was more a piece of brilliant scientific engineering than a single inspired invention. The components of the integrated circuit – transistors, diodes and resistors – already existed. The semi-conducting properties of silicon and other similar materials, first developed during the Second World War, were already well known. Furthermore, the invention by Walter Brattain, John Bardeen and William Shockley at Bell Laboratories in 1947 of the transistor made it possible to replace bulky thermionic valves with tiny solid-state amplifiers so small that millions of them could be placed on a silicon chip no bigger than a child's fingernail. But it was not until 1959, when Robert Noyce of Fairchild Camera and Instrument and Jack Kilby of Texas Instruments succeeded in linking up all the components of an electrical circuit by placing them on a single silicon chip to fashion the world's very first integrated circuit, that the electronics revolution came of age.

It was not just the Lilliputian dimensions of the chip that made people gasp: the real attraction was the combination of size, power and reliability. Using just a fraction of the power of a conventional valve and occupying only a minute fraction of the space, the new integrated circuits opened up an entirely new world for both civil and military electronic engineers. It was this combination of power and the scope for minaturization that so appealed to the military. The ability of the new chips to do so much in so small a space lent new impetus to almost every aspect of defence procurement – from satellites to torpedoes. The development of micro-electronics led to their use in a whole range of applications: lasers, fire-control and communications systems, head-up displays, infra-red sights. Electronic devices became the key components in virtually every kind of weapon from small arms to the ICBM. The consequence was that the cost of ships, planes, tanks, even bombs, rose exponentially, very largely because of the amount of electronics (and electronic R&D) that went into them. As that dedicated student of the defence industry, Susan Willett, observed in 1989 in her paper on the defence industry and technological change:

> The military has a huge vested interest in microelectronics, as the developments that have taken place in the last fifteen years have transformed military technology. In particular it has revolutionized the guidance and control of weapons, and military communications, command and intelligence. Microelectronic devices are applied to

every major weapon system, tanks, combat aircraft, missiles and warships. Given the breakdown of détente and the outbreak of a new phase in the Cold War, the resultant dramatic increase in defence expenditure in the US and the UK has led to a new phase of technological-push in military equipment. Microelectronics is now at the heart of this arms race.[1]

This technological breakthrough, combined with the continuing tensions of the Cold War, fuelled a massive increase in defence expenditure throughout the countries of the Western Alliance. In Britain, the amount spent on defence rose from £2.2 billion to £6.7 billion between 1967 and 1977 – an increase of 208 per cent. But from the point of view of defence contractors like GEC, the best was still to come. Over the next ten years, the British Government's expenditure on arms and weapons systems rose more than two and a half times more quickly than the growth of manufacturing production: by 1986 the MOD's annual budget for defence procurement was just under £9 billion – a rise of 270 per cent since 1977. By comparison, manufacturing GDP rose by some 108 per cent over the same period – from £38 billion to £79 billion.

The main beneficiaries of this largesse were British Aerospace and GEC. An analysis of the latter's turnover by General Technology Systems in 1987 shows that not only did defence sales account for just under a third of its annual £6,000 million turnover, but that the MOD paid for about 45 per cent of its total expenditure on R&D.

To what degree this growing involvement in the defence business affected GEC's corporate character and culture is a question discussed in more detail in chapter seven, but at this stage it is, perhaps, worth quoting a comment made by the Advisory Committee on Science and Technology in its report on defence R&D which was published in 1989. It wrote:

> Many companies are dependant on the MOD for much of their production and also for their R&D funding. It appears that the increasing orientation of the electronics industry in the 1960s and 1970s occurred partly because of a preference to invest in defence rather than civil R&D combined with the fact that the technologies associated with defence work were unlikely to have much potential relevance in the civil sector.[2]

For Weinstock and his shareholders, it was fortunate that the creation of the new combine coincided almost exactly with a great surge in British defence spending, and from the very beginning, defence was a very important component of the new GEC – though, oddly, much less discussed and analysed than the heavy engineering and consumer products

side of the business. In 1968, the three big divisions of Marconi/Elliott – radar, communications and avionics – had an annual turnover of about £200 million – just over a quarter of the total for GEC as a whole. The bits and pieces, such as the Stanmore laboratory and parts of Elliott that nobody knew what to do with, were put together in a company that was given the futuristic name of GEC/Elliott Space Weapons. Its first managing director was a 35-year-old tyro called Arthur Walsh and it had a turnover of £12 million. By the time Walsh left GEC in 1986, it had become, as Marconi Space and Defence Systems, a £600 million-a-year business and was one of GEC's biggest and most profitable subsidiaries.

From the start, Walsh was what Mike Bett calls an 'Arnoldchik'. Though he was nominally answerable to Bob Telford as head of the Marconi operation, Walsh looked to Weinstock for inspiration. 'Bob is a very nice man,' he said. 'I used to treat him like a father, but he was a kind of hands-off manager. If you wanted somebody to put spice into something and scare the living daylights out of you, you had better go and talk to Arnold. I always felt I worked for Arnold.'[3]

Apart from his wartime stint as a pen-pusher at the Admiralty in Bath, defence was a business that was almost wholly foreign to Weinstock; but the fact that at the outset GEC's managing director knew next to nothing about the mysteries of defence contracting did not seem to matter very much. However unfamiliar he may have been with the technical details of the defence business, there were many aspects of the work that Weinstock found very much to his liking. Put crudely, there was an awful of lot of money to be made out of defence contracting and, what was more, under the system then in place, a great deal of the work was almost entirely risk-free.

In the eight years he had been at GEC, Weinstock had become accustomed to working with all-powerful customers such as the Post Office and the CEGB. But even these monoliths could not compare with the Ministry of Defence, which had until very recently had done its own contracting on major projects and was, through Royal Ordnance, still a major player in munitions making. The defence business was one where the normal conditions of the marketplace did not apply. It was a world where the name of the game was monopsony – one in which there was only one buyer and few sellers. As Weinstock himself would point out in 1995 after more than thirty years of hard pounding with the Ministry of Defence:

Where big systems are concerned, we are all the time confronted by a situation that there is one buyer, the MOD, and maybe two or three suppliers. That is not really a market. A market reflects a situation in which you have many buyers and many sellers and

*Arnold Weinstock's birthplace,
50 Belgrade Road, Stoke
Newington in North London.*
(Stephen Aris)

Arnold Weinstock, aged 43.
(Neil Libbert © Times Newspapers
Ltd)

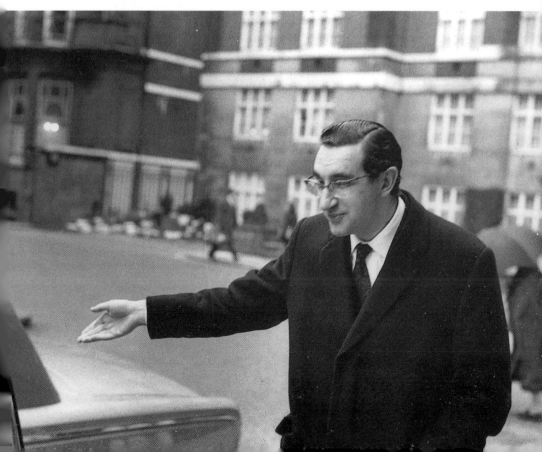

A night at the opera. Weinstock leaving the Royal Opera House, Covent Garden as GEC's bid for AEI hangs in the balance.
(John Goldblat © Times Newspapers Ltd)

The moment of triumph. Weinstock leaves the office of Hill Samuel with Sir Joseph Latham, deputy chairman and managing director of AEI in November 1967.
(© Times Newspapers Ltd)

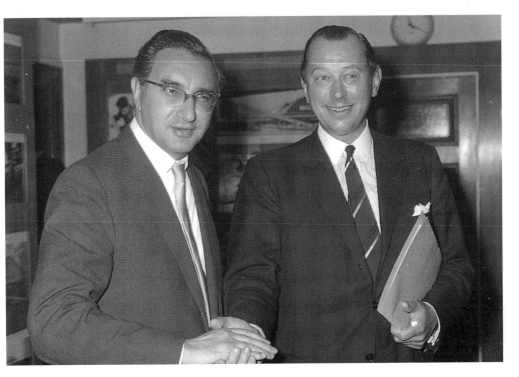

Sealed with a handshake. Weinstock greets Lord Nelson of Stafford, chairman and chief executive of English Electric, after the merger with GEC in September 1968. (© Hulton Getty)

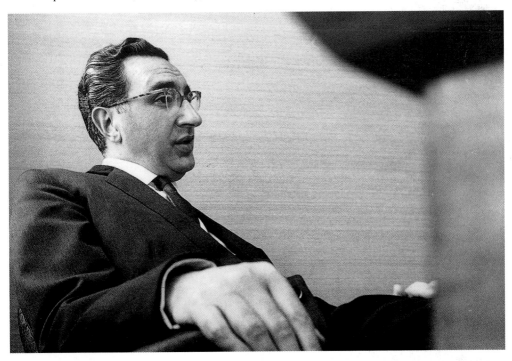

In command. Weinstock in his Stanhope Gate offices in October 1969.
(Kevin Brodie © Times Newspapers Ltd)

*Batman and Robin.
Weinstock and his alter
ego, Kenneth Bond, in
1971.*
(Michael Ward © Times
Newspapers Ltd)

*The third man, David
Lewis.*
(© GEC)

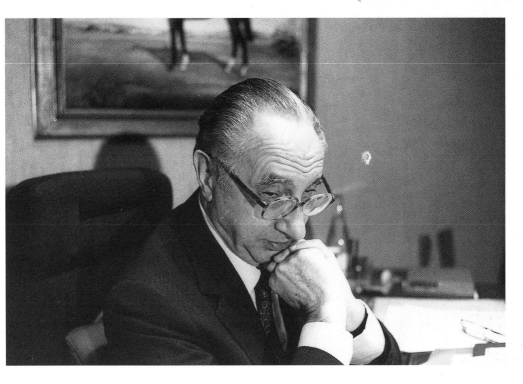

In pensive mood, 1988. (Sally Soames © Times Newspapers Ltd)

A day at the races. Weinstock and his son, Simon, at Ascot in 1983.
(Michael Ward © Times Newspapers Ltd)

Sir John Clark, chairman of Plessey, in January 1989.
(Alan Harper © Times Newspapers Ltd)

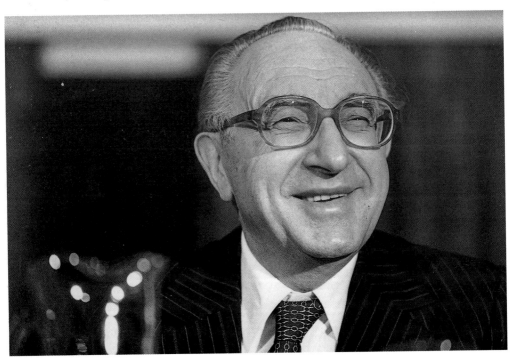

Things are looking up. Weinstock announcing link-up with General Electric of America in January 1989. (Mark Pepper © Times Newspapers Ltd)

*A month in the country.
At home at Bowden Park,
Wiltshire.*
(Matt Ford © Times
Newspapers Ltd)

*With his wife, Netta, at
their London flat.*
(Martin Beddall © Times
Newspapers Ltd)

Sir Peter Levene, head of procurement at the Ministry of Defence, 1985–91.
(Simon Townsley © Times Newspapers Ltd)

Approaching his 71st birthday. Weinstock poses in front of the Venom helicopter. (Ashley Ashwood © Times Newspapers Ltd)

buyers are making choices as between the value they get as between different sources for the same product and as between different sources for different products.[4]

What the service chiefs wanted – but often failed to get, at least until long after it was needed – was equipment that was better and more effective than that of the potential enemy. Questions of cost and availability were, of course, always a factor, but throughout the 1970s and into early 1980s they remained secondary. The emphasis was much more on equipment that was truly state-of-the-art: as good as, if not better, than that which the Americans could produce. Consequently, defence contractors were encouraged to work up to, and often beyond, the limits of their technological capability. As GEC put it in a paper to a joint session of the Defence and Trade and Industry Committees of the House of Commons in April 1995: 'The overall defence requirement tends to push technology to the limit.'[5]

It was only in the mid-1980s, after a series of scandals which revealed that billions of pounds of public money had been squandered on weapons systems that either did not work or were, in some cases, quite literally decades late, that the emphasis began to shift. Michael Heseltine, then defence minister, brought in his own hatchetman, Peter Levene (later Sir Peter), from the private sector with a brief to make the whole business more competitive, and the National Audit Office, the House of Commons Public Accounts Committee and even the largely sympathetic Defence Committee began to ask hard questions – about the capability of the hardware, about the waste of billions of pounds of public money by the MOD, and about the competence and efficiency of GEC, a company which only a few years before had been hailed as the white hope of British industry.

In 1968, most, if not all, the major defence contracts awarded to suppliers by the Ministry of Defence were on what was known as a cost-plus basis. In other words, the contractor was guaranteed a profit no matter how long or how costly the job turned out to be. In June 1985, the new head of defence procurement, Peter Levene, told the House of Commons Defence Committee that cost-plus was 'something I dislike intensely'. The reason, he continued, was:

In a cost-plus contract what happens is that you are effectively going to somebody and saying, 'Well, please go away and build this and send me the bill when you've finished.' In a cost-plus contract you must not forget that a contractor is paid a profit on what he spends, so there is no disincentive on him to spend money, because for every pound he spends he will be paid so much on top

of that project. I think one is aware of the fact that for one reason or another, the Ministry of Defence in the past has not always got the best value for money.[6]

While the cost-plus system may have encouraged an over-cosy relationship between the Ministry and its major contractors, when challenged, the MOD argued that one of the main advantages of the system was to give contractors like GEC some much-needed protection against the costs and hazards of working on the frontiers of technology. Just as important but less frequently mentioned was the fact that the cost-plus system also gave the MOD almost infinite freedom to change a project's specifications as often as it wished. As Susan Willett says, 'The rigid specifications demanded by the MOD allowed for constant product revisions resulting in soaring development costs and long lead times. MOD funding took the risks and liabilities out of R&D and capital funding, while sales, margins and profits were effectively assured.'[7]

From his perspective as a former senior manager at GEC, Derek Jackson has reached a very similar conclusion. 'In the 1960s and 1970s,' he says, 'there was a buoyant market for defence. The contracts were all fixed price. You got 70 per cent progress payments and the cash flow was very good. You didn't have to invest. And you got paid for development.' Jackson, who worked for Elliott and Marconi for thirty-two years, believes that the commercial attractions of defence work to GEC were so great as to be irresistible.

I think we tried to get a balanced portfolio at Elliott in the 1960s, but when we found out what the risks and time-scales of the civil side were, we just couldn't see a way of getting civil business in a sensible way. The problem with the civil aircraft systems is that there generally isn't a guy who is paying all your fixed, non-recurring development costs. From the time GEC took over English Electric and Elliott, I don't think we got any major civil systems, other than a contract with Airbus when I got half a million out of the DTI. And it's only in the last five years that they have got some business on the fly-by-wire for the Boeing 777. It wasn't just the fact that you had to invest out of your present earnings – everybody's got to do that. But somehow Arnold wasn't sympathetic to these long-term contracts.[8]

Not everybody shared Weinstock's prejudices. On leaving GEC in 1987, Jackson was head-hunted to run Smiths Industries' Cheltenham factory where 2,800 people were employed. He says:

I signed a contract for Smith's power management on the 777 and we ended up going £13 million negative on cash flow. But we are now selling these things at over half a million a shot. Another ten years, and it's going to be hugely successful. And the question is: how do you do that kind of thing in GEC?

Jack Pateman, the former head of GEC Avionics and the man in charge during the great Nimrod disaster, admits that, from the contractor's viewpoint, cost-plus has much to be said for it.[9] 'Cost-plus is great in one respect,' he told me. 'Your military customer can set a very high target and on a cost-plus basis the industrial organization can go on trying to meet that target until it runs out of money' – which, as we shall see, is more or less what happened with Nimrod. 'There has never been a major loss on a cost-plus contract,' said Pateman. 'If the manufacturer says it's costing more than we thought, the customer either says "okay" or we stop.' But, he says, even from a contractor's standpoint there are some very real disadvantages to cost-plus. 'The customer can change his mind as often as he likes. He can and does. And if you remonstrate, he says, "Well, you're being paid on a cost-plus basis: what are you worried about? Just do as you're told." That, in my experience, can lead to disasters.'

One of most intriguing aspects of the GEC story is the highly ambiguous relationship, to which I have alluded earlier, between Arnold Weinstock and GEC's scientists and engineers on whose skill and knowledge the company's prosperity largely depended. Some agree with Sir Derek Roberts, who was GEC's technical director for twelve years and who says, 'I found him refreshing, easy to talk to and utterly unpompous.'[10] But others, like Roland Dunkley, who ran GEC's Stanmore operation in the early 1960s, say that Weinstock never really understood or appreciated his technical people. 'He used to give me lectures on his business philosophy based on his times in the radio industry with his father-in-law. He thought we were long-haired scientists who had no real experience of life. There was a total mistrust of engineers in general.'[11]

The consensus is that Weinstock tended to regard scientists and engineers as people whose mission in life was to spend money, not to make it. But he was, it must be said, shrewd and modest enough to recognize his own limitations and to appoint well-qualified people to run the operational side of GEC's defence business. While being very different characters, both Bob Telford and Arthur Walsh were technically highly competent, like all Marconi's graduate recruits. Both went to university in Cambridge where Telford studied engineering and Walsh won an exhibition to read physics at Selwyn College. But what earned them Weinstock's confidence was not their academic achievements or even their technical prowess but their proven ability as managers. While Telford was the

steadier and the more analytical, Walsh was the buccaneer who was not afraid to stand his ground with Weinstock when necessary. 'Bob was a manager not a changer, while Arthur was a bit of an Arnold clone,' says a colleague.

Once in charge of his little empire, Walsh set out to look for new business. He says:

> We pushed the artillery computer systems that Elliott were good at. So we tried to get some of that into America. And we got an American army contract. We were dedicated engineers, we were engineer-driven throughout, though it would make Arnold's hair curl to hear me describe it like that. We were very keen to build satellite earth stations. And we couldn't challenge Marconi, partly because we were part of the same company. But because Arnold allowed us, we decided to have a go. The easiest way to do that was to go and crib off the Americans. I've always believed that you don't want a guy with first-class honours because he's had to do all the work. You want a guy with a third whose's cribbed his way through. We got the Americans to help us and we built a ground station. And then a satellite came out. It was evident that the life of building satellite stations wasn't going to go on for ever and it looked like torpedoes. And we made a play to get the lead role in torpedoes.[12]

In pitching for the torpedo business, Walsh was putting his head into a hornet's nest. The contract for the development of the Mark 24 Tigerfish torpedo – the Navy's heaviest underwater weapon – had been started by the MOD itself as long ago as 1959 with the expectation that it would go into service in 1967; but it was not long before the project began to run away with them. In 1969, with Tigerfish already two years late and with no prospect of a workable torpedo, came the first of four MOD investigations into the debacle. The arrival of the Polaris nuclear submarine involved upgrading the entire weapons system including a new, much more sophisticated torpedo which was much closer to an airborne guided missile than to the conventional Second World War weapon that the Navy had been using up till then.

The MOD came to realize that they did not have the technical know-how to design and build such a sophisticated device. Increasingly, from the early 1970s onwards, the MOD handed over the job of making Tigerfish to a small army of contractors and sub-contractors: the guidance system was made by Plessey, the electric motors were supplied by a company called Laurence Scott Motors and the warhead was made by the MOD's own Royal Ordnance. GEC's only direct involvement in Tigerfish was the

manufacture of a little ceramic transducer at the front end of the torpedo.

Initially, Walsh was looking for a piece of the Tigerfish action for himself; his plan was to grab as much of Tigerfish for GEC as he could:

We made a play for the whole guidance system but couldn't get it because Plessey did it. We hoped to use GEC Small Motors to get the electric motor contract but couldn't because Laurence Scott Motors had that bit. So we didn't have very much at all. So we went to the chap at Portland – a man called Butterfield – and said, 'Look, we'll co-ordinate it for you.'

Not only did they make us systems co-ordinator but they also gave us the contract to run the trials – in effect, to run the Navy submarine for them. It was a bugger's muddle. The guidance wires on the submarine sent signals that bore no relation to the sort of signals the torpedo expected to get. So most of the Navy's trials were down the drain. The Navy's project manager was a guy called Captain Evans. I felt he was a rough sod so I recruited him – and we ended up as the long-term co-ordinator.

Having been appointed systems co-ordinator and project manager, his next step was to get GEC appointed as the lead contractor for the entire project and so put his rivals' noses out of joint. 'As each bit wasn't working with another, we said to the Navy, "Give us the development contract, and we'll modify them."' The Navy agreed that GEC should do the development work but insisted that under the terms of the so-called 'get well' programme, the production work should return to the original contractors once the problems had been sorted out: and to prove that they had been, GEC should produce twelve workable torpedoes.

Walsh accepted these conditions and then put into action an elaborate plan to prise as much of the business as he could away from Plessey. 'We went over to the Plessey place in Ilford and got them set up with the best team we had – the one that had been working with the Navy at Portsmouth,' he recalls. 'The idea was to show them how to do it and then wave goodbye.' It was only after the first twelve torpedoes had been made and successfully tested that Walsh sprang his trap.

I told all our people working at Plessey to get the hell out and to change everybody who had been working on the team. In their place, we put people who had been working on the lorries. But we reckoned Plessey would keep them on the torpedoes because we knew Plessey hadn't the foggiest clue. All of sudden, these torpe-does stopped coming out. Plessey shouldn't really have fallen for that, but they did. We sat back. And the Ministry got more and

more cross because the thing wasn't working and we weren't bloody helping, were we? So we said, 'If you want us to help, the quickest way would be if we made another twelve. All right make it thirty. And then fifty.' Then they said, 'This is getting out of hand. We'll split it. You can make the guidance and Plessey will make the sub-assemblies.' So Plessey starts making these things. I insisted on very large penalties for missed dates. And, of course, they'd miss them.

So eventually, the Ministry split it down the middle and said, 'you can make half the sub-assemblies and Plessey can make half.' You can see what it led to: our prices were well down on Plessey. And eventually the Ministry said, 'Act as prime contractor and get on with it.'[13]

Walsh says that the Tigerfish project finished up as virtually all GEC with Plessey as a sub-contractor.

The victory in the battle for Tigerfish not only made Walsh's reputation inside GEC as a hard-driving, profit-hungry manager: the winning of the contract was to have a huge influence on the shape and character of the entire company. It accelerated the swing away from traditional heavy power engineering and towards defence contracting. None of this could have been guessed from the company's official pronouncements. Walsh's triumph was signalled by little more than three lines tucked away at the back of the 1973 GEC annual report which read simply: 'Marconi Space and Defence Systems successfully completed the redevelopment of the Mark 24 torpedo, the most advanced of its type in the world, and this is now entering production.' It was also, as things turned out, grossly misleading.

Twelve years later, the House of Commons Public Accounts Committee reported that the Mark 24 was still not operational despite the expenditure of one billion pounds at 1984 prices. An MOD official told the PAC in secret session that although Tigerfish was theoretically in service with the Navy during the Falklands War in 1982, it was only used twice, never fired in anger and that the torpedoes that had sunk the Argentinean heavy-cruiser *Belgrano* dated from the Second World War.[14] Surveying the whole sorry story, the PAC noted that 'it had been one of the most conspicuous records of failure in the whole field of Public Accounts.'[15]

With the exception of the Polaris missile programme, the government was to spend more on its family of torpedoes than on any other single piece of military equipment. In 1985, the PAC, examining the troubled torpedo programme for the third time in two years, reported that since the conception of the Tigerfish project in 1959, the government had spent the

truly staggering sum of £5,000 million at current prices on various torpedo projects.[16]

The biggest and the most expensive had been Tigerfish. But there was also its successor, Spearfish, on which Marconi had started work several years before Tigerfish was ready for service, and a lightweight weapon known as Sting Ray. Of the three, only the £700 million Sting Ray, the first UK-built torpedo to be developed entirely by private industry, was delivered anything like on time and within budget. The £1 billion Tigerfish never worked properly and was, after some thirty years of development, replaced by Spearfish, which was itself by no means trouble-free. MPs, sitting in secret session in 1991, were told that during trials, the torpedo had performed a U-turn and proceeded to home in on the submarine that had fired it, placing the vessel and the crew in, what Dr Malcolm McIntosh, the head of defence procurement at the MOD, described laconically, as 'some jeopardy'.[17] However, because these contracts had all been awarded on a cost-plus basis, it was the taxpayer, not the manufacturers, who bore the cost of these disasters. Exactly how much GEC made out of its torpedo monopoly is impossible to say, but Walsh himself estimates that 'GEC must have made half a billion pounds out of torpedoes eventually.'

Not surprisingly, as main contractor and monopoly supplier, GEC came in for much criticism for these undoubted failures. One of its most caustic critics was the Labour MP, Dale Campbell-Savours, who in May 1985, as a member of the PAC, inquired of Peter Levene:

> Is it not clear that there is something wrong in Marconi, that they seem to be in a seller's market, they can do almost what they want, they treat the public purse as almost bottomless, their products are little better than shoddy and there are many reports of divisions between MOD personnel, between Marconi middle management and higher management, between the design team in Marconi and middle and higher management?[18]

Levene's reply was revealing. 'To be able to answer all those questions at once is not going to be terribly easy,' he said cautiously, adding, 'I would certainly agree with some of the points that Mr Campbell-Savours made and not all of them.'

In pinning all the blame on GEC, Campbell-Savours was being a little harsh. Whatever Marconi's shortcomings may have been, it is clear from the record that incompetence and mismanagement by the MOD was at the root of the trouble. Surveying the wreckage of the Tigerfish programme in 1982, the MOD itself found that:

A major cause of the problem was that organization in MOD and in industry was too fragmented and lacking in a total systems approach. No person was in charge of the total weapons system, there was no prime contractor to draw the weapon system together in industry and there were problems in interfaces between the different authorities in MOD, the Navy and industry. Other causes were under-estimation of technical difficulties, insufficient development trials and inadequate funding and resources in the post-design phase. [19*]

In his authoritative report on the entire saga, the Auditor-General concluded: 'Failure of the overall system cannot be attributed to one contractor.' But in almost the same breath he remarked:

Successive torpedo projects have suffered delays and cost increases and optimum weapon effectiveness has not been achieved. This suggested to me that the taxpayer in the past may not have received good value for the considerable sums spent. A major difficulty is the lack of competition in the United Kingdom for the prime-contractor role. [20]

The criticism GEC received for its part in the Tigerfish fiasco still rankles. 'A big stink was kicked up about that Mark 24,' Walsh said to me. He went on:

It was terrible. If you wanted to run a trial, you had the Navy messing about with their submarines, you had interface equipment that was built with no attention to what the guidance people wanted and none of the dates on which people were supposed to deliver ever coincided. But we put it right and we got all the bloody blame for it.

The torpedo programme was to prove a painful, if profitable, experience for GEC; but it was as nothing compared to the great Nimrod disaster. Nimrod undermined the company's reputation for technical competence, raised serious questions about Arnold Weinstock's hands-off, financially orientated management style, led to a shattering row between the MOD and its second biggest supplier, and hastened the demise of the cost-plus system. In 1987 the Public Accounts Committee's verdict on the Nimrod affair was blunt. 'It was,' it said, 'a major example of how not to approach a development project.' [21]

*GEC's appointment in 1972 as main contractor for Tigerfish was in respect of the torpedo itself and not the overall system including warhead, weapon handling and discharge, and fire control.

It is fair to say that after Nimrod the cosy world of UK defence contracting would never be quite the same again. The episode, which lasted nine years and cost the British taxpayer more than £1 billion – not to mention the cost of buying an American replacement, left its mark on both sides. Peter Levene was to describe the Nimrod programme as 'one of his worst experiences' in the Ministry of Defence,[22] while GEC admitted that the cancellation of the Nimrod project 'cost us dearly financially and was a blow to our pride'.[23] In fact, the financial cost in relation to the overall size of the programme was tiny, some £24 million. Far more damaging was the harm it did to GEC's standing.

The story starts in 1975, when GEC and British Aerospace joined forces to offer a replacement for the RAF's ageing Shackleton aircraft, which filled the Airborne Early Warning role for Britain's air defences. Based at Lossiemouth in Scotland, the job of the six Shackletons (whose design lineage went back to the wartime Lancaster bomber) was to patrol the Western Approaches and the huge area of the north-western Atlantic and the North Sea. Equipped with a primitive American-made radar, the plane's task was to keep a lookout for incoming Soviet bombers and missiles and send back a warning to RAF fighter stations and missile bases. But as their radar often failed to even spot aircraft, let alone track them, and as they had little capacity to process data and were unable to transmit it down to the ground, the Shackleton's utility as an airborne sentinel was clearly limited. Both the politicians and the RAF were clear that the Shackleton had to go. 'It's a disgrace that the Shackleton is still in service,' James Wellbeloved, a junior defence minister in the Callaghan government, told BBC's *Panorama* programme.[24] But what should replace it? The Airborne Warning and Control System (AWACS) being developed by Boeing and Westinghouse and based on a 707 airframe or the GEC/British Aerospace project based on the Nimrod maritime patrol plane, which in turn was a development of the Comet, the first commercial jet airliner?

The RAF preferred the AWACS even though it looked like being more expensive than the British alternative and would be in service nearly two years after the date GEC had promised for the Nimrod AEW. Furthermore, the MOD argued, the AWACS was already up and running (the first planes were delivered to the US Air Force in 1977), while the GEC version was still only a gleam in the company's eye. When the GEC/BAe prototype made its début at the Farnborough Airshow in 1975, there was a block of concrete in the nose where the radar was supposed to be. Nonetheless, GEC promised that for a shade under £500 million it would install its as yet undeveloped and untested radar in eleven converted Nimrods and that the first would fly with the RAF in 1981, with the full squadron in operation by 1984–85. By comparison, the American system, it was thought, would cost more and arrive later.

Apart from the attractive price and delivery dates, two factors tipped the balance in GEC's favour. The first was growing impatience with indecision within NATO over a scheme for the European members of the alliance to buy a number of AWACS planes; the second was the fierce buy-British lobbying campaign in the early spring of 1977 by British Aerospace and GEC, who exploited the Labour government's desire to provide the jobs the programme would, of course, create. Fred Mulley, Labour's Minister of Defence, admitted to the BBC's *Panorama* that there was 'very strong pressure from the Nimrod lobby'.[25] The government, therefore, decided to ignore the advice of the service chiefs and 'Buy British' – thereby guaranteeing several thousand jobs for British Aerospace and GEC workers and exciting the hope of substantial export orders.

The Nimrod job could not have come at a better time for GEC. The big civil contracts for the avionics in the VC10, Concorde and the BAC 1-11, which had sustained Elliott Automation and Marconi throughout the 1960s, were coming to an end and there was little in the pipeline. The decision by the Wilson government to abandon the British TSR2 multi-role combat aircraft and buy the American F111 instead had also been a blow. But Jack Pateman, the head of Marconi Avionics, which was based at Rochester, was not someone to take these setbacks lying down. He sent teams to the United States to drum up sales of head-up display equipment for America's new F16 fighter while intensively lobbying the British government for defence contracts.

In fact, 1977 was Pateman's year. Not only did the Rochester company win the Nimrod job but it also secured the equally massive contract to build the Foxhunter radar system for the air defence version of the Tornado fighter being built by British Aerospace. Though one would never had guessed it from the cryptic references in the GEC annual report for 1977, these were major triumphs. The company chose to throw a veil over its defence profits by lumping them in with in the infinitely less profitable telecommunications activities, but the record shows that the division was growing extremely rapidly and that it was defence that was the driving force. In the five years between 1972 and 1977, the turnover of Marconi's electronic, automation and telecommunications businesses had leapt by 64 per cent – from £351 million to £576 million. The number of people employed by Marconi Avionics grew from around 1,000 to a peak of 6,000, and returns on investment regularly exceeded 50 per cent. In Weinstock's eyes, Jack Pateman was a man who could do no wrong.

The work on Nimrod was to be divided into two halves: British Aerospace was to convert existing Nimrods to their new role by adding the bulbous nose and tail for the radar and stripping out the inside of the fuselage for the

electronics, while GEC would develop an in-flight radar, data-processing and communications system that could pick-up incoming Soviet aircraft and missiles at a range of 200 miles and transmit information on their range, course and speed down from 30,000 feet to RAF ground stations. These specifications were based on the RAF's original assumption that the main threat would come from the north-western approaches of the North Atlantic in the gap between Iceland and Norway, and that Nimrod would therefore be operating almost exclusively over the sea.

It was obvious from the start that the schedule was extremely tight. As the PAC noted:

> Because of the operational urgency, MOD had opted for a compressed and overlapping development and production programme, without stage-by-stage reviews, including only limited expenditure on models and test equipment, and allowing very little margin for unforeseen difficulty. At that stage the estimated cost of development and production of the system was £319 million at September 1976 prices, of which £73.5 million was for airframe development and £67.5 million was for MSA development.[26]*

What was equally clear was that GEC would bear the brunt of the project. While BAe's job of converting the Nimrod was comparatively straight-forward, in promising to design and develop an airborne early warning system in roughly one third of the time and at about one third of the cost of the American AWACS, GEC was offering up several hostages to the gods all at once. The technology was new and quite untested; the airframes into which the whole system had to be shoe-horned were small and far from purpose-built; there was no single authority to co-ordinate the two main contractors (GEC and BAe were answerable to two quite different masters at the MOD); and, finally, because the concept had never been properly tested, nobody had the slightest idea whether Nimrod would actually work. It took a further nine and a half years and a £1,000 million of the taxpayers' money to find out.

The 1975 mock-up of Nimrod at Farnborough was in no sense a test bed. Its purpose was simply to sell Nimrod's feasibility. The RAF, on the other hand, tended to regard it as a working model and, for this reason, were very reluctant to fund further tests. Jackson explained the problems:

> What we wanted was to fly an aircraft to gather inputs and radar reflections and then feed the results into a rig to see how the bloody

*MSA stands for Mission System Avionics, i.e. the radar and computer equipment that make up the early warning system.

thing worked. But the MOD would not allow it. They said that they had paid for the testing already. The tragedy was that we were not free agents to do the checks we wanted to do. And yet the guys were under such pressure to make something. When we protested, the Ministry said, 'Well, you did your demonstration in the Nimrod in 1975.'

As Nimrod was a radar project, it was decided that the work should be done, not at the company's base at Rochester, but at the radar research centre at Borehamwood in Hertfordshire. Instead of taking charge himself, Pateman appointed the former head of research, Peter Marriner, to head up the project. In the classic GEC tradition, Marriner was told to hire the people and get on with it. From being the head of a 100-strong research operation, the hapless Marriner found himself responsible for a £500 million project employing 3,000 people. It was a prospect that would have daunted the most experienced manager and, as a research man, Marriner was very far from that.

The need to find so many people so quickly meant, so Derek Jackson says, that GEC could not afford to be choosy about whom they hired.

At one stage they were supposed to hire at the rate of 1,000 people a year. If one takes wastage of say 20 per cent into account that means you had to hire 1,200 people, and what happened was that they recruited a lot of rubbish: there were some good guys but a lot of people were out of their depth.

Apart from the people problem, there was the technology. At the heart of Nimrod was the GEC 4080M, a machine which dated from the days when GEC had had its own line of commercial computers but which had been strengthened and adapted for military use.* In Nimrod, the 4080's job was to process the enormous flow of data coming in from the radar aerials in the nose and tail of the plane; to sort out which signals mattered and which didn't; to eliminate the 'clutter' and to indicate the range, speed and direction of potential threats. It then had to convert all this into moving pictures on the tracking screens before sending a digital data stream back to earth. It was the single most important piece of equipment in the whole system: if the computer could not do its job, the rest of the sophisticated electronics would just be so much high-tech ironmongery.

*By 1977, GEC had long abandoned any ambition to be a mainstream computer manufacturer: as far as the government and the company itself was concerned, that role was reserved for ICL (International Computers Limited), in which GEC had a minority stake. GEC continued to make its own line of relatively low-tech, rugged machines for industrial and military use.

Work on Nimrod had hardly started when GEC's own computer people began to question whether their machine was up to the job.* Colin Bramald, who had joined Marconi Space and Instrument Division as computer-obsessed 22-year-old in 1969, says that quite early on the Marconi scientists had managed to get hold of the specifications of the computer that was to drive the American AWACS and from what they learnt, they realized their own machine was most unlikely to be able to cope.[27] This had a serious effect on morale, which, as Bramald says, was already very low amongst the scientific people at Marconi following the GEC takeover. 'All the younger ones wanted to leave, while the older ones stayed put. Among these were a number of institutionalized GEC hands, of whom most were concerned to keep their heads down and not make waves.' Far from being apostles of scientific excellence and leading-edge technology, Bramald says that their approach was very down-to-earth and practical. He says, 'Working as a contractor for the Ministry of Defence meant that you became rather detached from the real world. The team put effort into those contracts they thought they might win but didn't bother much about the others. There was very little upfront, speculative money.' Bramald believes that the reason the GEC computer was chosen was because that was what had been specified and as far as everybody was concerned that was that.

Derek Jackson also identifies the shortcomings of the GEC computer as a key problem and is very critical of the decision to stay with it. 'There were other computers available,' he says, 'and it was already abundantly clear that sticking to that size of computer – which was a mid-1970s model – was a nonsense. The speed was too slow. For an extra million we could have gone to a new computer.'

By 1982 – four years after GEC had started work and a year after the first Nimrod should have been delivered – it was clear to everybody that things were going badly wrong. One of the things that had delayed the project was labour troubles at British Aerospace, which meant that the Nimrod airframes were late in being delivered. But the main problems were with GEC's avionics, particularly the computer. And as the difficulties mounted, the efforts to solve them became more and more frantic. 'Marriner used to take his work home every night,' Jackson recalls. 'He'd have his supper and then work from 7.30 to 11 every night up in his study. And he'd work all day Saturday.'

In the autumn of 1982, four years into the project, Jack Pateman asked Derek Jackson to move to Borehamwood as general manager to oversee

*With a clock speed of one megahertz it was about 200 times slower that the sort of PC which today can bought off the shelf at Dixons, but even by the standards of the mid-1970s it was underpowered.

the Foxhunter and Nimrod projects. Jackson later discovered that the initiative came not from Pateman but from the MOD, which was losing confidence in Marriner. Jackson himself was not impressed by what he found:

> They should have finished the development and been delivering the first production units. But they went for an impossible time-scale. Quite frankly, there are a lot of people to blame for this. The politicans, the MOD. I found a huge morass of problems. Maybe three Nimrods had been built and the remaining eight were 80 to 90 per cent finished. But they hadn't got a working system or flown anything. It was not just the hardware that was giving problems. With the RAF constantly changing its mind about what it wanted, we had a huge committee of blokes writing the software specifications for something that should have already been delivered. There were hundreds of engineers rushing about. And both GEC and the MOD knew that the time-scale was critical. But the whole job was being run from the MOD's point of view by an assistant director. A hard-working guy. Worked enormous hours. Quite often these progress meetings would finish at nine o'clock at night with fifty people around the table. Not a way to run a project.

As costs escalated and the project fell further and further behind schedule, the MOD produced a large stick. With increasing force and frequency, GEC was told that if they spent more than about £80 million a year, the project would be cancelled. For its part, GEC protested that such tight cash limits made it next to impossible for them to sort out the outstanding problems. The plain fact was that the RAF was losing its patience while the politicians were losing their nerve.

According to Jack Pateman, the main problem at that stage was that while Nimrod's radar worked splendidly, the system was having difficulty in distinguishing moving from stationary targets. 'It was in the detection of moving targets that the computer was inadequate,' he told me. 'The displays became confused. There was clutter and the computers became overloaded and therefore couldn't handle as many targets as they should have done. So targets were being missed. Now, that's a bit disastrous.'

When word of these setbacks reached the MOD, Geoffrey Pattie, the minister in charge of defence procurement, lost his temper. 'Something inside of me snapped. I just felt that something had to be done,' he told me.[28] A formal ministerial visit to Borehamwood for 23 October 1983 was therefore arranged. The visit was intended to last for five hours during which Pattie intended to leave GEC in no doubt of his displeasure. He says, 'As I saw it, the object of the exercise was twofold: one, to flag up

that we had a problem and two, to bring the tortured features of Lord Weinstock to the window.' But before setting out for Borehamwood, Pattie thought it best if he took some precautions. He knew that what he intended to say would ricochet around Whitehall and might even reach Number 10. He feared that if he mounted a headlong attack on GEC, Weinstock would mobilize his powerful contacts in Whitehall to suggest that Pattie's judgement was none too sound and that it would be best if he were ignored. 'If a minister of state is involved, the ground has to be prepared,' he said.

Pattie's preparations were nothing if not thorough. Anticipating that his visit to Borehamwood might be shorter than officially planned and concerned lest his official car might not be on hand when he stormed out, he told his driver to stay close by, ready for the ministerial summons, if need be. 'I wanted to avoid a Jacques Tati-type scene,' he says disarmingly. As things turned out, the message was delivered without undue incident. Pattie told his hosts that unless there was progress, there would be no more money. He then left, satisfied that the message had got home. A visit that had been planned to last five hours had taken exactly fifteen minutes. 'At GEC they understand that kind of talk,' Pattie says. 'Putting pressure on that part of the corporate anatomy is something that really works.'

Pattie may have been pleased to have delivered his ultimatum without any awkward incident or loss of ministerial face, but he now thinks that his intervention could have been counter-productive. Instead of 'bringing the tortured features of Lord Weinstock to the window' as he had hoped, the company closed ranks. And it took the MOD another six months to persuade GEC that Marriner had to go. In the spring of 1984, Jackson was called into the office to be told that Marriner was leaving and that he was to take his place. 'I was staggered and even Jack [Pateman] was surprised. Frankly, it was a political decision.'

By the time Jackson had assumed command, the Nimrod project had been under way for some seven years and the atmosphere at Borehamwood and Hemel Hempstead, so Jackson says, had become somewhat surreal.

I went round and found all kinds of optimism, errors and, in some cases, total falsehoods in the data people were presenting. People had been threatened, you see. And you got into a situation where there were up to ten guys working on some piece of kit for a complex system. Quite honestly, the management of the whole thing was too loose. There were certain people appointed by Peter Marriner who were his group leaders in the research group who had been kind of pushed into being general managers. I started

getting rid of these people, or at least getting them out of the firing line. I could never get good guys out of Rochester. Pateman just didn't want to know.

It was in the midst of this imbroglio – and very largely because of it – that in 1984 the then Minister of Defence, Michael Heseltine, asked Peter Levene to be the head of defence procurement. It was the first time the job had gone to someone from the defence industry and his £95,000 salary raised hackles in Whitehall. His brief was to dismantle the old cost-plus system and let the cold wind of competition blow freely through the corridors of the MOD.

If Hesletine was looking for someone to bell the GEC cat, he could not have done better than Peter Levene. Like Weinstock himself, Levene was self-made and autocratic. He once said of his management style at United Scientific Holdings, the arms company he built from almost nothing into something quite sizeable, 'This company is run like a dictatorship. I'm the dictator.'[29] Like Weinstock, he came from a traditional Jewish background. But unlike Weinstock, his upbringing was comfortable and his education was in the classic Jewish middle-class tradition: City of London School and Manchester University, where he read economics. When I interviewed him in 1984, he told me that when he joined USH at the age of twenty-three he knew so little about day-to-day business life that he didn't know the difference between an invoice and statement. At that time USH was an obscure company operating on the fringes of the arms industry, dealing in surplus military equipment. It mainly grew by acquisition, taking over companies making such items as tank sights and in 1981 raised its profile dramatically by acquiring Alvis, the maker of the Scimitar family of light armoured vehicles, from British Leyland for £27 million.

Although not famous for his sense of humour, Levene does have a grim sense of irony. When in March 1991 the time came for him to leave the MOD, the memento he chose to remind himself of his stint as the scourge of defence contractors was a tiny screw. Set in a presentation jewel box, it was one of a batch bought by the Ministry at a cost of £47.80 each. (One of his favourite tales of the defence industry concerns the $1,000 ashtray: a saga which relates how the Pentagon contrived to inflate the cost of an off-the-peg $5 item by 20,000 per cent by purchasng it, complete with a twenty-page specification, from a prime contractor in the defence industry).

One of the first dossiers to land on Levene's desk when he arrived at the MOD at the beginning of 1985 was Nimrod. As Levene saw it, not only was Nimrod the misshapen child of the cost-plus system, it was also a flagrant example of the excess and mismanagement he had been hired to stamp out. With Levene's arrival, GEC's troubles multiplied. While Geoffrey Pattie fended off criticism of the Nimrod programme by

doggedly stonewalling on the floor of the House of Commons, behind the scenes he and Levene did little to conceal an attitude bordering on contempt for the GEC management. Twenty years on, Pattie is a little more forgiving. 'There's no comfort to say that the thing was badly managed,' he says. 'It needed to be properly project-managed. We should have worked out in advance exactly what resources were needed, because otherwise you end up on the wrong side of the drag curve.' He recalls being told by GEC's Bob Telford 'If projects are to go wrong, they usually do so in the first six months. And once they do, it's the devil's business to get them back on track.'

The results of further trials in the summer of 1985 at the RAF's station at Boscombe Down only served to increase the MOD's sense of frustration. Up to now, the MOD had paid all development costs under the terms of the cost-plus contract. But under pressure, Weinstock agreed that GEC should pay for these trials itself. The purpose of the exercise was to see whether the radar problems had been sorted out and how well Nimrod performed in meeting the revised specifications, which laid down that it now should be able to operate as effectively over land as over the sea.

The added complications of identifying targets over land was one that had been troublesome throughout the project. It was therefore decided that the Boscombe Down trial should take place at 3 a.m. when traffic would be at a minimum. Unfortunately for GEC, the radar was all too effective. As Nimrod flew off the coast of Norfolk, the sensors picked up even the very slowest-moving traffic within a radius of about 150 miles – as far away as the A1, the M1 and the M25. Derek Roberts, GEC's director of technology, put his finger on an obvious but uncomfortable truth when he observed that the analysis job was 'easier in the north because there are fewer cars.'[30]

The two sides – which is what they had now become – drew quite opposite conclusions from these results. The GEC people argued that they demonstrated that the system now worked perfectly and all that was needed was a bit of fine tuning of the filters to eliminate the road traffic problem. To the MOD, Boscombe Down showed that Nimrod was still a problem child. On 26 February 1986, George Younger, the new defence secretary, said that GEC had six months to come up with a solution and that if it failed the government would look to other solutions. Meanwhile, costs would be shared 50:50 between GEC and the MOD, up to a limit of £50 million. Far from being down-hearted, GEC genuinely believed that victory was in their grasp. Jackson explained why:

We were all convinced we were going to win through. Once we had done the measurements and started putting in the filters, we had actually solved the bloody problem. By mid-1986, we were actu-

ally getting some very good results. But by then we had lost the hearts and minds of the Air Force.

It is hard to tell what finally tipped the scales against the company, but Jackson thinks that the fact that one of his key people had a nervous break-down had a good deal to do with it. 'I put the guy to work alongside an air commodore in Lincolnshire. But then he had this breakdown and pulled out of the job. And that killed us because the air commodore was convinced that the poor guy had decided that the job would never work.'

On 18 December 1986, two days after Arnold Weinstock had been summoned to Number 10 to hear the bad news from Mrs Thatcher herself, the government announced that it was abandoning Nimrod and was buying six Boeing AWACs instead at a cost of £860 million. The defence secretary said that '*disregarding past expenditure*' [author's italics], the cost would be £200 million more than what was needed to acquire the eleven Nimrods, but that, looked at over twenty years the differences would, he thought, be marginal. By the time Nimrod was eventually cancelled, the project had cost £882 million at 1985–86 prices and looked set to consume a further £375 million, to bring the total to well over £1 billion.

Assessing the disaster, the Public Accounts Committee said that 'without a full technical post-mortem it was impossible to apportion fairly the blame for the Nimrod MSA debacle.'[31] It concluded that GEC did not appreciate the difficulties of meeting the RAF's requirements and was over-optimistic about overcoming them. For its part, the MOD, carried away by the urgency, failed to apply either a discipline or a monitoring and control procedure which would have checked these weaknesses.

One of the best and most even-handed assessments of what went wrong comes from John Streeter, a computer expert and research scientist who was brought in to run his own development team at Marconi's research laboratories at Great Baddow in Essex.

The Nimrod story is not about the computer being too small. It's not as simple as that. Defence jobs of this size and complexity are not so much about technology as about politics. What happened could have happened to any defence company: it was not specifically a GEC disaster, bad though the consequences in loss of jobs and face were.

From the start, the imperative, as far as the politicans were concerned, was that there should be a British solution that would provide British jobs; so that GEC's warnings, such as they were, were disregarded. The politicians, having little or no understanding of the technical implications and eager to give GEC the job in pref-erence to the Americans, clutched at straws. In response to GEC's own misgivings they would say, 'Yes, we know it can't do every-

thing, but will it make one interception?' On hearing that it could, they would say, 'Well, what about two or three? Could it do that?' And so it went on with nobody quite realizing just how long and dark the path ahead would be.[32]

Streeter goes on to say that the underlying problem was a lack of good systems engineering. He remembers having lunch with the salesman – later sacked – who landed the job.

> He was euphoric and talked about how a whole hangar was to be set aside at Elstree and filled with 300 programmers. Quite what they would be programming was left entirely vague. Nobody had laid down exactly what the job might entail or had made allowance for contingencies, which, in the event, had included multiple changes of mind by the MOD. It was true that by the end the computer turned out to be too small with insufficient memory to handle the huge volume of incoming data. It's very common on a large project to start off with a computer that's too big and end up with one that's too small. In fact, the GEC 4000 was a good machine with good communications links built into it: basically it was a control computer that could talk to other computers. What should have been done when it was clear that there were problems with computer capacity was to have multi-computers linked to one another. But to change the software to run on lots of computers would have been a mammoth task.

The effect of the cancellation on the Nimrod team was, so Jackson says, 'shattering'. Nearly 2,000 people – one third of the staff of GEC Avionics – from plants at Borehamwood, Hemel Hempstead and Radlett were given notice, although nearly half were found jobs elsewhere in the company. As general manager of the Nimrod project, it was Jackson who had to carry out the redundancy programme, but when it came to his own future, he ran into a wall of silence. He was summoned to Rochester where he was shown an organization chart on which his name did not feature:

> I said, 'What am I doing?' And they said, 'We haven't got a job for you. Why don't you go on holiday for a few weeks?' I said, 'I can't do that.' Eventually I went to up to Derek Roberts (the director of technology) and asked to know what my position was. And he said, 'It's all failed.' And I said, 'I know it's failed.' He wouldn't come out with anything straight but it was quite clear I wasn't going to be offered a managing director's job. Roberts told me to stick it for a couple of years and I'd be okay, but it was quite clear

I'd got the black spot from Arnold. The least I'd have expected
would be a word with Jack Pateman or Arnold, but Derek said it
was a difficult situation and said, 'I would strongly advise you not
to go and have a chat with Arnold.'

Eventually a place was found for Jackson as a divisional general
manager back at Rochester, but effectively it was the end of a 32-year
career with Elliott/GEC. 'Until the last couple of years, I enjoyed going
in every day,' he says. 'I never thought of work just as a means of earning
a living. I was an engineer and I wanted to work on inventions and things
like that.' Six months later, he was head-hunted to become managing
director of Smiths Industries' Cheltenham factory in charge of some 2,800
people.

The failure of the Nimrod project left deep scars. It blighted GEC's repu-
tation; it cost 1,000 people their jobs and ruined the lives of several senior
executives. Not to mention the cost to the public purse. But the real signif-
icance of the story from the present point of view is not the managerial
and technical failings of either GEC or the MOD, but the light it throws
on the nature and effectiveness of Arnold Weinstock's style of manage-
ment. As we have seen, one of the central tenets of the Weinstock
philosophy was the emphasis he placed on the individual managing direc-
tor as the *fons et origo* of everything in his domain. That's fine as far as
it goes. But what if the project is too large and too complicated for one
man, no matter how tough or how able to manage?

Derek Jackson thinks it is a system that works for small to medium-
sized projects – worth some £20 to £30 million and employing perhaps
150 people. But he adds, 'I don't think it's anything like so good for a
thing the size of Nimrod. And I don't think the way Jack Pateman ran the
company was too successful for a Nimrod-type operation.' It is generally
agreed that Pateman was an extremely able and highly effective executive.
But imbued as he was with the Weinstock doctrine of devolution, he
seemed to be curiously reluctant to get directly involved when things
started to go wrong. Looking back over twenty years, Jackson says:

The divisional system was almost sacrosanct: all the divisions
reporting to Rochester were largely autonomous. So while Jack was
his boss, it was left to Marriner to run Borehamwood. He was
expected to get in there and do the job himself. But the trouble was
Marriner was the kind of guy who would mislead people. He didn't
want Jack on his back, so he would tell Jack a few porkies, I think.
But Jack was extremely shrewd about everything else. He should
have realized long before 1982 that things were going wrong and

that he would have to do something about it.

Just as Marriner was reluctant to tell Pateman that Nimrod was going off the rails, so Pateman seems to have been a little reticent when it came to explaining to Stanhope Gate the exact nature of Nimrod's technical shortcomings. But then there was every reason for him to keep quiet. GEC Avionics was one of GEC's most profitable subsidiaries. Measured by the six standards laid down by Stanhope Gate, its performance was outstanding. And as the cost of developing Nimrod was being met by the government, even if the project collapsed, the financial impact on GEC would be minimal.

'If Arnold had a weakness,' Pateman reflects, 'it was that he was never very keen about moving out of his office. I wanted to show him what was going well and how things could be improved. But that wasn't Arnold's style. He would say, "I'm not interested in what's going well, I want to know what's going badly."' Like many other GEC people, Pateman confesses that he suffered from time to time from a well-known GEC occupational disease which could be called 'motivational starvation'.

I think the desire to get Arnold out of his office was as much an emotional thing as anything else. If I sit back and reflect, I have to admit that there was not much he could actually do by going out of his office. Probably the best thing would be for him to sit in his office and fire those people who don't perform and reward those that do.[33]

There is, as with other aspects of Weinstock's character, a paradox here. How could a man whose passion for detail bordered on the obsessional allow Nimrod to unravel to the point where the company had lost the confidence of its most important customer and the politicians at the very moment when it needed every ounce of support it could get for the Plessey bid (see chapter nine)? As the internal memos quoted earlier clearly show, Arnold Weinstock's grasp of almost every aspect of GEC's affairs was quite extraordinary. Like Robert McNamara, John Kennedy's Secretary of Defence during the Vietnam War, Weinstock had an uncanny ability to absorb a mass of detail and order it into tidy, logical patterns. But, also like McNamara, his vision was focused almost exclusively on data he could analyse and quantify. As a London Business School study of management styles put it: 'GEC has a leader who prefers to peer at businesses through the numbers.'[34] Stanhope Gate was far more comfortable with numbers than with operational or technical reports. As Geoffrey Pattie said to me:

The point about the GEC system is that people send Arnold reports which are financially driven. They are not about operational matters. GEC was keen on reporting mechanisms which did not encourage people to dive into prose. This was a ratio-driven company. And it was quite clear to me that Weinstock did not know what was going on.

GEC's reaction to the humiliating failure of Nimrod was characteristically low-key. In contrast to the grilling Weinstock would give his managers about their budgets, his reaction to the Nimrod disaster seems to have been very mild. According to Pateman, all he said was, 'If that's the best we can do, that's the best we can do and there's no use shedding tears about it.' A new management team was installed at the reorganized avionics business, the company was split into three separate divisions and, although each had its own managing director, the business was put under the supervision of the overall head of Marconi, Dr Ian MacBean. It was a reshuffle that was not only designed to reinforce Weinstock's basic belief in managerial autonomy but also to rectify some of the managerial shortcomings revealed by Nimrod. The business itself, however, emerged almost totally unscathed. As part of an elaborate damage-limitation operation, Dr MacBean forecast that the turnover of the avionics business would rise to a record £450 million in the coming year. But despite this brave face, morale inside the company was so low that Weinstock thought it necessary to write to everybody. Characteristically, he did not try to bind up the wounds with consoling words. Instead, he set a new target: to double profits within three or four years. 'We were depressed,' he said. 'We had to redefine our aims. If you set a short time like that then it means something.'[35]

SEVEN

CHIPS WITH EVERYTHING

The old GEC took great pride in its slogan 'Everything Electrical.' Long before Arnold Weinstock appeared, its radios, its domestic irons and its new-fangled washing machines were familiar items in ordinary post-war homes throughout Britain: The GEC, as it liked to call itself, was, quite literally, a household word. It was, as we have seen, with consumer durables that the young Arnold Weinstock made his mark. He shared with men like Jules Thorn and Michael Sobell a sharp eye for what the public wanted plus an ability to produce it at a price they could afford. Yet it is one of the many ironies of the Arnold Weinstock story that it was precisely with the products with which he made his reputation that he was to fail.

All the initial signs were promising. The mergers with AEI and English Electric had meant that the new GEC had become one of Britain's largest manufacturers of radios, TVs, washing machines, cookers, refrigerators and other household equipment. With total sales of £85 million in 1969, the consumer durables division accounted for something like ten per cent of total turnover. Under the umbrella of British Domestic Appliances, which had been jointly owned by AEI and EMI, were such famous brand names as Hotpoint, Morphy-Richards, Astral and GEC itself. Domestic cookers were made by GEC subsidiaries Cannon and, later, Creda. It was, however, the prospects on the TV side that were the most enticing.

The introduction of colour TV in 1967 heralded a boom. In 1971, sales of GEC's colour sets trebled. So great was the demand that in the following year the factories doubled their output. By 1973, fuelled by the Barber boom, GEC's consumer products accounted for 18 per cent of the group's total earnings. Demand was so strong that GEC, along with Britain's other TV manufacturers, was unable to keep up. But then, with equal suddenness, everything started to go wrong. The TV boom vanished as quickly as it had come; the threat from the Japanese, who had arrived in force in the early 1970s, intensified; and equally worrying, the company also

began to lose ground to the Italians in the white goods business. At the same time, it was plagued by complaints of poor service, outdated designs and a wave of strikes and labour disputes.

To help him sort out these problems, in 1974 Weinstock took the rare step of turning to a complete outsider. The man in question was an ebullient fitness fanatic called Chaim Schreiber who had built up a flourishing furniture and fitted-kitchen business. Schreiber came to Weinstock because he saw the need for a nation-wide chain of distribution depots but lacked the £11 million needed. He therefore asked Weinstock for a loan. As GEC was having trouble with Hotpoint and felt that it knew too little about the white goods business, a deal was arranged. 'I'll help you with the loan if you help me with Hotpoint,' Weinstock told Schreiber. The upshot was the creation of a jointly owned company in which GEC had the majority share but where Schreiber was in charge as the managing director. For the first time since setting up with his father-in-law, Weinstock was in daily contact with someone who shared his background, his religious beliefs (such as they were) and who was just as prepared to defend his own corner as Weinstock himself. There was nothing deferential about Chaim Schreiber.

GEC people say that the relationship between the two entrepreneurs was volatile. 'Chaim would go in with his little black book and they would start telling Jewish stories to each other and roaring with laughter and trying to outdo each other,' says one man. But at other times they would quarrel fiercely. 'The rows were incredible. You could have heard them the other end of Curzon Street,' says another witness.

Schreiber took one look at the operation and concluded that in order to gain the time he needed to restore Hotpoint to health, he would have to buy washing machines from Zanussi and the other Italian manufacturers whose cheap imports were the source of the British manufacturers' woes. Weinstock's reaction was to call Peter Gillibrand, GEC's chief spokesman, and instruct him to tell Schreiber that he was anti-British. Undeterred, Schreiber went ahead anyway. At the same time, he set about trying to put Hotpoint into some kind of order. By striking a deal with the workforce to abolish piecework and by shaking up a poor after-sales service operation, Schreiber succeeded in increasing productivity. However, he had less success in stemming Hotpoint's losses. Apart from the general economic climate, one of the drawbacks was that GEC was slow to bring in new models. Until the late 1970s, most of the Hotpoint line consisted of expensive, hard-to-service, top-loading washing machines. They had been good sellers in their time but were rapidly being superseded by more convenient front-loaders. In 1976, while the furniture side turned in a profit of £3 million, Hotpoint lost £2.3 million. However, by the early 1980s, Schreiber managed to stem Hotpoint's losses and turn

in a profit – only the situation had been reversed: now, the furniture side was in trouble, and its losses were threatening to bring Hotpoint down. In the meantime, the company had pulled out of the field of smaller electrical appliances altogether by selling off Morphy-Richards.

Working with GEC gave Schreiber a high profile. But his colleagues say he was never very happy at Stanhope Gate – he was perhaps too much of an entrepreneur to fit easily into the GEC mould. And perhaps he was also too much his own man to be able to adapt his style to Weinstock's. Kenneth Bond has vivid memories of the Schreiber experiment. He told me:

Schreiber knew everything. Arnold was always a bit wary that he might be wrong. But Schreiber knew everything. And in the end that led to friction. If Schreiber had laid his hands on money, his own business would have gone like that – it would have gone bust. Schreiber had got into trouble – he had overstretched himself. And so we said, we had better bring him in and get him to run Hotpoint. And that turned out to be a great success. Unfortunately, again, he became too ambitious. And we tried to restrict him and put impositions on him. But in the end it was obvious we were not going to succeed. So we let him hive off Schreiber. And we took Hotpoint back again. He was a bit of butterfly in some respects. We refused to put up more money that he wanted for certain ventures. Schreiber was not a manager but an owner. If someone is a born entrepreneur, he's going to run his own business. He won't be satisfied being a paid manager.

On 7 June 1983, the Schreiber family sold their 25 per cent holding in the joint venture to GEC for £6,025,000.

But while the clash of personalities was important, it was probably not decisive. The real reasons for Schreiber's departure were GEC's failure to stem the incoming tide of cheap Italian imports from such companies as Zanussi and Indesit; its reluctance (or inability) to reposition Hotpoint as a viable up-market contender; and its poor performance in export markets. As the economist, John Williams, remarks:

Comparisons of national industrial performance in the white goods field suggest the real failure of the British industry is in the export field. The French, West German and Italian producers have all managed a substantially higher level of exports to near European countries than Britain has achieved. Hotpoint constitutes a significant part of the British white goods industry, and thus must take its share of the blame. Because of the failure of British firms like

Hotpoint to make export sales, they have been sidelined as weak marginal producers.[1]

In recent years, GEC has laid a good deal of stress on its export performance and has trumpeted the achievements of its outgoing chairman, Lord Prior, in selling the company's power stations and turbines overseas. But throughout the 1970s, the company was a good deal more insular and more dependent on its domestic market than it is now.

Britain's belated entry into the Common Market should have been the opportunity GEC was looking for. While Weinstock welcomed the prospect of Britain's entry to the Common Market, his endorsement was cautious and philosophical. It's hard to imagine that what he had to say would have spurred hard-pressed Hotpoint executives into immediate action. In a memo to his senior managers Weinstock wrote:

> There is now virtually no doubt that the UK is going to join the Common Market. It is not clear how it will turn out in practice. On the one hand, we shall have to cope with more severe competition and, on the other hand, there will be a big expansion of opportunities open to us. We must renew our efforts in many directions; to step up our selling effort in Europe and find the best means of distribution; to get down our costs; to make our products more attractive to old and new markets; to improve our margins and sales; to reduce debtors and inventories; and where these efforts tend to work against one another, to establish a proper balance of pressure to maximize our profits. That is management. There is going to be a political row before Mr Rippon signs the Treaty of Rome and the unions are going to be on the anti side of it. That is in the political sphere and is not the Company's affair. But if in the industrial area we go into the Common Market divided, with management at odds with labour, everyone will suffer. Things must be explained to people and their views heard. Not whether or not we are to join the Europeans; that will be decided by others, democratically elected for the purpose. But on how we can make a success of it.[2]

In his memoirs, Tony Benn tells an anecdote about Weinstock's attitude to foreigners which, he thought, had some bearing on GEC's export performance. In the entry for 15 April 1969, he records:

> I had lunch with the Polish ambassador and his staff and Arnold Weinstock. On Anglo-Polish relations, Arnold Weinstock was hopelessly naïve. He said, 'I've just heard about a new switch we've invented in GEC and it's the best thing ever.'

142

So the Poles said very courteously, 'Well, we are doing a deal with Ericsson.'

'Oh, you can't buy Ericsson's equipment,' said Weinstock.

'Well, why don't you come and visit Warsaw?' said the Poles, not without a hint of rebuke in their voices.

'Oh, I don't like foreign travel,' said Weinstock. Weinstock somehow assumed that people just buy stuff because it's the best. I was really rather disappointed with Weinstock and it confirmed my suspicion that his export effort wasn't terribly serious or good.[3]

If the problems of the white goods side of the business were serious, the ones facing the radio and TV operations were even worse. By 1978, Radio and Allied, which had turned in a loss for the first time in its history, was in trouble. Stock levels were too high and the overheads had been out of hand for at least two years. 'How did GEC manage to allow a perfectly good ship to run on to a sandbank?' Weinstock asked himself.[4] The answer, he concluded, was that the management had disregarded the policies he had laid down when he himself was in charge and had decided to go for expansion at precisely the moment when the market started to contract: the product range had been expanded, new plants had been opened in Malaysia and Kidgrove and new sales organizations had been set up in Germany and Sweden. Unfortunately for GEC, all this took place at the very moment when the market started to look distinctly sick. 'The overheads went up by several orders of magnitude, demand did not,' Weinstock observed.[5]

This episode is a good example of one of the great weaknesses of the Weinstock approach. When asked why he allowed such a disastrous situation to develop, he replied that managers would never become real businessmen if they constantly were being told not to do things they were convinced they should do. 'If a bloke, having argued with me, is not convinced by what I say,' he explained, 'then he is entitled to his chance.' He adds, 'I don't treat my managers like small boys. I don't need to approve their plans. They have to decide what to aim for and then show they can do better than that.'[6]

His critics argued that this doctrine of managerial free will was all very well, but, they asked, what is the point of forcing managers to operate within the constraints of a highly elaborate control system, if they are then to be given the freedom to take decisions that would destroy the business? In other words, what is the chief executive and the board there for?

For once Weinstock was at a loss for an answer. When Graham Turner of the *Telegraph* asked Weinstock why he allowed Radio and Allied to get into such a mess, he replied defensively that he was perhaps over-conscious of the temptation to interfere with a business with which he had

been so closely connected. Also, he accepted that perhaps he should have acted sooner. And finally, he confessed that consumer goods were no longer such an attractive proposition. He said, 'The hard fact is that consumer goods are usually a bigger headache, and you can make more progress for a given effort in other things. I prefer to bang my head where we're going to get some benefit.'[7]

Here again, just as with white goods, Weinstock did not surrender without a fight. In the summer of 1978, he made what looked like a promising alliance with Hitachi, the Japanese TV and electronics company. The deal was that production would be shared 50:50 but that the project would be managed by the Japanese. Weinstock recognized that no matter how hard GEC tried, it would be unable to match Hitachi's superior technology and mass-market expertise. It was a case, so he believed, of 'if you can't beat 'em, join 'em.' However sound the reasoning, the success of the venture depended on the satisfaction of both parties. Unfortunately for GEC, the hoped-for benefits did not materialize, as GEC's brand names were already devalued. 'We were demolished by the Japanese,' says Martin Jay, who spent most of his time in the company trying to sort out the troubled consumer products division. Of the Hitachi deal he says, 'There were identical sets going down the line, one branded GEC and the other Hitachi. And they were both sold by the same distribution network. But the terrible thing was that everyone wanted Hitachi and nobody wanted GEC. That's how I remember it.' By 1986, two years after GEC had finally parted company with Hitachi, Japanese and other Asian manufacturers were responsible for 30 per cent of colour TV production in Western Europe and in the list of major manufacturers, headed by Philips and Thomson, the name of GEC was nowhere to be found.

When asked what went wrong, Kenneth Bond blames the British government as much as the Japanese. He complained about the government's removal of controls which sucked in imports and allowed GEC's foreign competitors to set up in Britain. 'It was impossible to plan ahead,' he said, 'because nobody knew what the government was going to do next. The market was fiercely competitive: sets were being sold at prices much lower than in Japan.' He also complained that the government's prices and incomes policy discriminated unfairly against GEC in that it was prevented from increasing service engineers' pay while foreign competitors were not restricted in the same way. 'The result was,' he said, 'that a lot of our people were pinched. We had a rough time with the government – both Conservative and Labour.' He went on:

The people who succeeded Arnold in the radio and TV business had been building up production at a time when the whole market had been cut back. And we had no option but to try and do deals

because our competitors were being favoured by being offered subsidies. Running a business is not just a question of handling things in an orderly manner. You have to cope with circumstances which exist whether you like them or not and there's no point in bellyaching. It gets you nowhere. You have to do the best you can. When you are being heavily shelled, you've just got to keep your head down.We got out, not because we wanted to, but because there was pressure on us to do so. We did voluntarily say we wanted to be lighter in this end of the market.[8]

GEC was not the only company to fold its tent in the face of awesome Japanese assault on the British market. Of the ten manufacturers of colour TVs in Britain in 1967, eight were British owned and the remaining two were subsidiaries of Dutch and American multi-nationals, Philips and ITT. By the time Thorn sold its Ferguson brand to France's Thomson in 1987, not a single indigenous British TV manufacturer remained standing. By the end of 1988, there were eleven producers, of whom eight were Japanese. The remaining three came from France, Taiwan and the People's Republic of China.

As the authors of a study of the development of the European electronics industry in the 1970s and 1980s observe:

The success of Japanese firms in the 1970s in exporting to Europe ... was not built on superior product technology, but rather on more efficient manufacturing processes based on the widespread use of automatic insertion of components, and on higher standards of quality and reliability, which is part derived from the use of far fewer components. The European industry was fragmented into a large number of plants with relatively small production volumes serving segmented markets; the Japanese firms had the advantage of the large combined ... markets in Japan and the United States in which to exploit scale economies.[9]

But if anyone had been able to withstand the Japanese challenge, it surely should have been GEC. Alone of all the British companies it had the resources and the experience to mount an effective counter-attack. Furthermore, if the Japanese could use their UK-based manufacturing operations as a jumping-off point for an assault on Europe, then why not GEC? But did it have the will? It would have undoubtedly have been an expensive and risky business. And to ask the GEC managers to take such a decision without Weinstock's personal backing would perhaps have been expecting too much from a group of men whose fate depended directly on the goodwill of the sage of Stanhope Gate.

To quote John Williams again:

The pace and scale of the mid-1970s decline in television and related products suggests a failure to fight. The company certainly had the means to sustain substantial short-run losses to protect its position in the home market. Such a policy would, however, not have met the usual stringent financial requirements. In all events, it is mildly surprising and depressingly instructive to see that a company as strong and as successful as GEC was in this area no more able to hold its share of its home market than BL [British Leyland] was in cars.[10]

That outsiders like Williams should be critical is, perhaps, to be expected. What is more surprising is to find people who have held very senior positions inside GEC holding similar views. 'In many cases, I think GEC could have done better in terms of commercial exploitation,' Sir Derek Roberts said to me. 'It's nothing to do with R&D. The real weakness was lack of marketing skills. The general approach was to make something for the British market and then try and persuade the rest of the world to buy it.'[11]

Inflation served to mask just how badly all of GEC's consumer products were doing throughout the 1970s. While the company's own figures show that output grew threefold from 1970 to 1982, when adjusted for inflation, the picture is more gloomy. Instead of a healthy increase, it shows a decline of 15 per cent. This retreat was the direct result of the massive invasion of Japanese radios and TVs. In 1970, imports had a 14 per cent share of the market; 10 years later, they were nudging 50 per cent and climbing. In the same period, the percentage of British-made radios and TVs being exported actually fell slightly – from 18 to 16 per cent. All this took its toll on GEC: in the early 1970s, sales of consumer products accounted for nearly 20 per cent of the group's total sales; by the end of the decade they contributed no more than 2 per cent of earnings. While continental rivals like Siemens in Germany and Philips in Holland battled on to retain a hold on their domestic markets for radios, TVs and other small-scale electrical goods, under admittedly very difficult domestic circumstances, Britain's largest manufacturer had more or less opted out after more than fifty years as a dominant force in the domestic marketplace. It was not quite what the IRC and the Labour government had been hoping for when they had given Arnold Weinstock *carte blanche* a dozen years before. In later years, Weinstock was to confess to Derek Roberts, the man he made technical director, that one of his biggest regrets was his failure to keep GEC in the colour TV business. He used to say to Roberts, 'Can't you get us back?', adding, 'It's an area in which

we have failed.' He also told Roberts that his biggest mistake was going into the joint venture with Hitachi. 'We should have done it ourselves,' he said.

The creeping takeover of the brown goods industry by the Japanese and of the white goods industry by the Italians was, as far as Whitehall was concerned, not a matter of any national significance. The failure of the British electronics industry, on the other hand, to grasp the opportunities presented by the semi-conductor revolution was a question of real concern. In September 1978, encouraged by the Rothschild 'think tank', a body known as the Advisory Council for Applied Research and Development (ACARD) published a report under the austere title, *The Applications of Semi-conductor Technology*. Surprisingly, it was a best-seller and ran to four editions. It also attracted the personal interest of the Prime Minister, James Callaghan.

ACARD did not pull its punches. Of semi-conductor technology, it warned: 'If we neglect or reject it as a nation, the United Kingdom will join the ranks of the undeveloped countries.' It continued:

> The United Kingdom has thus far failed to respond adequately to the changes which semi-conductor technology has already brought about in a number of areas. As a result, we have been overtaken by competitors in fields such as cash registers, food processing equipment, process instruments, machine tools, telephone switching systems, printing machinery and even in ships' chronometers. In many of these fields we previously had a dominant position.[12]

Back in the 1960s, before Weinstock arrived on the scene, GEC had been quick to recognize the importance of the transistor by setting up a special factory to make the new devices at Hazel Grove near Manchester. But, in common with other European manufacturers, it was much slower off the mark with micro-electronics, which, as we have seen, took off after the invention of the integrated circuit by Fairchild and Texas Instruments in 1958. While the Americans eagerly embraced the new technology, the Europeans, frightened of the cost and even more of the risk, held back and were, for the most part, content to buy American expertise under licence. As Professor Franco Malerba has observed: 'The firms concerned decided not to change their efficient production processes and commercially successful products in favour of new, highly uncertain ones. In fact, a high-level Siemens official was quoted as saying: "There is no real demand for integrated circuits."'[13]

With the benefits of hindsight, the Americans find it difficult to understand why the Europeans should have been so timid. 'They definitely

could have been second,' says Dr Sheldon Weinig, chief operating officer of the Materials Research Corporation.

> They had established the enormous entities of the Thomsons, the Philips and the Siemens. They were well-established technical companies. They chose literally not to compete because of an inability to commit monies and ideas; in other words, to make a commitment. The semi-conductor/integrated circuit breakthroughs occurred in the middle sixties. It's about then that all those guys, Siemens, Philips and so on should have sat down and said we want to be on the frontier. These are tremendous technological organizations entrenched in markets and technology; they don't have to be created. Many of the Japanese semi-conductor companies had to be created from whole cloth. These existed.[14]

Of the potential European players, GEC was probably as well-placed as any to take the initiative. But it didn't.

By the late 1960s, when Arnold Weinstock's GEC first took over AEI and then English Electric, he and his colleagues not only assumed control of a major part of Britain's heavy engineering industry, but they had also become owners of much of Britain's nascent semi-conductor business. With the purchase of AEI came two semi-conductor research centres at Rugby and Trafford Park and a semi-conductor plant at Lincoln, operating under an American licence. The acquisition of English Electric/Marconi increased GEC's involvement still further: both the Nelson laboratories at Stafford and the Marconi laboratories at Chelmsford were engaged in semi-conductor research, Marconi had just set up at factory at Chelmsford and English Electric/Elliott Automation had built a promising new facility at Glenrothes in Scotland, which Weinstock later shut down.

Derek Roberts, who came from Plessey to become GEC's technical director, says:

> Instantaneously GEC found itself the proud possessor of their own business, the English Electric business, the Marconi business and the Elliott business. The only companies doing significant work outside the GEC sphere of influence were Ferranti and Plessey. But the point is that quite honestly none of them were any good. Not as good as the Ferranti and the Plessey operations. They were all working under American licences, and there was no home-grown technology.[15]

Roberts believes that GEC's weakness in semi-conductors stemmed from Weinstock's decision, taken shortly after he took control at GEC, to set up a joint company called Associated Semi-conductor Manufacturers (ASM) in partnership with Mullard, a subsidiary of the Dutch-owned Philips. As Roberts explains it:

Arnold had to find a short-term solution because of a shortage of cash ... In those days, the GEC research labs at Wembley were the number one in semi-conductor research in the country. All this, the research and the manufacturing, was put into the joint company with Mullard. But Arnold was quite content with that. He had a lot of respect for Mullard as an electronic component manufacturer, which GEC had never been. And he felt he had quite enough to worry about sorting out power engineering and the like. So what he was effectively saying was, 'Let Philips run this on my behalf and I'll just take my 40 per cent.'

But this joint venture, like with the one with Hitachi a few years later, was not to last. What irritated Bond and Weinstock was that it was Philips, not GEC, that was in the driving seat. Bond says, 'Associated Semi-conductors was quite profitable, but it was dependent on what Philips charged. We were in their hands. They could just load it as they wished.' After about five years, GEC withdrew and a venture that could have been the focus of a serious European response to the American challenge was quietly abandoned. Though it may not have seemed so at the time, it was a momentous decision. By itself, GEC may not have had either the will or resources to do the job, but if a real working partnership with Philips had been established, the story might have been very different. As it was, not only did the collapse of ASM weaken GEC's own semi-conductor operations, but it took the company's eye off the ball. It was to be another ten years or so before GEC thought again about venturing into this exciting but hazardous business – and by then it was too late.

Roberts is convinced that the origin of the problem can be traced to from GEC's decision to put most of its semi-conductor eggs into the ASM basket. 'The problem for GEC,' he told me, 'was that what previously had been one of the jewels in their crown, the R&D at Wembley, disappeared because, when it was under Philips/Mullard control, a lot of people moved over to Eindhoven. So when it was split up again, there wasn't an awful lot on which GEC could build. And so they were thrown back on starting something on a very tiny scale at Wembley. They then found it wasn't possible to turn the clock back. They couldn't withdraw the strength they had put into it.'

With the invention of the micro-processor (the computer on a chip) by

the American company Intel in 1971, the stakes in this poker game were raised still further. Not only did the cost of remaining at the table increase, so did the penalties of failure. Even in early 1970s it was becoming clear that anyone who wanted to be a player in the micro-chip business was going to need deep pockets.*

Ian Mackintosh, the former head of English Electric's Glenrothes plant and one of the first people in Britain to see the potential, recalls wild nights he spent with the boys from Silicon Valley:

> The American semi-conductor business was founded by gamblers ... 'I've been in El Camino Real with three or four CEOs of semi-conductor companies who played poker dice for $300 a throw. These were real cowboys. The founders of companies like National Semi-Conductors were men who were an incredible blend of entrepreneur, scientist and businessman.[16]

To succeed, a firm needed a large home market; a strong backer to underwrite the huge R & D costs and a good, if not a brilliant, technical idea. Even if all three were available, generous quantities of luck were also required. It was not a business for a man like Arnold Weinstock, who expected every penny to multiply, who was reluctant to invest a single pound in anything until the market he was aiming at was clearly in his sights and who regarded a negative cash flow as an attribute of the Devil. No, it was a business for gamblers.

It was against this background that, in November 1975, Harold Wilson's third Labour government launched the National Enterprise Board, whose prime aim was to give state backing to those companies which could not raise money from the private sector: a kind of state-sponsored venture capitalism. It was, in effect, a rather more didactic version of the Industrial Reorganization Corporation of ten years before. This time its inspiration came, not from Italy, but from Stuart Holland, a left-wing intellectual who had worked with Wilson at No 10. Like the IRC, it was set up as state-controlled investment bank led by businessmen and staffed by technocrats from the private sector whose mission was 'to promote or assist in the reorganization of an industry'. However, unlike the IRC, one of its avowed purposes was to 'extend public ownership into profitable areas of manufacturing industry' and 'to promote industrial democracy'. To help it achieve these worthy aims, parliament voted to give the NEB £700 million and approved the appointment of Lord Ryder, formerly Don Ryder of Reed International, the paper company, as its first chairman.

*Today, a state-of-the-art micro-chip factory can cost $2 billion, while the development of a new chip can consume several hundred million dollars. In 1997, Intel, the industry's market leader, was spending $4.5 billion a year on development costs.

For its first three years, the NEB was much concerned with propping up an ailing British Leyland and a troubled Rolls Royce: together these two accounted for 80 per cent of the NEB's £700 million. But from about 1978 onwards, attention shifted towards encouraging firms working in such high-tech areas as computer hardware, software, information technology and biotechnology. By this time, Lord Ryder had been succeeded by Sir Leslie Murphy, a former oil man and deputy chairman of Schroders, the City merchant bank.

Under its new leadership, the NEB began to take a close interest in semi-conductors. The problem was that, while all the players involved recognized the need to build a stronger national presence in the industry, at the same they were very reluctant to give up any advantage to a rival. Their first instinct was to look after themselves. Thus, while the parties indulged in a series of elaborate courtship dances, no weddings resulted. There were exploratory talks between Plessey and Ferranti, for example, about finding a way to combine their semi-conductor operations. These eventually led to an NEB-sponsored plan to set up a joint Ferranti/Plessey semi-conductor company in which Plessey would have 50 per cent, Ferranti 25 per cent and the NEB the final 25 per cent. But that was not good enough for John Clark, the autocratic head of Plessey, who insisted on a controlling interest, even though he had first rights of refusal on the NEB's share. And so a promising initiative collapsed.

GEC, however, remained aloof from all this activity. According to Stephen Dawson, who joined the NEB in 1977 and rose to be the deputy head of the computer and electronics division, while the NEB had close working relations with Plessey and Ferranti, it never really established contact with GEC. He says:

The thing that GEC, Plessey and Marconi all had in common was that they were in a large number of businesses as second-raters. The one that had the money to do it was GEC: the others were all strapped for cash. But GEC was in the right place, with a lot of cash and a lot of technology in-house. The leaders were Fairchild, Motorola and Texas Instruments. And it would have been a high-risk business for GEC to have to have gone into the mainstream semi-conductor industry. It would have been hard for a broadly based, long-established company like GEC to keep up with American youngsters like ITEC. But having said that, GEC could easily have established quite big niches. There were a tremendous number of opportunities, but Arnold Weinstock chickened out of all of them.[17]

Although the NEB's efforts to act as marriage broker may have ended

in failure, they did have one positive result. They pushed the semi-conductor issue towards the top of the agenda and they resulted in the NEB having at least one member of staff who had become a real expert in a difficult and complicated area. So, when a young man called Iann Barron turned up in the spring of 1978 asking them to help him set up a state-of-the-art semi-conductor operation with factories in Wales and Colorado, they were very interested.

Although Barron was only forty-two, he had already been in the computer business for twenty years and he had built up a reputation as a brilliant and highly inventive technician who was abreast, if not ahead, of the gurus of Silicon Valley. His record as a money-maker, however, was less than spectacular. He had been enthralled by computers ever since he was a schoolboy at University College School in North London in the mid-1950s. He says that he became hooked after devouring the only book on the subject. While still a schoolboy, he wrote to Lord Halsey, the chairman of the National Research and Development Council, saying that he was interested in computers. He was interviewed by Halsey himself and Christopher Strachey, then a master at Harrow. They were sufficiently impressed to recommend young Barron to Elliott Automation, for whom he worked in the holidays before going up to Cambridge. After leaving university, he joined Elliott full-time. At that time, the pace in the industry was being set by Digital in the States, who had just launched its PDP8, the world's first mini-computer, which signalled the beginning of the end for the giant mainframe machines that then dominated the industry. Elliott negotiated to manufacture the machine under license and then told Barron to design a better, faster one.

But Barron had other ideas. With the arrogance of youth, he decided that rather than trying to compete with Digital head on, he would develop the next generation. So in 1965 he left Elliott and set up his own company, called Computer Technology, and built a machine called Modular One. 'We were one of the very first computer companies to use integrated circuits and the machine was very fast, cost-effective and easy to configure and test,' he says.[18] It was a research machine intended for universities and research establishments and it took three years to develop. But however brilliant the company might have been technically, it was always short of funds. 'The underlying problem was the financing of the company,' says Barron. 'The idea was to finance in stages of up to £1 million. But just when we were coming to market, Plessey took our business away from us by offering a phantom machine – one that had a similar specification to ours but which they never intended in reality to put on the market. That shook the confidence of the shareholders who refused to put up any more money. Then Digital came out with their modular machine and, starved of investment, we were unable to compete.'

Undaunted, Barron picked himself and started again. After a chance meeting with a American computer scientist called Dr Richard Petritz at a conference in Montreal in the autumn of 1977, the idea was hatched of forming a company called Inmos to make advanced semi-condutors. The following spring, Barron approached NEB with a proposal that they should support Inmos and by July the NEB had agreed to put up £25 million.

The project, which involved building greenfield sites in Wales and in Colorado at great expense, was plainly risky, and there were many who thought it unwise. The National Economic Development Office (Neddy) was worried about the expense and believed that the NEB had rushed into things without consulting widely enough. One person the NEB did consult, however, was Derek Roberts, then head of research at Plessey, who told me:

> The NEB was very disappointed when Plessey pulled out of the proposed joint venture with Ferranti. So when Barron and Petritz came along they were very interested. Petritz came knocking on the door at the right time. I had a call from the NEB to say they had had a greenfield operation put to them. Would I be prepared to look at the business plan and give some advice? I was keen but only half and half. I'm sure there was an opportunity for a greenfield site. I was not convinced by their actual product and market strategy. They were not going to make a go of it with the initial emphasis they were placing on memory in the beginning. It was changing so rapidly it was ludicrous. They were saying that the only competitors were the Americans but in six months the Japanese were dominating the field. It was proposing a very high level of capital investment but also a lot of people. And it seemed to me you could neither afford or need both. You either put in a lot of capital and automation or you were employing a lot of people to do it manually. To have both seemed crazy.

After he had written his report, the NEB asked Roberts if he would be willing to meet Petritz and discuss the proposal with him. When Roberts pressed Petritz about the large number of people he planned to employ in Wales, Petritz replied that to get Tony Benn's [then Secretary of State for Industry] approval, 'you had to demonstrate you were going to be a big employer – which is why they had bumped the number up by a thousand.'

Roberts told Petritz that if the NEB failed to come up with the money, he should go and talk to GEC because 'they've got the money, and, by God, they've got the need.' But the NEB did come up with the money, so the proposition was never put to GEC. Roberts goes on to say that were

at least two other occasions when GEC could have bought Inmos if it had wanted to:

> I remember on one occasion going out to Colorado Springs and looking at their facility and also the outfit in South Wales. Technically it wasn't brilliant, but it was a good project and it would have been a great help. But I think one of the factors that really put Arnold off – apart from the fact that Inmos didn't want to be taken over by GEC – was that a hell of a lot of money would have flown off to Dick Petritz and Arnold didn't like that. He didn't think it had been earned.

Weinstock never attempted to conceal his hostility to the Inmos project.* For his part, Barron describes Weinstock as 'a very malign influence'. Barron only met Weinstock twice. The occasion he remembers best was when he was still in charge at Inmos. Weinstock berated him for wasting public money and was particularly scathing about the Inmos building in Newport, South Wales, which had been designed by Richard Rogers and which, like Rogers's later and more famous Lloyds building in the City, had the air-conditioning on the roof, exposed to the elements. 'Ridiculous,' said Weinstock. 'Not at all,' replied Barron. 'It saves 25 per cent on the rates.'

There was, however, a more fundamental reason for Weinstock's hostility. Unbeknownst to the NEB, GEC had been in talks with the American semi-conductor manufacturer, Fairchild, who, only ten years before, had launched the semi-conductor revolution and spawned dozens of imitators: by the early 1970s twenty-one out of the twenty-three semi-conductor operations in Silicon Valley were what the industry came to call 'Fairchildren'.

Weinstock and his technical director, Bob Clayton, saw the Inmos project, small as it was, as a threat. According to the *Daily Telegraph*, they were worried that the new venture would deprive them and other UK electronics firms of key staff and resources and they were jealous of the fact that Inmos was being given public money, while they had to fund the Fairchild venture from their own resources. There seems to have been a real lack of communication here: the NEB only learnt about the GEC/Fairchild link-up after talks with Inmos were already well under way, while GEC's Bob Clayton said, 'We heard about the Inmos deal when we were in serious discussions with Fairchild,' adding, 'The way the NEB has gone about this is rather odd.'[19] What particularly upset GEC

*Weinstock did not have much time for the NEB either. When consultants conducting a survey for the NEB on the state of the British electronics industry sent Weinstock a questionnaire, he replied, 'I see you have some extremely expensive embossed notepaper.'

was the realization that both ventures were aiming at exactly the same market: the high-volume, best-selling memory chip business. And although Inmos was most unlikely to be in business before the Anglo-American venture, it would be in direct competition. Behind the scenes, GEC pulled strings and did its best to undermine Inmos. According to Stephen Dawson, Weinstock was extremely negative about Inmos and there was, he says, a lot of political lobbying to kill it. In his view, the announcement of a joint deal with Fairchild, accompanied by a promise of a £10 million factory in the Wirral, was designed by GEC as a classic spoiling tactic to demonstrate that 'We don't need Inmos.'[20]

There might be a grain of truth in this. But it is also an exaggeration of GEC's role and of Inmos's importance. As far as GEC was concerned, its joint venture with Fairchild was, without doubt, potentially the most important semi-conductor development since the collapse of the Mullard/Philips deal a few years earlier. By 1978, Fairchild was no longer the leader of the American semi-conductor band. Its founders had left and there were those, like Derek Roberts, who believed its choice of bi-polar technology was ill-advised. It had only switched to making the industry-standard metal oxide silicon (MOS) products a couple of years earlier and was thought to be lagging behind its American and Japanese competitors.

'I personally did not believe that GEC should get involved in the mass production end of the chip business,' says Martin Jay, who was on the board of the GEC/Fairchild joint venture company. 'I thought there were other companies in America and Japan that were better suited. But even so, Fairchild was a very significant player in the early days and Weinstock had an excellent relationship with Fairchild's Corrigan. It did look quite exciting and it was the only time, in my view, that GEC could have acquired a significant presence in the IT world.'

GEC was hopeful that, with Fairchild behind it, the company could break into European and American markets for the first time. As GEC's Bob Clayton acknowledged, the key to success would be marketing. 'We have always considered that we should start with a marketing force, which both companies have in Europe,' he told the *Financial Times*.[21] Briefed by Clayton, the paper observed that:

Volume production means securing very large markets – hence the stress on marketing. That means that GEC-Fairchild must sell in Europe as well as the UK, and will probably have to sell in the US as well, since it represents by far the largest market – and is likely to continue to do so.

GEC is making the assumption – or bet – that there will be several new markets in Britain and Europe chip-hungry in a year

or two. They will be the automobile industry, telecommunications, computers and, increasingly, consumer electronics, including television and washing machines.

The decision to set up the factory in the Wirral means, the *Financial Times* said, 'that the UK follows the US and Japan into volume production of micro-processors and micro-computer memories.' The paper headlined its story 'GEC-Fairchild plans to become king of Silicon Island' and it forecast that, when coupled with the NEB scheme, 'the project could put the UK in the lead among European countries in the new technology.'

Sadly, these hopes were never fulfilled. At the same time, despite strong backing from the NEB, which ended up investing a fraction over £65 million in the company, Inmos continued to promise more than it actually delivered. At its peak in 1984, it had total sales of $160 million, while Japan's NEC, by this time the world's number two, had global sales of $2.2 billion. Not only did Inmos fail to make more than a tiny dent in a Japanese-dominated market for memory chips, but Iann Barron's revolutionary transputer, which had been designed to be used in the 'parallel computers' that many experts believed to be the next major step in computing technology, made its appearance at the very moment when the market for semi-conductors was about to collapse. In its five years as an independent company (before its sale to Thorn-EMI in 1984 for £125 million) it made total losses of £56 million.*

Inmos would probably have failed anyway, but its demise was hastened by the reluctance of Keith Joseph, the trade and industry secretary of the new Thatcher-led Conservative government, to release tranches of government funding which had already been promised. 'They froze Inmos's money,' says Stephen Dawson. [The NEB aroused fierce emotions in the breast of Joseph, who was a free market ideologue – none of them kind. On ministerial visits to NEB-backed companies, he used to throw down a 2p coin, saying, 'There! That's what the NEB's worth.']

Today, Barron lives in a stately pile called Barrow Court, a dozen or so miles ouside Bristol. The main house with its twin gables was heavily remodelled by the Victorians, but parts, which include a former nunnery and a church, date back to the fifteenth century. Barron's office has mullioned windows with a knight in armour guarding the doorway. The only concession to the twentieth century is a computer on the desk and, on the day I saw him, Barron appeared to be alone in a house which has at least ten bedrooms in the wing he himself occupies. The rest is rented

*In 1989, Inmos changed hands again when it was sold by Thorn-EMI to SGS-Thomson, the Italo/French electronics company.

out as flats. The place struck me as a kind of British San Simeon, a setting for success, but without the success. If Inmos had fulfilled its founders' dreams, it would have been a spectacular setting for a British computer tycoon. As it is, Barron is disappointed but philosophical: 'When I started Inmos, the Japanese were not a major force in the chip business. To succeed in this business what we needed, unfortunately, was a lot of money, an adequate product, and then – to back it up – sheer determination to make it successful.'

Inmos was not the only disappointment. Within eighteen months of its launch, GEC's alliance with Fairchild had collapsed. The French company, Schlumberger, which had bought Fairchild in the interim, decided it no longer wished to continue. With the ending of what turned out to be GEC's last serious foray into the semi-conductor business, the new factory in the Wirral was, ironically, turned over to making torpedoes – a case of beating ploughshares into swords, perhaps. As Derek Roberts who had just joined GEC from Plessey recalls:

Arnold was bitterly disappointed. He felt he had really been let down. It was assumed in the press at the time that it was GEC that had had cold feet and didn't want to make the investment. That was not the case. At that time he did not have a lot to do with me but he phoned me and said that the Schlumberger thing is all off. So I said it was a pity, but in one sense it was a relief because personally I never believed it would be a total success. Fairchild were at that time probably the world's number one bi-polar company. And the deal did not cover bi-polar. It covered the very technology that Fairchild were not great at.

In luring Roberts away from Plessey, Weinstock had acquired one of the most distinguished and knowledgeable research scientists in the country. Roberts was a Plessey man through and through. He had joined at the age of twenty-one, straight from Manchester University – 'our baby scientist' Michael Clark of Plessey called him – and was put straight to work in the company's main research laboratory at Caswell. During most of the twenty-five years he worked for Plessey, Roberts was a tireless (but not always successful) advocate of the silicon chip. As the man in charge of semi-conductor research, he was sceptical of the company's use of germanium chips; and he pressed for a link with the Bell Laboratories mafia a good dozen years before GEC struck its deal with Bell's graduates at Fairchild. Eventually, frustrated by the shortage of money for research and by John Clark's autocratic yet indecisive style of management, Roberts left Plessey for GEC. He arrived just as the Fairchild deal was falling apart. 'I'm sick and tired of our future being in the hands of

outsiders. It's your job to ensure that I'm not put in that position again,' Weinstock told him. 'That's fine by me. But it's going to be expensive,' Roberts replied. 'How much?' asked Weinstock. 'I would like half an hour to think about that.'

Roberts was wise to duck the question, for what he eventually said was brutally frank. 'What we've got is so pathetic that we need a few million instantly to create a new research facility and then we need to increase the ongoing R&D by a factor of ten.' Weinstock simply replied, 'Okay, Get on with it.'

From then on, Roberts says, he saw Weinstock frequently and is quick to defend him against the often-made charge that he skimped on R&D.

In the 10 years I was there, I attended 90 per cent of all budget meetings – about 500 in all. I can only think of one meeting when his immediate attitude when presented with the figures was to say, 'I do not accept that high level of R&D in the budget.' On that occasion, Weinstock explained to the managing director that he had turned him down because the increase over the previous year was so large that he thought he didn't know what he was doing and suggested he talked it over with me.

I said, 'I think I can save you time. We have discussed it; I think they know what they are doing and it's a well-conceived programme.'

He said, 'All right.'

Sometimes, as with the medical equipment business, it worked the other way around. When I saw the budget, I immediately went to see the MD and said, 'You are destroying the business. You are proposing to cut the R&D next year.'

'Business is difficult and I have to give him the profits,' he replied.

'Who says so?'

'Arnold.'

'Well then, let him do the dirty work.'

He went ahead anyway. I said he would destroy the business and took it to Arnold, who asked the man if this was right. There was a lot of shuffling of feet. Eventually he said, 'Well, I have to preserve the profits.'

To which Arnold replied, 'I'll squeeze you on costs but it's not for you to destroy the business. Put it back.'

Martin Jay is more critical of Weinstock's attitude to R&D:

Weinstock's proud boast used to be that he had never stopped a development project. That may well have been true. But what he

did stop was the fact that next year's margins were going to be lower than this year's margins because the R&D cost had gone up. What he was saying was, 'Of course, Martin, you can spend 10 per cent of sales on R&D, but you have to ensure that your profit as a percentage of sales is better this year than it was last year.' There's no way of squaring that circle. You can't do it. So what we actually did all the time was to cut back on R&D to a level that enabled you to achieve the profit margins.

All the expansion of the R&D effort took place in the early Roberts years. Arnold was enormously under the influence of Derek and Derek was jolly impressive, I always found. He argued his position magnificently. He was put in charge of the Hirst Research Centre and was given a very large budget. And in the first year or two he was allowed to get on and spend it.[22]

In obtaining Weinstock's sanction to spend some of GEC's mounting cash pile on semi-conductor research and development, Roberts won a battle but he lost the war. For all his instinctive caution, Weinstock was more than half-convinced that GEC needed to be strong in semi-conductors. And against his better judgement, Weinstock decided to give Roberts his head – at least for the time being. Roberts says:

I don't wish to sound arrogant. But I persuaded him. I did substantially turn it round. First of all, by getting him to put, by the GEC standards of the time, a lot of money into R&D, to put money into the Lincoln semi-conductor factory and to build a new manufacturing facility. I did this despite a good deal of opposition from people. But Arnold was always nervous. He backed me for two or three years to get it going, but he always had the feeling that money was made in the operating units and it's not for the head office to spend what the rest of the company is making. And that's why he doesn't like the lavish corporate-style fountains in the foyer and all that sort of stuff. But that also means he doesn't like corporate R&D. He likes the decisions to be made by the operating companies who have to apply it and have to generate the money. So while he was quite willing to ignore that lot completely for a time, after about three years or so, he said, 'Now we are going to look at this the way I normally like to look at these things.'

In 1985/86, GEC suffered an embarrassing setback. In its centenary year, during which the Queen Mother paid a ceremonial visit to an exhibition at the Wembley conference centre whose theme was 'GEC: A National Asset for 100 Years', profits fell for the first time in seventeen

years. Although the drop was comparatively small (down £25 million to just over £700 million) and the cash reserves undiminished at over £1,300 million, Weinstock began to have second thoughts about the Roberts initiative. Martin Jay describes the results:

> He began to become more and more worried that what had actually happened was that he had set up the one thing that totally terrified him: an ivory tower research operation that would spend money and wasn't commercially driven. So he tried to change the system, with Derek Roberts doing lots of wonderful research in the centre but having the likes of me as the MD of a subsidiary picking up the tab. And, of course, in the main, this was something I was not prepared to do. I *was* prepared to pick up the tab for something which would lead to a profit in the short-term. If it had been necessary for me to reduce my profits by, say, half a million pounds a year, in order to be reasonably certain of increasing it by two million pounds the next year, now that would have been something that would have interested me. I would probably have gone for that: particularly if I could have concealed the fact that I was doing it, which is the other game that we all played.

The opposition of the managing directors to the Roberts plan was to prove fatal. 'The difficulty I always had was that I never believed that that rate of spend on R&D was like GEC. It was contrary to the culture,' says Martin Jay, who was on the group management board.

> I remember sitting on the sixth floor one evening discussing this decision to spend this amount of money – £60 million I think it was – to get into this VLSI (Very Large Scale Integration) stuff.* It was all being done at the Hirst laboratories. I can remember opposing it on the grounds that this was not a project that GEC would simply see through to the end. I didn't say it was wrong to do it. But I said it was not part of our culture. We would spend half or two-thirds of the money needed and not get the benefit. The managers, including Bob Clayton, thought that rather than spend the money and take the risk, it would be cheaper and easier to buy from the Americans.

If Roberts had had his way, all semi-conductor operations would have been concentrated at Marconi. But for that to have happened it needed the active support of the managing director. Roberts says that as long as Arthur Walsh had that job, things looked reasonably bright.

*It was this technology that was the main thrust of the Alvey programme, see p. 162.

Arthur and I were on the same wavelength. He was something of a buccaneer. He was very relaxed I was spending all this corporate money and feeding it into his factory. But once Arthur left and Ian MacBean took over, things changed. He was a super guy, but in this particular context he was a more cautious individual who didn't really understand the semi-conductor business and was nervous to see this high level of investment going in. He was also less inclined to stand up to Arnold. So if Arnold said to Walsh, 'It's your business but I don't think we are going to invest any more.' Walsh would reply, 'Yes, we bloody well are.' But when Arnold said the same to Ian MacBean, he would say, 'Yes, sir,' and we wouldn't invest any more. And that was the difference. I was fighting a rearguard position. I was in a weak position because, in the last analysis, power lies with the operating companies. That's not a criticism. It's a way of running the company. I didn't leave GEC with any sense of anger or anything of the kind and I stayed on the board for five years after I left.'*

With at least one third of their R&D paid for by the Ministry of Defence, the Marconi managers were under less pressure from Weinstock than most. Over the sixteen years he was in charge at Chelmsford, Bob Telford told me that he had devised a system whereby one third of the R&D at the Great Baddow research laboratories was 'sponsored' by the customer, one third was initiated and funded by the laboratory itself and one third was raised by means of a levy on the operating companies. It was this last item, he says, that was unpopular with Stanhope Gate – and, of course, the operating companies. Telford explained that the reason Weinstock hated it so much was that it went against his belief that each company ought to be totally autonomous and wholly accountable. He said that Weinstock carried this principle to such an extreme that he opposed the idea of a single phone system for the Marconi group of companies. 'If Arnold had had his way,' he said, everybody would have had their own telephone system.'

In 1982, the Government made one last despairing attempt to recover lost ground. Kenneth Baker, the newly appointed minister for information technology, appointed a committee, headed by John Alvey, a former government Chief Scientist and director of technology at British Telecom, to orchestrate a response to the challenge of Japan's 'Fifth Generation' computers which would, it was widely believed, utterly transform the IT

*In June 1988, Derek Roberts resigned as Joint Deputy Managing Director (Technical) following his appointment as Provost of University College, London. He remained on the GEC board as a non-executive until 1993.

industry by rendering existing machines obsolete. The result was the grandly named Alvey Programme for Advanced Information Technology, and was launched with great fanfare in 1983. With a total budget of £350 million, of which two thirds came from government, it was the largest single public initiative of the 1980s. What is more, it was initiated by a government instinctively hostile to any form of state sponsorship or intervention in the private sector. Its aim was 'to bolster the academic and industrial science and technology base, transfer academic know-how into industry, and enhance the competitive potential of the sector'.[23]

By concentrating on very large, application-specific chips (ASICs), the semi-conductor part of the programme was intended to help British firms catch up with the runaway Americans and, especially, the Japanese. But although GEC was willing to help by lending its executives to staff the project and although it was the largest recipient of Alvey money (some £22 million in all), it never had much faith in the exercise itself. As Jack Pateman of GEC Avionics said to me:

I've always been very much opposed to projects like the Alvey project. So when you set up something like Alvey, the first thing that happens is that all the companies' research departments rush about asking, 'What can we do to get money from this programme?' Now, the one certain thing with a government programme is that you agree with the government scientist on what should be done. Unfortunately, government scientists, however excellent they might be in many respects, are not in the commercial business. The way they look at it is to ask, 'What would be fun to develop?'. And all the research directors agree and say, 'Let's have a few million quid and we'll start work on it.' The net result is the programme's useless. It doesn't actually address the commercial requirements.

Alvey was an almost total failure in that none of the 200 projects in which industry joined hands with academia led to anything tangible. From the start, relations between the academics and the industrialists were poor. And by giving the big industrial firms like GEC and Plessey, which dominated the committees, an effective veto on the research projects, the government virtually guaranteed that nothing useful would emerge. As the author of a long and thoughtful piece in the *Times Higher Educational Supplement* pointed out, the Alvey playing field was tilted in favour of the very people who had created the problem in the first place. Commenting on Alvey's insistence that no project should go ahead without the support of an industrial 'godfather', Piers Burnett wrote:

In effect, both academics and the small entrepreneurial firms which make up the most adventurous sector of the IT industry find themselves competing for the support of the big companies. Some critics feel that such an arrangement offers the major firms a temptation which must be almost irresistible: they are, in effect, being handed the *de facto* control of the entire British IT programme.[24]

Instead of moving forward, the industry went backwards.'We should have cancelled all those projects and faced the political row,' says Brian Oakley, who was seconded from his post as Deputy Secretary at the Department of Trade and Industry to become the director of the Alvey Programme. A study by the Science Policy Research Unit at Sussex University goes further, describing Alvey's demonstrable failure to enhance competitiveness as 'a major disappointment'.[25] 'All the major indicators of performance,' SPRU said, 'show declining competitive performance of the UK IT sector over the lifetime of the programme; market shares declined and major firms passed wholly or partially into foreign ownership.' The authors were particularly critical of the firms' reluctance to co-operate with each other.

With hindsight it now looks naïve to have even contemplated a programme which could have resulted in a common fabrication facility for a large number of firms small by world standards. For most of the participants their commercial survival as independent units depended on product differentiation, which in turn stemmed largely from the idiosyncrasies of their fabrication technologies. This was the major reason why the firms fought so hard at the beginning of the programme to have their own Whole Process projects.

While Brian Oakley shares SPRU's disappointment at Alvey's lack of success, he is also outspoken about Weinstock's attitude to Alvey in particular and IT in general. According to Oakley, 'Weinstock believed that the government was daft to invest money in something like Alvey, but if they were going to be so bloody foolish, he was going to get the lion's share of it.' Oakley went on:

I despair at the way the UK has thrown away all its advantages in the IT field and its failure to make capital investments. With that body of skilled manpower, Weinstock should bear some measure of responsibility. What he has done has been to lock up skilled manpower who fooled themselves that one day he would exploit their skill. But he never did. Even so, I don't entirely blame him.

His object is to maximize the return to shareholders. That what it says in company law. But unfortunately, there's nothing about serving the greater good of the UK. I must say, I'm very torn. In my charitable moments, I think he had no real alternative. But mostly, I think it's a tragedy.[26]

In 1987, four years after Alvey had been closed down and a year before Derek Robert's resignation, GEC finally withdrew from semiconductor manufacture (apart from some specialist military work). It marked the effective end of any ambition Britain might have had to play a meaningful part in the most dynamic technological development of the second half of the century.

There was never any real hope that GEC would catch up with the Americans or the Japanese, but Europe was a rather different story. And here GEC's withdrawal left the field open to Siemens in Germany, to Philips in Holland and to Thomson in France. Though the decision attracted nothing like the same attention, it was, in its way, as much of a defining moment in the long story of the decline of British manufacturing as British Aerospace's decision in January 1994 to sell what remained of British Leyland to BMW.

In 1988, the management consultants McKinsey, who twenty years earlier had suffered the lash of Weinstock's sarcasm, delivered their own verdict on GEC. In a devastating report on the performance of the UK electronics industry commissioned by the industry's 'Little Neddy', the consultants highlighted the extent to which British firms had lost ground to the Americans and the Japanese over the previous ten years and, in a clear reference to GEC, put much of the blame on their decision to focus on the defence industry:

> Increasing concentration on defence and telecom was, for some companies, a conscious strategy to maintain relatively high financial returns provided by these 'protected' sectors. In other cases, the increased concentration was more the result of a failure to build a viable competitive position in the other major electronic sectors.[27]

The consultants found that not only were UK companies overdependent on domestic sales, but over the previous ten years their share of their own home market had fallen from almost half to less than one third. In seeking to explain this decline, McKinsey, in another unmistakable reference to GEC, highlighted the disadvantages of a decentralized management style.

> In terms of organizational evolution, many UK electronics companies have structures and management processes which were 'state

of the art' for the management of diversified portfolios in the late 1960s and early 1970s, but which have worked against the development of successful international businesses. Each have lean corporate centres primarily playing the role of a financial holding company, monitoring financial performance tightly but providing very limited planning and strategy formulation support.

These organizational structures and processes are an obstacle to growth in global markets. Decentralization to small units has limited the scale of ambition to that of the units rather than the company as a whole. 'Numbers-driven' rather than 'issue-driven' planning has reinforced a focus on shorter-term results rather than long-term investment to create major new businesses. The limited role of the centre in many UK companies has meant that the potential synergies and scale benefits of a large company – in creating a customer franchise, in producer development and in attracting and developing highly talented management – have not been achieved.

It is a formidable indictment. But looking back, Kenneth Bond does not see how GEC could have behaved any differently. He says:

The thing is that, unless you have something that no-one else has, in the near-genius category with your own niche, you are competing with very big people in the same game. They have existing products with margins. The amount of money Philips and Siemens were spending was absolutely enormous – and the Americans. One was having to swim very strongly against the tide. The fact is it was never going to be a success. It couldn't be. You see, you are going to have to work jolly hard to get up to where people are at the moment. Those people are already a couple of laps ahead. And that's one of the problems. It's not just a question of getting there. You have got to be ahead of them to succeed.[28]

As a summary of the reasons why, after much debate and hesitation, GEC backed away from semi-conductors, Bond's analysis carries conviction. But at the same time his comments demonstrate both an aversion to risk and a failure to understand the dynamics of the IT business which, when taken together, go a long way to explaining why GEC has had so little impact on what is probably the defining industry of the second half of this century.

EIGHT

CASH IS KING

Whatever the traumas of the consumer goods division and the frustrations of the semi-conductor saga, elsewhere the benefits of four years of cutting, pruning and reshaping were beginning to show through by 1976, and GEC was being hailed as a brilliant financial success. After a tour of some of the manufacturing subsidiaries, one of Weinstock's most uncritical admirers, Keith Richardson of the *Sunday Times*, described GEC as 'Britain's most successful large engineering company' and observed: 'The business is becoming steadily more lucrative.'[1] The *Investors Chronicle* was equally impressed. Measuring the company by Weinstock's own yardsticks, it noted that such key indicators as return on assets, profit margins, stock turnover, debtor turnover, cash flow and borrowings all showed that the company had been transformed.[2] But while the tone of the *Investors Chronicle* piece was favourable ('We think the shares could prove a very good investment at their present level'), it achieved what a friend of mine calls 'a scoop of interpretation' by being the first to draw attention to a phenomenon that was to become famous, not to say notorious: Arnold Weinstock's cash mountain.

At the time of the mergers, GEC had a negative cash balance and was clearly collecting its debts too slowly – debtors exceeded creditors by more than £100 million. Six years later, the company's credit control had obviously become more aggressive and had improved its suppliers' terms – debtors were £417 million but creditors were £455 million. The sizeable overdrafts inherited from AEI and English Electric had disappeared as Bond and Weinstock sold off surplus assets and waged war against waste.

However hard the 1970s might have been for British industry as whole, for GEC they were good times – or so it seemed. The company's turnover, based on current prices, increased by 382 per cent – up from £965 million to £3,683 million. However, when adjusted for inflation, the achievement looks a good deal less impressive. Using the index of wholesale prices of electrical engineering goods (not a perfect measure but

better than the retail price index), John Williams has calculated that in real terms GEC's output rose by only 13 per cent. Within that overall figure, the winners were electronics, automation and telecoms – up one third – while the losers were industrial products like diesels, electric motors and lifts – down one fifth.[3]

What is not open to dispute is the fact that throughout the 1970s GEC became steadily more and more productive: profit more than doubled as a proportion of total turnover and nearly trebled as a proportion of capital employed. Turnover per UK employee rose four and a half times over the same period. For the shareholders, the Weinstock style of management yielded rich (or at least moderately good) dividends: in ten years earnings per share rose seven times – from 7.25p in 1970/71 to 54.5p in 1980/81, while the dividend per share rose more than fourfold – from 3.3p to 14.6p.

From the late 1970s onwards, however, the shadow of GEC's growing cash mountain began to obscure Weinstock's once bright and shining reputation as the saviour of British industry. As GEC's creditors took the strain, the company moved from being cash-hungry to being cash-rich, and with managers responding to Weinstock's ceaseless nagging to squeeze more money out of the businesses, the cash mountain started to grow. In March 1972, the company's net cash balance was £51 million; by 1976, when the *Investors Chronicle* rang the bell, it had risen to £250 million; and ten years later the figure had topped the billion pound mark.

This mountain grew to be so large that GEC effectively ceased to be simply and solely a manufacturing company. As the 1970s came to an end, the heaped-up pile of gold was starting to make a significant contribution to the company's pre-tax profits. From 1977 onwards, so Williams has calculated, the net income from GEC's cash reserve regularly amounted to over 10 per cent of the company's total pre-tax profits; rising in some years to close to 15 per cent.[4] And, despite the dividends, shareholders began to wonder whether they had invested their money in a manufacturing company or in a bank.

The one group that did not share in this bonanza, however, were GEC's own employees, whose wages and salaries fell slightly as a proportion of turnover. This disparity between the rewards for the shareholders and those for the GEC workers is even more marked when one considers the employment picture. At the time of the Woolwich closure, Weinstock defended his decision to axe 5,500 people by arguing that the resulting increase in the efficiency of the group as a whole would create job opportunities elsewhere. His optimism was, unfortunately, unfounded. Far from being the standard-bearer of the new 'sunrise' industries, which Mrs Thatcher saw as the engine of a revitalized Britain, GEC came to be a symbol for the decline of traditional British manufacturing industry.

Between 1967 and 1980 the numbers employed by the businesses which made up new GEC fell from 265,000 to 145,000.

There were those, of course, who saw these cutbacks as wholly beneficial: evidence that at last there was somebody strong enough and determined enough to confront union power and over-manning head-on. In carrying out the post-merger rationalization programme, it could be said that Weinstock was well ahead of his time in implementing a Thatcherite agenda a good ten years before the arrival of Mrs Thatcher herself. Certainly when Mrs Thatcher did come to power in 1979, Weinstock was thought of by No. 10 as 'one of us'. For his part, Weinstock welcomed the pro-business stance of the incoming government and in memos to his staff celebrated the end of the Callaghan government's experiment in controlling inflation by means of a national incomes policy. On 12 July 1979, he wrote: 'Now that there is no need to resort to subterfuge to do what is in any case unavoidable, wages and salaries should be settled and defined in a straightforward and normal way. We will then recognize what we are paying for, and the recipients will know what they are going to get.'[5] Two days later he returned to the theme. 'You will no doubt have found the budget proposals quite exhilarating, or at least you would if you were being paid properly,' he wrote. 'The depressing argument about tax being a bar to increased effort and efficiency is now removed. Incentive has been restored to your staffs – now let them render the results unto the Company.' The following year, the new government decided to send Weinstock to the House of Lords, where he took his title from the name of his country seat, becoming Lord Weinstock of Bowden. The relationship between the new peer and the new prime minister began warmly but it soon become rather chilly. According to Lord Carrington: 'She never took against him, but she got new favourites, so he became less of a favourite.'[6]

That is probably putting it a little too kindly. From the beginning, Weinstock had little enthusiasm for the more dogmatic aspects of Thatcherism and had no time at all for the brand of monetarism conceived by Mrs Thatcher's guru, Sir Keith Joseph, and implemented by her Chancellor, Sir Geoffrey Howe. In a little-noticed speech in the House of Lords in Novermber 1981, Weinstock launched a scathing attack on the new fashion in economic thinking. 'It is probably too much to expect efficiency in public administration,' he said, 'but it is ridiculous to abrogate common sense in favour of a Treasury-dominated regime constructed around arbitrarily contrived statistics.' He continued, 'No one contends that money supply should not be controlled, even if few of us really believe it to be possible to identify exactly what that means. But the narrow system of cash limits, as applied, is too restrictive to permit departments of state and the nationalized industries to function even as

efficiently as they could. The result of this way of doing things is to stultify good ideas and initiative and to slow down the whole adminstrative and managerial process.' Later in the speech, in a remarkable passage that anticipated future debate, he set his face against the prevailing orthodoxy and argued that it might be better and less inflationary to stimulate demand rather than spending the money on the dole queues.[7]

Official honours in Britain often come too late and are often given for the wrong reasons. The irony of Weinstock's elevation to the peerage in 1980 was that it came at a time when his company was beginning to run out of steam. By the mid-1970s, when all the dead wood had been chopped out and carted away, it might have been expected that shoots would spring from the newly tilled ground and that GEC would begin to grow again. In fact, the reverse was the case. As John Williams observes:

> The basic fact is that GEC went into the 1980s employing substantially fewer people in the UK than it had employed in 1970. In the British context, the single most worrying aspect of GEC's performance is the decline in the overall size of the labour force. In our 'most successful' manufacturing company, employment actually declined faster than in the manufacturing sector as a whole, which seems to contradict the doctrines of Thatcherism as an economic faith.[8]

By the beginning of the 1980s, it was clear that the company had gone ex-growth. An analysis of GEC's sales and profit records by the Monopolies Commission investigating the second Plessey bid (see chapter nine) shows that in the ten years between 1979 and 1988, GEC's sales, when adjusted for inflation, grew by no more than one per cent a year and that operating profits, similarly adjusted, actually fell from £660 million to £561 million. What is more, a breakdown of the component parts of the business over the five years to 1988 indicates that, although the defence sales, when measured in current prices, continued to grow, sales of telecommunications and information technology equipment were on a plateau and, in real terms, actually losing ground.[9] In a book published in 1987, two academics from the London Business School, Michael Goold and Andrew Campell, compared the performance and management styles of various types of diversified companies. They put GEC in what they called the 'Financial Control group' (i.e. those driven by numbers) and noted:

> The financial performance of GEC has not matched that of other Financial Control companies.* It has delivered excellent profitabil-

*Other members of the same group were BTR, Ferranti, Hanson Trust and Tarmac.

ity ratios – return on sales, return on equity and return on capital – but a poor growth performance. Share price growth, earnings per share growth and sales growth have barely matched inflation, and on each measure it is among the bottom performers in the sample.[10]

When asked to justify his cash mountain, Weinstock has tended to brush the question aside. He has argued that his concern was with the individual trees – the operating divisions of GEC – and that, if they were taken care of, then the forest – the company as a whole – would look after itself. As he saw it, the generation of cash was not an object in itself but a by-product of good corporate husbandry. It is an attractive simile and an elegant explanation, but it is one that is open to other interpretations. The *Investor's Chronicle* made a telling point when it said:

> Forget the turnover in thousands of millions, forget products ranging from hair dryers to nuclear power station equipment. Strip GEC down to its components and the management outlook is close to that of a family business – a well-run family business, but a family business all the same. Sir Arnold husbands GEC's resources as if they were his own.[11]

David Lewis, one of Weinstock's closest friends and a member of the small group that created the new GEC, makes almost exactly the same point. When I went to see Lewis in the spring of 1996, I asked him if in the course of twenty-five years or so he had ever had a disagreement with Arnold Weinstock. He hesitated for a long time before answering and then he said, 'Yes, there was one. It was relating to the dividend. I always took the view that it was a good thing to build up the capital base but there must be a suitable object. To build it up for its own sake was not a suitable object.'

'The cash mountain, you mean?' I asked.

'In effect, yes. I took the view that the dividends were being held much too low. I preached this in the last years before I retired. But Arnold saw this [the cash mountain] as part of the power of GEC – and when asked, "What about the shareholders?" he would reply, "The shareholders? Who are they?"* I think the attitude was – the more we have, the bigger we are. That sort of thing. There was a bit of a miser in him.'

'But why was he so reluctant so spend it?' I persisted.

'In the first instance, we were prevented from buying by the Monopolies Commission. So the possibility of buying anything substantial

*Weinstock's attitude to shareholders has always been robust. At one annual general meeting, annoyed by persistent questioning, he told one shareholder to sit down and shut up.

in England had gone by the board.* We weren't then a really international company. We did buy one or two things – we bought Picker, another one in America.† But they were relatively small in relation to the money we had acquired. I wasn't against building the mountain. But it was just over-done – bearing in mind the history of it and how it had grown and grown and grown. The attitude has changed a lot now. That I think was the only area of importance that created a difficulty. Let's put it this way: with Arnold's way, you couldn't make a mistake. The money would be there if it was needed. Temperamentally, Arnold plays safe. He is not a gambler. He may have horses. But he is not a gambler. It was all talked around but nothing happened.'

While little was done to reduce the cash mountain, it would be wrong to suggest that King Arnold spent all his time in his counting house. As the 1970s drew to a close, he began, albeit somewhat tentatively, to search for new growth areas. In particular, he was looking for companies in Britain and in the States which were well established in promising markets but which needed the cash and the technical expertise that GEC could offer. In A.B. Dick of Chicago Weinstock thought that he had found a suitable launching pad for his entry into the fast-growing office equipment market – an area in which competitors like Philips, ITT, Olivetti and Siemens were all very active. Not only did A.B. Dick have a good track record with its copiers and other traditional office machinery, but it had developed a new ink-jet printing system, which had been taken up by IBM, and had just launched its own word processor.

The company was, however, earning very poor returns, was short of good, professional management and was in need of cash. In 1977 it had made a loss. To Robert Telford of Marconi who negotiated the £52 million deal, the beauty of the link-up with the Chicago company was that it would allow Marconi's research scientists the chance to show what they could do in an area that had nothing to do with defence. It also gave GEC the opportunity to become a player in the global information technology business.[12] The man chosen to lead the project was Geoffrey Cross, who had been hired the year before when he left ICL, the UK computer company in which GEC had a stake, to return to California.

What was lacking in the GEC/Dick liaison was a computer dimension.

*This must be a reference to GEC's first attempt to buy Plessey in 1985, which was rejected by the Monopolies Commission.

†GEC bought Cincinnati Electronic Corporation in 1985.

The personal desktop computer revolution was just beginning. And in the minds of Marconi's computer people, the purchase of A.B. Dick in October 1978 revived a long-cherished but unrealized dream: the building of a multi-purpose computer that would serve both civil and military needs. As noted, Weinstock himself had never shown much affinity for or understanding of computers.* Back in 1967, shortly after the AEI takeover but before the English Electric deal, Weinstock was on the point of selling all GEC's computer activities to Elliott Automation and was only stopped when one his senior executives, Joe Wiltshire, got wind of what was going on and told Weinstock that he was crazy. Weinstock may have backed down on that occasion, but computers were never a project with which he was comfortable. Peter Gillibrand, his long-serving press officer who came to GEC from AEI and stayed for twenty-five years, recalls an episode just after the English Electric merger. 'The one thing everybody wanted to ask was what was GEC going to do about English Electric's computer operations,' he says. A press conference was called to announce the GEC takeover, but Weinstock told Gillibrand that he wasn't going to attend and that Gillibrand should field the questions himself. Knowing better than to argue, Gillibrand reconciled himself to a searching examination on a subject he knew absolutely nothing about. When, at the very last moment, Weinstock turned up, one of the first questions he was asked was what was he going to do about computers. 'I'm going to do what's necessary,' he replied. And that, says Gillibrand, was all that he would say.

One of Weinstock's more eccentric decisions was to appoint David Lewis, the company's solicitor and one of his most trusted allies, to look after GEC's own in-house computer requirements. Lewis had many qualities, but, as he admits himself, a knowledge of computers was not one of them.

> We were having lunch after a board meeting and it was said we
> have got computers all over the place and managers here there and
> everywhere and we don't know what they are doing. It was agreed
> that somebody has got to be in charge of that. And somebody said,
> 'You read mathematics: why don't we put you in charge of comput-
> ers?' I took this very seriously and went off on a fortnight's course.

*In a memo dated 10 September 1984 to his managing directors, Weinstock recommended that all managers should use a computer called Dragon on the grounds that it was sold through the company's Hotpoint outlets. Among the large number of small home computers on offer in the early 1980s, Dragon had always been one of the weakest contenders and in May 1984 it called in the receivers. When the bankrupt company was later put up for sale, there were only three bidders: America's Tandy Corporation, a government-backed Spanish concern called Eurohard SA, which had been formed to promote industrial development in Extremadura, one of the poorest parts of Spain, and GEC. The prize, such as it was, went to Eurohard.

But I never was an expert and the managers had to come to me for authority to buy the systems.[13]

Lewis also tells the story of how he overheard two managers talking about him. One said, 'He'll tell you to talk in plain English, not use any jargon, how he doesn't understand anything about it. But don't believe him, he knows everything.' What this story illustrates, if anything, is Weinstock's faith in general managers and his ingrained distrust of technicians and boffins.

Prior to the A.B. Dick acquisition, the nearest the company had come to producing an all-purpose computer was a plan hatched by Marconi's Bob Telford and Ferranti's Derek Allen-Jones to combine the two companies' computer activities to produce what was, in effect, an upgrade of the old Elliott 803 machine, which was still in service at the RAF's Fylingdale's air defence station in Yorkshire. But the plan needed government money and this was never forthcoming. So nothing happened.

With the purchase of A.B. Dick, the idea resurfaced. At the American company's research laboratories in Phoenix, Arizona, work started on what was code-named the 'R' machine, later known as the Series 63. There was a lot of excitement, and the project was adopted by Alvey. To save money, it was decided that the British would make the software while the Americans would design the hardware: together they would produce something that was faster and more flexible than the machines GEC had made years ago for the Science Research Council. But, again, everybody was frightened by the cost and, according to GEC sources, the machine never got off the ground.

In addition, there was a gap between the company's view of the project – Alvey regarded the computer as a prototype in a long-running research project – and that of the scientific community, which expected a finished machine. In the end, only ten machines were built and the hopes that A.B. Dick would become the platform for GEC's assault on the fast-growing information technology market faded away. Someone who was close to the project but who wishes to remain anonymous wonders if a computer project of this kind could have ever flourished under the GEC style of management with its tight financial controls (see Chapter 7). More, he argues, should have been spent on both seed corn investment, and, most emphatically, on marketing. Even so, he finds it hard to be dogmatic about the decision not to press on. 'Half of me says it was the right thing to do: the other that huge opportunities were wasted.'[14]

The story of 'the computer that never was' has its counterpart in the tale of 'the disappearing smartcard'. Here, too, a failure to carry through and a reluctance to spend money on development and marketing were key elements. And here again the main players were the research scientists at

Marconi. The story starts in the early 1970s with a company called Revenue Systems, which was founded by a man called Bernard Hunn. He had come up the idea of configuring the magnetic strip on a credit card in such a way that it could be 'decremented', as the boffins called it. In other words, instead of just being a passive carrier of coded information, the data on strip could be altered in such a way as to record credits and debits. It was not unlike the present-day phonecard but more versatile and sophisticated. The theory was that a customer would first 'fill up' the card at a bank or building society and then use it as a kind of electronic purse to pay bills. After the money had been spent, the card would be taken back to be replenished.

After working on this concept for some time, Hunn ran into difficulties and the company fell into the hands of the receiver from whom it was bought by GEC, where it caught the attention of Laurence Clarke, another ex-Elliott man who was now technical director (automation) of GEC/Marconi. To help him get the idea off the ground, Clarke turned to John Streeter, who had been working with Hunn, and installed him in Marconi's research laboratories at Great Baddow. After toying with the idea of embedding a micro-processor on the card, Streeter and his colleagues came up with the notion of a card that could pick up information by induction. The idea was years ahead of its time and was developed to the point where there were serious talks in the 1980s with Westminster City Council about its use with parking meters. But, says Clarke, 'the trouble was the idea was never pushed. There was no real financial backing for the marketing. Arnold's principle was that the company had to provide what it needed out of its own revenue. Anything like the smart-card idea takes management time and that's risk.'[15]

What upset Clarke and Streeter about the smartcard project was GEC's reluctance to back the idea with anything like the necessary conviction. Streeter says:

> GEC mashed it to death by chewing it over with their teeth. And, by the time they had digested the idea, the lead had evaporated and there were others in the market. They were never close enough to the market and the idea came in later than intended.[16]

For his part Clarke says:

> Arnold is a very good lemon squeezer. The trouble was that he promised the City too much – the whole pint. In fact, if he had given the City just half a pint and kept the other half for himself, it would have been a whole lot better for GEC and for everybody else. I'm talking about cash flow here – not capital expenditure.

I'm not half as critical of the cash mountain as you might think. By building up and then maintaining the cash mountain, he probably saved the company by having no borrowings at a time when interest rates were going through the roof and companies were collapsing right, left and centre. Unhappily, what he was quite unable to do was to use the second half of the lemon to develop new markets and technology. And eventually, of course, he ran out of lemons.[17]

In 1988, GEC passed the idea over to Avery, the weighing machine company it had bought in 1978.* And though there were reports of promising trials, the idea fizzled out. In the summer of 1996, an electronic purse developed by a company called Mondex very similar to the GEC model went on trial in Swindon. In February 1997, Mastercard, the US credit card company, bought a 51 per cent stake in Mondex International for a sum reported to be between £100 million and £150 million.[18]

In 1981, as the promise of the A.B. Dick initiative was beginning to fade, Weinstock made another stab at the office equipment market by setting up GEC Information Systems, which brought together under a single management the activities of four distinct GEC companies: GEC Telecommunications, GEC Computers, Reliance Systems and GEC Viewdata Systems. 'The wide product range of these companies, together with A.B. Dick,' the company explained, 'enables GEC Information Systems to provide integrated information networks based on voice and data switching systems, computers, word processors and local area networks.' According to the annual report: 'The purpose of the company was to co-ordinate the GEC effort in the field of information technology, including the "electronic office".'[19] If it could have been made to work, the operation could have been a formidable competitor to Philips and Siemens, both of whom were well established in this area; but, as ever, the initial optimism was to prove unfounded. Three years and two managing directors later, the information

*Like A.B. Dick, the purchase of Avery, the weighing machine company, which GEC bought in 1979 after a Monopolies Commission inquiry, was a deal that never realized its potential. After a promising start in which the entire product line was revamped and modernized, the company was overtaken by more aggressive and more flexible competitors and fell into loss. As Weinstock explained nearly twenty years later, Avery was to be part of a grand design to build a business out of the technology of measuring flows. The component parts were to be fuel (with Gilbarco's petrol pumps); electricity (in GEC's meters); gas (in Fisher Controls) and weight data (with Avery). 'We would have ended up with a range of products whose technology was underpinned by similar forms of electronic measuring in the place of old-fashioned mechanical methods,' Weinstock said. 'We would also have built a complementary services organization capable of maintaining the whole lot. It was said within the group that the project was too ambitious, but the fact is we didn't succeed because we didn't find anyone capable of making the idea work.'

systems company was quietly disbanded and its various operations where returned from whence they came. 'We never able to identify the product,' says Malcolm Bates, the deputy managing director. 'They kept telling us about this great opportunity in office systems and why we needed to put computers together with word processors and telephones. But we could never find the product. Our units are based on products. We then know what we are dealing with.'[20]

That is one explanation. But it is also true to say that GEC's atomized structure and highly distinctive culture worked to its disadvantage in this and other similar cases. 'The trouble was that it didn't fit with the GEC system,' says Bob Telford. 'Arnold liked everything in self-contained divisions whereas the IS thing overlapped different GEC companies. So the question arose: to whom did this thing belong? And in the end it fell between stools.'[21] Likewise, the bid to capitalize on Marconi's electronic expertise in the defence area by launching a number of mould-breaking products such as car navigation systems and phone videos never got off the ground. Of all the forays that GEC made into North America at the end of the 1970s, the only ones that were at all successful were the Picker medical equipment business, which was bought to fit in with the potentially world-beating but financially disastrous body-scanner business that GEC bought from EMI, and Video-Jet, the computer printer operation which came with A.B. Dick.

The effect of all these various disappointments and setbacks was cumulative. Not only did the company fail to grow in any real sense, but it missed what many people believe to have been a large number of promising opportunities. As Stephen Dawson, the ex-NEB man, said to me, 'In the 1970s there were a number of industries that appeared to be rapidly growing areas but GEC ended up by not having a significant presence in any of them. What they have done has been to go for safe, low-growth markets like defence and heavy engineering. They have gone for cash cows.'

The idea that GEC missed a whole series of opportunities is one that does not go down well with Weinstock. In August 1989, he was subject to an unusually fierce cross-examination from Hugo Dixon of the *Financial Times* which made him lose his temper. When asked why he didn't make more of personal computers and semi-conductors (see chapter seven), he replied:

We didn't regard those fields as areas where we were particularly likely to succeed or as areas likely to be profitable for the company – and neither would they have been. We would have failed like everybody else. Nobody has consistently made money out of that sort of thing apart from the large American companies and perhaps the Japanese.[22]

But, he was asked, what about GEC's failure to put together transnational deals like ITT's 1987 joint telecoms venture with Alcatel? Wasn't that a missed opportunity? To which Weinstock answered tartly:

> We didn't have an opportunity. If the number 73 bus goes down Park Lane and you are in Oxford Street, it is not a missed opportunity if you didn't get on it in Park Lane. This is one of the most efficient and successful companies in the country and I sit here being told by a journalist how much the thing is being run down. You keep telling me that we've missed opportunities. Of course, we've missed opportunities. Everybody misses opportunities. We're not perfect. But the idea that there's something wrong with this company or its management isn't worth talking about.[23]

The difficulties GEC experienced in getting its individual companies to work together and pool their combined knowledge and skills were undoubtedly compounded by Weinstock's management style and by the way in which the company was organized. But they were not, as some have argued, all Arnold Weinstock's fault: the record shows that, from the late 1970s onwards, he was aware of the opportunities he was missing and attempted to build on GEC's existing base to create new growth businesses in new growth areas. It should be also be said that his failures to do so were at least as much to do with the inherent characteristics of GEC's business as they were with any flaws in the managing director's character, his instinctive caution or his lack of imagination.

Throughout the 1980s, as the failure of Britain's electronics industry to keep up with its American and Far Eastern rivals became more and more glaringly obvious, the question of why there was, in contrast to the United States, so little spin-off from the defence industry was frequently and anxiously debated. One of the experts called in by the electronics 'Little Neddy' to report and advise was Sir Ieuan Maddock, the former chief scientist to the Department of Industry. Sir Ieuan began his report by noting that 'the United Kingdom's electronics industry has a number of technological strengths, but it is relatively weak in most of the businesses where world markets are growing fastest and amongst which are the best opportunities for growth.'[24] After visiting all the main players and taking evidence from a wide cross-section of witnesses, Sir Ieuan said that he was most struck by 'the distance between the attitudes of the civil and defence-orientated companies, even when they exist within the same group,' and he added that 'there already exists a large culture gap and it is getting even wider.'

Sir Ieuan did not point the finger directly at GEC. But his description of the classic defence-orientated company (which he described as Type 'A') is GEC to the life.

Their whole stance is governed by the requirements of their single dominant customer – the MOD – and much of their decision-making is subsidiary to that of the MOD. It has to be faced that the likelihood of Type 'A' companies making a major contribution in the civil areas (other than aerospace) is vanishingly small and even strong measures by the government are unlikely to have more than a marginal effect.

He found that defence work was jealously guarded. 'Only exhortation or bribery,' he wrote, 'would persuade the 'A'-type defence contractors to give other companies access to 'the riches that lie unexploited on the benches and in the workshops.'

Five years later the 'Little Neddy' was hearing much the same story from the management consultants, McKinsey, who had been hired to report on why the electronics industry was doing so badly (see p. 164). In a clear reference to GEC, McKinsey wrote:

A focus on defence and telecoms has become self-reinforcing. It is clear that the capabilities and skills required for success in the defence industry and in the supply of telecoms equipment and a national PTT are very different from those required for success in globally competitive markets. Research in the former sectors is focused on projects agreed with the customer, and development is to specification and/or tends to be strongly engineering-led. Thus companies focused in these sectors do not develop skills in the speculative creation of new products to create new markets, nor in the management of the associated risks. Manufacturing cost reduction of mass volume manufacturing is rarely vital to the defence business, whereas it is the key to consumer electronics and to much of computers and automation. And the marketing and selling approach adopted when dealing with a small number of defence ministries is quite different from that typically required for success in competitive markets.[25]

Less than six months after McKinsey had published its damning report, GEC mounted its second bid for Plessey, its old defence rival and ertswhile partner in the telecoms business. While the first attempt in 1985 had been thwarted by the opposition of Peter Levene and the Ministry of Defence, this time GEC – with a little help from Siemens, its German partner – overcame Plessey and outmanoeuvred the MOD. By coincidence, the £2 billion bid for Plessey came almost twenty years to the day after Weinstock's acquisition of English Electric. And just as the EE deal completed the foundations of the new GEC, so the purchase of Plessey put

the coping stone on the work that had begun almost a quarter of a century before.

With its heavy bias towards telecoms and defence, Plessey served to reinforce GEC's image as a company that was happiest when doing business with monopoly customers. By 1990, GEC was virtually the only major defence electronics company left standing. Apart from the companies that Weinstock himself had bought and which were now part of the combine, Ferranti was about to sell its radar business to GEC, and Thorn, now part of EMI, had ceased to be a major force. Of the major defence contractors outside the aerospace business, only GKN, Lucas, Smiths Industries and Racal remained. William Rees-Mogg told me that he believed that the acquisition of Plessey marked the end of Arnold Weinstock's great period 'when, virtually single handed, he saved the British electrical industry'. But Plessey was not the end of Weinstock's long journey down the acquisition trail. The prolonged flirtation with British Aerospace which began in 1983 and the purchase of VSEL, the nuclear submarine builders, in 1995 showed that the old fires had not entirely died down. But after Plessey Weinstock liked to give the impression that he had ceased to look on Britain as the main theatre of his activities and had turned his attention to Europe. The joint ventures with the Germans and French confirm this. But equally important, at home he was forced to come to terms with the economic consequences of Mrs Thatcher. The Tories' deregulation of the telecoms business and the privatization of British Telecom were developments that vitally affected GEC. The result was a direct attack by Arnold Weinstock on Thatcherism and, by extension, on the prime minister herself.

NINE

TELEPHONE WARS

Weinstock's attack on Mrs Thatcher's economic policies came quite unexpectedly on 16 January 1984 in the course of a debate in the House of Lords on the bill to privatize British Telecom. Weinstock had already spoken once in the debate, but quite late in the evening, towards 10 p.m., he rose again. Speaking from the cross-benches, he politely apologized for detaining their Lordships at such a late hour but explained that he wanted to say something important about manufacturing industry. He began:

> In this country there is a tendency to regard manufacturing industry as something of declining importance. I have forgotten what is the exact percentage said to be now employed in manufacturing industry, but it is of the order of 20-something per cent. That indicates that 70-something per cent is employed in other industries, said to be mostly service industries. Servicing what? The insurance companies, the banks, the stockbrokers, the pension funds are providing services to industry. At the base of all this great service industry activity in which we place so much hope for the future lies manufacturing industry. I fear that if manufacturing industry fails, unless we become merely a country entertaining tourists, the service industries, or a large part of them, will go with it.[1]

The speech created quite a stir and papers sent reporters to the Tower of London to interview the beefeaters about their new role in keeping the country afloat.

Although the words 'Thatcher' or 'Thatcherism' had never been mentioned, Weinstock's remarks were instantly recognized for what they were and for what they were meant to be: an assault on the prevailing orthodoxy. At the time, all eyes were on the service sector. The City was booming, Big Bang was just round the corner and estate agents were

becoming seriously rich. Yet here was Britain's best-known and most celebrated industrialist – a man whose achievements in the government's eyes had merited a peerage only a few years before – saying that its industrial strategy was a nonsense and probably destined to fail. Furthermore, Weinstock went on to attack the centrepiece of the Tories' privatization programme: the selling off of British Telecom – the largest exercise of its kind anywhere in the world.

What Weinstock objected to was, as he saw it, the conversion of BT from a public into a private monopoly. He asked rhetorically:

> What does the government's policy really amount to? It is to turn British Telecom into a privately owned monopoly not regulated by parliamentary sanction. The government's policy is paraded under the banner of the market economy. Where does the market economy get a look-in? The fact is that it is simply not possible for real competition to take place while BT is at the same time the network operator and the major provider of terminal equipment.

This was not just an intellectual debating point or an acknowledgement that the old order had changed. Weinstock went on the attack to defend his business. He believed that the liberalisation of the telecoms business and the privatization of BT had dealt GEC a double blow by opening up the protected British market to its competitors while simultaneously denying it the opportunity of business overseas.

That Arnold Weinstock was obliged to go public in the debating chamber of the House of Lords rather than conduct his campaign discreetly with ministers in the corridors of Whitehall, as had been his custom, was a measure of the degree to which events were moving away from him. Far from regarding him as a stalwart champion of private enterprise and competition, there were many in Mrs Thatcher's circle (among them Keith Joseph, Cecil Parkinson, Norman Tebbit and Kenneth Baker) who saw him as an exemplar of the old corporatist way of doing things: one where government and industry made private deals with one another and, even worse, with the trade unions, while taking good care not to let others in on the secret. These ministers viewed Weinstock's protests about the privatization of British Telecom as motivated not, as he had argued, by patriotism, but by a simple desire to preserve the old way of doing things and to defend and protect GEC's position in the face of intensified competition.

For more than thirty years, the business of supplying Britain's telephone service, part of the Post Office, had been in the hands of a cartel of telephone equipment manufacturers of which GEC was a leading

member. Under formal agreements dating back to 1934, the Post Office was obliged to buy the bulk of its equipment from the ring, who then divided the work up between themselves. But with few penalties for poor performance and little or no scope for new entrants, there was no great incentive for the ring to innovate or even to charge competitive prices. It was a cosy arrangement which suited both sides. It was, however, not very dynamic. As the authors of *Hostile Brothers*, a detailed study of the European electronics industry in the 1980s, remark:

> Prior to 1969 the Post Office was a revenue-earning department of government, internally governed by cumbersome civil service conventions and externally subject to detailed Treasury and parliamentary interventions. It was a somewhat ponderous organization, poorly equipped to respond to the challenges of the 'white heat' of the technological revolution.[2]

Until far too late in the day, the Post Office remained faithful to an American-designed electro-mechanical telephone switching system called Strowger, which had been patented by a Kansas City undertaker as long ago as 1889. As Weinstock himself pointed out:

> Part of the price that manufacturers have had to pay for the advantages they have enjoyed has been the acceptance of virtual dictatorship by BT as to specifications of main telephone exchanges which, until System X, have been woefully wrong-headed and have eliminated the larger part of industry's exports of this equipment.[3]

The fact that British manufacturers were locked into Strowger equipment through their dependency on the Post Office long after their international rivals had moved on to more modern electronic digital systems meant that the opportunity to sell what they were making on the world market was almost zero. In answer to Lord Stoddart's charge in a House of Lords debate on the Telecommunications Bill in February 1984 that manufacturers were not cooperative because 'they had other fish to fry', Weinstock replied tartly:

> There were no other fish to fry. As a result of the insistence by the Post Office, and subsequently by British Telecom, on the equipment they specified, all our other fish were drowned or lost at sea. We lost our export markets because ... we did not have modern equipment because British Telecom and its predecessor would not buy it. There was no question of manufacturers having other fish to

fry. We always fry the fish our customers demand of us.[4]*

The Post Office first started seriously to look for a replacement for Strowger in 1968. But it was not until 1977, nine years later, that the main development contracts for what was known as System X were actually signed, and it took a further four years before the first digital exchange was installed in 1981. Although the cartel had been broken up in 1969 when the Labour government terminated the industry's agreements, the work was still allocated between the members of the club along the old lines. 'The termination of the Agreement may have ended the least defensible features of the telcom club,' write the industry's historians, 'but it did not spell the end of the club itself. The latter continued to exist until BT was privatized, although it was under considerable strain before then ... These firms, it seemed, possessed an inalienable right to a share in the Post Office investment programme.'[5]

From the inception of System X, the civil servants determined the division of labour between the suppliers of the new network system. Plessey would manufacture digital switching, timing and synchronizing equipment, GEC would develop digital trunk, small and medium exchanges and control processors, and STC would supply message transmission systems for connecting the exchanges' computer systems together. Nonetheless, BT, as it had now become, soon decided that to have three domestic manufacturers on the job was to have at least one, and possibly two, too many. In 1982, the Department of Trade and Industry sent Jeffrey Sterling, the property magnate and later chairman of P&O, who was then working as a personal adviser to the Secretary of State, to persuade STC, the smallest of the three manufacturers, to drop out. The inducement offered was a highly lucrative contract to supply BT with an updated version of the interim system, TXE4, worth £100 million a year over the next five years. As this offer was far more profitable than developing System X, STC accepted and left the scene. The departure of STC meant that the spoils, such was they were, went to GEC and Plessey.

Everybody knew that it would take time to develop System X, but nobody thought it would take as long as it did. Part of the trouble was the Post Office. Like its sister branch of government, the MOD, it had a predilection for rigid and over-elaborate specifications and, also like the MOD, it was an immense bureaucracy where even the smallest details had

*The British Telcom debates are, with the exception of a couple of interventions on horse-racing matters, about the only time Weinstock has spoken in the House of Lords. This is a pity as his public comments were as pithy as his private ones. He also told good jokes. I especially like the one he told about Machiavelli on his death bed. A priest comes to administer the last rites. 'My son,' says the priest, 'you must renounce the Devil and all his works.' 'Father,' replied Machiavelli, 'this is not the time to be making new enemies.'

to be authorized at high level. But the fact that the firms were wrestling with an entirely new technology was also a cause of delay. The Post Office became so worried about the lack of power available from GEC's central processor (shades of Nimrod) that it took the extraordinary step of forcing GEC to sub-contract the processor to a Californian design company – a step which led to a staggering improvement in its price–performance ratio.[6]

If the work they did on the System X project brought GEC and Plessey closer together by requiring them to collaborate, it also drove them further apart by fuelling an already intense rivalry. The two companies fought fiercely over the body of System X. And although it was Plessey that won the first round, it was to be a Pyrrhic victory.

GEC and Plessey never exactly hit it off. One reason was that they were in the same businesses, shared the same customers and were after the same talent. The other reason was personal. 'The relationship was always taut. We didn't like them,' David Lewis said to me. Weinstock had a low opinion of the Clark brothers' abilities and thought, as one of his chief lieutenants put it to me, 'that Plessey was a weak company which should be eliminated'. For their part, the Clarks' feelings for Weinstock were less than warm. When I wrote to Michael Clark explaining that I was research- ing a biography of Arnold Weinstock, he replied saying that he would be delighted to help me on the history of the electronics industry in this country 'as long as the name Weinstock is totally precluded from any and all of our discussions'.[7] As things turned out, the prohibition was not absolute and over the course of a pleasant lunch at the family seat of Braxted Park in Essex, the subject of Arnold Weinstock cropped up several times without a noticeable drop in temperature. In fact, Michael Clark's main complaint seemed to be that it was his brother John who had hogged the limelight, while his own achievements as head of the elec- tronics side of the business had not received due recognition.

The GEC/Plessey rivalry goes back a long way – to the days when Arnold Weinstock was a young man just beginning to make his way in the radio business at Radio and Allied. Plessey, then under the control of Allen Clark, was already well established as a manufacturer of compo- nents for the radio and TV industry; it was also an important supplier of radio and communication equipment to the MOD and a leading member of the cartel of telephone equipment manufacturers that supplied the Post Office with telephone exchanges and switchgear. With a turnover of £30 million or so, it was much smaller than GEC, but Plessey had always taken pride in its technical expertise and looked down on Arnold Weinstock as an interloper and an outsider. In short, it always believed that it was a cut above GEC.

The two companies' management styles were very different: Plessey's was as erratic and volatile as GEC's was disciplined and consistent. But both companies bore the imprint of a strong and all-powerful personality. If GEC had been fashioned in Arnold Weinstock's image, so Plessey was a reflection of the equally powerful but far less multi-faceted personality of Sir Allen Clark, who ran the company from 1946 to 1962. For all his qualities of leadership and dynamism, Clark was a tyrant and bully. In his standard history of the radio industry, Keith Geddes describes the day when Clark walked through one of the shops at the factory shouting, 'Sack everybody from A to K,' and Geddes says that sackings at Plessey were so routine that the men would organize a sweepstake on which of them would be the next to go: with the winner giving his winnings to the victim. Geddes offers a memorable example:

Clark set great store by good time-keeping, and one day demanded to see all those who were more than five minutes late for work. Among those was one of the company's most skilled toolmakers, who seemed to Clark to be insufficiently penitent. He was there- fore told to collect his tools and go. This he did, pausing on the way out to unscrew every detachable handle and knob on Clark's Rolls Royce, in full view of the gatekeeper, who assumed he was doing a repair job.[8]

Lest anyone should be in any doubt, even Plessey's own company history contains a less-than-flattering portrait of Allen Clark's manage- ment style. The author, Berry Ritchie, writes with admirable candour:

Nothing could stop him running Plessey himself. He wouldn't dele- gate and he was obstinately opposed to many ideas for developing the company, particularly when they cost money. He never doubted himself at all. It made him a redoubtable leader – one of the few industrialists not afraid to fight the excess powers of the unions after the war – and an erratic employer. Plessey had a fearsome reputation as a hire-and-fire company both at management and shop-floor levels, which was entirely A.G.C's doing. His random sackings brought more than one factory to a standstill before and after the war and his subjective management appointments were as often disastrous as successful.[9]

For all his faults, however, Clark was a creative and highly effective businessman. Throughout the 1920s and 1930s, he kept pace with the fast- growing radio industry by simultaneously supplying components and by doing sub-contract work for the radio makers. But unlike GEC, he never

ventured into the radio-making business himself. He used to say, 'You take the publicity and I'll take the money.' In 1929, Plessey worked on the first production models of John Logie Baird's TV set which boasted a screen measuring 2 inches by 4 inches (5×10 cm) with only 30 lines of definition, compared with the current British standard of 625 lines. It may have been tiny and hard to see, but Plessey was there first. The move that was to establish Plessey as a serious contender in the new digital telecom market came in 1962, when Allen Clark made a grab for the potentially lucrative telephone exchange business by making a takeover bid for two of the three remaining equipment makers in the club, AT&E and Ericsson.* These acquisitions transformed Plessey. Its assets were doubled overnight and telecoms became the most important aspect of the business, accounting for very nearly half its turnover. Suddenly, Plessey possessed 40 per cent of the British telephone exchange market.

It was undoubtedly a bold move. Whether it was also wise is more debatable, as it meant that Plessey had become dangerously dependent on the Post Office and, ultimately, upon the success of System X. Nonetheless, the takeovers were a clear signal both to the Post Office and to GEC that Plessey meant business. Clark was determined that, when the Post Office eventually decided on a successor to the Strowger system, Plessey would be in the driving seat. He never lived to see it. Only months later, Clark was dead. He died of cancer and was buried in consecrated ground on 7 July 1962 at No. 2 stand, Nursery Wood, beside one of the coverts, where he had once shot twelve cock pheasants, on his estate at Braxted. The succession passed to his sons, John and Michael.

When Allen Clark died, John and Michael were thirty-six and thirty-five, respectively. Their first task was to escape their father's shadow. As Jones and Marriott put it in their *Anatomy of a Merger*: 'Both had been brought up in a world dominated by their autocratic and highly successful father. His death unleashed in them a powerful urge to be his equal in power and influence'.[10] One consequence was that within six years of Sir Allen's death, Plessey was challenging GEC for English Electric's hand. And the fact that the prize went to GEC only served to harden John Clark's determination to equal, if not surpass, GEC wherever and whenever he could.

In 1982, he won a significant victory when British Telecom, as the Post Office had now become, appointed Plessey to be the prime contractor on the System X project. GEC was relegated to the number-two spot as the sub-contractor. However gratifying this might have been for Plessey, the project itself was failing to deliver the anticipated rewards.

*Confusingly, there were two Ericssons in the telephone business: the Swedish and the British. The company Allen Clark bought was the British Ericsson Telephone Company, which had been independent of its Swedish parent since 1926.

Not only was System X nothing like as profitable as the old electro-mechanical (or even the TXE4 and Crossbar systems), but, like the old system, its market was exclusively British. Apart from BT, the only other orders for System X were from the locally owned telephone company in Hull, the Channel Islands and the Caribbean island of St Vincent. The following table illustrates the position of British telecoms manufacturers in the world market.

DIGITAL MAIN EXCHANGES:
LINES ON ORDER AND INSTALLED

Company	Country	Exchange	Millions
CIT/Alcatel	France	E10/E12	8.5
Western Electric	US	ESS	n/a
Northern Telecom	Canada	DMS	5.1
NEC	Japan	AXE	4.3
L.M. Ericsson	Sweden	NEAX 61	3.8
Thomson-CSF	France	MT20/MT25	3.6
ITT	US	System 12	1.1 *STC was ITT UK subsidiary*
General Telephone	US	EAX	1.1
Philips	Netherlands	PRX/D	1.1
Siemens	W. Germany	EWSD	0.6
Stromberg-Carlson	US *(Plessey subsidiary)*	System Century	0.4
GEC/Plessey	UK	System X	0.2

(source: *Financial Times*, 6 October 1982)

What was worse, BT was not prepared to stay as loyal to its suppliers as its predecessor, the Post Office, had been. From 1982 onwards, BT had begun to look for a way of breaking the GEC/Plessey duopoly by opening up the market to overseas competition. After holding back at the DTI's request until after the 1983 election and the privatization of BT itself, the plan came into effect in 1984 with the selection of the Anglo-Swedish alliance of Thorn/Ericsson as the official 'third force'.

Although the Thorn/Ericisson joint venture was to fall apart six years later, at the time it was seen as a sufficiently serious threat for Weinstock to press John Clark to pool their telecoms businesses. But Clark, who was a proud and stubborn man, rejected these overtures. His view was that if the telecoms businesses were to merge, it should be Plessey that was in

control, not GEC, and he suggested he should buy out GEC's interest in System X. This met with a flat refusal from Stanhope Gate. Then, following the failure of what proved to be a final round of talks with Plessey and BT, GEC launched a £1.2 billion bid for the entire company on 3 December 1985. At 160p per share, it valued Plessey at just over £1 billion, compared with GEC's market capitalization of nearly £5 billion. In delivering the bid to John Clark, Weinstock said, 'I hope you will consider this proposal in the constructive spirit in which it is made.'[11]

'Constructive' was the last word John Clark would have chosen to describe GEC's approach. Between the beginning of December and the third week of January, when hostilities ceased with the referral of the bid to the Monoplies Commission, there was what Weinstock was later to describe as 'a bruising public relations battle'.[12] Masterminded by Sir Gordon Reece, Mrs Thatcher's PR consultant, Plessey's campaign reached a climax on 14 January 1986, when John Clark told his shareholders that GEC was 'a lacklustre conglomerate with a poor record in high technology and with a financial performance characterized by mediocrity'. 'GEC's management,' he continued, 'is obsessed with financial considerations and is addicted to short-term profits at the expense of investment in product and market development on which Britain's position in electronics depends.'[13] GEC's chairman, the normally genial Jim Prior, was so angry that he threatened to sue John Clark for libel; Arnold Weinstock said nothing publicly, but privately, so Peter Gillibrand told me, he was very hurt. 'Plessey's very hostile reaction to the first bid shook Arnold badly,' he said. 'It was the first time that anybody attempted to tear him to shreds and after that he was more cautious.'

As he had with AEI eighteen years before, Weinstock had timed his offer shrewdly. The market was already unimpressed by the quality of Plessey's management, worried by the continuing losses from the American telecoms company, Stromberg Carlson, which Plessey had bought in 1982, and concerned by the delays in delivering System X. But what opened the door to GEC was the dramatic decline in its rival's share price. When Plessey published its results for the year ending 31 March 1985, they showed that, while turnover had continued to rise, pre-tax profits had dropped by £12.5 million to £163.5 million. The reaction was a 15 per cent fall in Plessey's share price. In the course of a single year, Plessey lost 44 places in the *Financial Times* list of top 500 European companies, falling from 34th to 78th.

When asked to explain why it had made a grab for Plessey, GEC stressed the telecoms angle. The Monopolies Commission report stated:

GEC told us it had reached its decision to offer to acquire Plessey because it had become clear to GEC that a combination of the two

businesses was the only practical solution to the United Kingdom's widely acknowledged structural problems in telecommunications. Such a combination was also the best solution to the less widely acknowledged but equally threatening problems that faced the electrical components and defence systems industry in the future and that such a combination could only be brought about by GEC taking the initiative.[14]

But telecoms was only part of the story. The need to rationalize System X may well have been what triggered Weinstock's strike, but there were those who found GEC's talk of creating GEC/Plessey as a platform from which to launch a new era in electronics and telecoms unconvincing. Bill Coleman of James Capel expressed a commonly held City view when he remarked:

When GEC took over AEI and English Electric, that should have been the basis to grow internationally, not simply to cut out dead wood. Over the past decade, the group lived too heavily on the Ministry of Defence, the Central Electricity Generating Board and British Telecom, instead of expanding in international markets. GEC has to change its culture, but to me this merger proposal is still too defensive, concerned too much with protecting the home market.[15]

Many, including some of GEC's own senior managers, suspected that for all GEC's telecom talk, the real attraction was Plessey's £460 million defence business. It is a charge that GEC strongly denies. 'It's quite untrue,' Malcolm Bates, who as GEC's deputy managing director was one of the main architects of the deal, said to me. 'The bid for Plessey was made because of the need to sort out the System X situation. BT was keen that there should be one single UK manufacturer.' Bates says that, although nobody exactly gave GEC the nod, 'The inclination of everybody we talked to was in favour of the bid and we got the impression that if we went ahead it would be all right.' Bates does, however, concede that there were, as he puts it, 'one or two defence things we were interested in'. Plessey may have been only one third the size of GEC, but the two businesses complemented each other very neatly.

The capture of Plessey would mean that over two thirds of the MOD's defence equipment business (£1,200 million or 71 per cent of the total) would go to GEC/Plessey. Furthermore, there were few areas in which the two companies competed head to head for MOD business. While GEC/Marconi had a monopoly in torpedoes and was strong in avionics and battlefield command and control systems, Plessey's expertise was in

mines, minehunting and sonar equipment. The main area of overlap was in radar, where both companies were very active. Between them, they had getting on for 50 per cent of the military radar business.

At the Ministry of Defence, officials examined the fine detail of the GEC bid and they did not like what they saw. First, they thought it was a flagrant breach of the competition policy that Michael Heseltine and Peter Levene had been working so hard to introduce and, second, the bid came at a time when GEC was in extremely bad odour because of Nimrod. The MOD saw no reason why it should do GEC any favours and it lobbied hard to have the bid referred to the Monopolies and Mergers Commission. The DTI, more tentatively, took GEC's part and argued that the bid should be nodded through for telecom reasons. But the MOD was too strong, and on 20 January 1986 the bid was referred. Eight months later, the MMC ruled that the GEC bid was against the public interest. It did its best to be even-handed by saying it thought that there were aspects of both the telecoms and the defence proposals which were anti-competitive. But it was quite clear to everybody that it was the MOD that had saved Plessey and killed the deal. The Monopolies Commission report, however, did have one positive outcome: it opened the door to a settlement of the nagging and long-running System X problem by acknowledging the potential benefits from merging the public switching activities of GEC and Plessey.

The following year, much to the astonishment of Stanhope Gate, John Clark suggested that perhaps it would be a good idea if the two companies were to merge their telecoms operations after all. 'After we had picked ourselves up off the floor, we did just that,' Bates recalls. The result was GEC Plessey Telecommunications (GPT). It was what Weinstock wanted, but compared to its French, American and German competitors, it was still a relative minnow. Its sales were just over £1 billion compared with Siemens's £4.5 billion, Alcatel's £6.8 billion and about £9 billion for AT&T.

While Stanhope Gate was concentrating on sorting out the manufacturing side of the telecom business, there were many in the industry who thought that the big opportunities lay not in making the hardware – the public and private exchanges, the switching equipment and the telephones themselves – but in becoming a systems operator for the new cellular phones. Among them was Raymond Brown, who started his career with Plessey. As a young man in the 1950s, he had worked for the newly formed communications division but quickly decided that he and his friends would be better off on their own. Their decision to leave to form what became Racal coincided with Michael Clark's arrival.

'I came in one morning to find absolutely no one there,' Clark said. 'They had just buggered off, taking everybody with them, including the secretary – a blonde.' Michael called up his father.

'What do I do, Daddy? There's no one here.'

'Just get on with it.'[16]

In 1982, Racal, which specialized in communications equipment for the military and which in 1980 had beaten GEC in a contest for the hand of Decca, the famous radar and navigation equipment company, won one of the two licences awarded by the government for what was then called cellular radio. It was the beginning of the mobile phone boom. To establish its network, Racal formed a company called Vodafone, which it later floated off. By the late 1990s, it had become a £9 billion business. It was a prize, so many believe, that Weinstock could easily have won if he had put his mind to it. 'Arnold missed that. Absolutely missed it,' says one senior GEC executive with long experience of the telecoms business. One of the City's most experienced GEC-watchers agrees. 'The failure to get into mobile communications was a major, major missed opportunity,' he said. 'In effect, it was not one but two missed opportunities. In the first place it could have bid against Racal for the cellular licence; and second, it could easily have bid for Racal before Vodafone was demerged. It did neither.' In 1987, there was, I understand, a private agreement between GEC and Cable and Wireless to make a bid for Vodafone, but the plan came to nothing and all efforts at Stanhope Gate were concentrated on trying to make the new telecoms accord with Plessey actually work, which proved to be far from easy.

After all that had gone before, the chances of GEC and Plessey working harmoniously together were always slim. But Malcolm Bates says that what ruined the partnership was the departure of Plessey's managing director, Sir James Blyth, and the arrival of a new man, Stephen Walls, who came to Plessey after Chesebrough-Ponds, the US health care company where he had been finance director, had been taken over. In the battle for Chesebrough-Ponds, Walls had acquired a formidable reputation as a man who could squeeze out the last dollar for the shareholders. 'When I arrived at Plessey,' he said, 'I saw a company that had assets in the shape of a tremendous bank of technology and first-class people, but had an under-utilized balance sheet with a lot of cash in it.'[17] He promptly reversed John Clark's telecoms initiative by reducing the company's dependence on System X and bought instead a whole series of unrelated high-tech businesses in the US and the UK.

This was not what Weinstock had bargained for when he pressed for a single GEC/Plessey telecoms company. 'Stephen Walls's ideas about System X were diametrically opposed to ours,' says Bates, 'and progress was very slow.' It was for this reason that in August 1988 there was a secret meeting at Stanhope Gate between Arnold Weinstock, Malcolm Bates, Dr Karl-Heinz Kaske, the president of Siemens and Dr Bauer, the head of that company's telecoms operations. The subject

under discussion was a joint take over of Plessey. Weinstock suggested to the Germans that GEC should takeover Plessey's defence business and the GPT telecoms operation should be split 50:50 between GEC and its new German partner.

The Siemens people liked this idea, chiefly because it gave them access to the hitherto inaccessible UK market. They did not even demur when Weinstock proposed that Siemens should put up all but £500 million of the £1.7 billion cash offer. For what they were being offered, it was, they thought, a price worth paying. Oddly, their only objection to Weinstock's ingenious plan was not that it was too harsh but that it was too generous. 'Arnold offered them 50 per cent,' said Bates, 'but they said they were worried that BT might think they were dealing with a German company and would prefer to give GEC control and only have 40 per cent.'

For GEC, it was a stunningly good deal. For an outlay of £500 million, it would eliminate a major competitor in the defence business while strengthening the company's position in Europe. On the telecoms side, Weinstock would have the controlling interest in a joint company that had, with Plessey out of the way, a virtual monopoly of BT's System X business. The only drawback was that Siemens insisted on keeping its own, much larger, telecoms business quite separate from GPT. But although both companies stood to gain from these arrangements, the real point of the Anglo-German alliance was that it gave Weinstock the chance of a second bite at Plessey without incurring the automatic veto of the MOD.

On 16 November 1988, Siemens and GEC finally came out into the open and made their joint bid for Plessey with a cash offer of £1.7 billion. The deal was cunningly constructed to defuse the criticism that GEC was trying to monopolize the defence business. To head off the MOD, it was proposed that ownership of the Plessey defence business would be shared 50:50 with Siemens and, furthermore, would be run separately from GEC's Marconi. Siemens' involvement in the British defence industry would be balanced by a provision that GEC should buy into Siemens' defence activities in Europe.

If Weinstock's first bid for Plessey in 1985 led a war of words, his second led to a threatened assault on his company. On 7 January 1989, a consortium inspired by Plessey but led by Sir John Cuckney, the former chairman of Westland with strong MOD and intelligence connections, announced it intended to bid for GEC. Although it was rumoured that members of the consortium included the French Thomson-CSF and the American AT&T, the putative bid was no more than a diversion which left Weinstock unruffled. 'We have to see the rabbit first before we can shoot it,' he said.[18] As it was, the bid never materialized.

A more serious threat to GEC's plans came from its old adversary, the MOD, which let it be known that it considered the second Plessey bid

almost as unacceptable as the first. Once again, Stanhope Gate thought it detected the not-so-hidden hand of Peter Levene. As Weinstock was determined that he was not going to be thwarted a second time, he put forward a second set of proposals designed to meet Levene's concerns about competition. It was proposed that instead of running Plessey's defence business as a 50:50 joint venture, there would be a Judgement of Solomon, in which Siemens would take over Plessey's radar and communications business while GEC would acquire the naval and avionics activities. It was also agreed that GEC would drop its plan to take a 50 per cent stake in Siemens's own defence business.

If this second plan partially allayed the MOD's anxieties, it infuriated Plessey, who described it, with some reason, as 'nothing more than a good old-fashioned carve-up of an aggressive competitor by two tired European monolithic enterprises'.[19] Plessey was particularly critical of the new telecoms regime. It told the Monopolies Commission that the plan:

> would leave Siemens with 100 per cent of its own telecommunications business and a 40 per cent share in a competitor. In consequence, it would be impossible to realize the potential benefits that would arise from a full merger; yet competition between GPT and Siemens' wholly owned telecommunications business would be almost as fully eliminated as if there had been a merger.[20]

It was Plessey's belief that the proposals 'would lock GPT into a most unsatisfactory position as Siemens' junior partner.' Later events showed that Plessey's fears were well founded.

These arguments, however, failed to move either the Monopolies Commission or the government. Following a report which more or less endorsed the revised GEC/Plessey proposals, in August 1989, Nicholas Ridley, the Secretary of State for Trade and Industry, gave Weinstock and his German partners the green light. The renewed share offer, which valued Plessey at just over £2 billion, was a formality and the long and acrimonious battle was over. The result was that the MOD was confronted with an even larger and stronger supplier than before, while BT had achieved the rationalization it was looking for. What is far less certain is whether, as GEC claimed at the time, the Siemens alliance marked the beginning of a new era for the company.

Weinstock was to maintain that the decision to join hands with Siemens in the second Plessey bid was the beginning of a grand plan to release GEC from the shackles of being a UK-based company by forming joint ventures with powerful European companies. As he saw it, GEC had now reached a stage where further significant growth by acquisition in the UK

was next to impossible thanks to a lack of opportunity and to the attitude of the regulatory authorities. He complained that acquisition in Europe was almost equally difficult, as the continent was 'peopled by large companies which will cling to their independance, that are relatively invulnerable to takeovers, and which are frequently larger than GEC... So you have the option of adding bits piecemeal, or doing something bolder. And that means coming to arrangements.'[21]

He told the *Financial Times* that companies like GEC and others in Europe had been hampered by the absence of the large industrial bases enjoyed by their US and Japanese competitors. As he saw it:

The US is an indigenous market of 250 million with common standards. In Japan we have 120 million people living in a tribal society with close connections between government and the industrial organizations, and where the financial institutions do not place much of a burden on industrial managers' shoulders. The GEC/Siemens offer for Plessey is the first step in the strategy of international expansion which makes sense for both companies, for the UK and for the development of European industry. The proposed addition of Plessey to GEC was not designed simply as a domestic industrial rationalization in the UK. It was aimed also at giving GEC the sort of structure that would make it easier to push through international collaboration agreements.[22]

As a personal credo for a new era, it was vintage Weinstock. But as a rationale for the Plessey bid it smacked of special pleading.

There was nothing wrong with Weinstock's logic. He knew better than anybody how important it was to strengthen GEC's telecoms operation. As a very senior GEC man who was closely involved with the steps leading to the creation of GPT told me:

Up until the late 1970s or early 1980s, we were in the hands of BT and there was not much we could do about that. The fact is we ended up with a lot of equipment that was unsaleable. From the bust-up of AT&T in 1975, it was obvious that things were going to change. But Arnold was slow to move. I don't think he saw how the markets in telecoms would emerge in the future.

Because GPT was so dependent on the public sector, it was inevitably slow in developing the next generation of switching gear to succeed System X. 'After the creation of GPT, what became obvious was that GEC did not have sufficient technology in the company,' Malcolm Bates told me. 'It did not have the right digital switching. It never had an oppor-

tunity to become an international player because the British were so late in the game. GPT was also unstable because, unlike Siemens, it did not have another telecoms business.'

From the beginning, it was Siemens that set the pace. GEC may have had the overall control, but 80 per cent of the technology, so insiders say, came from Siemens. This disparity, plus the huge difference in management styles, caused tension. Less than a year after the deal was set up, the *Financial Times* reported that 'it is clear that the relationship has reached its limits' and quoted a GEC spokesman as saying that the relationship had achieved GEC's goal in acquiring Plessey and had therefore 'run its course'.[23] GPT's British management was, the *Financial Times* said, moving closer to Siemens and added that 'many in the telecommunications industry believe that in the long run Siemens will displace GEC by integrating much more closely with GPT. By dividing the company so neatly, GEC and Siemens have set up as clear a test as could be imagined of whether British financial discipline or West German engineering will be better at developing Plessey's assets for the long term. As things stand, most former Plessey managers working for either GEC or Siemens believe the West Germans will come out ahead.'[24]*

If the Siemens deal turned out to be more of a carve-up than a grand design, it remains true that the last weeks of 1988 and the first weeks of 1989 marked a watershed for GEC. After secret negotiations lasting for a year, GEC made the remarkable decision to team up with Alsthom, a subsidiary of Compagnie Genérale d'Electricité of France to form what would be the world's sixth largest power engineering company. The union was born out of GEC's realization that it was too small to be able to continue to go it alone. As *Management Today* put it in a long analysis of the new company:

> On GEC's side, top managers Bob Davidson and Jim Cronin were aware that, while the UK power engineering group was profitable, it did no business in Europe and at world level was hardly a terrifying rival to the likes of GE, the newly combined ABB, Siemens in Germany and the Japanese. For a broad-line supplier, GEC's small size was a real disadvantage, as it was obliged to carry otherwise uneconomic capacity to cater for every type of order. Costs were high and offered little scope for reduction. The firm needed volume.[25]

*In 1990, GPT's turnover was just over £1 billion. But since then, while its profits have improved, sales have remained flat and its position in the league table is unchanged. In July 1997, in announcing a major shake-up of the company, the new managing director, George Simpson, indicated that GEC would like to sell GPT to Siemens but had still to agree on a price.

With total sales of £5 billion, the new company, GEC-Alsthom, was the largest Anglo-French merger in history, with 6 per cent of the world market, and it ranked sixth after the Swedish/Swiss owned AAB, America's General Electric, Japan's Mitsubishi, Germany's Siemens and another Japanese firm, Hitachi.

William Rees-Mogg believes that one of the motives behind the Alsthom deal was Weinstock's desire to make GEC bid-proof. But Malcolm Bates denies this.

Our European policy started with the privatization of the telecoms business which opened up markets internationally. And it went on from there. There was no sudden conversion on the road to Damacus: merely a realization by Arnold that, as he said one day, 'It was time we got on with it.' We looked at all the European markets for opportunities to buy into. But you can't buy French public companies and the German ones are owned by the banks. We had got to know Alsthom well over the joint work we were doing on the Channel Tunnel. And so we said, 'If we can't buy each other, why don't we get married?'

In the sense that Alsthom's power engineering business was twice the size of GEC's, it was a marriage of unequals. 'It was a wonderful deal for GEC shareholders,' says Bates. 'We put in a third and came out with a half. They were twice our size in sales and had a lot of advanced technology, but it wasn't all one-sided. They had the TGV [the French high-speed train], whereas we had the bits and pieces left over from British Rail's attempt at the same thing. But we had superb steam turbine technology.'

Apart from the differing technological profiles, the attitudes and culture of the two companies were dissimilar. 'Development of managers was poorer in GEC,' said Jean-Pierre Desgorges, the chairman and joint chief executive of the joint venture. In Alsthom, R&D decisions were made by the centre, while at GEC they were by and large left to the individual companies. The result was that GEC spent about 1 or 2 per cent on R&D while the Alsthom figure was between 3 to 4 per cent.

That GEC/Alsthom would be run by a Frenchman from Paris was accepted from the beginning. 'It would have been nonsensical to have an Englishman as MD,' says Bates. 'The head office was in Paris. Common sense dictated that it needed a Frenchman in the job.' Whether GEC would have been quite so happy with the distribution of the jobs further down the executive ladder, is a moot point. But as things turned out, two of the three managing directors were French, as were all but two of the heads of the seven divisions and the two operating subsidiaries. At the time of

the link-up, neither of the two GEC men on the board spoke French, though it was said that they were learning. The new system of financial controls, however, was pure GEC. 'It was a big triumph,' says Bates.

When questioned about these departures from the traditional GEC way of doing things, Weinstock admitted that the new arrangements were something of a compromise. 'There is no longer that strong line which says that the managing director of power systems does exactly what he likes,' he said. 'He has a partner. From the point of view of quick action that is not the ideal form of organization, but it is the best available to meet the circumstances.'

The ink was barely dry on the Alsthom agreement when, in the first week of January 1989, Jack Welch, the head of the American General Electric, arrived in London. He had intended to reveal that GE had joined the consortium that had been cobbled together to thwart the Plessey bid, but Arnold Weinstock headed him off at the pass by announcing that GE and GEC had formed a 50:50 joint venture to sell their consumer products, including GEC's Hotpoint washing machines and its Creda cookers. In the space of a little more than a month, the shape of GEC had been completely altered. Of the group's £8.7 billion total sales, joint ventures now accounted for over one third.

The joint venture alliances with the German Siemens on telecoms, with the American General Electric on the consumer goods side and with the French Alsthom on power engineering and rail transport signalled that the course on which Arnold Weinstock had been sailing for the past thirty years had been radically altered. By agreeing to go 50:50 with the Americans and the French, Weinstock was, in effect, admitting that GEC, for all its size and its resources in cash and manpower, was too small and too weak to go it alone, either in Europe or in the rest of the world. The judgements made by the IRC and others when backing Arnold Weinstock thirty years earlier were sound enough. Their feeling that individually GEC, AEI and English Electric lacked the size and muscle to compete with their European rivals proved to be entirely correct. But what they did not foresee was how the new technology of the transistor and the microchip would create an entirely new consumer electronics industry and transform the defence business. While Arnold Weinstock's GEC fully met expectations in rationalizing the heavy electrical part of its inheritance, I would argue that it failed to take advantage of the new opportunities.

By 1989, GEC had ceased to be a force in computers, had stopped making all but the most specialized semiconductors, had all but abandoned the consumer electronics business to the Japanese, the Dutch, the French and the Americans, and had seen the Swedes, in the shape of Electrolux, and the Americans, in the form of Whirlpool, seize control of the domes-

tic appliance business. Events were to show that the much-trumpeted deal with GE had come too late for the new combine to have much of an impact. By 1997, its share of the western European market was no more than 3 per cent.[26] Only in power engineering and defence was GEC still a force to be reckoned with on the world stage. The alliance with France's Alsthom meant that the combined company was, in the coming years, to build a useful share of the steam-powered turbine market and Marconi's expertise in avionics and other electronic systems was to give GEC a small stake in the international arms business. But by the mid-1990s, the defence business was not what it was.

Between 1985 and 1995, UK defence spending, without taking inflation into account, fell by 17 per cent, while the US total has dropped by a massive 40 per cent in response to political pressures and the ending of the Cold War. In America, these developments led to a wave of mega-mergers. The number of players almost halved as the industry regrouped into a series of giant combines led by Lockheed Martin, Hughes and McDonnell Douglas (itself shortly to be taken over by Boeing), who between them had an estimated 55 per cent of the $250 billion world defence equipment market.[27] With a 5 per cent share, GEC, which trails France's Thomson-CSF and British Aerospace, is simply not in the same league as the Americans.

Arnold Weinstock has little time for those critics who point out that GEC's growth record is poor when compared to Philips, Siemens and its other European rivals. 'You think growth is necessarily benign, do you? People just getting bigger for the sake of it: you think that's a good idea?' he growled at a *Financial Times* reporter who was brave enough to make this point.[28] Weinstock prefers to judge GEC's performance primarily by the financial yardsticks he has used for more than thirty years, and specifically those that measure how well the company has performed for the shareholders. In this he epitomises the fixation of the British City establishment with short-term, shareholder-orientated financial performance in preference to long-term growth and job creation. While the German Siemens has been prepared to play the long game and invest billions in projects like its £1.1 billion semiconductor factory on Tyneside, Arnold Weinstock has preferred to concentrate on those aspects of his business where the returns are sure and the outcome predictable.

Until very recently, Weinstock could have justified this approach by arguing that the shareholders of Philips and, for that matter, Siemens have not been particularly well served by the management of their companies. Indeed, until the new management took a grip of Philips in the spring of 1996, the company, which has embraced new technology with seemingly indiscriminate enthusiasm, looked as if it had seriously over-reached itself and was, after years of horrendous losses, almost beyond rescue. Siemens,

which operates on a much larger and wider scale than GEC, had also been turning in extremely pedestrian results. But since the autumn of 1996, the share price of Philips has almost tripled as international investors have come to realize the extent to which the company is being transformed by its management team. A few months later, the Siemens shares also awoke from a long sleep, with a rise of 66 per cent in just nine months.

There was no such transformation at GEC, even though it is (or was) a better managed, though less ambitious, company than either Philips or Siemens. At just under 18 per cent, its real return on capital compared well with Philips at 14.3 per cent and Siemens on 6.6 per cent. Likewise, GEC's operating margins, at 7.6 per cent, were better than Philips' 5.5 and Siemens' 1.3.[29]

But for the long-suffering GEC shareholder, what rewards there were came in the form of income rather than growth. Between 1985 and 1997, net adjusted earnings per share rose respectably from 14.14p to 21.63p.[30] Dividends too were up. But those GEC investors who were looking for growth were to be sorely disappointed. The chart below, which shows how the GEC share price has performed relative to the *Financial Times* All-Share index (represented by the horizontal line at 100 per cent), reveals that, after reaching a triumphant peak in the early 1980s, the price has fallen back to the point where it barely outperforms the market average.

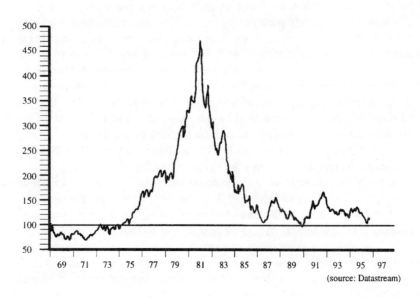

(source: Datastream)

By the end of 1980s, GEC had become a prisoner of circumstance. Its domestic market was too small to finance its ambitions to become a world player, and the areas in which it had chosen to specialize were shrinking and over-crowded with hungry and aggressive competitors. The logic of Arnold Weinstock's decision to seek European and American partners as a means of escaping from his prison was impeccable. It was also right. But it meant that GEC would not, and could not, ever be the same again. The biggest change was that Arnold Weinstock was no longer the undisputed master of the company he had created. Intellectually he saw what had to be done. But emotionally he found it hard to come to terms with. And the tragedy was that he was to spend the last seven years of his career trying to avoid the consequences of a situation which he himself had made but which he was unwilling or unable to acknowledge to others – or even to himself.

TEN

THE LONG GOODBYE

However much the alliances with the Germans, the French and the Americans might have loosened Weinstock's grip on GEC, his concern was to protect and, if possible, to improve the company's already powerful position as the UK's premier defence contractor. Having already accounted for Elliott, English Electric, Plessey and the Yarrow shipyard, which was bought from the government in 1985, there were only a very few defence companies left for GEC to target. One was VSEL, the builders of Britain's nuclear submarines, based in Barrow on the fringe of the Lake District. Another was Ferranti, the defence electronics company started at the end of last century in Manchester by the grandfather of Sebastian de Ferranti. The third was, of course, British Aerospace, the company that was created by the nationalization of the aircraft industry in 1977.[*]

Ferranti is one of those depressingly familiar stories of British industry. Though never in the best of financial health (it went bankrupt very early in its life and had to be rescued), it played a pioneering part in the early development of computers in Britain and its semi-conductors enjoyed, for a time, a world-beating reputation. But the quality of its management never quite matched its technical brilliance. For GEC, the attraction was Ferranti's missile guidance systems and airborne radar. The Blue Vixen which Ferranti had been building for the Navy's Sea Harriers would neatly complement the Foxhunter radar system Marconi was making for the air defence version of the Tornado. Even more important, in early 1990 Ferranti was in the running for a £2 billion contract for the radar on the European Fighter Aircraft for which Marconi (together with DASA) was already building the flight control system and the head-up display.

[*]Through the aircraft activities of English Electric, which built the Lightning fighter and the Canberra bomber, GEC had a 50 per cent interest in the British Aircraft Corporation, which was, together with Hawker Siddeley, nationalized by the Labour Government in 1977 to form British Aerospace. Four years later, BAe was floated off in one of the new Tory government's first privatizations.

But just as things were looking good for Ferranti, disaster struck. Its American subsidiary, International Signal and Control, suffered a £215 million fraud which so weakened the company that the Germans threatened to award the EFA radar contract to a consortium led by Daimler-Benz. With hundreds of jobs at risk in Ferranti's four Edinburgh factories, and with two of the Tories' ten Scottish seats lying within the city (including those of the Scottish Secretary, Malcom Rifkind, and Lord James Douglas Hamilton), the Government indicated to Weinstock that it would not object if he bought Ferranti's defence business.

Weinstock took the hint. And after his son Simon, who was GEC's commercial director, had made the initial soundings, a deal was quickly struck with Ferranti's chairman, Sir Derek Alun-Jones. For a relatively modest £310 million, Weinstock acquired not only Ferranti's entire defence business, but a half share of its Italian operation as well. Weinstock is far too diplomatic to admit publicly that he had been given the go-ahead by Mrs Thatcher, but he came quite close to it when he said, 'There is an element of wanting to please the customer, the government, to help it over an intractable problem.'[1] Others were blunter. 'You can be sure there was a *quid pro quo* and that Arnold got more than a quid,' said one observer.[2]*

But useful though Ferranti may have been as an addition to GEC's defence portfolio, it was the nine-month-long battle with British Aerospace for VSEL that was to be the crucial step in GEC's battle to complete its portfolio of defence businesses. It was also to be the last contested takeover in Weinstock's career. As the battle unfolded, it was clear that he had lost little of his former flair. Though he was now close to seventy, the campaign was conducted with a skill and determination that forced critics to revise their view that he was a spent force and it inevitably renewed speculation that, in going head to head with British Aerospace, his real quarry was not his target but his opponent. He deliberately played his cards to give the impression he was holding all the trumps – which, with a cash mountain of, by now, £1.6 billion, he was.

A subsidiary of Vickers until the nationalization of the shipbuilding industry in 1977, VSEL had gone full circle to become a self-standing private company with the privatization of the state-owned British Shipbuilders in 1986. As Britain's only builder of nuclear submarines, the company had played a key part in maintaining the credibility of Britain's

*The deal was not enough to save Ferranti. In October 1993, Ferranti was sold to GEC for a nominal 1p, but Weinstock had been well aware that Ferranti was a basket case some time before the final collapse. Industry sources say that when Ken Grantham-Wright, a project manager at GEC-Marconi, learned that Ferranti was heading for disaster over a Rapier missile contract, he rushed to tell Weinstock what he had learned, but Weinstock merely said, 'Thank you for telling me. I'll buy them when they go bankrupt.'

independent nuclear deterrent. Employing 5,800 people on the building of Trident- and Trafalgar-class submarines, VSEL dominated the economy of Barrow-in-Furness – an archetypal company town.

The battle began on 12 October 1994, when British Aerospace made a £492 million bid for the submarine builder. A fortnight later, GEC responded with a offer worth £532 million. 'We only moved in when we thought that BAe was going to buy it. Our tactic was to give the impression that we were going to win whatever happens,' says John Nelson, vice chairman of Lazards, the merchant bankers who acted for GEC. What worried GEC, Nelson says, was that, although VSEL was not currently in competition with the GEC-owned Yarrow yard which built the Navy's Type-23 frigates, if BAe had acquired control, it could in theory build frigates at Barrow. Even more to the point, the Navy was about to place a £2.5 billion contract for five Trafalgar-class nuclear attack submarines and whoever won VSEL would automatically get the contract.

Although each side claimed to respect the other, the exchanges became quite sharp. One BAe director said, 'I begin to wonder whether you can do business with Lord Weinstock. Everything seems to be on his terms or not at all.'[3] For his part, Weinstock turned the cash mountain argument to his advantage by contrasting GEC's financial strength with BAe's less impressive balance sheet. 'Who would you rather take on as a prime contractor?' he inquired. 'A company with nearly £3.5 billion in the bank which can pay for its own mistakes, or one which owes the bank £200 million? I know which I would choose.'[4] On 18 November, BAe raised the ante, topping GEC's offer by £27 million. Three weeks later, the trade and industry minister, Michael Heseltine, referred GEC's bid to the Monopolies and Mergers Commission.

In the eight years that had passed since the government had blocked Weinstock's first bid for Plessey, the MOD had become a good deal more sympathetic to GEC. Its officials now largely accepted the force of Weinstock's argument that the pressure from the giant American defence firms had become so strong that worries about GEC becoming over-dominant in the domestic market were largely irrelevant. This shift in opinion had been well-enough signalled for nobody to be very surprised when Michael Heseltine decided to ignore the Monopoly Commission's unfavourable finding and announced that the GEC bid could go ahead. It was a matter to be decided by the stock market, not the government, he said.

After a series of short but sharp exchanges in the market, the fate of VSEL was decided when, on 8 June, GEC delivered what proved to be a knock-out blow with a bid worth £835 million. Three days later, at the Paris Air Show, BAe's Sir Dick Evans, signalled that he was ready to concede, saying, 'The acquisition of VSEL is not a necessity for us. For

us, VSEL is a growth opportunity. For GEC, it is a must, which is clearly reflected in the price GEC is prepared to pay.'[5] Ten days later, BAe formally withdrew its offer. Weinstock had won what was to be his last battle.

A month after the VSEL coup, Arnold Weinstock reached his seventieth birthday, the age at which all GEC directors – except the managing director – are obliged to retire. That same month, the GEC board agreed unanimously that Weinstock should continue to serve for a further two years. It was the board's way of ducking the question that nobody quite dared to confront directly: after Arnold, who? Perhaps the only person who could have persuaded Weinstock that the time had come for him to leave would have been Kenneth Bond, but he had been gone for nine years. I am told on very good authority that Bond did tell his friend that he should retire on reaching sixty-five, as Bond himself had done, but Weinstock was in no mind to heed the advice. 'He never wanted to retire at all,' one of his closest colleagues said to me.[6]

One reason the question of the succession was so prolonged and so intractable was that Weinstock was determined that, if he had eventually to go, it should be his son, Simon, who should succeed him, even though he always insisted that it should be Simon's choice. 'Of course I would like it,' Weinstock once said, 'but only on condition that it fulfilled his life and not that he did something to please me.'[7] It was a subject on which he could become extremely emotional. The journalist Adrian Hamilton, then the industrial editor of the *Observer*, remembers interviewing Weinstock and asking him in the course of the conversation what seemed an innocuous question about Simon and the succession. To his astonishment Weinstock burst into tears and the interview ended in some confusion.[8]

Simon was his only son (there is an elder daughter, Susan) and the relationship was, by all accounts, exceptionally close. From his boyhood, Simon enjoyed advantages his father had never had. From Summerfields, the Oxford prep school, he was sent to Winchester and then on to Magdalen College, Oxford, where he read Greats. After Oxford, Simon joined S.G. Warburg as a graduate trainee, and it was only in 1983, when he was thirty-one, that he joined his father at GEC. He did so, so Jim Prior has said, not because he wanted to, but out of a sense of duty and because that was what his father wanted.[9] 'He had an extraordinary relationship with his father,' says someone who knew both men well. 'He spent the day in the office next door; he spent almost every weekend in the country with him; and whenever Arnold went abroad on holiday, Simon and his family would go too. I can't see how he had time to make any other friends.'

Certainly Weinstock was an attentive, even a doting, father. Simon's wife, Laura, tells the story about a family lunch at Claridge's when Simon was eight. As his main course Simon chose the *supreme de volaille*, but, when it arrived, it turned out not to be to his liking. After consulting his father – who agreed – Simon sent it back. 'Simon was famously fussy about his food,' said Laura.[10] But it was not all indulgence. Weinstock was also hugely ambitious for his son, and could and would drive him hard. David Lewis, whose friendship with Weinstock dates from Radio and Allied days, says:

> Even as a small boy, Simon was very shy and very retiring. I remember one year when we were staying the summer in the south of France and Arnold was staying in some place nearby, and we saw a fair amount of him. Arnold was sort of always telling him to do this and do that and not to retreat into a corner, so to speak. And when he was older – and right up to the present day – he didn't have a forceful personality.[11]

Graham Turner who knew him when he was at Oxford says that he was very quiet and extremely shy. 'He had beautiful manners and was rather scholarly. But he was also very awkward,' Turner recalls.[12] He says that, after leaving Oxford, he and his wife invited Simon over for dinner a couple of times, but the striking thing was that Simon never knew when to leave. 'It would be 2.30 in the morning and we would say, like, "It's time we took the dogs out," or "We had better do the hot water bottles," but still Simon wouldn't take the hint and leave.'

Laura agrees about the shyness. 'He was the shyest man I ever met.' The couple first met at dinner party in the family flat in Grosvenor Square organized by Simon's sister, Susan. Simon did not say a single word to Laura throughout the meal, but as the party was preparing to leave for a ball, Simon turned to her and said, 'You can come with me.' She was so taken aback that the Aston Martin Volante made little impression.

However, she says, Simon was, for all his shyness, somebody who took charge. She remembers a disagreement Simon had with the designer David Mlinaric, who was helping them redecorate their house in South Kensington. After the outburst had subsided, Mlinaric turned to Laura and asked, 'And what's he like when it's something important?' Simon was, like his father, a stickler for detail. On one occasion, the Weinstocks were having a dinner party. Simon was late and the guests had already arrived when he came in and noticed that one of the table lights was dim. Without saying a word to anyone, he went out. Only after he had replaced the defective bulb with a fresh one did he greet his guests.

Even after he had been at GEC for several years, senior GEC people could never quite make up their minds about his commitment to the job. One director recalls:

> He was a very dark horse. He was always late for everything. He was a bit of a cold fish and enigmatic. Whenever there was specu- lation in the press about Simon's suitability for the job, he would come in on Monday mornings with renewed enthusiasm, as if he had had a good bollocking. And then things would quieten down and it would be back to a 9.30 start instead of the bright and early 8.15. He liked the good life. Small things troubled him as well as big things.[13]

He was, however, an unquestioned member of the GEC inner circle which included Malcolm Bates, the successor to Kenneth Bond as Weinstock's number two, Michael Lester, the legal director who had replaced David Lewis, and David Newlands, the finance director. Four years after joining, Simon was appointed to the GEC main board as commercial director. He had special responsibility for GEC/Marconi and was among the small group that planned the VSEL takeover. He was also the manager of the family's racing interests. He was part-owner, with his father, of nearly all the Weinstock horses (there were thirty-seven in 1996). He did occasionally run horses in his own colours, the best-known being Ela-Mana-Mou, which in 1980 won the Eclipse Stakes at Sandown and the King George VI and Queen Elizabeth Diamond Stakes. According to Dick Hern, who trained many of the Weinstocks' most successful horses, Simon developed a real talent for breeding bloodstock. Father and son would usually meet at the end of the day in Weinstock's own office (though the door between the two offices was never shut) and the talk would be as much about horses as about business. As Jim Prior describes it, 'There was debate and argument as ideas were tested, not just about business but about the ability of horses and trainers. But there was also love.'

It was the summer of 1995 – a year after the board had extended Weinstock's tenure by a further two years – that the succession question became both a live question and an embarrassingly public one. What trig- gered it was not so much grumbles from the City or outside pressure from institutional shareholders, but a botched attempt at a boardroom coup by one of GEC's own directors. Richard Reynolds, the former chairman of GPT, the telecoms company, was one of GEC's longest-serving execu- tives. He had been with GEC, off and on, since joining the company in 1960 straight from Cambridge, where he read natural sciences at Queen's. Although he left briefly in 1965 for a couple of years with Plessey, he

208

returned in 1967 to help out with the AEI acquisition. In 1988, he became GPT's first managing director following the company's formation and the alliance with Siemens.

Reynolds had been unhappy for some time about the way the succession question was being handled – or rather not handled – and when he heard that Jim Prior had told a board meeting that he was thinking of resigning as chairman (he was sixty-eight), Reynolds tackled him in the corridor. Prior, the old politician, neither confirmed nor denied that he intended to resign. He merely inquired, 'Well, who would you suggest?' 'Well, me,' replied Reynolds, who thought that GEC needed an insider for the top job. Prior made no comment but suggested that Reynolds should write to him. Reynolds, believing that his intervention had served its purpose by kick-starting the search for a new chairman and, by inference, a new managing director, went on holiday.

When he returned in September, however, he found to his dismay that nothing had been done. It was at this point that Reynolds made a serious mistake. Instead of keeping his worries in the corporate family, he shared them with a reporter from the *Sunday Telegraph*. Within hours of the story being printed, Reynolds was summoned to see the chairman, Jim Prior, who told him that he was not standing down, as had been reported, and asked Reynolds if he had been talking to the paper. Reynolds decided that the only course was to tough it out and denied it. But within a day or so he was summoned for an interview with GEC's legal director, Michael Lester, who told him that the company had hard evidence that he had been talking to the newspaper. Reynolds could only speculate as to precisely what that evidence was and where it had come from. His suspicion was that his phone had been bugged. If that was the case, he reckoned he would stand little chance if GEC decided to sue and a settlement was agreed. In return for a payment of £206,000, which included a year's salary, benefits in kind and a contribution to his company pension, Reynolds agreed to go quietly. When, a year later, a shareholder inquired at the AGM why Reynolds was getting compensation for loss of office when the company said at the time he had resigned, Jim Prior replied with a bluntness worthy of Weinstock himself, 'I'm not sure he would have resigned if he had not been told he was getting a year's salary, and that is why it was done.'

Unknown to Reynolds, Prior had by this time finally made up his mind that the issue of the succession could no longer be delayed and that, painful as it might be, Weinstock would have to go. GEC sources say that the initiative was taken by Jim Prior himself and was endorsed by the non-executives. Prior reasoned that it was his job as chairman to find the successor and that, in any case, it should not be left to Weinstock. He told the non-executives that obviously Weinstock would need to be consulted and would need to approve, but that the recommendation would come

from him and that ultimately, as the board's non-executive directors, the choice would be theirs. The board was well aware that the City was becoming increasingly anxious about the company's apparent reluctance, if not inability, to solve what had become the 'Weinstock problem' and the directors also knew exactly what the City thought of Simon; but there was no visit from 'the men in grey suits'.

There is a strong irony in all this: in taking steps that would bring the Weinstock era to an end, the board would for the first time be stepping outside its time-honoured role as the managing director's rubber stamp.

There were a number of possible candidates, mostly from within GEC. They included: Peter Gershon of GEC/Marconi, Malcolm Bates, the deputy managing director, David Newlands, the finance director, and Simon Weinstock himself. But the more they thought about it, the more the non-executives felt that they should not appoint someone who had grown up under Weinstock's shadow – least of all his son. If was there was going to be a change, they reasoned, then it should be a real change. A former GEC director puts it more brutally when he says, 'I always thought that an insider would never get the job. One of the less endearing features of Stanhope Gate was the way they were always rubbishing one another.'[14]

By the late autumn of 1995, all the signs were that the man on whose shoulders Weinstock's mantle was about to descend would be George Simpson, who, as managing director of Lucas, was in the middle of negotiating a mega-merger with the American company Varity. Some senior people in GEC believe that one reason Weinstock agreed to accept Simpson as his successor was that Simpson had said in the course of the negotiations that he would only take the job for five years, by which time he would be close to sixty. Weinstock's friends say that this condition gave Weinstock some small hope that, when Simpson left, the door would open for Simon. But whatever these calculations, the truth remained that, in choosing Simpson, whether they quite realized it or not, the board had decided that GEC was about to become an ordinary company again.

The 54-year-old Simpson had an impressive track record as a manager, but his personal and corporate background was utterly different from Weinstock's. So too was his style: while Weinstock was argumentative, disputatious and didactic, Simpson was open and easygoing. He likes a game of snooker with the lads and will talk golf to anyone. Simpson, who hails from Dundee, grew up in the motor industry. He joined British Leyland as an accountant in 1969 and by 1978 had risen to be finance director of BL's heavy truck business. Ten years later, he was managing director of Rover – a job that eventually led him to becoming deputy chief executive of British Aerospace after its acquisition of Rover in 1988.

Although Weinstock now realized that he could not postpone his depar-

ture much further, he still hoped to make one final gesture that would reshape GEC as dramatically and as definitively as he had done twenty-eight years before. Just as Weinstock at the beginning of his career had remade the old GEC in his own image, now at the end he was planning to leave his mark on the new GEC. In the late autumn of 1995, less than four months after his VSEL victory over British Aerospace, he started a series of very private conversations with BAe's chief executive, Dick Evans. There were, Evans says, no advisers or colleagues at these meetings: just the two of them. And what they were talking about was the merger of the two businesses, which, if successful, would have created Europe's largest defence company.

The idea that GEC and British Aerospace should get together is one that has been hanging around the City for so long that it seems as old as Threadneedle Street itself. Almost every City editor of every national newspaper has, at one time or another, forecast that the merger was 'inevitable'. And yet somehow it never seemed to happen. The nearest the two companies had come to it was in the summer of 1993, when talks between Weinstock and BAe's then chairman, John Cahill, about the merger of the two companies' defence interests had gone so well that each side had called in its merchant bankers to work on the details of an agreement. The problem was that Cahill did not have the backing of his entire board; and when the *Sunday Times* leaked the story, the critics were alerted and the talks were called off.

The City and the press were always much keener on a GEC/BAe link-up than Weinstock himself was, so his friends say. 'Arnold was never a great fan of merging with British Aerospace,' a GEC director told me.[15] 'He was very sceptical of the property and the commercial aircraft side. He was also very wary of the rationalization involved. He knew that he would have to chop out some 30,000 people and he didn't want to go through the whole AEI thing all over again.' Although GEC had the financial resources to buy BAe several times over, Weinstock always insisted both to his colleagues and to BAe itself that he would never make a hostile bid for the company. Indeed, in July 1993, as part of the ongoing merger talks, the two companies negotiated a secret two-year pact by which they undertook not to make a hostile bid for each other. This was caution not generosity on Weinstock's part. He knew that if he made a hostile bid he would not be able to see BAe's books. And as the losses were piling up from ill-judged ventures into property and commercial aircraft, Weinstock reckoned he needed to know just how deep the hole was before he committed himself. 'For Arnold to have gone hostile would have been seriously unwise,' Dick Evans said to me.[16]

By the time Weinstock and Evans began talking around November 1995, many of these anxieties had evaporated. The new management that

came in after the debacles of the regime of Professor Roland Smith had largely succeeded in turning the company round. Despite the war of words in the battle for VSEL, there were no hard feelings. 'Business is business and friendship is friendship,' says Evans. 'Besides, Arnold has always recognized that the interests of the two companies were best served by closer integration.'

Up until then, the GEC position had always been that it was only interested in BAe's defence activities while BAe insisted on all or nothing. 'It is totally unrealistic to think you could separate the defence business from the non-defence business,' says Evans. 'That was one of the differences between the two companies.' But during his talks with Weinstock in the weeks before Christmas, Evans sensed that Weinstock was amenable to a full-scale merger. 'We were closer to doing a deal than we have ever been,' he told me. 'I felt we were very close and I think Arnold felt so as well. If we had been left to our own devices I think we could have very quickly walked away with a deal.'

In their enthusiasm, Weinstock and Evans believed for a brief moment that it was a done deal and that they could carry all before them. But what Weinstock did not count on was the scepticism of his board and the outright opposition of his own son. Evans says, 'I remember sitting in his office when Arnold called him in and said, "What do you think about this, Simon?" Simon was quite taken aback by it.' GEC insiders confirm that Simon's opposition was critical and that Weinstock was very upset by it. But they add that it was not Simon alone that caused the collapse. 'Arnold was too old,' one man told me. 'At the age of seventy-one, he didn't have the chutzpah for it. And if he had pushed it, it would not have had a good reception.' It's easy to see why. Although George Simpson was by this time the front-runner for Weinstock's job, a number of main board directors still fancied their chances and thought a deal with British Aerospace would damage these.

Prospects of Weinstock staging a grandstand finish were already fading when a tragedy occurred. On 14 February 1996, Simon Weinstock suffered a stroke just ten days before his forty-fourth birthday. Doctors found it had been caused by a cancerous tumour on the brain and that the cancer had spread so far into other parts of the body that his condition was inoperable. He died just three months later on 18 May.

His father was utterly devastated. In March it was formally announced that George Simpson would take over from Weinstock after the annual general meeting in September and that Weinstock would remain as president. Although there was still business to be done, much time was spent arranging a suitable farewell for Simon. Weinstock decided that it should take the form of a memorial concert at the Royal Opera House, Covent Garden. There would be just one work, Giovanni Battista Pergolesi's

Stabat Mater, played by the Philharmona and conducted by his old friend Riccardo Muti, who would bring two soloists from La Scala, Milan.

The concert was held in October and was an exceedingly smart affair: more like a first night at the opera than a memorial service for a young businessman. Before the concert started, everybody milled about in the foyer, politicians side by side with bankers and lawyers as well as distinguished figures from the world of music and the arts. Among those who came were Willie Whitelaw, Geoffrey Pattie, Jonathan Aitken, Duke Hussey, George Solti, Lord Woolf, and Prince and Princess Michael of Kent. It was, I thought, as much a tribute to Arnold Weinstock and the power of GEC as it was a farewell to a beloved son. Once again, I was struck by Arnold Weinstock's ability to impose his personality and his will on events. The friends and colleagues had come, it seemed to me, as much to console the father as to celebrate the life of the son.

Before the concert started, Simon's widow, Laura, went up on to the stage to say a few words about her husband – 'Simon would have expected it of me.' The tone of speech was affectionate but dry. It was as if she was talking not so much about a husband as about a rather difficult commanding officer. Throughout the five-minute speech there were more references to 'duty' and 'challenge' than to fun. In her introduction, Laura explained that there was no religious significance in the choice of the *Stabat Mater* and it was being sung in Latin because that was the language of the piece. And she added, 'Simon was born a Jew and we buried him a Jew.'

For Arnold Weinstock, his last six months at GEC were bitter ones. Not only had he lost a son in whom he had invested great hope, but he felt that the job that had been his life's work had been taken away from him. A close friend who saw him during these last days found him sitting in an office with bare walls, with all the familiar pictures of his favourite racehorses gone. When the friend remarked on this, Weinstock replied, 'What do you expect? I've been hounded out.'[17]

EPILOGUE

Arnold Weinstock's final public appearance as managing director of GEC – a post he had held for thirty-three years and nine months – came at the annual general meeting of GEC shareholders, which was held in the Grand Ballroom of the Hyde Park Hilton on 6 September 1996.

With his granddaughter Pamela sitting in the front row, Weinstock took his place at the long table, on the right of his chairman, Jim Prior, and a few places along from his successor, George Simpson. He listened impassively as Prior apologized for the way the company had dealt with the new chief executive's pay package: 'I don't think we have handled this very tidily at all and I very much regret the embarrassment caused to Mr Simpson.'*

After the formalities had been completed and the shareholders had had their say (one lady complained about the way her Hotpoint washing machine tore up her clothes, while a smartly dressed young man inquired how GEC could justify killing people and whether it felt happy about this), Prior rose to pay his official farewell to Weinstock whom he described as 'a legendary figure in British industry'. Prior praised Weinstock's brilliant, original mind and said that no other industrialist in the whole of the post-war period had made a comparable contribution to the survival and success of British industry. 'He questions the commonplace and turns things upside down. When the fashion was for centralization and massive head offices, he led the move to decentralization.' Prior noted that throughout British industry there are successful managers who have worked for GEC and he concluded by paying tribute to Weinstock's courage and resourcefulness. Weinstock was, Prior said, a shy but humorous man.

Throughout this panegyric, Weinstock sat with his face down on the table top in front of him, his hands clasped together over the back of his head. And when the time came for him to rise and speak, his voice was husky and the first sentences inaudible.

He said, 'I'm very grateful to you. No one does these things on his

*The trouble arose in August when it was learned that Simpson had negotiated a pay package worth up to £1.5 million plus £1 million in share options which could be exercised if GEC's share price out-performed the FTSE 100 index by 10 per cent over the previous six months. In addition to a 'golden hello' of £500,000, Simpson's basic salary was £600,000 a year as compared to Weinstock's £568,000 in 1995.

own. It takes teams of people striving to achieve common objectives.' But he added that, while George Simpson would be in charge from now on, it was his conviction that Simpson would not destroy the old GEC regime. 'We have not got everything right but we got quite a lot right.' The shareholders gave him a standing ovation.

In the months that followed, his confidence that in his absence the old GEC would survive turned out to be grievously misplaced. He still came in to Stanhope Gate almost every day, but, as winter turned to spring, he began to complain to his friends that Simpson was ignoring him. Simpson is no butcher, but he is, so it seems, a determined man. By the following July, nearly all of the GEC old guard had disappeared. Malcolm Bates, Weinstock's faithful number two, went in March; the Honorable Sara Morrison, one of Weinstock's closest confidantes, lost her executive position on the board; Richard Needham became a non-executive director; in June, it was announced that the faithful Jim Prior and Lord Rees-Mogg would be retiring in September; and in July, David Newlands, at one time a contender for Weinstock's job, left abruptly after well-publicized differences with Simpson.

Hard on the heels of these changes came the publication, in early July, of George Simpson's nine-month-long strategic review of GEC's entire operations (see appendix). The language was mild, but to Weinstock the underlying message must have been clear enough. In the course of 750 words, Simpson indicated that he intended to demolish most of the foundations on which Weinstock's creation had rested. The cash mountain was, he implied, too large and should be reduced; the amount spent on product development was too little; and the joint ventures with Alsthom and Siemens would be reviewed and probably dismantled. Only Marconi was singled out for special mention and even here it was plain that there would be changes. Four days later, it was announced that Marconi was to link up with Finmeccanica, the Italian state holding company, in a joint pooling of defence interests. Under his leadership, he promised, GEC would become an altogether less sprawling, better focused and more growth-orientated organization than it had been. But just how this was to be achieved was left extremely vague.

Interestingly, Simpson's plan was not well received. The City, which had been expecting something more definite and more exciting, marked GEC's shares down very sharply. But whatever the immediate reaction, no one reading Simpson's report could doubt its meaning. When he said that GEC needed 'to transform itself through a process of radical change' and 'to create greater value' for its shareholders, he was saying exactly the same thing Arnold Weinstock had said some thirty years before: even the words were virtually identical. That they needed to be said does not mean that Arnold Weinstock's epic journey ended in failure. The company

he built is, for all its shortcomings, infinitely larger, more prosperous and more influential than it was. The sum has proved to be greater than its parts. But for all that, there are elements of tragedy in GEC's story. For Weinstock himself there is the personal tragedy of the loss of a son in whom such hopes were vested. There is also a feeling that, after a life of such single-minded dedication to a goal, the end result was not as magnificent as had been hoped. The comments on his departure were respectful but the tone was rather muted. It is perhaps the inevitable fate of those who carry on as long as Arnold Weinstock did that when they finally go their departure is greeted with a sigh of relief. But that cannot take away from the fact that Arnold Weinstock during his time at GEC proved himself to be not just a remarkable industrialist but a quite remarkable man. What he achieved was done not through influence or intrigue but through sheer force of intellect and character. It is, in many respects, a very unBritish story. But it is none the worse for that.

APPENDIX

Statement by George Simpson, GEC's managing director, announcing the results of his strategic review, 7 July 1997.

Since arriving at GEC, I have spent much of my time assessing the company's competitive position and performance potential and have carried out a wide-ranging strategic review.

This process has confirmed that GEC is indeed a strong company, a valuable national asset with a solid platform for future development. GEC has many leadership positions in the industries in which it operates. Numbered amongst its employees are some of the world's most creative engineers and technologists. The company has a very strong balance sheet – some would say too strong – and, despite the significant impact of the strengthening pound and a few troublesome contracts, has again in 1996/97 increased its pre-exceptional earnings. GEC today is a large and diverse company whose coherence comes from a common management style based on a strong cost control culture and whose future is closely linked to its major joint venture partners.

Despite the strength of this 'opening position' and the undoubted solidity of the platform, I believe that GEC has reached a stage in its development when it needs to transform itself through a process of radical change. This belief does not stem from a general feeling that it is 'time for a change' but from two inescapable facts. Firstly, GEC, as an increasingly global company in a rapidly changing environment, must anticipate and respond to external change more quickly. The extent and speed of the change happening in GEC's world can be illustrated by the rapid consolidation of the US defence industry, by the quickly changing profiles of its customers in the telecommunications industry and by the far reaching effects of deregulation and privatization in the energy and transport industries. Secondly, our corporate performance needs to create greater value for shareholders.

Against this background, I believe it is my job as the new chief executive of GEC to reposition the company over the next three to four years in order to create new value opportunities for our shareholders.

This repositioning will move GEC away from a disparate industrial grouping with very heavy joint venture emphasis to a more tightly focused and more GEC-managed international group whose activities will centre around market/segment leadership positions where our electronics exper-

tise and systems integration capability can be better exploited.

Our financial capacity will be deployed to strengthen GEC/Marconi's position in the USA and Europe and to build up our industrial electronics businesses worldwide. Discussions with Alcatel Alsthom are under way to determine the future of GEC Alsthom and we are in discussion with Siemens about the repositioning of GPT.

This repositioning strategy will have three elements – performance improvement; simplification and refocusing; and investment and growth. Actions are already underway in all three areas.

In the field of performance improvement, we have restructured the Board, strengthened top management, reorganized a number of businesses, introduced effective performance-related compensation policies and launched a culture change programme centred around growth, customer focus and people development while retaining our current strong cost control culture.

In terms of simplification and refocusing, our businesses have been reorganized into five business groups, several disposals have been achieved and others announced, and within each business grouping core activities worthy of investment and development have been identified.

It is clear that the growth element of our repositioning strategy will come from a combination of higher levels of product development expenditure and an acquisition programme aimed at developing a leadership position in our chosen sectors. The speed and direction of this programme will, of course, depend on the value opportunities which arise and what is happening globally in the industries in which we participate. I expect that this acquisition programme will fully utilize the Company's considerable cash resources. We shall, however, keep the opportunities for returning cash to shareholders under constant review bearing in mind the possibility of significant disposal proceeds.

Although this ambitious repositioning strategy will challenge our management teams, I believe the underlying strength of the company and its people will enable us to complete a necessary transformation.

<div align="right">G. Simpson</div>

NOTES

ONE: LEAVING STOKE NEWINGTON

1. Interview with the BBC's Sue Lawley, *Desert Island Discs*, 23 May 1993.
2. Quoted by Michael Billington, *The Life and Work of Harold Pinter*, p. 2.
3. Morris Beckman, *The Hackney Crucible*, p. xii.
4. Ibid., p. xiii.
5. Letter to author from Weinstock aide, Hon. Sara Morrison, 9 October, 1996.
6. Stephen Aris, *The Jews in Business*, p. 221.
7. Lawley, *op. cit.*
8. Interview with author.
9. Lawley, *op. cit.*
10. Ibid.
11. Robert Harris, *Enigma,* p. 3.
12. Lawley, *op. cit.*
13. Quoted by Ralf Dahrendorf, *LSE: A History of the London School of Economics and Political Science*, 1895–1995, p. 345.
14. Ralf Dahrendorf, *LSE: A History of the London School of Economics and Political Science, 1895–1995.*
15. Interview with author.
16. Lawley, *op. cit.*
17. Carol Leonard, *The Times*, 12 October 1991.
18. *The Times*,19 June 1978.
19. Interview with author.
20. Aris, *op. cit.*, p. 235.
21. Lawley, *op. cit.*
22. Aris, *op. cit,* p.190.
23. Robert Jones and Oliver Marriott, *Anatomy of a Merger: A History of GEC, AEI and English Electric,* p. 208.
24. *London Evening News,* 10 November 1967.
25. *Guardian*, 3 September 1993.
26. Christopher Sykes, *Cross Roads to Israel*, p. 438.
27. Aris, *op. cit.*, p. 221.
28. Aris, *op. cit.*, p. 239.

29. Leonard, *op. cit.*
30. *Guardian, op.cit.*
31. Keith Geddes, *The Setmakers: A History of the Radio and Television Industry*, p. 298.
32. Ibid., p. 298.

TWO: RADIO DAYS

1. Interview with author.
2. Brian Connell, *The Times*, 19 June 1978.
3. *Financial Times*, 9 July 1992.
4. Interview with author.
5. Jones and Marriott, *op. cit.*, p. 210.
6. Interview with author.
7. Interview with author.
8. Interview with author
9. Aris, *op. cit.*, p. 171.
10. Private interview with author
11. *The Times*, 12 October 1991.
12. *Guardian*, 3 September 1993.
13. Interview with author.
14. *Guardian*, 3 September 1993.
15. Interview with author.
16. Interview with author.
17. Quoted by Jones and Marriott, *op. cit.* p. 206.

THREE: EVERYTHING ELECTRICAL

1. GEC annual report, 1961.
2. Jones & Marriott, *op. cit.*, p. 80.
3. Geddes, *op. cit.*, p. 112.
4. Interview with author.
5. Ibid.
6. Graham Turner, *Business in Britain*, p. 312.
7. Interview with author.
8. Ibid.
9. Aris, *op. cit.*, p. 239.
10. GEC annual report 1965.
11. Interview with author.
12. GEC internal memo, 9 January 1969.
13. Ibid., 6 March 1975.

14. Ibid., 12 March 1963.
15. Ibid., 22 February 1965.
16. Turner, *op. cit.*, p. 312.
17. Interview with author.
18. *Financial Times*, 31 December 1996.
19. *Financial Times*, 30 December 1996.
20. Interview with author.
21. Interview with author.
22. Interview with author.
23. GEC internal memo, 13 May 1982.
24. Interview with author.
25. Interview with author.
26. *Financial Times*, 9 July 1992.
27. *Sunday Times*, 6 March 1966.
28. Ibid.
29. Jones & Marriott, *op. cit.*, p. 221.
30. Interview with author.
31. Antony Dale, *James Wyatt*.
32. Author's interview with David Ponting, head gardener at Bowden Park, 1980–96.

FOUR: THE BIRTH OF A GIANT

1. Ben Pimlott, *Harold Wilson*, p. 305.
2. Douglas Hague and Geoffrey Wilkinson, *The IRC – An Experiment in Industrial Intervention*, p. 27.
3. Sir Joseph Latham, *Take-Over: The Facts and Myths of the GEC–AEI Battle*, p. 39.
4. Interview with author.
5. Interview with author.
6. Latham, *op. cit.*, p. 33.
7. Interview with author.
8. Ibid , p. 59.
9. Hague and Wilkinson, *op. cit.*, p. 52.
10. Jones and Marriott, *op. cit.*, p. 275.
11. Interview with author.
12. Jones and Marriott, *op. cit.*, p. 274
13. *Sunday Times*, 1 October 1967.
14. Latham, *op. cit.*, p. 114.
15. *Sunday Times*, 12 November 1967.
16. Latham, *op. cit.*, p. 85.
17. Interview with author.

18. Interview with author.
19. Interview with author.
20. GEC internal memo, March 1970.
21. Interview with author.
22. *The Times*, 16 February 1968.
23. *Kentish Independent*, 9 February 1968.
24. *Kentish Independent*, 16 February 1968.
25. Ibid.
26. *Kentish Independent*, 15 March 1968.
27. *Daily Telegraph*, 6 March 1968.
28. *Kentish Independent*, 23 February 1968.
29. Tony Benn, *Office Without Power*, p. 28.
30. *Sunday Times* 2 April 1967.
31. *Sunday Times*, 11 July 1971.
32. Quoted in *The General Electric Company Anti-Report*, CIS, 1972.
33. *Sunday Times*, 11 July 1971.
34. *GEC Anti-Report, op. cit.*
35. Kentish Independent, 9 February 1968.
36. *Whatever happened to the workers in Woolwich?* PEP pamphlet no. 537, 1972.
37. John Williams, '*GEC: An Outstanding Success?*', in *Why are The British Bad at Manufacturing?* p. 139.
38. Ibid.
39. Hague and Wilkinson, *op. cit.*, p. 53.
40. *Financial Times*, 27 May 1969.
41. GEC annual report, 1969.

FIVE: ASPECTS OF ARNOLD

1. Interview with author.
2. Interview with author.
3. *Sunday Times*, 11 July 1971.
4. GEC annual report, 1969.
5. Interview with author.
6. *Sunday Times*, 11 July 1971.
7. Interview with author.
8. GEC internal memo, 15 December 1992.
9. GEC internal memo, 2 June 1982.
10. Interview with author.
11. Interview with author.
12. Interview with author.
13. Interview with author.

14. *The Times*, 19 October 1994.
15. *Observer*, 3 February 1967.
16. Private interview with author.
17. Interview with author.
18. Interview with author.
19. Anecdote recounted by Lord Rees-Mogg to author
20. Interview with author.
21. *Financial Times*, 27 May 1995.
22. *Guardian*, 4 September 1995.
23. Denis Healey, *The Time of My Life,* p. 503.
24. Private interview with author.
25. Hague and Wilkinson, *op. cit.*, p. 62.
26. GEC annual report, 1972.
27. *Financial Times*, 31 December 1996.

SIX: ARMS AND THE MAN

1. Susan Willet, *Defense Industry and Technological Change*, unpublished paper.
2. ACOST, *Defence R&D: A National Resource*, 1989.
3. Interview with author.
4. Evidence to the House of Commons Trade and Industry Committee, 4 April 1995, *Hansard*, 170.
5. Ibid.
6. Evidence to the House of Commons Defence Committee, 11 June 1985, *Hansard*, 157.
7. Susan Willett, in *The Military In Manufacturing*, Paul Quigley, Steve Schofield and Tom Woodhouse (editors), 1988.
8. Interview with author
9. Interview with author.
10. Interview with author.
11. Ibid.
12. Interview with author.
13. Interview with author.
14. The Committee of Public Accounts, Twenty-Eighth Report, 1984–85.
15. The Committee of Public Accounts, Fortieth Report, 1985–86.
16. The Committee of Public Accounts, Twenty-Eighth Report, 1984–85.
17. *Independent on Sunday*, 10 September 1995.
18. Ibid.
19. Comptroller and Auditor-General's Report, National Audit Office, 1984–85.
20. Ibid.

21. The Committee of Public Accounts, Sixth Report, 1987.
22. Ibid.
23. GEC annual report, 1987.
24. BBC *Panorama*, 18 February 1985.
25. Ibid.
26. The Committee of Public Accounts, Sixth Report, 1987.
27. Interview with author.
28. Interview with author.
29. *Independent on Sunday*, 2 June 1992.
30. *Financial Times,* 7 February 1986.
31. The Committee of Public Accounts, Sixth Report, 1987.
32. Interview with author.
33. Interview with author.
34. Michael Goold and Andrew Campbell, *Strategies and Styles: The Role of the Centre in Managing Diversified Corporations*, p. 221.
35. *Sunday Telegraph*, 17 September 1987.

SEVEN: CHIPS WITH EVERYTHING

1. Williams, *op. cit*, p. 164.
2. GEC internal memo, 27 July 1971.
3. Benn, *op. cit.*, p. 160.
4. *Daily Telegraph*, 26 May 1978.
5. Ibid.
6. Goold and Campbell, *op. cit.*, p. 238.
7. *Daily Telegraph*, 26 May 1978, *op. cit.*
8. Interview with author.
9. Alan Cawson and others, *Hostile Brothers*, p. 224.
10. Williams, *op. cit.* p.165.
11. Interview with author.
12. Advisory Council for Applied Research and Development, September 1978.
13. Quoted by Fred Warschafsky in *The Chip War: The Battle for the World of Tomorrow*, p. 231.
14. Ibid.
15. Interview with author
16. Interview with author.
17. Interview with author.
18. Interview with author.
19. *Financial Times*, 10 August 1978.
20. Interview with author.
21. *Financial Times*, 10 August 1978.

22. Interview with author.
23. *Evaluation of the Alvey Programme for Advanced Information Technology*, Science Policy Research Unit, Sussex University, 1991, p. ii.
24. *Times Educational Supplement,* 22 March 1985.
25. Science Policy Research Unit, Sussex University, *op. cit.*
26. Interview with author.
27. *Performance and Competitive Success Strengthening Competiveness in UK Electronics*, McKinsey & Company Inc., 1988.
28. Interview with author.

EIGHT: CASH IS KING

1. *Sunday Times*, 19 December 1976.
2. *Investors Chronicle*, 10 September 1976.
3. Williams, *op. cit.*, p. 145-6.
4. Williams, *op. cit.,* p. 154.
5. GEC internal memo, 12 July 1979.
6. Interview with author.
7. *Hansard*, House of Lords debates, 12 November 1981, col. 370.
8. Williams, *op. cit.*, p. 152.
9. *GEC plc, Siemens AG and Plessey Company plc*, Report of the Monopolies and Mergers Commission, 1989.
10. Goold *et al.*, *op. cit.* p. 138.
11. *Investors Chronicle, op. cit.*
12. *Financial Times*, 22 October 1978.
13. Interview with author.
14. Private interview with author.
15. Interview with author.
16. Ibid.
17. Interview with author.
18. *Financial Times*, 30 December 1996.
19. GEC annual report, 1982.
20. Quoted by Goold *et al.*, *op. cit.*, p. 113.
21. Interview with author.
22. *Financial Times*, 14 August 1989.
23. Ibid.
24. Sir Ieuan Maddock, *Civil Exploitation of Defence Technology*, 1983.
25. McKinsey, *op. cit.*

NINE: TELEPHONE WARS

1. Hansard, House of Lords debates, 16 January 1984, col. 436.
2. Alan Cawson and others, *Hostile Brothers*, pp. 87–88.
3. Hansard, House of Lords debates, 16 January 1984, col. 862.
4. Hansard, House of Lords debates, 9 February 1984, col. 1346.
5. Cawson and others, *op. cit.*, p. 98.
6. Ibid., p. 111.
7. Letter to author, 11 March 1996.
8. Geddes, op. cit., p. 179.
9. Berry Ritchie, *Into The Sunrise*, p. 29.
10. Jones and Marriott, *op. cit.*, p. 291.
11. Berry Ritchie, *Into The Sunrise*, p. 55.
12. *Financial Times,* 30 December 1988.
13. Ritchie, *op. cit.*, p. 56.
14. Monoplies and Mergers Commission, *The General Electric Company plc and the Plessey Company plc*, August 1986 p. 26.
15. *Observer*, 8 December 1985.
16. Interview with author.
17. *Sunday Times*, 20 November 1988.
18. *Observer*, 8 January 1989.
19. *Financial Times*, 7 February 1989.
20. The Monopolies and Mergers Commission, *GEC plc, Siemens AG and the Plessey Company plc*, 1989.
21. *Financial Times*, 30 December 1988.
22. Ibid.
23. *Financial Times*, 16 November 1988.
24. *The Financial Times*, 3 July 1990.
25. *Management Today*, July 1993.
26. *Financial Times*, 2 July 1997.
27. NatWest Securities Ltd, *GEC under Simpson*, 9 September 1996.
28. *Financial Times*, 14 August 1989.
29. NatWest Securities, *op. cit.*
30. Source: Datastream.

TEN: THE LONG GOODBYE

1. *Independent on Sunday*, 28 January 1991.
2. Ibid.
3. *Financial Times*, 29 October 1994.
4. *Financial Times*, 4 November 1994.

5. *Guardian*, 12 June 1995.
6. Private interview with author.
7. *Financial Times*, 9 July 1992.
8. Conversation with author.
9. Address at Simon Weinstock's memorial concert, 4 October 1996.
10. Ibid.
11. Interview with author.
12. Conversation with author.
13. Private interview with author.
14. Private interview with author.
15. Private interview with author.
16. Interview with author.
17. Private interview with author.

BIBLIOGRAPHY

OFFICIAL SOURCES

GEC annual reports 1960–1997.

Hansard, House of Lords debates, vols 413, 415, 425, 436, 446, 447, 448, 455.

Monopolies and Mergers Commission, *The General Electric Company plc and the Plessey Company plc,* CMD 9867, 1986.

Monopolies and Mergers Commission, *The General Electric Company plc, Siemens AG, and the Plessey Company plc,* CM 676, 1989.

Monopolies and Mergers Commission, *The General Electric Company plc and VSEL plc,* CM 2852, 1995.

Ministry of Defence: *The Torpedo Programme.* HC 291. Session 84/85. HMSO.

Twenty-Eighth Report of the House of Commons Committee of Public Accounts, HC 391, Session 84/85 HMSO.

Fifth Report of the House of Commons Defence Committee, HC 430, Session 84/85. HMSO.

Fortieth Report of the Committee of Public Accounts, HC 406, Session 85/86. HMSO.

Minutes of Evidence to the Committee of Public Accounts, HC 189, Session 87/88. HMSO.

Minutes of Evidence to the Committee of Public Accounts, HC 295, Session 89/90 HMSO.

Forty-first Report of the Committee of Public Accounts, HC 246. Session 90/91. HMSO.

Ministry of Defence, *Initiatives in Defence Procurement,* HC 189, Session 90/91. HMSO.

Minutes of Evidence to the Defence and Trade and Industry Committees (joint session). HC 333-ii. Session 94/95. HMSO.

SECONDARY SOURCES

Advisory Council on Science and Technology, *Defence R&D: A National Resource,* HMSO, 1989.

Advisory Council for Applied Research and Development, *The*

231

Application of Semiconductor Technology, HMSO, 1978.

Aris, S. *The Jews in Business*, Cape, London, 1970.

Beckman, M. *The Hackney Crucible*, Valentine Mitchell, London, 1996.

Benn, T. *Office Without Power*, Hutchinson, London, 1988.

Billington, M. *The Life and Work of Harold Pinter*, Faber and Faber, London, 1996.

Blackstone, T. and Plowden, W. *Inside the Think Tank*, Heinemann, 1988.

Calder, A. *The People's War, Britain 1939–45*, Cape, London, 1969.

Cawson, A. *et al.*, *Hostile Brothers, Competition and Closure in the European Electronics Industry*, Clarendon Press, Oxford, 1990.

Dahrendorf, R. LSE. *A History of the London School of Economics and Political Science, 1895–1995*. Oxford University Press, Oxford, 1995.

Dale, A. *James Wyatt*, Basil Blackwell, Oxford, 1956.

Geddes, K. *The Setmakers, A History of the Radio and Television Industry*, The British Radio and Electronic Equipment Manufacturers Association, London, 1991.

Goold, M. and Campbell, A. *Strategies and Styles, The Role of Centre in Managing Diversified Corporations*, Basil Blackwell, Oxford, 1987.

Hague, D. and Wilkinson, G. *The IRC: An Experiment in Industrial Intervention,* George Allen & Unwin, London, 1983.

Lord Healey, *The Time of My Life*, Michael Joseph, London, 1989.

Jones, R. and Marriott, O. *Anatomy of a Merger, A History of GEC, AEI, and English Electric*, Cape, London, 1970.

Sir J. Latham, *Take-Over: The Facts and Myths of The GEC–AEI battle*, Iliffe, London, 1969.

Sir I. Maddock, *Civil Exploitation of Defence Technology*, NEDO, 1983.

McKinsey and Company Inc., *Performance and Competitive Success, Strengthening Competitiveness in UK Electronics*, NEDC Electronic Industry Sector Group, 1988.

Morgan, K. *et al.*, The GEC–Siemens Bid for Plessey: The Wider European Issues, Science Policy Research Unit, University of Sussex, 1989.

NatWest Securities, *GEC Strategic Assessment*, September 1996.

Sir G. Owen, *National Environment and International Competitiveness, A Comparison of The British Pharmaceutical and Electronics Industries*, The Foundation for Manufacturing and Industry, London, 1994.

Pimlott, B. *Harold Wilson*, HarperCollins, London, 1992.

Ritchie, B. *Into the Sunrise, A History of Plessey*, James and James, London, 1989.

Science Policy Research Unit *et al.*, *Evaluation of the Alvey Programme for Advanced Information Technology*, HMSO, 1991.

Sykes, C. *Crossroads to Israel, Palestine from Balfour to Bevin*, Collins, London, 1965.

The General Electric Company: Anti-Report, CIS, London, 1972.

Thomas, S. and McGowan, F. *The World Market for Heavy Electrical Equipment*, Nuclear Engineering International Special Publications, Sutton, Surrey, 1990.

Williams, J. et al., *Why Are the British Bad at Manufacturing?* Routledge, C. & Kegan, P. London, 1985.

Warshafsky, F. *The Chip War. The Battle for the World of Tomorrow*, Charles Scribner's Sons, New York

INDEX

Tomlin, George 72
Touche Ross 34, 41
trade unions 72–4, 75–7, 87–90
Trollope, Glen 87
Troy (racehorse) 30
Turner, Graham 94, 143, 207
 Business in Britain 39–40
Tynan, Kenneth 62

Ultra 20
unions *see* trade unions
United Scientific Holdings 132
Urwick Orr 41

Veale, Sir Alan 62–3, 69–70, 72,
 84, 85, 107
Vesely, Kurt 15–16, 22
Vice, Anthony 54
Vickers (Crayford) 74
Villiers, Sir Charles 28, 61n, 78,
 109
Vodafone 192
VSEL 180, 203, 204–6, 208, 211,
 212

Waldegrave, William 32n
Walls, Stephen 192
Walsh, Arthur 46–7, 48, 107,
 116, 119, 120, 121–2, 123,
 124, 160–61
Walsh, Stephen 47
Warburg, S. G. (merchant bank)
 28, 29, 64, 206
Warburg, Siegmund 28–29
Weinig, Dr Sheldon 148
Weinstock, Arnold (*see also*
 GEC):
 at Admiralty, Bath 9–10
 and air travel 52
 and Alvey Programme 163–4
 assumes command of GEC 43–6
 and bill paying 32
 birth 1
 and Bond 25–7
 budgetary meetings 49–50
 buys Bowden Park 57–8

 and cash 50–51, 150, 167, 168,
 171–2
 childhood 3–4, 5–6
 and death of son 212–13, 217
 dislike of management
 consultants 41–2
 dislike of personnel staff 42–3,
 75 *and n*
 education 5, 6–7
 elevation to peerage 169, 170
 factory visits 40, 102
 and foreigners 142–3
 and GEC/British Aerospace
 merger 211–12
 and government departments
 107–8, 110–11
 and Hirst 36
 horror of perks 51–2
 hostility to Inmos 154–5
 House of Lords speeches
 168–9, 181–2, 183–4
 interest in horses 8, 29–30, 53
 Jewishness 3–4, 13–14, 61 *and n*
 leisure interests 26, 57–8
 love of music 4–5
 management style 31, 32,
 69–71, 98–103, 104–5,
 106–7, 136, 137–8, 143–4,
 161, *see also* memos
 marriage 12, 14
 memos 9–10, 42–43, 44–6, 48,
 70–71, 91–4, 97–8
 and missed opportunities 175–6,
 177–8, 192
 monthly reports 47, 49
 personality 8, 11, 12, 21, 22,
 36, 94–5, 96, 102, 105, 106,
 184n, *see also* management
 style
 as private employer 103–4
 in property business 10, 11–12
 at Radio and Allied 19, 20–24,
 27–9, 30–32
 and R&D 158–61
 and redundancies 46, 53–5,
 68–9, 72–7